SCOTTISH ART SINCE 1900

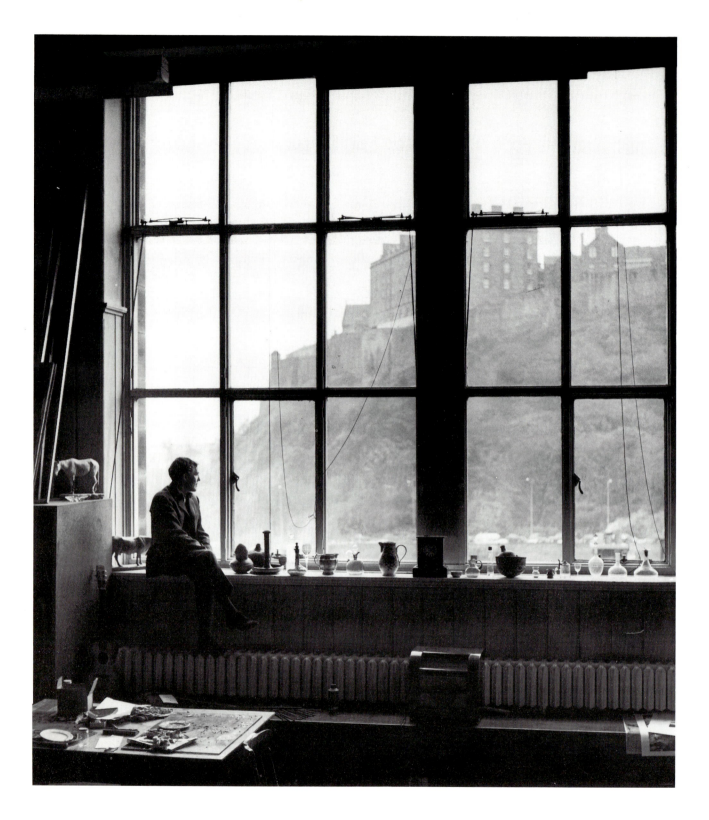

Keith Hartley

Scottish Art since 1900

NATIONAL GALLERIES OF SCOTLAND

IN ASSOCIATION WITH

LUND HUMPHRIES LONDON

First edition 1989
Published by Lund Humphries Publishers Limited
16 Pembridge Road, London W11
in association with the
National Galleries of Scotland

British Library Cataloguing in Publication Data
Hartley, Keith
Scottish art since 1900
1. Scottish visual art. History
I. Title II. National Galleries of Scotland
709′411

ISBN 0 85331 559 0

Catalogue of the exhibition
Scottish Art since 1900

Scottish National Gallery of Modern Art, Edinburgh
17 June–24 September 1989

Barbican Art Gallery, London
8 February–16 April 1990

SPONSORED BY BAILLIE GIFFORD & CO

Edited by Richard Calvocoressi, Keith Hartley and Charlotte Burri
Designed by Caroline Johnston
Printed in Great Britain by BAS Printers Limited,
Over Wallop, Stockbridge, Hampshire

front cover
J.D. Fergusson
Dieppe, 14 July 1905: Night 1905
(cat. 113)

back cover
James Cowie
Portrait Group 1932/c.1940
(cat.69)

frontispiece
Robin Philipson in his studio
at Edinburgh College of Art, 1965

Contents

Foreword and Acknowledgements

The last few years have seen a rapidly growing interest in twentieth-century Scottish art, from the Colourists in the decade before the First World War to the young figurative painters of the 1980s who were the subject of our own exhibition, *The Vigorous Imagination*, at the 1987 Edinburgh Festival. The present exhibition is the first of its kind to trace in depth the history of modern Scottish art from 1900 to the present day. It comprises some 360 paintings, sculptures, prints and drawings by 110 artists, over two-thirds of which are drawn from the permanent collections of the National Galleries of Scotland. A certain amount of architectural material has been included where relevant – for example, the work of Charles Rennie Mackintosh and Basil Spence, both of them fine draughtsmen – and also because architecture is an art at which Scots have traditionally excelled.

When the Scottish National Gallery of Modern Art opened in Edinburgh in 1960, a handful of paintings was transferred from the National Gallery of Scotland, including Peploe's *The Black Bottle*, Pringle's *Poultry Yard, Gartcosh*, Cadell's *The Model* and Hunter's *Reflections, Balloch*. The massive task of building up the Scottish collection was undertaken by Douglas Hall, Keeper of the Gallery from 1961–86, and has been pursued by his successor Richard Calvocoressi. Although many artists, schools and styles are now well represented, we are conscious of significant gaps, particularly in the area of inter-war realist painting.

The exhibition has been conceived by Keith Hartley, Assistant Keeper at the Gallery of Modern Art, in consultation with Richard Calvocoressi and the other members of the curatorial staff. Keith Hartley has also written the major essay in this catalogue, which breaks new ground in its analysis of the development of Scottish art this century. The artists' biographies have been compiled by Patrick Elliott, Fiona Pearson and Ann Simpson (who also compiled the bibliography). The chronology of artistic life in Scotland is the result of a collaborative effort involving all the names mentioned above. Initial research was carried out by Pamela Stott and Jonathan Livingstone. The typing was done by Moira Spence and Alice O'Connor: we are especially grateful to the latter for her willingness to work unreasonably long hours in order to see the typescript finished. On the administrative and practical sides, Jonathan Mason and his team have been responsible for the efficient handling of over 100 borrowed works; in addition, Margaret Mackay has been in charge of the arrangements for siting sculpture outdoors. This is the place to thank those artists who have created work specially for the exhibition: Doug Cocker, David Mach, Tracy Mackenna, Bruce McLean and Valerie Pragnall. The considerable task of conservation and framing has been carried out by John Dick and his staff. At Lund Humphries, Charlotte Burri's impeccable copy-editing has greatly improved the text of this catalogue; while Caroline Johnston's design is a model of clarity and elegance.

An exhibition and publication of this size could not have been achieved without a large measure of outside assistance. Our first debt is to Baillie Gifford & Co. for making possible such a handsome catalogue. In addition to the lenders, who are listed at the back, we would particularly like to thank the following, all of whom have given invaluable help or advice: Anne Barlow, Neil Baxter, John Bellany, Halla Beloff, Roger Billcliffe, Freda Bone, Boyle Family, David Brown, Michael Brown, Neil Cameron, Hugh Cheape, Ruth Christie, Glenn Craig, Ivor Davies, Richard Demarco, Ann Donald, William Gear, Esme Gordon, Ian Gow, Andrew Guest, Douglas Hall, Sean Hignett, Martin Hopkinson, Margaret Cursiter Hunter, Lady Hutchison, Victoria Keller, Nora King, Barclay Lennie, Hew Lorimer, Robin Lorimer, Kathleen Mann, Rosalind Marshall, Margaret McCance, Nigel McIsaac, Charles McKean, Margaret Mellis, Michael Moss, Andrew Neil, Ian O'Riordan, Cordelia Oliver, Andrew McIntosh Patrick, David Patterson, Benedict Read, Alan Reiach, Sir Norman Reid, Barry Roxburgh, Sarah Shott, William Smith, Joanna Soden, William Turnbull, Meta Viles, Valerie Walker, Alexander Carrick Whalen and Clara Young.

Finally, we are delighted that the exhibition will be shown at the Barbican Art Gallery, London in early 1990.

TIMOTHY CLIFFORD
Director, National Galleries of Scotland

Introduction

Any attempt to define a national school or style of art in this most international of centuries runs a high risk of failure, and yet some explanation is needed for the pinning of a national badge on the artists included in this publication and in the exhibition which it accompanies. To determine whether a person's work is 'Scottish', we took the view that he or she will almost certainly have been educated for all or part of the time in Scotland, or may have taught here for a significant period, or both. A Scottish education is different from an English one: this applies equally to art school training. Being Scots by birth, or being born in Scotland, helps but is not enough on its own. For example, we felt we had to exclude Duncan Grant who, though born in Inverness-shire, was educated in England, attended art school in London, became a leading figure in the Bloomsbury circle of artists and writers, and for the last forty years of his life lived permanently in Sussex. On the other hand the Sussex-born Englishwoman Joan Eardley moved to Scotland at the age of eighteen, studied at the Glasgow School of Art and later at Hospitalfield under James Cowie, and spent the remainder of her short life in Scotland. She was both nourished by, and contributed to, a vital tradition in Scottish painting. More borderline is the case of foreigners who had some influence on the course of art in Scotland, such as Jankel Adler and Josef Herman in Glasgow during the Second World War. Each arrived with a more or less fully formed style, neither stayed long, and so on balance we thought it fairer to leave them out.

If residence outside Scotland, for economic, personal or other reasons, were a disqualifying factor, there would be no book or exhibition. But the often repeated theory that the best Scottish artists are those forced by neglect to go south is not one that we find wholly convincing. It has recently been suggested that the image of Charles Rennie Mackintosh 'spurned by Glasgow, abandoned by Scotland, and only rediscovered in mid-century' has become something of a myth; and that Mackintosh's influence on Scottish architecture in the 1930s was profound.[1] One of the points to emerge from this survey is the alternating importance of Glasgow and Edinburgh as artistic centres. In 1900 Edinburgh was still overshadowed by Glasgow, with its internationally famous school of painters, the Glasgow Boys, its industrialist collectors and dealers in French art, and its brand new art school, hailed by *The Studio* as 'one of the most complete and best equipped in the United Kingdom'.[2] The reputation of the Glasgow School of Art was still high in the 1920s but by the 1930s it was Edinburgh's turn to usurp the limelight. Under Hubert Wellington, Principal from 1932–43, Edinburgh College of Art became arguably the liveliest and most liberal art school in Britain. Thanks to the Andrew Grant Bequest, Wellington was able to award travelling scholarships, in order, as one distinguished beneficiary recalls, 'to make the students good Europeans'.[3] Himself a painter, from 1919–23 Wellington had been the first guide lecturer at the National Gallery in London. The notion of the painter-teacher was one that he was able to encourage in Edinburgh through the College's links with Moray House College of Education, where a number of his students trained after taking their degree.

Andrew Grant Travelling Scholarships and Fellowships were also awarded to architectural students at Edinburgh College of Art, where John Summerson was a junior lecturer from 1929–31. Summerson's vision of an 'Edinburgh of the future, a glittering spectacle of steel, glass, and concrete'[4] may not have met with widespread approbation, but there were a handful of young architects prepared to build in a Bauhaus or Scandinavian-modern idiom while still conscious of traditional Scottish forms.[5] One such was Alan Reiach who in 1940 designed a museum of modern art for Scotland at the request of Stanley Cursiter, then Director of the National Galleries of Scotland. The design was never built but from surviving notes and sketch plans, together with a model made by Cursiter himself, it is possible to form a good picture of what the gallery would have looked like.

Cursiter's ideas were ahead of his time. Throughout the 1930s he had been campaigning for a museum that would show not only modern art but also craft and industrial design. There would be facilities for film, performance and sound, and a circulating exhibitions department. Above all, he saw his ideal museum as having a didactic function. Cursiter's writings on art education were very much in line with those of Herbert Read. It is worth recalling that from 1931–33 Read was Professor of Fine Art at the University of Edinburgh. In his inaugural lecture, 'The Place of Art in a University', he argued forcefully for the inclusion of contemporary art in the syllabus: 'We cannot fully

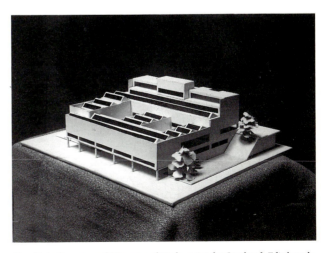

Alan Reiach, proposed Museum of Modern Art for Scotland, Edinburgh 1940 (cat.314). Model made by Stanley Cursiter

participate in modern consciousness unless we can learn to appreciate the art of our own day'.[6] Read's subsequent course of lectures, which students from the Art College would also have attended, followed to a certain extent the format of his book *The Meaning of Art*, published in 1931 shortly after he came to Edinburgh.[7] In 1937 Cursiter, perhaps echoing Read, lectured on 'The Place of the Art Gallery in the Life of the Community'.[8] In outlining the benefits which he felt his museum could bring, both aesthetic and commercial, i.e. as a means of improving both public taste and industrial design, Cursiter seems to have been thinking on this occasion (unusually) of a gallery consisting exclusively of modern *Scottish* art and craft. He certainly saw his 'art centre', as he later called it, as incorporating 'an historical collection of works considered important in the development of Scottish Art.'[9] And from now on the proposal to found a museum of modern art in Scotland becomes confused with the patriotic desire for a gallery exhibiting modern Scottish art.

Another who promoted the idea of native qualities in Scottish art, in which he included the long tradition of anonymous craftsmanship in Scotland, was Ian Finlay, who joined the Royal Scottish Museum in 1932. After the war Finlay published two important books, *Scottish Crafts* and *Art in Scotland*. The latter ends with a plea for 'the establishment of a gallery of modern art in Edinburgh'. Finlay did not restrict this to a collection of vernacular art, but he recognised that 'the Scottish point of view is not the English, and a quite different emphasis may be required in selecting paintings in relation to the living Scottish tradition'.[10] In the same year, 1948, the Academician W. O. Hutchison took the debate a stage further by calling for 'a gallery where the best of Scottish work could be seen':

It is only by a permanent, carefully screened and chronological collection that we can show that there is a

Scottish tradition reflecting the minds and characteristics of those that live in Scotland.[11]

The Gallery of Modern Art that was eventually founded in 1959, as an extension to the collections of the National Gallery on the Mound, represented a compromise between the internationalist outlook of the 1930s and the nationalist mood of post-war Scotland. In his opening address, Kenneth Clark gave official (if somewhat patronising) recognition to modern Scottish art:

You will inevitably buy many works of Scottish artists and here you are fortunate in having many young or youngish men and women of real talent so that patriotism will not be (as it so often is) the enemy of truth.[12]

Much has happened in the last thirty years. Edinburgh's role in the underground movement of the 1960s has passed into history.[13] Jim Haynes's Paperback bookshop and experimental Traverse Theatre; the International Drama Conference at the 1963 Edinburgh Festival, with its Happenings devised by Ken Dewey and Allan Kaprow; Mark Boyle's first show at Richard Demarco's Traverse Theatre Gallery the same year; and the subsequent growth of the Demarco Gallery, culminating in *Strategy: Get Arts* and the first visit of Joseph Beuys in 1970 – all these helped secure Edinburgh's place on the international map. More recently, Glasgow has shown signs of reasserting its position as Scotland's leading cultural city. In the last decade a dynamic group of painters has emerged from the Glasgow School of Art, which is once again regarded as one of the top art colleges in Britain. Finally, the 1988 Glasgow Garden Festival gave a big encouragement to young Scottish sculptors, a number of whom are now producing exceptionally interesting work. Scotland lacks a strong and continuous sculptural tradition but there are signs that this may be changing too.

Notes

[1] Charles McKean: 'The Influence of Mackintosh in the 1930s', *Charles Rennie Mackintosh Society Newsletter*, No.47, autumn 1987, pp.3–4. See also McKean's *The Scottish Thirties: an Architectural Introduction*, Edinburgh 1987.

[2] *The Studio*, Vol. XIX, 1900, p.56.

[3] Sir Norman Reid: letter to the author, received 12 April 1989. Reid's fellow students at Edinburgh in the 1930s included William Gear, Margaret Mellis and Wilhelmina Barns-Graham.

[4] J. N. Summerson: 'Modernity in Architecture: an Appeal for the New Style', *The Scotsman*, 21 February 1930, p.8.

[5] For example, William Kininmonth (1904–88), Robert Matthew (1906–75), Basil Spence (1907–76) and Alan Reiach (b.1910), all students at Edinburgh College of Art in the late 1920s–early 1930s. Spence also lectured at the College part-time from 1931–34. Reiach, together with Robert Hurd, published *Building Scotland: a cautionary guide* in 1940 (revised and enlarged ed. 1944). Resembling a Bauhaus book in its use of photographs and typography, it called for a return to the strength and simplicity of native Scots architecture while also pointing to new developments in Scandinavia, Czechoslovakia and Switzerland.

[6] Herbert Read: *The Place of Art in a University*, Edinburgh and London 1931, p.25.

[7] Picasso, Chagall, Klee and Henry Moore are the principal twentieth-century artists whose work is

discussed in *The Meaning of Art*. In his Edinburgh lectures, Read also mentioned, and illustrated work by, Munch, Matisse, Derain, the Cubists, Severini, de Chirico, Ernst, Arp, Zadkine, Brancusi, Giacometti, Epstein and Hepworth. One lecture was devoted to modern architecture, with particular reference to Le Corbusier (typescript of Herbert Read's lectures, collection Benedict Read).

[8] Address given to the Edinburgh Group of the Institute of Public Administration, January 1937 (typescript in National Library of Scotland).

[9] Stanley Cursiter: *Looking Back: a Book of Reminiscences*, Edinburgh 1974, p.28 (published privately).

[10] Ian Finlay: *Art in Scotland*, Oxford 1948, p.172. Finlay was a curator of the Royal Scottish Museum when the exhibition of *Scottish Everyday Art* was held there in 1936. Selected and designed by Basil Spence, with the assistance of a sub-committee (which included Hubert Wellington) of the Scottish Committee, Council for Art and Industry, the declared aims of the exhibition were 'to improve the artistic taste of the public, and . . . to show visitors . . . the very high artistic standard of Scottish manufactures'. The objects were grouped according to the following categories: aluminium, furniture, printing, books, tweeds and woollens, lace, linens and silk, muslins and artificial silks, carpets, sports requisites, metal work, glass, book-bindings, leather and sculpture. In addition, there were four 'specimen rooms' designed by Spence.

Reviewing the exhibition, Finlay was concerned that the strong craft tradition in Scottish industries might be damaged 'by an attempt to educate the taste of the designers themselves' (*The Studio* vol. CXII, July 1936, p.28). He returned to this theme in his book *Scottish Crafts*, singling out metal work and the vernacular architecture of the sixteenth and seventeenth centuries for their 'native qualities' of functional ornament, unconscious beauty and 'a certain ruggedness and vigour and bluntness of statement' (London 1948, pp.11–12). In his 1937 talk (see note 8), Cursiter had also referred to the Scots' 'genius for construction, in engineering and in many other directions'; and to 'the use of pattern, in Celtic ornament, in tartans, in tweeds', as 'an outstanding feature of our native art'.

[11] 'Modern art: Edinburgh's Need for a National Gallery', *The Scotsman*, 17 December 1948, p.4. Between 1949 and 1956 Alan Reiach prepared a number of schemes for a modern art gallery in different parts of the city, none of which was adopted.

[12] Address delivered by Sir Kenneth Clark at the opening of the Scottish National Gallery of Modern Art, Inverleith House, 10 August 1960 (typescript in SNGMA archive).

[13] See, for example, Robert Hewison, *Too Much: Art and Society in the Sixties 1960–75*, London 1986.

Scottish Art since 1900

The question of what constitutes a Scottish identity and a Scottish artistic tradition is a leitmotiv that runs throughout the history of art in Scotland this century. This is a necessary concomitant of being a nation within a nation. Questions of identity naturally arise, when 'British' is all too often equated with 'English', simply because it is the dominant (ie much larger) culture in the union. Scots artists tend either to emphasise what they see as their specifically Scottish characteristics in the face of this cultural hegemony or to see themselves in an international art context rather than be subsumed under the label 'British'. This latter stance has become much more tenable and understandable this century with the increasingly rapid spread of information from one country to another. Movements started in one country have appeared almost simultaneously in another, albeit with different emphases, because similar artistic debates are being conducted in all the major art schools, art journals and other artistic fora in the western world. News travels quickly. Nevertheless, national artistic consciousness has by no means disappeared. In a world of increasing standardisation the particular and the individual become prized. Small is beautiful. And, indeed, the search for national identity has played no small part in the development of key movements in twentieth-century art. German Expressionism grew, at least in part, out of a desire to stress the German-ness of German art, its concern for spiritual content, strength of feeling and spontaneity, as opposed to the order and balance of French art. Similarly, Scottish artists such as J. D. Fergusson and John Bellany have sought to define a Scottish tradition within which they worked, which gave their art added resonance in the life of the nation and which would form a solid basis for future artists to work upon. It is worth examining the particular characteristics that these two artists picked out as being Scottish, because they have in many ways formed the two poles (*not* mutually exclusive) around which much of Scottish art (and debate about Scottish art) has centred. In his book *Modern Scottish Painting* (1943) Fergusson talks about 'the Scots characteristic of independence, and vigour, colour and particularly quality of paint, which means paint that is living and not merely a coat of any sort of paint placed between containing lines like a map'.[1] I am sure Bellany would not deny the importance of any of these characteristics – they are, indeed, qualities very evident in his own work – but he lays the emphasis elsewhere: not so much on *formal* as on *human* values. Independence, vigour and colour are merely means to an end, which is a heightened awareness of our human potential, both negatively for evil and positively for good. Wilkie is in this respect one of Bellany's local heroes.

Significantly, both Fergusson and Bellany (and these artists are only taken as representatives, albeit highly influential, of views widely expressed) do not merely attempt to locate these characteristics within a purely Scottish tradition. Scotland is a small country that constantly feels the presence, culturally as well as materially, of its much larger neighbour south of the Border. To assert its own identity, it needs to differentiate itself from English culture and to seek cultural allies elsewhere. Fergusson, who spent a large portion of his life in France and was actively involved in the artistic revolutions that took place in Paris before the First World War, naturally looked to the 'Auld Alliance'. He wrote:

> To go to Paris was the natural thing for the Scot. It is not as the modern Scot or the Teutonic Scot seems to think, a new fantastic idea. Besides that, it doesn't seem to have occurred to the modern Scot that the Scottish Celt, when in France, was among his own people the French Celts. French culture was founded by the Celts, and invasions have not changed the fundamental character of the French people. Every Celt feels at home in France. The 'esprit Gaulois' (the Celtic spirit) still exists and has not been submerged by Calvinism as it has been in Scotland. If Scotland or Celtic Scotland would make a 'new alliance' with France, not *political* like the 'Auld Alliance' but *cultural*, it would perhaps put Scotland back on to the main track of her culture, and let the Scots do something Scottish instead of imitation English, or rather second-rate British,[2]

This Franco-Scottish alliance is echoed by many Scottish artists, critics and writers this century, who have wished to uphold *belle peinture*. It has often been seen as the hallmark of the best of Scottish art this century. However, there are other traditions and Bellany's espousal of the North European, Germanic (in the widest sense) tradition which is expressive, often earthy, sometimes realistic, sometimes symbolic, and runs from Bosch, through Breughel, Cranach, Rembrandt, Fuseli, van Gogh, Munch, Kirchner, Beckmann and Dix, is only the most recent renewal of an alternative cultural alliance. The Teutonic Scots of whom Fergusson speaks were extremely vociferous in the nineteenth century[3] and in the 1930s there was an attempt to shift the focus away from France to Germany and Scandinavia.[4]

While maintaining the importance of these foreign links as powerful symbols and psychological supports for many Scottish artists, it would be wrong to ignore the very real links between Scottish and English art this century. While it is true that many Scottish artists, at least until the 1960s, would tend to go to Paris rather than London to continue their studies, London has always been the natural target for Scottish artists wanting to make their reputations.[5] This was, and is still, the main centre for showing (and selling) contemporary art in Britian, where an artist is most likely to be seen by an international audience.[6] Many Scottish artists (and often the most enterprising and best) have felt the need to move to London in order to enjoy the advantages that it has to offer. This has meant that not only have they become more closely linked with the *English* art world, and thus, of course, enriching the general *British* heritage, but they have been removed, at least on a day-to-day basis, from direct contact with their Scottish contemporaries. While some artists

such as John Bellany, however, have maintained a very close link with Scotland, returning frequently and showing there regularly, others have almost cut off their contact with the Scottish art world. This makes it very difficult to talk about Scottish art as a 'school', developing in one definable place with a centre (or even centres) to give it cohesion. And yet, the fact that, in all but very rare instances, the artists in question would never think about themselves as anything but Scottish, that there are certain traditions, certain characteristics, that one can trace from artist to artist and from generation to generation which are distinct from, say, English traditions and characteristics, does make the term Scottish art more than just a label, but a living thing.

The history of art cannot be parcelled up into neat periods with a beginning and an end, but the start of a new century and 1900 in particular did excite the imagination of artists and quickened the pulse with an optimism that a new, brighter and healthier future was in store. In Glasgow there had in fact, already been a renewal in painting with the Glasgow Boys and in design with Glasgow Style (Glasgow's version of Art Nouveau). Modern life subjects, often painted *en plein air* and with a bright, colourful palette, reflected the pride in achievement of a wealthy Glaswegian middle class. Glasgow, second city of the Empire, was booming and following on from its successful 1888 International Exhibition, it planned another such exhibition in 1901. However, by 1900 the Glasgow Boys had ceased to be the innovative force they had once been. Artists such as John Lavery and James Guthrie turned increasingly to painting fashionable society portraits, George Henry and E. A. Hornel became increasingly formulaic in their pictures of oriental scenes or sentimentalised groups of children. It was left to John Quinton Pringle to carry on and develop the best of the tradition of the Glasgow Boys. He was even more consequent in depicting the world as he saw it, painting the working streets and back courts of Glasgow in a way that recalls contemporary photography: objective, detailed and unsentimental. He also developed the small square brushstroke used by some of the Glasgow Boys to create a form of *pointillisme*, of small touches of pure colour, that make such a painting as *Poultry Yard, Gartcosh* 1906 (cat.303), vibrate with light. Pringle, who certainly sought out any innovations that he thought might help him in his art, may have been influenced by Neo-Impressionist works that he saw at the Glasgow Institute exhibitions. Certainly he realised the importance of pure colour in emphasising the surface qualities of a picture. He was not, however, to play an influential role in the development of Colourism in Scottish art. He showed infrequently, painted only a small body of work and remained an optician by profession all his life. He is one of several Scottish artists this century whose innovations have not yielded their fullest fruit.

Charles Rennie Mackintosh was another such artist. What he achieved in the field of architecture, and furniture and interior design, was to clear away the historical accretions of centuries of succeeding styles, to get away from the Victorian obsession with past art and base his art on a fresh look at natural forms and a feeling for light and freely flowing spaces. His masterpiece, the Glasgow School of Art (1897–99 and 1907–9) has memories of Scottish baronial architecture, but it is indubitably a building of this century with an emphasis on form follow-

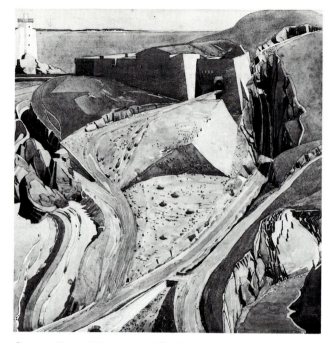

CHARLES RENNIE MACKINTOSH **The Fort** *c.*1924–26 (cat.214)

ing function, on clean lines, on airiness and on discrete decorative detailing. His furniture became more geometrical and less organic in the early years of this century. The revolving bookcase designed in 1904 for Miss Cranston's house, Hous'hill, at Nitshill, Glasgow (cat.213), illustrates this development to perfection. First appearances suggest a highly geometrical, almost Constructivist rigour in the treatment of white painted upright dividers, the number of which doubles on each succeeding level from bottom to top. This serial progression does, however, have an organic origin, representing the natural division of a tree from trunk to branches, to twigs. Even the blossoms are represented in the form of inset squares of purple enamel. It is as much a sculpture as a piece of furniture. Mackintosh's move in design and architecture from Art Nouveau, organic forms to an increasingly geometrical functionalism is paralleled in his watercolours by the abandonment by 1900 of the rather fey symbolism as practised by his wife Margaret Macdonald, her sister Frances McNair and other Glaswegian artists such as Jessie M. King, and a concentration on a detailed depiction of plants and flowers. As disillusion set in by 1920 at the lack of appreciation of and even hostility towards his architecture he turned to painting watercolours and gave up practising architecture. Glasgow largely turned its back on the bold innovations he had made and it was not until the 1930s and particularly after his memorial exhibition in 1933 that Scottish architects (mainly from Edinburgh) turned to his architecture for inspiration.[7] In the 1920s Mackintosh painted a series of landscapes in watercolour, at first in Dorset in 1920, and then in the South of France from 1923 to 1927. These French watercolours are quite remarkable. A mixture of obsessive detail and bold stylisation, of flat patterning and sculptural form, they convey no sense of life or lived experience. They are more like hallucinated visions.

While they probably owe something to the repetitive, decorative quality of Klimt's and Schiele's landscapes (particularly their townscapes), they also have a strong affinity to the prints being done by James McIntosh Patrick and Ian Fleming in the late 1920s of Mediterranean landscapes.

Edinburgh in the late nineteenth century was not as lively artistically as Glasgow. To be true it had outstanding individuals such as William McTaggart, but there was no whole movement as represented by the Glasgow Boys. The Royal Scottish Academy, which was supposed to be a national institution, but was largely orientated towards Edinburgh, did not show the adventurous spirit towards new art, especially from France, that its younger sister organisation, the Royal Glasgow Institute did. However, things began to alter significantly after 1892 when James Guthrie, a leading 'member' of the Glasgow Boys, was elected President of the Academy. Gradually, more of the best Glasgow artists, including John Lavery and George Henry, were elected members. The breath of fresh air from the west was to effect such young artists as J. D. Fergusson and F. C. B. Cadell, both of whom were influenced by Arthur Melville in their early years. James Pryde, however, came from an earlier generation and attended the schools of the Royal Scottish Academy in the 1880s. Admittedly he did receive encouragement from James Guthrie and E. A. Walton, who advised him to go to Paris, but it was to London that he eventually gravitated in about 1890, and it was here that he came under the influence of Whistler and Velazquez (whose reputation was then extremely high and who was to influence another Edinburgh artist living in London, Ethel Walker). Pryde is one of those Scottish artists, whose style has more in common with contemporary English art than with the work of his fellow Scots. The paintings of his brother-in-law (and co-creator of the 'Beggarstaff Brothers' posters of the 1890s) William Nicholson, of William Orpen and Walter Sickert are nearest in general tenor to his dark claustrophobic world, and yet Pryde's work is very much that of a Romantic Scot. It is filled with memories of the Edinburgh he grew up in, memories made more vivid and haunting by physical separation. The paintings are redolent of spectacular theatre sets – Pryde was a friend of Edward Gordon Craig and actually toured Scotland in 1895 acting in Craig's company – but they are even more redolent of the monumental architecture of Edinburgh, the Georgian Churches of the New Town, the old Linen Bank building on St Andrew Square, the massive Piranesian bridges that link the various hills of the city and the narrow, atmospheric closes of the Old Town, lit by dramatic shafts of light that descend between the tall dark tenements. Pryde even constructs a sort of narrative, a journey from life to death, based on his memories of Mary Queen of Scots's four-poster bed in Holyrood Palace in the form of a series of thirteen paintings entitled *The Human Comedy*. Highly mannered (not to say Mannerist), unreal, even dreamlike, Pryde's pictures belong to the world of Symbolism rather than to any contemporary movement, although remarks made in the 1930s to the effect that he was 'Britain's de Chirico' are not that wide of the mark considering the genealogy of de Chirico's own art.

Pryde did for a while at the turn of the century exert a certain influence on his fellow Scots. Certainly J. D. Fergusson in such a picture as *Bar at Public House c.1900* (cat.110) shows the same broad handling and dark, tonal palette that Pryde used for his

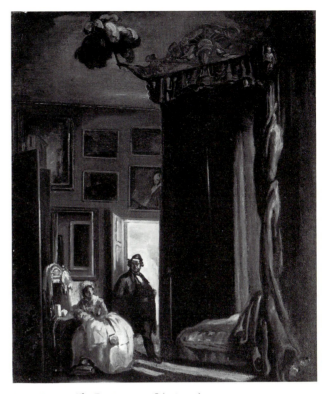

JAMES PRYDE **The Doctor** *c.*1908 (cat.304)

own paintings of London low life and bohemian haunts. However, the more general influence at this time on artists such as Fergusson and Peploe came from Whistler and Manet. Both Fergusson and Peploe were Edinburgh men and both attended the 'free' academies in Paris in the mid-1890s. In Edinburgh they could see works by Whistler shown regularly at the Royal Scottish Academy, particularly in 1904 when twenty-five paintings were included as a memorial tribute. Professor J. J. Cowan also owned a large collection of Whistlers in his house to the west of the city centre of Edinburgh.

Whistler had been an important influence on several of the Glasgow Boys, particularly on portraitists such as Guthrie and Lavery, so it was quite natural for Fergusson and Peploe to be drawn to the tonal harmonies and free brushwork of Whistler. In the early 1900s Fergusson painted several pictures, both full-length and shoulders, of elegantly dressed women, which are strongly Whistlerian in format, handling and general feel, but which still have the unmistakeable earthy vigour of all Fergusson's figure paintings. Even more Whistlerian is Fergusson's *Dieppe, 14 July 1905: Night* (cat.113), whose depiction of a firework display owes a direct debt to the American's firework paintings. But again, Fergusson is more assertive and less atmospheric than Whistler; he lays greater stress on surface colour in keeping with his increasing interest in Impressionist painting.

Peploe's debt to Whistler was less than Fergusson's. He was more interested in the deft brushwork and fluent paint of Manet,

to whom he came via an early enthusiasm for Frans Hals. Portraits, such as *Man Laughing* c.1901–5 (cat.281) and *The Green Blouse* c.1905 (cat.283), still have a strong Dutch feeling about them, with their more sombre colouring, but *The Black Bottle* c.1905 (cat.282) reflects his growing interest in Impressionism. The treatment of the forms is more elliptical, brushstrokes no longer define objects so much as suggest them, while retaining an independent existence of their own. This process, whereby colour and form are emphasised for their pictorial qualities and the image is simplified and reduced to its essence (rather like a caricature, an art form Peploe was very good at), gained in pace as Peploe and Fergusson spent more time in France, often on painting holidays together. Fergusson, in what amounts to an artistic credo, described his adherence to the Impressionist cause in a catalogue introduction to an exhibition at the Baillie Gallery in London in 1905. He wrote:

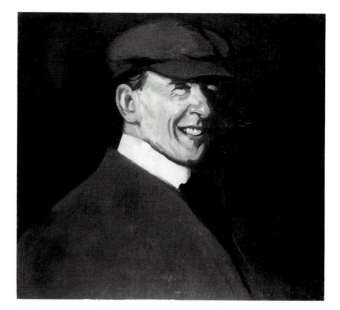

J.D. FERGUSSON **Self Portrait** c.1902 (cat.111)

> That he [the artist] is trying for truth, for reality; through light. That to the realist in painting, light is the mystery; for form and colour which are the painter's only means of representing life, exist only on account of light.
> That the only hope of giving the impression of reality is by truthful lighting.
> That the painter, having found the beauty of nature, ceases to be interested in the traditional beauty, the beauty of art.
> Art being purely a matter of emotion, sincerity in art consists in being faithful to one's emotions.
> To be true to an emotion, is to deal with that impression only which caused the emotion.
> As no emotion can be exactly repeated, it is hopeless to attempt to represent reality by piecing together different impressions.
> . . .
> What is on the surface may explain everything to one with real insight.
> That the artist is not attempting to compete with the completeness of the camera, nor with the accuracy of the anatomical diagram.

So closely were Fergusson and Peploe working together at this time, so similar were their approaches, that these views expressed by Fergusson undoubtedly overlapped with Peploe's. Eventually Fergusson moved to Paris in 1907 and Peploe joined him in 1910. Fergusson's art changed rapidly as he came into contact with the Fauves, and in particular with Othon Friesz, Kees van Dongen and Auguste Chabaud. The last, a poet-painter who used strong dark outlines and flat colour, was to have a considerable influence on both Fergusson's and Peploe's work. By 1908 Fergusson had moved completely away from any kind of tonal painting or colour harmonies; he was also no longer so concerned with conveying fleeting impressions. *La Terrasse, le Café d'Harcourt* c.1908–9 (cat.114) is very much stage-managed, so that the woman in pink assumes a pivotal role in the composition. Colour is now used as much as a building-block in constructing a well-composed painting as in describing a particular scene. It is no longer simply a creation of reflected light. Black, a non-colour as far as the true Impressionists were concerned, is now used as an important foil for other colours, making them glow all the brighter,[8] and as a vital part of the painting's structure.

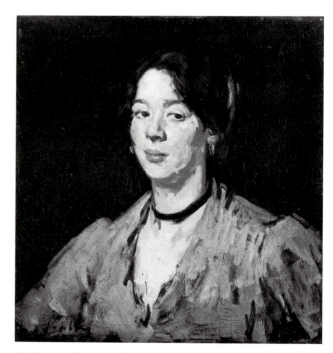

S.J. PEPLOE **The Green Blouse** c.1905 (cat.283)

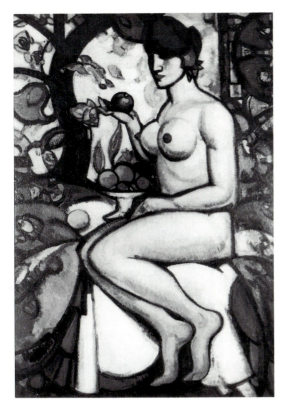

J.D. FERGUSSON **Rhythm** 1911 (cat.116)

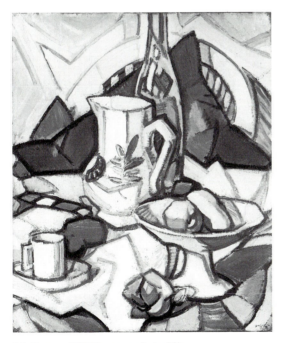

S.J. PEPLOE **Still Life** *c.*1913 (cat.288)

Peploe concentrated more on landscapes and still lifes while he was in France and always remained truer to Impressionist principles than Fergusson. *Verville-les-Roses* 1910–11 (cat.286) and *Boats at Royan* 1910 (cat.285) both attempt to capture the impression of a single moment, a variegated pattern of bright colours, of changing light and moving shadows. Peploe's touch is not the dappled fleck of the Impressionists, he does not worry about using larger areas of one colour, but the intention is of conveying a sense of immediacy and airy brightness. However, by 1911 Peploe was also using dark outlines to give structure and a sense of permanency to his pictures. In *Ile de Bréhat c.*1912 (cat.287), for example, the houses and landscape are outlined in different colours and 'filled in' using brushstrokes of varying direction to create a flat jig-saw of forms that has a distinctly Cézannesque feeling of order about it. This was to be the direction that Peploe's work took, increasingly, after the First World War.

Fergusson's concerns began to diverge more and more from Peploe's in the immediate pre-war years. He became interested in modern dance – this was the heyday of the Ballets Russes and of Isadora Duncan – in eurythmics, and the philosophy of Henri Bergson. The human body, or rather the female body, became the focus of much of his art. In splendid nakedness, brimming with health and curving (over-)voluptuously, it became a symbol of a new age, where humankind would once more be in harmony with its surroundings, where people would be able to feel the rhythm of the world within their own body. The painting *Rhythm* 1911 (cat.116) depicts a female nude whose ripe curving forms echo those of the fruit, tree and flowers that surround her. She is fecundity personified. Her perfectly round breasts are equated with apples and oranges, Nature's other fruits. It is a very rich and gorgeously painted picture, whose strong black outlines and glowing colours give it the feeling of a stained-glass window in a church. Indeed, the idea of a naked woman holding up an apple is archetypically that of Eve. *Rhythm* was shown in the 1911 Salon d'Automne in Paris and provided the name for an avant-garde magazine of the arts edited by John Middleton Murry and published from 1911 to 1913. Fergusson became the art editor and provided illustrations by himself and other artists such as Chabaud, Derain, Friesz, Gaudier-Brzeska, Manguin, Marquet, Picasso and Segonzac. Thus, for a short while Fergusson was in touch with the very latest developments in European art, although his own art never 'progressed' far down the road of abstraction.

Peploe returned to Edinburgh in 1912. By this time the pace of the city's art life had begun to quicken, undoubtedly under the impact (reverberating northwards) of such London exhibitions as Roger Fry's two 'Post-Impressionist' shows in 1910–11 and 1912, and of the Futurist exhibition at the Sackville Gallery in 1912. The Society of Scottish Artists, in particular, began to bring recent European art up to Edinburgh for its annual exhibitions. In 1913 it exhibited important paintings by Cézanne, Gauguin, Herbin, Matisse, Picasso, Russolo, Sérusier, Severini, Van Gogh and Vlaminck.[9] In the same exhibition Peploe showed what *The Scotsman* critic called 'daringly, vivid still life studies with a leaning to cubism'.[10] The sort of painting he was referring to is exemplified by his *Still Life c.*1913 (cat.288) with its pronounced blue outlines that produce a strongly faceted effect. This is only superficially Cubist. Peploe does not in fact break up any

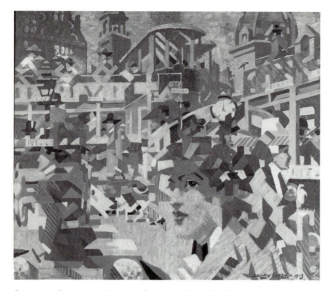

STANLEY CURSITER **Crossing the Street, the West End**
(or **The Sensation of Crossing the Street – West End, Edinburgh**) 1913
(Mr and Mrs William Hardie)

of the objects into their respective planes and re-arrange them in a grid structure. He rather aims at an all-over pattern that owes more to *cloisonnisme* than Cubism. It was also the furthest Peploe ever went into abstracting from his subject.

One artist who was for a short time much influenced by recent European developments in art was Stanely Cursiter (later to become Director of the National Gallery of Scotland). At this same 1913 Society of Scottish Artists exhibition Cursiter showed a painting called *Crossing the Street, the West End*, in which he attempted a modern rendering of a busy scene in Princes Street, Edinburgh. The work shows a good knowledge and understanding of Futurist paintings, in particular those of Severini (whose *Le Boulevard* was shown in the same exhibition) and of Boccioni.[11] Inevitably both the reviewers of *The Scotsman* and of the *Glasgow Herald* note the fact that the head of the woman in the foreground is rendered relatively realistically.[12] But this was a device he no doubt took over from Boccioni to draw the viewer into the painting so as to experience the same hectic bustle as the figure depicted.

Cursiter's excursion into Futurism was brief but intense. He painted seven works in this style, all in 1913. Up to that time his work had been traditional, much of it treating mythical subjects similar to those of the still popular 'Celtic Revival'.[13] After 1913 he reverted to a more traditional style and became well known after the war for his paintings of elegant Edinburgh interiors, for his society portraits and his seascapes. What then are we to make of this short Futurist interlude? The paintings are highly accomplished, beautifully composed and very intelligent. What they lack compared with their Italian counterparts is passionate involvement. They seem to have been painted more out of intellectual curiosity, out of a desire to understand this exciting and complex new art movement.[14] In *The Regatta* 1913 (cat.90) he seems to go beyond this stage. The work is less analytical in its approach, and more naturally dynamic. Its mix-

ture of abstraction and figuration, of broken colour and large areas of flat colour, looks forward to Fergusson's battleship paintings of 1918.

Fergusson returned from France to Britain on the outbreak of the war and settled in London. It was here in Chelsea at the Margaret Morris Club (founded by Fergusson and his future wife Margaret Morris) that he got to know Wyndham Lewis. Although he never subscribed to the machine aesthetic of Vorticism, Fergusson did produce at least one memorable image of machines as modern monsters. His watercolour drawing *Tin Openers* c.1918–20 (cat.122) shows four of these household instruments close-up, standing like so many armour-clad warriors, their blades held aloft like swords. In the context of the war it is a telling image of cold, mechanistic violence. It was also at about this time that Fergusson painted a series of works of the Royal Navy dockyards at Portsmouth.[15] These are among his finest works. In them he comes close to rivalling the heroic modernism of Delaunay and Léger. The bold *mise-en-page* and aggressive contrast between curved and geometric forms in *Portsmouth Docks* 1918 (cat.118) combine to create a truly exciting picture. Never again was Fergusson able to recapture quite this intensity.

In Scotland by the end of the First World War the use of bright, unbroken colours and the simplification (although not disintegration) of forms had become acceptable means at an artist's disposal. The Royal Scottish Academy, the Royal Glasgow Institute and the Society of Scottish Artists were all showing the work of Peploe, Cadell and Hunter on a regular basis. In fact, their Colourist approach to painting gradually became one of the dominant strains in Scottish art. How this came about is too complicated a story to tell here, but mention must at least be made of the pioneering work that the Glasgow dealer Alexander Reid did, not only in showing the Colourists (as they

J.D. FERGUSSON **Damaged Destroyer** c.1918 (cat.117)

eventually became known) themselves, but in preparing the way through his introduction to a Scottish public of the French Impressionists and Post-Impressionists.[16] He, more than any other dealer, was responsible for the rich collections of French paintings built up by Glasgow and Dundee ship-owners and industrialists in the early part of the century. It was these same influential collectors and their peers who also bought works by the Colourists.

Another factor in the acceptance of Colourism was that the Scottish public was only gradually introduced to it. The more avant-garde, pre-war works of Fergusson and Peploe were (for the most part) not shown in exhibitions in Scotland. More importantly, it was the work of Cadell and Hunter that received wider coverage and was more widely bought before the First World War. Although Cadell had studied in Paris at the Académie Julian between 1899 and 1903 and continued to visit Paris in the following years, he did not come into contact with the most recent trends in French art. What he did assimilate was a freer handling of paint and a use of brighter, unmixed colours. It was this Impressionist approach that he succeeded, brilliantly, in marrying to the kind of subjects made popular by such Glasgow Boys as Guthrie and Lavery. Cadell's fashionably dressed women posing elegantly in smart Edinburgh drawing rooms had their equivalents in numerous contemporary works hung in the annual shows in Edinburgh and Glasgow. The difference was that Cadell became increasingly daring and clever in his composition, use of colour and simplification of forms. This process quickened after Peploe returned from Paris in the summer of 1912 and they became close friends. Cadell now began to make his compositions much more rigorous and architectonic, forms were given harder edges, colour was used in large flat areas. *Lady in Black: Miss Don-Wauchope* 1921 (cat.37) shows the extent to which he was prepared to pare down his works to a flat, formal arrangement of just a few colours. The Art Deco feeling of such works has often been remarked upon, but it should be remembered that they were painted several years before Art Deco became an international style.

Leslie Hunter had no formal art training and had come to painting very much through book illustration (both in San Francisco where he lived for much of his early life and, after 1906, in Glasgow). In the years before the war he modelled his work very much on traditional, dark, tonal painting. There is a heavy leaning towards the Dutch School, particularly in his still lifes. It was this type of painting, in the tradition of the Glasgow Boys, that proved popular with Alexander Reid's customers. But Hunter was aware that in France painting had undergone a revolution; he read widely and visited Paris on several occasions before the war. His notebooks kept during the war are full of long quotations from articles about Van Gogh, Cézanne and Gauguin. He even made careful notes of the palettes of William McTaggart and Whistler. He worked hard to improve his technique. He had got to know Fergusson in about 1914 and renewed this friendship after the war, particularly in 1922 in the South of France. Hunter was on a long tour of the continent, visiting Paris (where he saw Epstein and a Matisse show that impressed him), Venice and Florence. On the French Riviera he met up with Fergusson and Peploe and wrote back to Scotland with great enthusiasm: 'We [Fergusson, Peploe and Hunter] propose, if possible, some lectures in Glasgow on

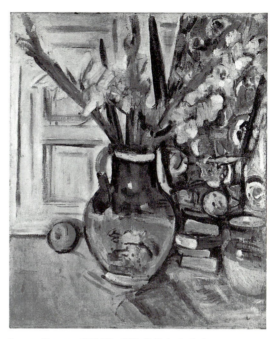

LESLIE HUNTER **Still Life of Gladioli** (cat.163)

modern art to colour this winter – Fry, if one can get him etc. . . . Fergusson proposes that Scotland takes its place as foremost in culture as in war. I've felt that the taste is here if they only get the chance. What a necessary adjunct art and beauty is to life! I believe this feeling is in the race, only submerged.'[17] Hunter was now developing his art quickly and he undoubtedly learned much from and was encouraged by his more advanced colleagues, Fergusson and Peploe. Between 1922 and his death in 1931 Hunter progressively lightened his palette; he began to use a white ground in the early 1920s; he allowed his brushstrokes to become much more visible; and he used coloured marks to suggest forms rather than to delineate them. In general, the move was towards a more spontaneous, elliptical expression, a move not really paralleled by his fellow Colourists and no doubt mirroring his growing interest in Matisse. The painting *Reflections, Balloch* 1929–30 (cat.160) is a superb example of his late style. It maintains a fine balance between a fresh and spontaneous response to a real scene and a sophisticated piece of picture-making. The water and its reflections are painted with all the fluidity and sparkle of early Impressionism; the house and boats, on the other hand, although still treated with a light and quick touch, assume a more decorative role. They are painted in a limited range of flat colours that provide a strong formal design, an anchorage, in the top half of the picture, that links up with the large expanse of water in the lower half (and prevents it from becoming diffuse) by means of the similarly coloured reflections.

The post-war work of Fergusson and Peploe perhaps lacks the excitement and intellectual thrust of their pre-war Paris paintings, but at its best it has a balance and assurance that lend it weight. Both artists were much influenced by Cézanne in their later years. In many of their paintings they used his technique

of small areas of parallel cross-hatchings, in order to define the various planes of a motif while still retaining an all-over sense of the plane. Peploe's *Landscape, South of France* 1924 (cat.291) is a good example of this approach. The groups of trees, the walls and roofs of the houses, the sea and the sky are each treated as separate flat areas parallel with the picture plane. Peploe paints them by using vigorous parallel brushstrokes in such a way that each area overlaps with the next. He thus avoids the harsh *cloisonniste* style of his 1913 *Still life* and achieves the *passages* from one plane to another that Cézanne spoke of. If this style can sometimes seem a little dry, particularly in Peploe's still lifes, it is always highly decorative and satisfying in its design. Fergusson's later paintings differ from Peploe's in that they depend so heavily on the human figure, and on his concept of rhythm. His landscapes are always animated by swelling curves, undulations and concavities which are redolent of the human body. The opposite is also true. This is, of course, an idea Fergusson developed before the First World War. The difference now between such works as *Rhythm* 1911 and *In the Patio* 1925 (cat.120) lies not merely in the more subdued colour of the later work, but in the way the surface of this work is knit together by a network of interlocking brushstrokes. There is a mellow unity in his later paintings that would have been quite foreign to the young man of fiery enthusiasms.

By the early 1920s the Colourists had firmly established themselves in the Scottish art world, with regular exhibitions of their work in Edinburgh and Glasgow. This made it natural for many of the artists who went through art school during and immediately after the First World War to see France as the obvious place to go for further study and helped predispose them to a modernist, if not avant-garde, outlook. That this was not everywhere the case, however, that Edinburgh tended to favour this route and Glasgow not, had a lot to do with the teaching staff at the relevant institutions, and perhaps also with the fact that both Cadell and Peploe lived in Edinburgh. One 'group' of artists who studied at Edinburgh College of Art between 1915 and 1926, who went on to study (or spend a lot of time) in France, and, who, to a greater or lesser extent, developed the Colourist aesthetic in various ways, became known eventually as the 'Edinburgh School'. It included, among others, William Crozier, William Gillies, William MacTaggart, John Maxwell and Anne Redpath. Today, Crozier is the least known, partly because he died young and only left a small corpus of work behind him, but also because his work was the least colourful and the most intellectual. After Edinburgh College of Art he went to Paris in about 1924 to study under André Lhote. The choice of Lhote as a teacher may now seem rather strange. We associate him with a rather dry, codified form of post-Cubist art, prepared neither to take Cubism to its ultimate conclusion, nor to abandon it for a more earthy realism. But it was precisely his ability to take the formal rigour of Cubist analysis and to use this to give structure to his figurative compositions that attracted students and made him, by all accounts, such a good teacher. This is what drew Crozier to him;[18] and Crozier was one of many Scots (including Gillies and William Johnstone) who trained under him. After his initial study trip to Europe in 1924 Crozier divided his time between Edinburgh, the South of France and Italy. He was drawn to the Mediterranean because of the way the strong sunlight created powerfully plastic effects in the land-

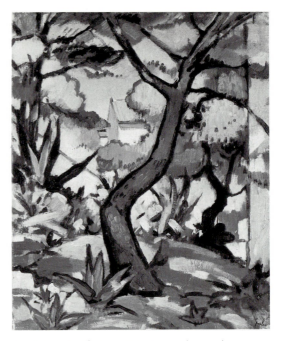

S.J. PEPLOE **Landscape at Cassis** 1924 (cat.292)

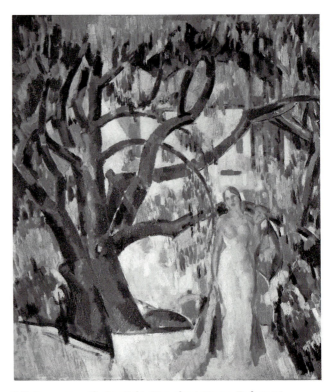

J.D. FERGUSSON **The Log Cabin Houseboat, Bourne End** 1925 (cat.121)

scapes, emphasising the solidity of masses. In his Italian land-scapes, for example, the forms of the houses are drastically simplified, with most detail being omitted, so as to stress the geometrical shapes and the strong contrasts between light and shade. Colour is kept to a minimum in order not to detract from the structure of the composition. In his Edinburgh paintings Crozier was presented with the problem that the northern light rarely produced the sharp contrasts that he was seeking in his art. The light in Scotland tends to soften outlines and to emphasise an all-over effect. However, in the painting *Edinburgh (from Salisbury Crags)* 1927 (cat.82) he succeeded brilliantly in creating a Cubist rendering of 'auld Reekie'. He uses to very good effect the fact that the Old Town of Edinburgh is built on a scarp of rock, so that the levels of rooflines and façades are constantly changing. Crozier has also cleverly exploited a raking south-west light to bring out the maximum contrast between sunlit fronts and deeply shaded sides of buildings. The actual topography of the view has also been shifted at various points so as to keep the interplay between light and shade constant throughout the main body of the painting.

William MacTaggart was Crozier's closest friend from art col-lege right up to the latter's death in 1930. Unable to attend Edin-burgh College of Art full-time or to go to study in Paris, he did however learn much from Crozier in the 1920s. In conversation with Douglas Hall in 1968, MacTaggart spoke of these early years of his career (many of which were spent in France):

> ... if you look at some of those French things, they are not bad as balanced and built-up compositions. Now, I am not really so interested in the structural composition, the built-up and balanced composition ... I think that if you look at some of my earlier stuff you will see the difference – of course it was William Crozier who was my greatest friend – we shared a studio – ... he was very keen on this idea of the composed picture; of course that was perhaps from Lhote, perhaps a second-hand influence. I was never with Lhote: I had intended to go with Crozier and Bill Gillies and one or two others and then I had this further deterioration of health and could not do it, but we were close friends and shared a studio. I heard a lot of Lhote's philosophy from Crozier and of his ways. Lhote was very much the man who, if you had a curve here said you must have a straight there, and almost it was a recipe, a formula. It influenced a lot of Edinburgh painters at that time and I got that, I suppose, second-hand and some of my paintings at that stage are perhaps more structural in that way ...[19]

If one looks at the paintings that Crozier, Gillies and MacTag-gart did in the mid to late 1920s, one can see the truth of MacTag-gart's remarks. Not only do they show the post-Cubist teachings of Lhote in their emphasis on structure and composition, but also a curious bleaching-out of colour. There are, in fact, real affinities with some of the contemporary work of Fergusson and Peploe, who also favoured structure over colour at this time.

However, by the end of the 1920s the work of the younger artists began to change. Formal composition was yielding to a concern for a greater feeling for nature. *Facture* was no longer simply a function of the structure of the painting, but a valuable means of evoking the materiality of a scene. This was perhaps more true at this stage of MacTaggart than it was of Gillies. The

former's *Snow near Lasswade c.*1928 (cat.238) still bears some of the formalising marks of earlier work, but there is now a definite attempt to use the paint impressionistically, to make us feel what it was like to be there. This shift may well reflect a growing interest in the work of such French artists as Dunoyer de Segonzac, who opposed Cubism in all its forms as 'foreign' and advocated a painterly form of naturalism. Certainly his work was regularly shown in Scotland and was represented in Scot-tish private collections.[20] In any case, sensibilities were chang-ing to such an extent that in 1931 the Society of Scottish Artists invited Munch to show in their annual exhibition.[21] Munch selected twelve paintings which were hung together on a separ-ate wall.[22] The works chosen were for the most part not the early Symbolist paintings of the 1890s but the later more Expres-sionist and vigorously painted pictures of the previous two decades.[23] The exhibition caused an uproar in artistic circles in Scotland. A reviewer for *The Scotsman* wrote:

> The main topic of visitors to the SSA Exhibition at the Mound is the Munch pictures. There are varied views, both amongst artists and mere laymen. Some artists modestly are ready to admit that there may be something really good, although they are unable to see wherein the goodness lies. There are others who express themselves in abusive terms, or even rendered speechless; while, of course, there are a numerous band who are highly appreciative and who find in the Munch pictures something revealing and stimulating.[24]

Although it was to be expected that the correspondence columns in *The Scotsman* would contain several letters savagely criticising the Munch exhibition, the main interest was diverted to the ramifications of a talk Herbert Read (then Professor of Fine Art at the University of Edinburgh) gave on BBC radio.[25] Read had welcomed the showing of the Munch paintings in Edinburgh because he felt that Munch's nordic art could provide the basis for a new national school in Scotland much as it had done in Germany.[26] Read saw the best qualities of contemporary Scot-tish art as being northern in sensibility (and, therefore, by impli-cation not allied to the French genius). This talk triggered off a lengthy debate in *The Scotsman's* correspondence columns between William Davidson (an artist), who argued that Munch would be a very bad model for Scottish artists to follow and that, in any case, there already existed a healthy Scottish school, and Stanley Cursiter (by now Director of the National Gallery of Scot-land) who maintained that Scottish artists should look to several sources, including Munch, for inspiration and that there was no separate Scottish school.[27]

The battle for the soul of Scottish art had been joined and it flourished in the nationalist climate of the 1930s. What is important is that the dominance of French influence on con-temporary Scottish art was no longer so unquestioned as it had been. Many, such as Fergusson, still argued that this was a natural and 'auld' alliance.[28] Others now began to take a cue from Herbert Read, whose view of art was heavily influenced by German philosophy,[29] and to be more open to North Euro-pean art. It is very noticeable that during the 1930s there was a series of loan exhibitions by German and Scandinavian artists in Scotland, the most important of which were a Klee exhibition at the Society of Scottish Artists in 1934, a German Sculpture exhibition at the Royal Scottish Academy in 1936, a group of

works by Max Ernst at the Society of Scottish Artists in 1937 and an exhibition of *Modern German Art* at the MacLellan Galleries, Glasgow in 1939.[30]

What impact did all this have on Scottish art? MacTaggart's interest in Segonzac, his thick earthy *facture* and more emotional involvement with landscape, certainly predisposed him to an interest in Munch's work. His marriage in 1937 to a Norwegian, Fanny Aavatsmark, who had done most of the arrangements for the Munch exhibition, strengthened his ties with Norway. By the end of the 1930s his paintings, such as *The Old Mill, East Linton* 1942 (cat.239), were much more colourful and fluid. He was also learning to give his brushstrokes more movement, emphasising the sweep of the landscape. These are characteristics typical of Munch's later paintings and also of Soutine's work.[31] MacTaggart's interests had gone beyond structural painting and now lay in evoking what he called a mood. This development was to intensify after the Second World War, when he was able once again to travel on the continent.

Although Gillies, later in life, recoiled from the lessons he had received from André Lhote in 1923–24,[32] there is no doubt that he found it difficult to shrug off his influence quite so easily. Traces of Lhote's post-Cubist formal style can be seen in works right up to the early 1930s. The Munch exhibition in 1931 came as a revelation, showing Gillies how different and more liberated painting could be. T. Elder Dickson, who knew the artist well, described the effect on Gillies as follows: 'Although not unaware of the existence of the Expressionist movement, he was quite unprepared for this startling confrontation. Fascinated, mystified, his critical faculties paralysed, he returned to the exhibition time and again to take in as much as he could assimilate. Everything he had seen before now seemed tame and spineless'[33] Gillies now embarked on a series of landscapes, both in oil and watercolour, which are everything that the earlier works had not been: full of emotion, expressed in rough, quickly applied impasto and dark, brooding colours. Works such as *The Dark*

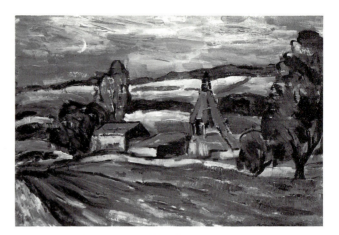

WILLIAM MACTAGGART **The Old Mill, East Linton** 1942 (cat.239)

Pond c.1934 (cat.148) and *Near Durisdeer* c.1932 (cat.139) are typical of this 'Expressionist phase'[34] in the early 1930s. A direct comparison can be made with MacTaggart's work of the same period.

But Gillies was no Expressionist at heart. On the contrary, his temper was calm and harmonious. He sought balance rather than conflict. It is therefore not surprising that he, like his close friend John Maxwell, was attracted by the work of Paul Klee, when it was shown in Edinburgh in 1934. Works such as *The Harbour* c.1938 (cat.141) and *Skye Hills from Near Morar* c.1930 (cat.146) show Klee's influence in the use of a grid structure, in the chequerboard effect of rectangles of alternating colours and a new lightness of touch. But at no time did Gillies come anywhere near abstraction. He had too great a love of places and objects. These were the years in which he would go off on painting holidays to the Highlands and other parts of Scotland, often accompanied by Maxwell. Although abstracted, the watercolour *Skye Hills from Near Morar* is still a very definite place with the Cuillin Hills standing dark on the horizon line. Perhaps more than any other Scottish artist this century Gillies has moulded our view of the Scottish landscape, simplifying, heightening colour but above all removing it from the solely heroic and sublime category so beloved of the nineteenth-century romantic tradition and giving it a more douce and human face. When unable to get away to the countryside through commitment of work or bad weather Gillies would paint still lifes, using his growing wealth of treasured pottery and china. As the 1930s wore on, Gillies returned once more to the French tradition for his inspiration, not to the cold austerity of Cubism but to the glowing colours and decorative compositions of Bonnard, Matisse and, in the 1940s, Braque. *Poppies and Cretonne Cloth* 1937 (cat.140) is characteristic of this type of still life. Using a brightly coloured and patterned cloth to provide a flat backdrop and the main plane of the painting, Gillies tips up the seat of the stool and table-top in alignment. The objects placed on top of these are also seen face-on, as flat decorative forms and the large sensuous shapes of the poppies become part of the backdrop. Other still lifes such as *Still Life with Breton Pot* 1942 (cat. 142) are more restrained in their colouring and less

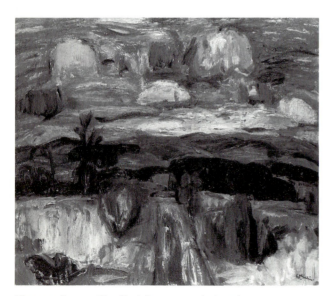

WILLIAM GILLIES **Near Durisdeer** c.1932 (cat.139)

exuberant in their forms. Gillies varied his still lifes and his treatment of them very much to suit his mood and to reflect his current interests. For example, his move to the village of Temple, a few miles outside Edinburgh, in 1939 certainly wrought a change in his art. His new surroundings, set in 'spare austere hills', helped to make his paintings simpler and more muted in colour. He used tones more closely related to each other. This new mood is very clearly seen in *Still Life with Breton Pot*.

Anne Redpath was a contemporary of Gillies (in fact three years older), but marriage and the bringing up of a family, at first in France and then in the Borders, prevented her from realising her full potential as an artist until the early 1940s. However, she had undergone a rigorous training at Edinburgh College of Art, had experienced the enthusiasm for Post-Impressionism and even Matisse of some of her teachers[35] and had been decisively influenced by the flat 'pattern-making' and shifts of perspective of the Italian Primitives, particularly the Siennese. Such lessons were to remain with her until she resumed painting on a full time basis in the late 1930s. In fact, as she herself said, she learnt one supreme lesson while bringing up her family: 'I put everything I had into house and furniture and dresses and good food and people. All that's the same sort of thing as painting really, and the experience went back into art when I started painting again.'[36] This view, that life and art are really one and the same, the latter simply being a heightened form of the former, is crucial to an understanding of Redpath's work, and, in fact, is what informs much of Gillies's work as well. Thus, it is not hard to understand why still life was one of her main subjects in the 1940s, and why Gillies and his French mentors, Bonnard and Matisse, guided the path she took. Her masterpiece from this period and one of her finest paintings is *The Indian Rug* c.1942 (cat.309). Looking down from above she immediately flattens out the space. The brightly coloured rug is seen as surface pattern on the picture plane, as an object in its own right. The ambiguous position in space taken up by the red slippers, part on the surface, part on the floor, helps tie the rug into the rest of the composition, especially to the red chair behind. The constant shift between surface pattern and pictorial space is highly sophisticated and gives the painting its peculiar dynamism.

John Maxwell has been left to last in this highly abbreviated account of the early years of the Edinburgh School, because in a way he is the odd man out. He certainly took part in the development of Colourism in Scotland, he also painted landscapes and still lifes – the very heart of the 'school' – but he was basically a painter of the imagination, of whimsy and dream, and in this was to prove of decisive influence on a subsequent generation of Scottish artists, in particular Alan Davie and William Gear.

After training at Edinburgh College of Art, Maxwell decided to spend part of his subsequent time abroad studying at the Académie Moderne in Paris, run by Léger and Ozenfant. This period seems to have left relatively little in Maxwell's subsequent work, although Léger's use of a wide variety of heterogeneous objects, both natural and man-made (including junk) which he put, with no attempt at an arrangement, on a table for his students to draw and make sense of, may well have helped nurture Maxwell's innate whimsy and imagination. Like Redpath before him, he was particularly impressed by the Italian Primitives when travelling in Italy. This taste for pre-

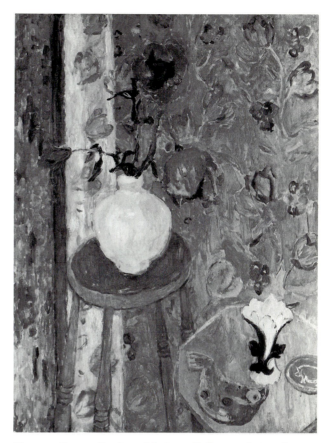

WILLIAM GILLIES **Poppies and Cretonne Cloth** 1937 (cat.140)

Renaissance art with its lack of one-point perspective and emphasis on surface design had been fostered in Britain by Roger Fry and Clive Bell; it influenced several Scottish artists in the early 1920s, predisposed many of them to an interest in modern, particularly French, painting and also drew their attention to the qualities of naïve and children's art. Untutored in the centuries of accumulated knowledge about technique, perspective and anatomy, unconcerned about tradition and good manners, Primitives and children were seen as painting directly and spontaneously what moved them at the time: their rich imaginations seemed to overrule any dictates of reason and perception. It was a whole new world that the Surrealists, in particular, looked into with enthusiasm. Thus, when Maxwell was asked in 1934 to do a mural at a new school in Craigmillar, on the outskirts of Edinburgh, he adopted a naïve style, as if painting from a child's viewpoint, and chose as his subject *Children's Games and Amusements*.[37] Even before that, in 1933 on his first painting trip to the Highlands with Gillies, Maxwell painted a work that clearly shows a primitivising tendency. The house and boats in *View from a Tent* 1933 (cat.242) have a childlike simplicity and homespun cosiness about them, that are reminiscent of contemporary work by Christopher Wood and Ben and Winifred Nicholson. The landscape on the other hand has more in common with the Munch-inspired 'expressionism' of Gillies's con-

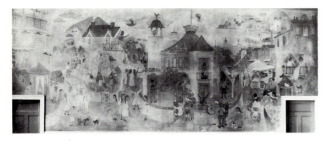

JOHN MAXWELL **Children's Games and Amusements** 1934–35.
Mural at Craigmillar School. 9.6 × 4.2m

temporary work. In the painting *Three Figures in a Garden* 1934 (cat.243) Maxwell took his primitivism one step further and removed his subject-matter completely into the realm of fantasy. It is painted in a completely non-naturalistic way. The childlike figures are seen frieze-like against a tipped-up garden, filled with magical blooms and a toy-like bird. The pastoral theme of figures dancing in a garden was to stay with Maxwell for the rest of his life. Various influences were to enrich his exploration of fantasy worlds, such as Klee and Chagall, but by 1934 Maxwell had already established his basic pattern.

If the Edinburgh School exemplified what one must consider the high road of Scottish art in the lead-up to the Second World War – the largely French-inspired Colourist approach to painting – there were alternative traditions which were to be revived only much later. In Glasgow, after the Glasgow Boys had done so much to introduce Impressionist colour into Scottish painting, a period of decline and, it must be admitted, self-satisfaction settled in. Looking through the illustrated catalogues of the Royal Glasgow Institute exhibitions, right up to the 1920s, one is struck by how conservative and nineteenth-century the works look. Fashionable society portraits, genre pictures and traditional landscapes are the keynotes. But things began to change slowly after the appointments at Glasgow School of Art of Maurice Greiffenhagen as Master in Charge of the Life Department in 1906, and Frederick Cayley Robinson as Professor of Figure Composition and Decoration in 1914. Greiffenhagen remained in post at Glasgow until 1929, Cayley Robinson until 1924. Their hard-edged figure style, schooled in Pre-Raphaelitism and Symbolism, and their love of Italian early Renaissance art was to have a profound effect on the type of painting and particularly the draughtsmanship that came out of Glasgow School of Art in the 1920s and 1930s. In general, one may characterise it as obsessively figurative, hard-edged and sharp-focused, often highly detailed and, increasingly, realistic.

One artist who shows this development very clearly is David S. Ewart. Two years after leaving Glasgow School of Art in 1924 he showed the painting *The Emigrants* 1926 in the Royal Glasgow Institute. It was an immediate success and went on to be exhibited in the Royal Scottish Academy in 1927. It shows a couple, in a resolutely frontal pose, sitting on the deck of a boat, sunk in thought, as they sail out to sea. It is obviously based on Ford Madox Brown's *The Last of England*, but is not in any way archaising. The details are all absolutely modern.

Ewart painted a pendant, *The Return* 1927 (cat.109) for the following year's exhibition in Glasgow. The couple are now shown returning home, older and more wealthy, to judge by their clothes. The work is painted in the same realistic manner, with the same clarity and focus, and the same high tones. A reviewer writing in *The Studio* about the Glasgow Institute's 1925 exhibition gives a very good feeling of what the art scene was then like in Glasgow:

> As one sees in the Glasgow Art Institute, what is known as 'modernism' has not sown any roots [*sic*] in Scotland because that process does not take place in a country where the traditions are held fast. The Scots temperament – with its restrained lyricism, brooding sentiment and searching sincerity – finds nothing akin in the Latin harshness of Gauguin or Picasso.
> One saw in the Art Institute here and there a stray survivor of the old brown landscape school from which the move was made towards the Dutch and Barbizon methods. Despite the turbulences of Cézanne's enthusiasts, the battles over John, the noisiness of Nevinson and Nash, the calm of Dutch placidity maintained its spell over Glasgow and still reigns. Yet youth must change and largely through the influence of the Glasgow Art School, a curious eddy has appeared. History has repeated itself, and a Pre-Raphaelite fervour has become manifest.[38]

The reviewer goes on to talk about individual works and artists, including Ewart, in this respect.

Ewart's work failed to maintain the interest of his early paintings and he went on to specialise in board-room portraiture, but it serves as a useful introduction to a kind of art then emerging from Glasgow. Of more enduring importance and influence was the work of James Cowie. He likewise trained under Greiffenhagen and came to have a fondness for *quattrocento* painting. In his scrapbook he had a reproduction of one of his favourite works, Piero della Francesca's *The Nativity*. He admired very formal, monumental compositions and figures with rigid poses and strong gestures. To achieve the same in his own work, he drew incessantly: not so much whole figures, but individual parts of the body and details. These drawings were usually highly finished, with a strong outline. For his models he drew the children he taught at Bellshill Academy near Glasgow, choosing those who had strong, pronounced features. These features not only give his figures character, but work as powerful two-dimensional shapes in their own right. This was something that he passed on to the artists whom he taught later at Hospitalfield House, Arbroath, including Robert Colquhoun, Robert MacBryde and Joan Eardley.

But Cowie was not a realist. His attention to detail was selective. He had an overall idea of what he wanted and the parts had to fit into this schema. The figures in his paintings are composites, made up of parts drawn perhaps from several people. This is very much a classical approach, where the particular is always subordinated to the general, where self-expression is anathema and reason must be seen to prevail. One of his finest paintings, *Portrait Group* 1932/c.1940 (cat.69), shows, however, that despite this, he loved to suggest an underlying current of mystery. In the first version of the painting, the group of children are sitting at a table overlooking what seems to be a railway

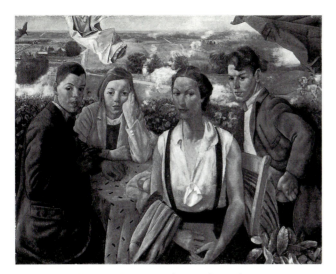

JAMES COWIE **Portrait Group** 1932/*c.*1940 (cat.69)

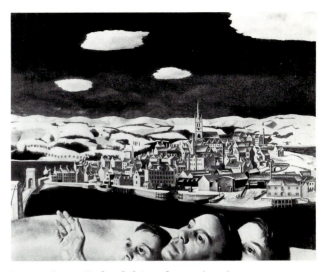

EDWARD BAIRD **Unidentified Aircraft** 1942 (cat.9)

embankment. There is smoke and steam in the air, suggesting that a train has just gone by. Although the relentless stare of the figures is rather unnerving, the painting is relatively straightforward. After the work had been repainted during the war, however, the situation is very different. The embankment has now disappeared, but the smoke and steam are still there, a strange red-coated horseman has appeared on the right-hand side and two articles of clothing hang down into the painting from an unseen clothes-line. These all give the painting a strongly Surrealist feeling. It is as if some event is taking place which we know nothing about, but which the figures depicted dare us to fathom out. Cowie was aware of Surrealism fairly early on. He was profoundly affected by Paul Nash's work, ever since he 'discovered' him in the mid-1920s. It was Nash's use of mirrors in creating ambiguities of space, of inside and outside, reality and reflection, that inspired such still lifes by Cowie as *Transparencies c.*1947 and *Composition* 1947. The mysterious and the surreal became ever stronger elements in Cowie's works as time went on, but he always began from the same starting-point – closely controlled drawings of real objects and people. It was this method that most influenced the artists he taught at Hospitalfield, thus passing on a tradition that exists to this day.

Along with Gillies, James McIntosh Patrick has done more than any other artist this century to change our perception of the Scottish landscape. There could not be two more different approaches. Patrick attended Glasgow School of Art where, like Cowie and Ewart, he trained under Greiffenhagen, but where he also specialised in etching. At this time printmaking in general was enjoying a boom in Britain and the Scots were among the leading exponents, particularly in etching. The works of James McBey, D. Y. Cameron and Muirhead Bone were very much in demand. The detailed drawing style that Patrick had learnt from the School of Art, but also from his love of Mantegna – his *Agony in the Garden* was Patrick's favourite painting – was ideally suited to etching. So it was in this technique that Patrick's first mature works were done, etchings of hill towns in the South

of France carried out in 1927. They proved very successful and after leaving Glasgow School of Art in 1928 until the print boom burst a couple of years later, Patrick made his living making highly detailed etchings of both Scottish and French landscapes. Already we can see his characteristic deep perspective and crystal-clear atmosphere. In 1930 Patrick began to teach part-time at Dundee College of Art and it was then that he turned to painting. The works that he had done before in the later 1920s were less detailed than his etchings but now he began to introduce the techniques he had learnt in his prints into his paintings. They were composite images (like Cowie's paintings), made up from several drawings executed on site (and indeed from other sites) and put together in the studio. In this way he was able to produce landscapes that satisfied his own compositional requirements: typically, deep pictorial space into which the eye is very carefully led by a road or the lie of the landscape features, and crisp, realistic detailing.[39] The actual painting of the works also decided very much what was finally depicted. Talking of the 1930s Patrick has the following to say about his technique: 'In those days . . . I had a way of putting on paint and then rubbing something all over it to soften the image and then sharpening it all up by careful reworking. I let the paint make the suggestions into something more solid. In other words these were abstractions which gradually were turned into realist pictures. The concept was abstract but the means was realism.'[40] This is an important point. Works, seemingly as photographic as Patrick's, are highly artificial constructions, into which invention, memory (for example, of Breughel's paintings) and technical know-how are carefully woven.

Edward Baird was one of Patrick's closest friends at Glasgow School of Art in the mid-1920s. It was here also that Baird gained his strong love of Italian Renaissance painting, particularly that of Mantegna and Piero della Francesca. He spent his scholarship year in Italy, but returned to his home town of Montrose where he lived somewhat isolated from the Scottish art world. This isolation was due in part to his bad health and poverty, but also to an obsession with his own personal vision

of the town, its past and its inhabitants and with the means to execute that vision. Like Patrick, Baird was fascinated by detail and finish. He believed that all parts of a painting had to be given equal attention, with the unfortunate result that he was never satisfied with what he did and kept reworking some paintings for years. However, the close-focus, seemingly photographic effect that he achieved in his finished paintings is hallucinatory and, as in some of Cowie's works, has Surrealist overtones. This was not accidental. Baird was very interested in Surrealism and read much about it. In *Birth of Venus* 1934 (cat.7) (a wedding present to his friend James McIntosh Patrick!) he creates an allegory of female sexuality. Venus, Goddess of Love, in the form of a young woman standing in the waves by the shore, is juxtaposed to a still-life of shells, orchid, magnifying glasses, driftwood and an enigmatic dummy's head. The juxtaposition of disparate objects and female nude is highly surreal, but it is never less than realistic and believable. This is what makes it so uncanny. The same is true of the painting *Unidentified Aircraft* 1942 (cat.9). The town of Montrose is shown in the background, lit by a harsh raking light that gives the buildings an otherworldly quality, like El Greco's view of Toledo. In the immediate foreground Baird shows three heads and a hand raised towards the sky. The title suggests that they are looking to see if they can recognise whether the plane they can hear is an enemy one or not. But the effect is quite different, they look as if they are supplicants to an unseen God, like benefactors in a Renaissance altarpiece.

Baird was very much a 'loner' and, although he taught briefly from 1938 to 1940 at Dundee College of Art, he did not influence many people. The situation was very different with Ian Fleming, who finished training at Glasgow School of Art in 1929. Fleming was first and foremost a printmaker (in etching and drypoint, mainly), who learnt much from his teacher in Glasgow, Charles Murray, and, in the Glasgow tradition, developed a highly detailed, linear style. His early print *Gethsemane* 1931 (cat.128) is a fine example of this. Through his teaching first at Glasgow School of Art and then at Gray's School of Art, Aberdeen, Fleming has had an enormous influence on printmaking in Scotland. His approach and his opposition to the suppositions that underlay the Edinburgh School are summed up very neatly in the following piece he wrote:

> I was always fascinated by a sharp point, I liked a line. The way you cut wood you have to be precise about it – you cannot have a dithery piece of woodcut or a vague line in engraving – you've got to be absolutely precise and know that line goes from there to there and there is no dubiety about it. This is one of the disagreements I had with Bobby Blyth.[41] He used to judge life-drawings on an entirely different basis from the way I would judge life-drawings. He used to think that anything that was vague and indeterminate was sensitive, which is a load of codswallop It was all the sort of genteel stuff that comes from Raphael, and Bonnard, too, has what I'd call that spongy line. Edinburgh fell hook, line and sinker for this and for colour, and if you had colour and mass, line went out of the window. Did not Willie MacTaggart in a television interview say that etching was quite meaningless to him?[42]

The Glasgow-trained artist who influenced perhaps more

people than any other of his generation was Hugh Adam Crawford. He taught at Glasgow from 1925 to 1948, leaving when he was Head of Drawing and Painting to become Head of Gray's School of Art, Aberdeen. He finished his career as Principal of Duncan of Jordanstone in 1964. During this long and distinguished career as a teacher he influenced several generations of artists, including Colquhoun and MacBryde, William Crosbie and Joan Eardley. His influence lay more in bringing out the individuality in others than in imposing his own vision, in 'kicking away the props' as he called it and getting his students to stand on their own two feet. Nevertheless, despite a very busy teaching career he did manage to paint a few impressive works and these helped reinforce the tendency in Glasgow art towards the depiction of reality.

In the late 1930s he did a series of portraits (one, for example, of the architect Jack Coia) which are candid and crisp, catching the sitter as if unawares and all the more revealing for that. His large painting *Tribute to Clydebank* 1941 (cat.76) is more staged and owes a clear debt to Renaissance artists, such as Piero della Francesca. But the impulse behind it, to depict life as it is and to give it dignity, was a lesson not lost on his students, least of all on Joan Eardley.

It was precisely at this time, during the war, that Joan Eardley studied under Crawford at Glasgow School of Art. Because the war had created special circumstances, with a vastly reduced number of students, Crawford experimented with a special course for the more gifted ones, where they were given much more personal tuition in drawing and painting. Crawford did the teaching himself and Eardley was one of his students. There is no doubt that this period at Glasgow under Crawford influenced Eardley tremendously. Her Diploma painting, a self-portrait, has great similarities to Crawford's own portraits. Eardley was then to come under an even stronger influence and one which was much more dogmatic than Crawford. She studied at the Patrick Allan-Fraser School of Art, Hospitalfield for six months in 1946 under James Cowie. Cowie's rigorously controlled draughtsmanship and concentration on detailed studies, his eye for strong linear shapes and for outline, undoubtedly left their mark on Eardley's figure drawings and paintings. He also helped distil in her a self-control that was a useful corrective to her powerful feelings of empathy. Eardley wrote at the time from Hospitalfield about her uneasy relationship with Cowie: 'I think I will have to be very strong to stand against Mr Cowie, and I don't feel very strong just now – he asked me if I had changed my way of painting since I left the art school, and when I said, yes, that I was trying to tighten it up a bit, he said "I'm very glad to hear it – this self-expression business is no good at all." '[43] Cowie was completely opposed to any form of gestural expression and it is therefore fortunate that Eardley had sufficiently developed her own mind and self-confidence at art school so as to pick and choose what she could learn from Cowie.

During her trip to Europe in 1948–49, and especially in Italy, Eardley was able to practise her draughtsmanship freely and to try out what she had learned at Hospitalfield. Interestingly it was not so much the art in Italy that attracted her, although she was deeply impressed by Giotto, but the people, the peasants going about their everyday lives. Eardley needed to form direct relationships with the life about her; this was and remained the life blood of her art. She wrote home from Italy, troubled by the

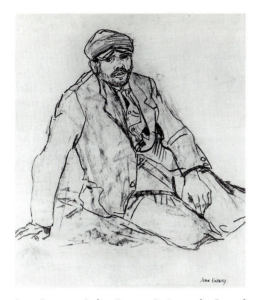

JOAN EARDLEY **Italian Peasant Sitting on the Ground** 1948–49 (cat.106)

fact that she could not speak any Italian and therefore found it more difficult to form these necessary relationships: 'To become friends and, in this way, to partly understand these people, is the only way I feel I can paint them with truth otherwise, as I am now, I only know what I see from outside. I suppose painting is only a visual reaction to things, in a way – but to me it must be more. The story part of it does matter.'[44] It is a revealing insight into the widely divergent interests of Scottish artists at this time, reflecting in part the differences between Glasgow and Edinburgh, that while Joan Eardley was in Venice in the winter of 1948–49, drawing people and fascinated by the bustle of the city life, Alan Davie was also there, discovering the Jackson Pollocks and Surrealist works in Peggy Guggenheim's collection.

The drawings that Eardley brought back from Italy, including *Italian Peasant Sitting on the Ground* c.1948–49 (cat.106), have a strong and rugged outline, not the smoothly flowing outline of Cowie but the staccato accents of Van Gogh. No schema is imposed; every inch is felt and emphasised accordingly. After her return to Glasgow in 1949, Eardley at first concentrated on drawing and painting the immediate surroundings of her studio in the centre of Glasgow. She later extended her views of the city to Port Glasgow. It was here that she found subjects that could grip her attention and force from her the same empathy that she had felt for the peasants in Italy. *Street Kids* c.1949–51 (cat.101) is a typical example of the paintings done at this time. The work is brightly coloured with large areas of flat primary colours, but this is not its main concern. This lies rather in the observation of human life, in thin legs, worn-out boots, rapt attention in a comic. Eardley feels her subjects so strongly that she identifies with them. When she was in danger of losing her studio in 1951, she wrote home:

It is desperate to lose the studio . . . because I have become attached to it and it has been so useful to my work in that

it is so near to the slum parts of the town that I draw. And so easy to get the slum children to come up. And I have become known in the district – in George Street and all the streets round about. It would be impossible to get another one in this type of district . . . you see I wouldn't like . . . anything that was not in town, because my work is among the towny things, particularly places like the tenements around my studio. I know that now, much as I love the country and country things, my work does lie in the slummy parts – unfortunately.[45]

This does not mean that Eardley was a social realist or that she was interested in poverty as a social question. She simply felt the life-impulse, the naturalness and directness of human beings more strongly here. And a heightened expression of life was what her art was about. She was wrong to say that she would be unable to find a comparable studio in Glasgow: she did and she went on to paint a whole series of works there. She was also wrong in thinking that her work lay only in the city. By 1952 she was working in Catterline, a small fishing village not far from Aberdeen, and was to invent a whole new language for herself as she identified with the sea and nature in general.

Two other artists who studied for a time under Cowie at Hospitalfield were the 'Two Roberts', Colquhoun and MacBryde. They had both attended Glasgow School of Art together from 1933 to 1937, studying under Hugh Adam Crawford and Ian Fleming. At Hospitalfield (1937–38) they continued to perfect their figure drawing moving increasingly from chiaroscuro and shading to line alone. There is also, at least in Colquhoun's work, a strong influence of Wyndham Lewis's acerbic figure style at this time. Travelling scholarships took them both – by this time they were inseparable – to Europe for a year (1938–39) and, after Colquhoun had been in the Army for a brief period, they both moved to London in 1945. Neither was to spend much or any time in Scotland again. But this self-exile only served to increase their Scottishness. In 1941–42 Colquhoun painted several Neo-Romantic landscapes (for example, *Marrowfield, Worcestershire* 1941, in Glasgow Art Gallery), then currently fashionable in London and derived mainly from their new found friends, espcially John Minton, with whom they shared a studio. But this did not last. Colquhoun, at least, was basically a figure painter. He liked the drama and pathos that the human (and even the animal) figure could evoke. An early painting *The Encounter* 1942 (Glasgow Art Gallery), still in a Neo-Romantic style, shows the way his art was to develop.

A decisive event for both Colquhoun and MacBryde was the move to London in 1943 of Jankel Adler.[46] An exile from his native Poland, Adler had trained at Düsseldorf Academy and, in the 1930s, had been much influenced by Picasso in Paris. In the insular atmosphere of the war Adler seemed a direct line to continental modernism. He was also a fellow exile and had spent three years (1940–43) in Glasgow. Adler's art was to exert a strong influence on Colquhoun for the next couple of years. Colquhoun took several things from his older colleague: his monumental hieratic figures, his flat, highly abstracted forms, which were separated by strong outlines and filled in with flat colour, and finally his use of textured surfaces. The important exhibition of Picasso's work at the Victoria and Albert Museum in London in 1945 served to emphasise these influences. The

first really mature works by Colquhoun to come out of this confrontation with modernism were a series of paintings of various unfortunates and lonely, isolated figures – a fortune teller, a one-legged whistle seller, a woman with a birdcage. *Seated Woman and Cat* 1946 (cat.50) is one of the most effective. Broken up into a series of heavily abstracted shapes, some textured, some monochrome, the poignancy of the image remains intact. The style has not yet become a mask, automatically donned and keeping real feeling hidden. This was, unfortunately, to be the fate of much of Colquhoun's later work. At this stage, also, Colquhoun's colour sense is bold and fresh, looking forward in some ways to the work of some of the British Pop artists.

MacBryde's work has been much less documented than Colquhoun's. No proper chronology has yet been established for its development. What is certain, is that he was no mere cipher of Colquhoun. His still lifes, painted in a heavily *cloisonniste* style, like stained-glass windows, are quite distinct from Colquhoun's work. There is, in fact, a strong resemblance to contemporary paintings by William Gear, but ultimately the common source of both is Picasso's geometric still lifes of the 1930s. Both Colquhoun and MacBryde made (rare) statements about their work in *Picture Post* in 1949. Neither goes beyond the rather bland and general, but there is a distinct difference in their expressed interests. Colquhoun emphasises formal innovation and experimentation as he, the artist, reacts to different subjects. MacBryde seems to have been more in touch with the current interest in nature's underlying structures – an interest owing much to a highly acclaimed exhibition of Paul Klee in London in 1945.[47] Colquhoun was intuitive and pragmatic; MacBryde tended towards systems, hence the grid structures that figure prominently in many of his works.[48]

If Colquhoun and MacBryde began their careers training in a Glasgow hard-edge, figurative tradition, they soon abandoned it after their move to London and eventually adopted a more international style. But there were other Scottish artists before them who had also moved away, if only temporarily, from Scotland and had learnt much from the most advanced contemporary art of their time. Whether the art that they developed out of this confrontation went on to become part of a Scottish tradition or to form a new one, depended on how much their work was shown in Scotland and how closely they maintained their contacts there. William McCance was one such artist. After initial training in Glasgow and a forty-year stay in England, McCance had little impact in Scotland and he has been largely forgotten today. This neglect is undeserved, because in the early 1920s he painted a remarkable group of Vorticist-inspired pictures that had no counterpart in contemporary Scottish art. McCance left Glasgow in 1920 and, about two years after arriving in London, he must have painted *Conflict c.*1922 (cat.195). It is a work containing elements of Cubism and Vorticism, but it does not really belong to either movement. The forms have a plasticity and inner vigour that makes them seem visceral and living. They resemble parts of a machine that have begun to fight each other like animals, twisting and turning as they struggle for supremacy. Nothing that McCance had learnt or seen displayed in Glasgow could have led him in this direction, except perhaps what he could have found in books and magazines.[49] More important probably was the general effect the Great War had on him. The images of tanks and other war machinery,

JANKEL ADLER **Homage to Naum Gabo** 1946 (Scottish National Gallery of Modern Art)

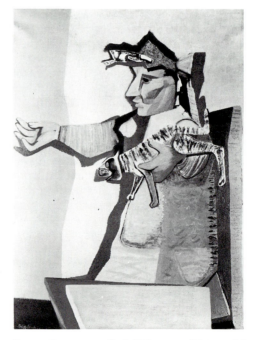

ROBERT COLQUHOUN **Seated Woman and Cat** 1946 (cat.50)

WILLIAM McCANCE **Conflict** *c.*1922 (cat.195)

whether in the form of photographs or works of art, must certainly have inspired the mechanical forms in *Conflict* and *Heavy Structures in a Landscape Setting* 1922 (cat.194). Once in London McCance could have seen Vorticist and Cubist works by Wyndham Lewis and Edward Wadsworth. Certainly his *Portrait of Joseph Brewer* 1925 (cat.197) owes a debt to Wyndham Lewis in its sharply focused and stylised forms and in the heightened plasticity of the figure. But McCance was too independent a figure to be an epigone of any movement. He never imposed a Cubist structure on his motifs, he never imposed mechanisation on his objects, but rather tried to draw out the inherent forces of growth from within nature itself, giving imaginative form to what they might produce once liberated. McCance in fact posited a new synthesis between Cubism and Expressionism in order to overcome the limitations of both. He wrote:

> Up-to-date, we have two chief streams of research which have a certain significance. Is it possible that a synthesis can be made from both which might create the lost element of art? Cubism symbolises art as cerebral organisation, or what is commonly confused with intellectualism, while Expressionism would attempt to create an externalised emotionalism. The former, in its crude state, leads to mechanisation. The latter is a mere hysterical gesture – the tame lion opening its mouth and letting its guts rumble at the sight of food. The fertilisation of the one by the other, however, may produce the real egg which may be hatched into that highest expression of man – idea.[50]

McCance felt that the Scots were well-placed by their natural qualities to exploit this. 'When the Scot can purge himself of the illusion that Art is reserved for the sentimentalist and realise that he, the Scot, has a natural gift for construction, combined

with a racial aptitude for metaphysical thought and a deep emotional nature, then out of this combination can arise an art which will be pregnant with Idea, and have within it the seed of greatness.'[51] McCance wrote these lines in 1930 in *The Modern Scot*, a magazine edited and published by J. H. Whyte as 'The Organ of the Scottish Renaissance'. This is significant. Although McCance did not return to live in Scotland until 1960, he maintained contact with the Scottish Renaissance movement, which was centred around the writer and poet C. M. Grieve (Hugh MacDiarmid) and the composer Francis George Scott. He had got to know Scott before leaving Glasgow in 1920. MacDiarmid had written about his work in 1926. And in 1935 he showed in a mixed exhibition of Scottish artists at The Gallery, St Andrews, run by Whyte.[52] McCance was therefore associated with the movement that was dedicated to the renewal of Scottish culture, not merely by looking in on itself in a provincial way but by seeking to relate its own traditions to the most forward-looking developments elsewhere.

Another artist who was closely involved in this movement for a while and who likewise failed (at least in the early part of his career) to have a real influence on the future development of art in Scotland was William Johnstone. This again was partly because he spent most of his working life in England, but also because, at a time (in the 1930s) when his radical art might have had a decisive influence, he was concentrating his main efforts on his teaching career. Johnstone met Scott and MacDiarmid while he was still studying at Edinburgh College of Art and together they formed a group bitterly opposed to the lack of a real cultural identity in Scotland. This was the beginnings of the Scottish Renaissance movement. Johnstone was particularly interested in the lectures he heard G. Baldwin Brown, Professor of Fine Art at the University, give on Celtic, Saxon and Romanesque art. The true relevance of this to his art only occurred to him later after he had started to study under André Lhote in 1925. In Paris he came into contact not only with Cubism and abstract art, but with Surrealism as well. The abstract, formal elements in art which modernism stressed had their equivalents in the early art of Scotland. Perhaps it was possible to build on this tradition, forging a vital link between the past and the present.

Johnstone had already shown himself to be interested in the Celtic past while he was still in Edinburgh. Two paintings, *Celtic Totem* 1925 and *Sanctuary* 1923–27, in fact deal with similar subjects to those of the 'Celtic Revival'. But the essays that he made in Cubism and abstraction in Paris from 1925 to 1927 taught him how to use the formal principles of the past rather than its subject-matter. The first successful painting to make this synthesis was *Painting, Selkirk, Summer 1927* 1927–38/51 (cat.172).[53] It is a painting inspired by the Borders landscape that he knew so well, but a landscape felt and experienced from within, not simply seen from without. Johnstone consciously uses the rhythms of Celtic art in a series of interlocking curves and segments that echo the swelling landscape forms of the Borders. However, in essence, the painting still remains an abstract work. The forms do not make sufficient reference to nature to elicit that type of elemental response that he was perhaps seeking and that he achieved two years later in *A Point in Time* 1929/37 (cat.174).

By the time Johnstone came to paint this major work, he had

WILLIAM JOHNSTONE **Painting, Selkirk, Summer 1927** 1927–38/51 (cat.172)

spent a year in America, mainly in California. It may be that he was influenced there by the paintings of Georgia O'Keeffe and Arthur Dove. Certainly Johnstone was now much more interested in natural forms and organic growth. *A Point in Time* also shares with Surrealism a feeling for forms caught in the process of constant change, a feeling for metamorphosis. But the hollows and caves, the contorted forms and references to human bodies may have held more specific memories and anticipated fears for Johnstone than the work does for us today.[54] In his autobiography *Points in Time* he wrote the following revealing remarks about the works he painted at this time:

> Some of these paintings . . . represented a feeling of disillusion after the war which had, of course, made a deep impression upon me. This tremendous, unnecessary slaughter of human beings dug into me, and to paint pretty pictures revolted me. I felt that the carnage was certainly not at an end, that it was continuous and only a matter of time before the next holocaust began. This undercurrent influenced all my work at the time. It was strained and harsh . . . Through painting I began to understand a concept of eternity in which always and forever there is illimitable change, a continuous metamorphosis and new identification. An osmosis occurs when I, the painter, become my subject; I am as much a part of nature as my subject; my inner vision is shared between nature as an external object and nature as myself. The culmination of this period of painting were three large . . . pictures called *Point in Time*, *Golgotha* and *Valley*. These paintings grew out of my horror of the disease of war, of the anticipation of future tragedy – . . .[55]

Although Johnstone was never in the trenches during the First World War, he did experience the general demoralisation in the

Army during its last months. It seems likely therefore that he would have been particularly receptive to Paul Nash's stark depictions of the wounds inflicted on the land by the war, his searing images of the trenches. Some of those drawings were shown in the 1919 exhibition of the Society of Scottish Artists in Edinburgh, just at the time that Johnstone was beginning at art college.[56] But they were also widely illustrated in books and magazines.[57] Some, in particular, with their crater holes, their furrows, their strange swelling shapes and concavities, look forward to Johnstone's *A Point in Time*. Just as the deathly landscape of Belgium and Northern France had an ambiguously organic feeling about it, as depicted by Nash, so does Johnstone's painting suggest both life and death, the eternal cycle of becoming and decaying. Red and yellow (symbolising life) gradually give way to black (symbolising death) via green and blue and back in the opposite direction. It is as much an optimistic painting as it is pessimistic; it is certainly fatalistic.

That Johnstone's work had so little impact at the time in Scotland, is a matter of regret.[58] Edinburgh, in particular, was really quite progressive in the arts at that time and more receptive to new ideas than it had been for a long time. Mention has already been made of the exhibitions of Munch, Klee and Surrealism at the Society of Scottish Artists. The main impetus behind these shows was the new go-ahead atmosphere at Edinburgh College of Art, which provided many of the artists sitting on the Society's committees. In 1932 Hubert Wellington became the new Principal of the college. He was a very cultivated and open-minded man, who was determined to make the college as international in outlook as its considerable financial resources permitted.[59] To this end he made an extended visit to the continent in April 1934 to study the art schools in Hamburg, Berlin, Leipzig, Dresden, Munich, Prague, Vienna, Milan and Paris, building up contacts that would help in sending out post-diploma students to study abroad. At the college itself, outside lecturers of international standing such as Gropius, Chermayeff and Mendelsohn were asked to give talks. Herbert Read, Professor of Fine Art at the University of Edinburgh from 1931–33, lectured there in the early 1930s. Gillies and Maxwell both taught at the college and were much appreciated for their liveliness and openness. Moreover, throughout the 1930s the National Galleries of Scotland gave much consideration to the provision of a Gallery of Modern Art. Their then Director, Stanley Cursiter, openly canvassed for a gallery along the lines of the Museum of Modern Art in New York, which would not only show modern art, but contemporary design, films and photography. He went so far as to commission Alan Reiach, a young architect of international-modern persuasions, to draw up a design. A model was built (by Cursiter himself) in about 1940, that shows a building very much in the mould of Bauhaus design. A site – opposite the Scottish National Portrait Gallery – was even available, but, as usual, Government finance for the project was not forthcoming.

What is, at first sight, curious is that this progressive, liberal atmosphere did not give rise in the 1930s to a truly avant-garde art. There was no Unit One,[60] no *Abstraction-Création*, no Surrealist movement. There was a group of modern architects in Edinburgh, including William Kininmonth and Basil Spence, who did build several very interesting buildings in Scotland in the 1930s; and Thomas Tait was responsible for the planning

and construction of the hugely successful Empire Exhibition in Glasgow in 1938, which was a prime showcase for progressive architecture. That the architects had a lead over the painters is a fact difficult to explain, but the presence of John Summerson, a leading apologist for modernism, on the teaching staff of Edinburgh College of Art in the late 1920s and early 1930s may have had something to do with it. The fact is, there were artists in Edinburgh who were deeply interested in abstraction and Surrealism but events conspired to prevent their flowering there. The war broke out – and Alan Davie and William Gear went into the services. Wilhelmina Barns-Graham and Margaret Mellis went off to live in St Ives. The promised 'flowering' of avant-garde Scottish art in the 1930s was postponed until after the war and then much of it took place away from Scotland.

Some of the most advanced work being done by a Scottish artist during the war was that of Margaret Mellis. Her low-relief, wooden constructions were made between 1940 and 1945 in St Ives where she lived with her husband, the artist and writer on art Adrian Stokes. These reliefs owe much to the example of Ben Nicholson and Naum Gabo, both of whom lived in St Ives during the war.[61] But they are also replete with a long schooled knowledge of formal relationships, varying textures and subtle changes of colour and tone, that Mellis had gained in Edinburgh (under Peploe and Maxwell), Paris (under Lhote) and London (at the Euston Road School). A comparison between the early *White Still Life* 1939 (cat.251) and *Construction in Wood* 1941 (cat.252) shows very clearly that the change from painting to reliefs was not as fundamental as one might think at first. The objects on the table in the still life are kept to the same tonal range as the table cloth and surrounding space and are so dematerialised that they begin to function as shapes as much as actual objects, merging and detaching themselves spatially from their background. The same principles operate in the *Construction*. Geometrical forms – oval, triangle, rectangles – are perceived on different planes and against varying colours and textures. There is a constant push-pull between figure and ground. Mellis was to develop these same concerns after 1945 when she resumed painting.

Wilhelmina Barns-Graham went to St Ives at an earlier stage in her development. She was still on a post-graduate travelling scholarship from Edinburgh College of Art. Since she could not go abroad because of the war, Hubert Wellington advised her to go to St Ives. She was particularly fascinated by the work of Gabo and his use of transparent material. But it was only after the war when she visited Switzerland in 1948 and saw the glaciers in the Alps, that she was able to make use of Gabo's ideas of transparency and multiple, superimposed planes in her own work. She wrote about this experience later:

At Grindelwald I was climbing on the two glaciers 'Upper' and 'Lower'. The massive strength and size of the glaciers, the fantastic shapes, the contrast of solidity and transparency, the many reflected colours in strong light This likeness to glass and transparency, combined with solid rough ridges made me wish to combine in a work all angles at once, from above, through, and all round as a bird flies, a total experience.[62]

Barns-Graham painted a whole series of works based on this experience: *Glacier (Vortex)* 1950 (cat.11) is one of the finest.

This type of cool and balanced abstract art never caught on in Scotland, however. St Ives was a long way away from Edinburgh or Glasgow; and the Colourist tradition, in particular, encouraged a more sensuous, hedonistic approach. It is true that Alastair Morton painted abstract, Constructivist pictures from 1936 until after the war, but these arose out of his connections with Ben Nicholson and the Hampstead avant-garde. He did not train in Scotland and he had left Edinburgh by 1933. Scotland had to wait until the 1970s before there was a sufficiently welcoming climate for a coolly considered abstract art.

What did come about, however, was a form of abstract Expressionism that, for a time, placed two Scottish artists at the forefront of British and, indeed, European developments. William Gear and Alan Davie were among the first artists in Britain to realise the importance of the new forms of gestural abstract painting that had been produced in Europe and America during the war; and they quickly incorporated some of its discoveries into their own art. Gear had trained in Edinburgh before the war and had gone on to study under Léger in Paris. The influences of his student days were to bear fruit after the war. Gear's interest in Klee, kindled by the 1934 Klee exhibition in Edinburgh and renewed by a large show of his work in London in 1945,[63] found expression in the delicate gouaches and watercolours that he did in 1946–47 in Celle, West Germany. These semi-abstract paintings, mainly of figures, have a delicacy and childlike whimsy that is reminiscent not only of Klee, but also of John Maxwell, one of his former teachers at Edinburgh. Already in these works one can see the emergence of a grid structure enclosing areas of flat bright colours, which was to form the basis of much of Gear's art for the next several years. Once he arrived in Paris in the spring of 1947, this grid or armature became more pronounced as Gear emphasised the black lines and used stronger colour. Delayed memories of Léger's work of the 1930s were no doubt reactivated by being in Paris. They certainly contributed to the earthy punch of what Gear was now doing. He described his work of this time as 'lyrical abstraction'. It shared a common basis and many of the aims of his Parisian friends and contemporaries: a knowledge of Cubism and Surrealism and the great French tradition of colour, but a desire to make a new beginning and not be hamstrung by the past. As Gear put it: 'There were no real threads to pick up and start again. The situation was wide open.'[64] Gear made no distinction between abstract and figurative art; his own art (like that of Klee) lay somewhere between the two. Inspired by nature, but not abstracting from it, Gear suggested organic forms as they arose out of the underlying structure of his grid. After 1950, and his return to Britain, Gear began to dissolve this grid, blurring the edges and allowing one area of colour to flow more easily into another. This new 'cellular' structure was less harsh and more overtly organic. It seemed better to justify the title 'Landscape' that he now frequently gave to his paintings.[65] But, at the same time, it was very much in line with *tachiste* developments in France, in particular with the works of Bazaine and Manessier.

For a few years in the late 1940s and early 1950s Gear shared a common interest with Alan Davie, Eduardo Paolozzi and William Turnbull in the principles of organic growth and their relevance to artistic form. Klee and the Surrealists were the ultimate sources of this, but Gear probably played a seminal role

WILLIAM GEAR **Landscape, March 1949** 1949 (cat.132)

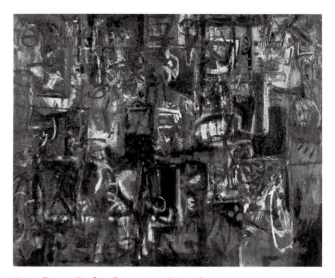

ALAN DAVIE **Jingling Space** 1950 (cat.91)

in showing Davie how it might create a new type of art. Davie met Gear in Paris in 1948 during the former's scholarship year abroad. Davie expressed a dislike for contemporary French painting, but his own interest in Klee's work[66] must have made him look closely at Gear's semi-abstract compositions. Thus, when later that year he saw works by Arp and Ernst in Carola Giedion-Welcker's collection in Zurich and early paintings by Pollock, Rothko and Motherwell in Peggy Guggenheim's collection in Venice, he was able much more quickly to grasp their importance. First, they relied heavily on improvisation and intuition: forms gave rise to other forms in a process akin to natural growth, accidents were accepted as part of an underlying scheme of things. Secondly, forms produced primal images and archetypal myths, naturally and with minimal conscious control. The Jungian belief was that these myths welled up from the unconscious mind. Thirdly, little attempt was made to tidy up paintings; the hard-fought history of their creation was there to be seen and felt by the viewer. This is what Davie now took from the Surrealists and the then (in Europe) largely unknown Americans, but he also brought his own concerns: his new-found interest in Romanesque art and Byzantine mosaics and his long-established and practised ability to improvise rhythms, learnt as an accomplished jazz musician.

The resulting paintings of 1949–50 are densely worked and architectural in their composition: a loose grid of horizontals and verticals from which organic forms emerge. Titles such as *Birth* and *Birth of Coloured Organisms* suggest the idea of growth, of natural and artistic creation. Others, such as *Pagan Music, Music for a Pagan Dance* and *Altar of the Blue Diamond* suggest religious rituals. *Jingling Space* 1950 (cat.91) is typical of these dark and slightly menacing early paintings. The space in question is shallow, almost Cubist; a black grid and sombrely coloured rectangles fill the background. Over this Davie improvises a rhythmic dance of gestural brushstrokes that enliven the whole canvas. As the title suggests, the space begins to vibrate and sing.

After 1950 Davie's paintings became less claustrophobic and dense; his colours became brighter; his forms cohered into specific imagery; and the grid either disappeared or was condensed into a more solid geometrical structure. Increasingly Davie became interested in religious and sexual imagery, the product of two of man's most powerful urges. In *Woman Bewitched by the Moon, No. 2* 1956 (cat.96) and *Articulated Masks* 1956 (cat.95) the imagery is explicit. In *Seascape Erotic* 1955 (cat.94) it is more generalised, evoking not so much human sexuality as universal progeniture, and the crucial role played by the sea in the creation of life. By now Davie saw painting as a form of self-revelation not as a purely artistic activity. In his introductory notes to his important exhibition at the Whitechapel Art Gallery in 1958, Davie wrote: 'Sometimes I think I paint simply to find enlightenment and revelation. I do not practise painting as an Art; and the Zen Buddhist likewise does not practise Archery as an exercise of skill but as a means to enlightenment. The right Art is purposeless, aimless.'[67] Art for Davie was anything but self-expression; it was rather an emptying-out of a consciousness of self; it was an attempt at one-ness.

By 1958, when this was written, Alan Davie's concerns had diverged quite considerably from his fellow Scots, Paolozzi and Turnbull. But in the late 1940s and early 1950s there were considerable overlaps of interest. It is often forgotten now, for example, that in 1949 Davie actually earned his living from making jewellery.[68] He also experimented with sculpture using the lost-wax casting technique and by pressing seals and various objects into clay to obtain reliefs. His willingness to experiment with techniques and media was typical of Davie's open-minded approach to art. This was also a hallmark of both Paolozzi's and Turnbull's work at the time.

For a nation of engineers and shipbuilders it seems strange that Scotland did not produce a strong tradition in sculpture. There were several highly accomplished sculptors working in Scotland before the war – Pittendrigh MacGillivray at the turn of the century and subsequently Alexander Carrick, Scott

Sutherland, George Innes, Tom Whalen, Hew Lorimer and Benno Schotz in particular – but none had been particularly innovative. Certainly they did not create a reputation beyond Scotland's borders. It is fair to say, therefore, that Paolozzi and Turnbull took nothing from an indigenous sculpture tradition. Like many Scots before them, they turned to Paris for inspiration. They found it in abundance in the post-war artistic ferment and created out of it two very individual approaches to sculpture.

Paolozzi's unique contribution to sculpture has been to relate the sculptor's most traditional subjects – the human body (as a whole or in its various parts) and the animal – to the modern technological world and to do so in such a way that the two have become fused into a new unity. Paolozzi is not judgemental about the impact of mechanisation, of the consumer society, of the new media age. He sees it as a fact and feels it is part of the artist's duty to acknowledge it in his art. Paolozzi's early enthusiasm for American popular culture, for illustrations of machinery, and for cinema imagery went hand-in-hand with his impatience with what he considered to be the outworn traditions of art taught at the Edinburgh College of Art and the Slade, both of which he attended in the 1940s. Paolozzi compiled scrapbooks of popular imagery and other illustrations that intrigued his sense of the absurd. The question was, how could this be made into art? because, despite everything, he still believed in the ideals of high art.

Answers began to suggest themselves as Paolozzi was confronted with pre-war European modernism. He read Ozenfant's and Jeanneret's *La Peinture Moderne*, which advocated the use of subjects not previously thought worthy of art, such as the products of modern technology. As early as 1944 he saw collages and assemblages by Schwitters. His friend and fellow student at the Slade, Nigel Henderson, introduced him to Dada and Surrealism. Paolozzi was particularly fascinated by Duchamp's use of *objets trouvés* and ready-mades. This all happened while he was still in London; and, in fact, Paolozzi was already at that time producing collages of antique sculpture and machinery, which looked forward to the machine god sculptures of the late 1950s.

Paolozzi's stay in Paris from 1947–1949 confirmed and strengthened his interest in Dada and Surrealism. He was particularly impressed by the Dada works of Picabia and the collages of Max Ernst. Together with his friend William Turnbull, who was also living in Paris, he visited Arp, Calder, Tzara and Giacometti. He spent a lot of time with Giacometti, watching him work, asking him questions and looking very closely at his early Surrealist sculptures. This had a decisive influence on Paolozzi's work and his future development. Up to then he had made only one or two small reliefs and sculptures (including *Horse's Head* 1946 (cat.263)), inspired by Picasso. The majority of his output had been in the form of drawings and collages. Giacometti showed him how the principle of collage could be given sculptural form. Sculpture did not have to be massive, either moulded or carved in the traditional manner; it could be created by adding various, often disparate, elements together, not to form a likeness, but a conceptual image. The breakthrough for Paolozzi came with *Paris Bird* 1948–49 (cat.264), which makes no pretence at verisimilitude. The bird is broken down into its conceptual parts – head, wings, tail, body and legs. As stand-ins for these Paolozzi has taken various machine-like parts. In fact,

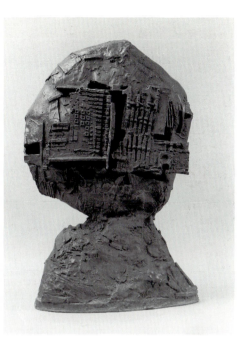

EDUARDO PAOLOZZI **Krokodeel** 1956 (cat.267)

he made a maquette for the work in plaster and did not use actual found industrial objects. *Two Forms on a Rod* 1948–49 (cat.265) and *Table Sculpture (Growth)* 1949 (cat.266) were also made in Paris and, like *Paris Bird*, are not true assemblages. In them Paolozzi was attempting to see natural and organic principles, such as aggression and growth, in terms of mechanomorphic shapes. The opposing aggressive forms in *Two Forms on a Rod* are like two cogs that no longer mesh together in harmony. The forms projecting above and below the flat plane in *Growth* are like tools on a workman's bench.

At the same time as Paolozzi was making these sculptures, he was continuing his exploration of collage (producing his highly influential *Bunk* collages that were to provide the basic iconography and much of the working method of British Pop art) and, more important for his later sculptural development, he created a series of low plaster reliefs. He made these by impressing various objects in clay so that they appeared, when cast, in profile. Inspired by Dubuffet's *hautes pâtes*, these reliefs were the starting point for his bronze sculptures of the mid to late 1950s.

After his return to London in 1949 Paolozzi had to earn his living by teaching (textile design, at the Central School); he became a founder-member of the Independent Group at the Institute of Contemporary Art, London in 1952 and was closely involved in such seminal exhibitions as *Growth and Form* 1951, *Parallel of Life and Art* 1953 and *This is Tomorrow* 1956.[69] Most of Paolozzi's energies went into these and other activities. It was only in 1956, after he had finished teaching, that Paolozzi devoted himself to sculpture again. He had made the occasional work in the early 1950s, such as *Mr Cruikshank* 1950 (a sculpture based directly on a wooden mannequin) and *Contemplative*

Object 1951, but he did not develop their potential with any consequence until much later. The series of sculptural heads, animals, heroes and gods that he made from 1956 to 1960 constitutes a culmination of the ideas worked out in Paris in the late 1940s. He developed the method of fixing the shape of found objects as a relief encrusted on the surface of his figures. Broken zips, toys, cogs, parts of cars, radios, gramophones, clocks, anything discarded by the modern consumer society were brought into use. But, remarkably, the effect achieved is not one of modernity, but of extreme age. The heroes and gods in particular look like ancient decaying statues, products of a civilisation long since defunct that made a fetish out of the machine. Paolozzi often chose famous figures who either died for their hubris or faith (*Icarus* I and II 1957 (cat. nos. 268, 269) and *St Sebastian* 1957) or who where in some way defective (*Cyclops* 1957). These, like *His Majesty the Wheel* 1958–59 (cat.271), were a doomed race.

Paolozzi's concern for linking ancient myths with modern times was shared by many artists of his generation, of whom Bacon is the most famous. Undoubtedly the climate of the cold war and of the newly invented hydrogen bomb hung over them all. Superficially, Turnbull's work of the late 1940s and 1950s bears a strong resemblance to Paolozzi's. They were certainly very close in Paris and even shared a studio for a short while after they returned to London in 1949. But, unlike Paolozzi, Turnbull was not interested in machine imagery and was actually opposed to the idea of making his work look modern. Whereas for Paolozzi imagery was of central importance, for Turnbull it came second to formal qualities.

Prior to going to live in Paris in 1948, Turnbull had already rejected contemporary Scottish or English art as models to follow and was looking to European modernism as a basis for his art. Like Paolozzi he had been fascinated in his youth in Dundee with American comics and illustrations. He found the approach to form more direct and less hidebound than what he learnt at art college in Dundee and at the Slade. The early sculpture *Horse* 1946 (cat.332) shows him looking at Cubist sculpture in the way it breaks down the subject into its basic planes and shapes. But Turnbull drew equally on the early sculpture of Giacometti. In fact, Giacometti was to form the most important influence on Turnbull's work while he was in Paris: not as in Paolozzi's case Giacometti's early Surrealist sculpture but his recent existential work of etiolated human figures and concern with space and direction. The sculpture that Turnbull made in Paris is stick-like and diffuse, recalling plants at an early stage of growth. Like Gear, Davie and Paolozzi, Turnbull was also fascinated by patterns of natural growth.

Compared with this work of the late 1940s, Turnbull's sculpture of the later 1950s is monumental, unified and eidetic. *Pegasus* 1954 (cat.334) and *Horse* 1954 (cat.333) still have much of the movement of the Paris sculptures, but the emphasis is now on a single structure and on the process that went into its making. The pronounced striations and obvious joints between the various parts are deliberately left rough and awkward – just as Davie allows us to see the growth of his paintings of this period. Turnbull now embarked on a long series of sculptures based on the form and image of the Greek female idol, which has proved to be his most enduring and fruitful subject: to the extent, in fact, that after a period in the 1960s and 1970s

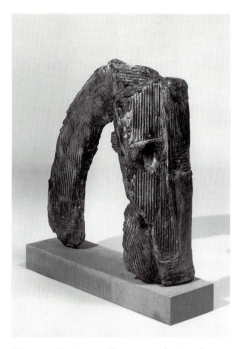

WILLIAM TURNBULL **Horse** 1954 (cat.333)

of highly abstract, geometrical sculpture, he has again returned to it. In the 1950s Turnbull developed two approaches to this female figure. The first was as an idol: hieratic, massively simplified (and increasingly so) and conceived to be viewed frontally. The second was more as a totemic figure: with a distinct head that in some works became a separate, discrete form placed on a vertical column. Turnbull went on in the 1960s to develop this approach and introduced several distinct elements, each in a different material (wood, marble, stone and bronze). Turnbull's idols and totemic figures are conceived as timeless and eternal, as basic forms that keep their relevance for us through the ages.

In the 1950s Gear, Davie, Paolozzi and Turnbull had a considerable standing both in Britain and abroad. The fact that they came from Scotland, that they all stood outside the English artistic establishment and that their art had several features in common, was not something that drew much contemporary comment. They, as artists, saw themselves as individuals working in an international context. They felt no need either to distance themselves from or to identify closely with Scottish culture; it was there in their background and partly in their training but it did not figure consciously in their work. They chose to live in London or the south-east of England because that was where they needed to be professionally: to work in a large and stimulating artistic community and to see the latest exhibitions in a fast-changing post-war art scene.

In fact, as far as the arts were concerned, the situation in Scotland after the war was by no means inward-looking and provincial. Considerable efforts were made to bring international art to Scotland and to show the best of Scottish art in the rest of Britain and abroad. The establishment of the Scottish Committee of the Arts Council (later to become the Scottish Arts Council)

and of the Edinburgh International Festival did much to boost the number of good exhibitions in Scotland. For example, in 1955 the Arts Council toured a show of seven Scottish painters (including Gear and Davie) who lived in the south of England in order 'to re-introduce them to their native land'.[70] The established exhibiting bodies were also very active and go-ahead. The Society of Scottish Artists was again the most enterprising. In 1945 it brought over from Paris a group of contemporary French paintings that was the first introduction to a British public of what had been happening in France during and immediately after the war.[71] Exhibitions it organised in the 1950s included German Expressionism (1950), de Staël (1956) and *Tachisme* (1958). In addition, the highly influential exhibition of works by Matisse and Picasso that had been shown at the Victoria and Albert Museum in 1945 was brought to Glasgow in 1946.

This increased artistic activity and, in particular, the growing internationalism of the art shown in Scotland, not only influenced the younger artists going through art college in the late 1940s and 1950s, but helped make the older, mature artists more daring and ambitious. This was especially true of the Edinburgh School of Colourist painters. By 1951, when Gillies and Maxwell were represented in the official Festival of Britain exhibition *Sixty Paintings for '51*, they had become part of the establishment. Gillies had become Head of Painting at Edinburgh College of Art in 1946; Maxwell, Senior Lecturer in charge of composition in 1947. Gillies had been made a member of the Royal Scottish Academy in 1947, MacTaggart in 1948, Maxwell in 1949 and Redpath in 1952. They all showed regularly at the annual exhibiting societies in Edinburgh and Glasgow, in the Scottish private galleries and also in London. They were seen as the leading Colourists in contemporary Scottish art. In general, one could say that the main development in their art was towards a stronger, more expressive use of colour; paint was increasingly applied by the palette knife in heavy impasto, forms became less distinct, as much a by-product of the paint itself as objects of representation. In short, there was a move towards abstraction and an evocation of mood. In this they were no doubt influenced by recent developments in French art, but one should also not underestimate the impact of Alan Davie on his own teachers.

The one exception to this general development was Gillies. He was too attached to specific places and objects to dilute their individuality in paint. If anything, Gillies's later work became more linear and less painterly. In his best work he simplified and omitted detail, concentrating on shapes as they appeared flat on the canvas. To this end he would often choose views that looked down onto hills, that blocked off most of the sky. In *Fields and River* c.1959 (cat.144), for example, Gillies is obviously fascinated by the way curves of the river and the drystone walls divide the landscape into very definable shapes. The shadow from a passing cloud cuts right across the river in the middle distance to create a series of interlocking shapes. A steep bank of earth in a distant valley forms a light brown cut-out shape, like a piece of collage. Colour is subdued and kept to a range of ochres, browns and greys, which are indeed faithful to what the Borders look like in winter.

In many ways it was Maxwell who pointed the way in which Scottish Colourism was to go after the war. Ever since the late 1930s he had used a heavily worked impasto and a generally

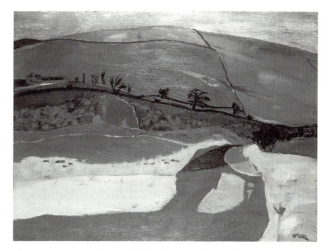

WILLIAM GILLIES **Fields and River** *c.*1959 (cat.144)

dark tonality through which a figure, a group or a bunch of flowers would glow like a jewel or stained-glass. Maxwell had been one of the first Edinburgh artists to draw on the work of Chagall and Rouault to achieve this effect. He outlined his figures in black and created a rich surface texture, in which colours were worked together like embroidery. Maxwell simply continued down this road after the war. His impasto became more pronounced until, towards the end of his life, it became almost like a relief. His subject-matter became more dreamlike and fantastic – enchanted, moonlit gardens, pottery figurines that come to life. Maxwell was bewitched by the idea of a lost paradise, but in his painting he could return there. This powerful evocation of a mood was to effect both MacTaggart and Redpath.

It was pointed out earlier that MacTaggart was deeply affected by the 1931 Munch exhibition in Edinburgh. After seeing it, he became increasingly interested in Expressionist painting as opposed to more analytical and constructive art. This development was confirmed for him after the war, when he saw the large Rouault exhibition in Paris in 1952. Rouault's glowing colours, his rich *facture* and, not least, his concern to express the spiritual dimension of life rather than be limited either to objective representation or formal analysis, these all left their mark on MacTaggart's work. In such a painting as *Poppies against the Night Sky* c.1962 (cat.240), MacTaggart concentrates almost exclusively on colour. The dark, ultramarine blue of the sky makes the red of the poppies stand out like a stained-glass window. Indeed, the fact of placing them in a window sill heightens this effect. MacTaggart aims to create a mood, not of spirituality as does Rouault in similar works, nor of elemental struggle and *Lebenslust* as Nolde does in his own flower paintings, but a mood of plenitude, of life's riches. MacTaggart loved to paint evening scenes with sunsets or full moons; he loved harvest scenes and the rich red soil of East Lothian. All this has strong affinities with Maxwell's harvest moons and abundant nature, although MacTaggart never ventured into the realm of fantasy.[72]

It is not coincidental that Redpath's palette and manner of

painting changed in this same post-war period. She too was sub-
ject to the same general influences. The rich surface textures
of the new French abstract (or rather semi-abstract) painters
such as Bazaine and Manessier, who were directly inspired by
religious interiors, and the evocations of altarpieces and cult
trappings in the work of Davie left their mark in Redpath's work,
although she herself never painted abstractly. The change in
her style began in 1951 when she visited Spain. Significantly
it was the actual look and feeling of the place that affected her;
she reacted directly and naturally to her surroundings. She des-
cribed this process in a 1960 radio broadcast:

> I couldn't paint Spain the way I painted France. It was a
> much harsher starker country. It was very bad weather
> when I was there and therefore it wasn't the blue-skied
> Spain. It was a dark grey sky, and the white buildings looked
> sinister sometimes in little villages . . . Most of the paintings
> I did there were black and white and grey and really quite
> sinister. One or two funerals, religious processions –
> inevitably more black and white. Well, they had to be painted
> with a kind of strength of manner which I didn't have before
> when I was painting the gentleness of even the South of
> France with its blue skies and palm trees. And therefore
> when I came back and painted still life – I always go back
> to still life – of course they showed the influence of this kind
> of painting, and therefore the still lifes that I painted were
> stronger. They were harsher too. Your palette sort of
> enlarges itself, so that even your very gamut of colour
> changes, becomes broader, wider.[73]

Indeed, after this visit to Spain Redpath's palette grew darker
and less tonal; contrasts in colour became more marked and
the colours themselves more saturated. The palette knife was
often preferred to the brush, making the surface of her paintings
look like polished stones and minerals. As she said in her broad-
cast, she alternated between landscapes and still lifes. The land-
scapes were usually memories of trips to Mediterranean
countries like Spain, Italy or Portugal. But she also painted a
large number of church interiors, attracted by the richly dec-
orated Baroque altarpieces. To all intents and purposes these
became still lifes and are among her most free and abstract
works. Back home in Edinburgh she would arrange on a table
some of her pots, vases and ornaments, many of them acquired
on her travels, and paint still lifes. Unlike *The Indian Rug* c.1942
(cat.309) and other still lifes done during the 1940s these give
no hint of any specific milieu. The table often fills the whole can-
vas and the objects are set against it as if it were a backcloth
in the classic Cubist manner. But unlike the Cubists, Redpath
was interested in colour rather than form. In *White Tulips* 1962
(cat.312), the colours are chosen for their maximum effect. The
white of the tulips and the green of the grapes stand out strongly
against the red cloth and the dark background. But, importantly,
Redpath never allowed her saturated colours to remain flat; they
are scumbled over another usually darker colour to allow maxi-
mum reverberation and intensity.

The impact of Expressionism, both figurative and abstract, on
a younger generation of artists was even more marked. Robin
Philipson trained at Edinburgh College of Art (at the same time
as Alan Davie) before the war. His career was interrupted by
the war, but it was during his time in the services that he dis-

OSKAR KOKOSCHKA **Summer (Zrání)** 1938–40 (Scottish National
Gallery of Modern Art)

covered the work of Kokoschka. Kokoschka was the first and
perhaps most lasting influence on his work. Kokoschka's dazz-
ling technique that captured both the immediacy of a scene and
his own reaction towards it, his rhythmic brushwork that could
be savoured for its own sake as well as the insight it gave into
what was depicted, this was a revelation to Philipson, and he
visited the National Gallery of Scotland regularly to look at its
only Kokoschka, *Summer (Zrání)* 1938–40.[74] This intensive
study influenced Philipson's work up to the mid-1950s. His
panoramic views of Edinburgh in particular owe a clear debt
to Kokoschka. Although not visionary or transcendent in the
way Kokoschka's cityscapes are, they have the same attack and
fluency of brushwork; no part of the picture is static, everything
is alive and in rhythmic movement.

This indeed has been the most consistently developed aspect
of Philipson's work. A painting has to have a living surface that
works in terms of its paint structure. He described his views in
the following way: 'I believe that the essential meaning of my
painting is made possible by the eye being carried back again
and again to each area of the picture plane, but always in a
different way; meaning thus makes its own unfolding through
a series of intuitive acts.'[75] These are remarks informed by the
formalist aesthetics of Abstract Expressionism (then enjoying
considerable acceptance in Britain), but still just as applicable
to figurative painting. Philipson has never ventured into pure
abstraction, but has painted various themes in series of pictures
that has allowed him to explore all their formal varieties. The
choice of the themes has been dictated in part by what new
aspect of movement, colour, light or composition they afforded
him, but of course associational values have never been shun-
ned. The first major theme painted by Philipson was the cock-
fight. Philipson had seen cockfights in Burma and had sketched
one. He took up a suggestion to develop this theme and gradually
came to realise how rich the subject was. Full of energy and
controlled movement, of agression and excitement, it was a per-
fect analogue of the cut and thrust of action painting. *Fighting
Cocks, Grey* 1960 (cat.300) is one of the most abstract and freely

painted. The birds are locked in close combat; wings, claws and spurs are flashing in a blur. Philipson does not paint the birds so much as the energy and force of their movement. Other themes, such as the stained-glass window and burning fires have concentrated Philipson's attention on light and colour and the insubstantiality of objects. The church interior was a common theme in the 1950s – broached as we have seen by Davie and Redpath, but central to the work of many French 'abstract' artists. It was a particularly suitable subject for abstraction and its otherworldly religious connotations were certainly not ignored.

Philipson, who joined the staff of Edinburgh College of Art in 1947 and was Head of Painting there from 1960, who became a member of the Royal Scottish Academy in 1960 and President in 1973, has exerted an enormous influence on several generations of artists, particularly those who studied in Edinburgh. Whether he was emulated or rejected, many of those who came into his sphere of influence took away with them a stronger feeling for the actual handling of paint. This has been one of the great strengths of Scottish, and particularly Edinburgh, painting since the war. It has also, as we shall see later, proved to be a skill that has to be constantly renewed and altered if it is not to degenerate into a strait-jacket for the imagination and a hindrance to innovation.

In theory artists have a whole range of styles and approaches that they can take up and develop as students. In practice, however, their choice is circumscribed, at best influenced, by the teaching they receive and the example of their immediate artistic community. This is how tradition works. To say that a young artist can adopt a style simply by looking at magazine illustrations or at a few works seen in an exhibition is to underestimate the power of tradition. But change does occur, of course, and at no time more quickly than in the last forty years. If this has been less marked in Scotland than in London, it is because a greater stress has been laid on cherishing tradition, on art colleges (Edinburgh in particular) employing many former students to teach. This has been due in part undoubtedly to a pride in achievement, but there has also been a fear of dilution, of losing one's identity in the face of a growing internationalism. In the 1950s one can sense the growing tensions between tradition and internationalism, or at least radical innovation, that were to erupt more openly in the 1960s. It is observable not only between different artists, but within individuals as well.

Elizabeth Blackadder and John Houston attended Edinburgh College of Art in the early 1950s when the Edinburgh School was enjoying both critical and popular success. Blackadder's watercolours of objects placed out on a table, and her paintings of Mediterranean landscapes owe much to Anne Redpath in subject and general approach but there is a distinct change of sensibility. This expresses itself in several ways. Blackadder prefers more muted colours – grey is a favourite – and often composes her pictures asymmetrically. Large areas of a painting will be monochrome, with small incidents (objects or people) to emphasise space. Objects are treated not so much for their colour or compositional value, as for their intrinsic qualities, as unique creations. This cooler, sparser, leaner approach owes much to the climate created by certain types of abstract art – Sam Francis, Mark Tobey, Adolph Gottlieb, Mark Rothko, Julius Bissier[76] – and to the Eastern meditative philosophies, such as Zen, which informed them. By learning these new lessons and enriching her own art, Blackadder has provided a valuable link between the traditions of the Edinburgh School and the meditative, more minimal approach of a later generation of Edinburgh artists.

Houston, on the other hand, has always leant more towards Expressionism and strong colour. His landscapes, in particular, have often come close to abstraction. *Village under the Cliffs* 1962 (cat.155) is made up of a pattern of coloured facets out of which the motif only dimly emerges. The jewel-like surface of such a painting has affinities to the late work of Maxwell and contemporary pictures by Philipson, but, equally, there are links with post-war French abstract art. This can be seen especially in the gestural jabs and flourishes made in red paint that animate the surface. The effect achieved is distinctly visionary.

Looking beyond the Edinburgh School, other Scottish artists in the 1950s were moving towards abstraction, albeit an abstraction based on nature or a specific experience. Joan Eardley felt the need to develop a new idiom to paint the sea and surrounding countryside at Catterline. It had to be broader and less concerned with detail than the form of realism that she used in her Glasgow paintings. Only gradually did she loosen her brushwork and quicken her attack sufficiently to paint the sea with the force it needed. The paintings of the abstract Expressionists and of de Staël in particular seem to have given her the answer. Paint could be allowed to exist in its own right expressing the force of the gestures that went into their making and, in turn, Eardley's own reaction to the motif. The paint no longer needed to represent the sea, but to be an analogue or equivalent. The wave breaking on the shore in *The Wave* 1961 (cat.104) is evoked by a wall of vigorous downward brushstrokes, repeated with incessant fury. It does not actually *look* like foaming water, but makes us *feel* the same energies and movement.

Similarly, in the early 1960s, John Knox and William Crozier, both of whom trained at Glasgow School of Art, used the language of Abstract Expressionism to convey a feeling of landscape. Knox, in particular, who had been very impressed by the exhibition of American abstract artists that the Museum of Modern Art, New York toured round Europe in 1958–59,[77] went beyond the evocation of landscape. In *Aftermath c.1961* (cat.178) Knox is concerned with a much more general mood, with the bleakness and despair left after a disaster, whether nuclear or whatever. One could read natural elements (a red sun, for example) into the forms, but this is not necessary; they work equally well as equivalents of pure feeling. Knox and Crozier were later to go on to work in a much more figurative way, so that by the 1980s their work came more to resemble (though not to be) 'new image' painting. Ian McKenzie Smith, however, who went to Paris with Knox on a scholarship in 1958–59, has remained true to his abstract style of large blocks of closely related colours (cat.322). Cooler and more deliberate than either Knox or Crozier, Smith's work is meditative in approach, more constructed and altogether more ordered. The references to landscape are less specific to the appearance of an actual motif than to a feeling of being at a particular place at a particular time.

Abstract art never became as popular among artists trained in Scotland as it did in England. Many of those Scots, such as Colin Cina, Alan Gouk and John McLean who did develop an abstract idiom in the 1960s either had no formal training in painting or trained in England. Even if they did train in Scotland,

like Douglas Abercrombie or Fred Pollock, they eventually settled in England. But despite this generally unwelcoming climate in Scotland for abstract painting – at least in its most uncompromising form – the fact is that some of the best post-painterly abstract work carried out in Britain has been done by Scots. In the 1960s Cina, responding to American colour-field painting by Noland and Stella but also to contemporary British Pop art, began a series of shaped abstract canvases that explored the issues of spatial ambiguity and flatness and the tensions between the two. He continued with these same concerns in the 1970s in a series of more traditional rectangular paintings, but now with a greater emphasis on colour. The paintings of the 'MH Series', as he called it, are characterised by a monochrome, but not totally flat, background, interrupted by a carefully worked out sequence of vertical and diagonal lines (cat.49). These are painted in different colours from the background, so that there is a constant movement not only across the canvas but between figure and ground, something that is alien to the American concept of colour-field painting, but is an essential part of Cina's aim. Cina explained it thus: 'The intention is a painting which is as much a celebration of its colour and surface substance as it is a demonstration of a linear logic at work. I hope for a tension between the two; a contest for the total rectangle.'[78]

Gouk's art also has a superficial resemblance to colour-field painting, but he does in fact resolutely reject flatness as a desirable quality in painting. His influences come rather from the generation of abstract artists who preceded Noland and Stella. Hans Hofmann and Patrick Heron are his heroes. Their exploration of the pictorial space created naturally by colour, and their manipulation of the push-pull effect of juxtaposed colours, are aspects of abstract painting that Gouk enthusiastically endorses and develops in his own work. The large horizontal paintings that he has produced in the last few years have a long lineage in what he has done before, but they are also a real breakthrough (cat.152). Their very width has allowed Gouk to be expansive and to give his colours a chance to breathe. He now paints in oils rather than acrylics, enjoying the material quality of the paint and the way that it has definite edges. In short, what he is trying to do is to build on a specifically European tradition of painting and, in particular, on the French way of handling colour. In this he is, consciously or unconsciously, furthering Fergusson's intentions.

McLean's approach is less ebullient and more restrained than Gouk's. He too wants to allow colour to speak for itself, but is anxious not to create a busy, articulated surface, where part answers part, and where composition becomes of paramount importance. To this end, following the lead of such American artists as Morris Louis and Noland, McLean uses bands (either vertical or horizontal) of colour placed next to each other across the canvas (cat. nos. 227–29). He takes care not to abut them too closely and not to create too great a leap in tonality or density, so as to avoid any one colour jumping out and destroying the all-over effect. This gives McLean's paintings a characteristic soothing and lyrical quality. The very lack of materiality in the quality of the paint, its translucency, allowing the light ground to give it luminescence, raises the paintings on to a spiritual level.

The 1960s have become synonymous with a liberation from past traditions and a feeling that 'anything goes'. Such an exag-

geration contains a fair amount of truth. That decade saw a widespread move away from painting, embracing assemblage, environment, photography and performance, a willingness to look at new subject-matter in the form of popular imagery and advertising and a feeling that the idea content of art was equally, if not more, important as its manner of execution. As we have seen, Paolozzi was one of the founders of Pop art in Britain. His slide lecture of his *Bunk* collages to the Independant Group in 1952 was one of the seminal events in the history of that movement. In the 1960s Paolozzi's sculptures (e.g. his painted machine-towers) and prints (e.g. the portfolio *As is When* 1965, for example) were among the most important Pop works of the time. It is therefore strange that there was little impact of British Pop in Scotland itself.

On a broader front, however, things were beginning to open up. The Edinburgh Festival had made the capital city more international in its outlook for at least three weeks in the year. Now there were various initiatives to make the city more lively throughout the year. A group of artists (including John Houston) opened a gallery in 1957, called appropriately the 57 Gallery, to show younger Scottish and international art. Jim Haynes started Britain's first paperback bookshop (The Paperback) in 1959 and provided Richard Demarco with his first space to put on exhibitions. Haynes was also instrumental in getting the Traverse Theatre Club off the ground in 1963. Again Demarco ran a gallery in part of the restaurant, before finally opening his own gallery in 1966. His importance for the development of the visual arts in Scotland in the 1960s and 1970s was crucial. What Demarco did was to expand the definition of art in Scotland. His ability to make people believe that what they were seeing in his gallery, or wherever he happened to be presenting an event, was of crucial importance and mattered, opened up whole areas of experimental art in Scotland. Demarco introduced Beuys, Kantor and numerous East European artists not only to Scottish audiences, but British ones as well. His presentation of avant-garde art from Düsseldorf in the 1970 Festival exhibition, *Strategy: Get Arts*, was a revelation for many. Joseph Beuys's *Pack* of sledges tumbling out of the back of an old Volkswagen minibus was an image that stayed in the mind – and altered it.

One of the first artists whom Demarco showed at the Traverse Theatre Gallery, during the 1963 Edinburgh Festival, was Mark Boyle. Boyle, working with his companion Joan Hills, exhibited a group of reliefs, which were assemblages of junk found on the street, in junk shops and in scrap yards. The works were given high-flown titles, such as '*Mine Eyes Have Seen the Glory*', c.1963 (cat.32) that were meant on the one hand to be taken ironically, but on the other had a serious intent. By mixing religious and profane imagery with the rusting junk of modern society, Boyle and Hills were debunking the dogmatism of religion and other faiths, making them as much a part of man's detritus as empty tin cans. In '*Mine Eyes Have Seen the Glory*' they juxtaposed a Victorian print of 'Christ before the people' with a photographic reproduction of Baudelaire and surrounded them with such discarded objects as a car number plate, an old bicycle wheel, a broken umbrella, half a table-top and scrap metal. Baudelaire, prophet of 'la vie moderne' and of the beauty that could be found in even the most superficially sordid of objects, is like a new messiah of the junk that surrounds him. The implication seems to

be that this is worthy of our consideration. Do not ignore it. It can be as beautiful as a conventional work of art, if we look in the right way.

This attitude towards the lowliest aspects of reality, this desire to be as open and as objective as possible, lay behind Boyle Family's still continuing project, *Journey to the Surface of the Earth*, launched in 1969. Their aim was to reproduce one thousand randomly selected sites around the world (chosen in part by throwing darts at a map), to document their own physical and emotional state when they were working on that site and then to present the results in a gallery simply for what they were. To this end they have developed a technique of taking a mould of the ground surface in question,[79] which also removes any loose debris. A fibreglass relief is then made and painted so as to resemble the original motif as exactly as possible (cat.35). In a curious way Boyle Family's search for truth has the same freshness and eagerness for discovery that the early Renaissance artists had. Truth and art are one and the same thing. Mark Boyle puts their aims with tremendous clarity:

In Boyle Family we are constantly and hopelessly trying to work towards the truth. Trying to remove the prejudices that the conditioning of our upbringing and culture impose. Trying to make the best visual description our senses and our minds can achieve of a random sample of the reality that surrounds us. Boyle Family are not social or anti-social, radical or anti-radical, political or apolitical. We feel ourselves to be remote from all these considerations. We want to see if it is possible for an individual to free himself from his conditioning and prejudice. To see if it's possible for us to look at the world or a small part of it, without being reminded consciously or unconsciously of myths and legends, art out of the past – or present, art and myths of other cultures. We also want to be able to look at anything without discovering in it our mother's womb, our lovers' thighs, the possibility of a handsome profit or even the makings of an *effective* work of art. We don't want to find in it memories of places where we suffered joy and anguish or tenderness or laughter. We want to see without motive and without reminiscence this cliff, this street, this roof, this field, this rock, this earth.[80]

What Mark Boyle articulates here is part of a general move in the 1960s to bring reality, life as it is, back into art after the subjective excesses of much abstract art. Paolozzi was in the forefront of this movement and Bruce McLean continued it in the late 1960s with his debunking of what he saw as the arbitrary nature of 'New Generation' sculpture and with his minimal interventions in the actual environment. Time and especially the idea of ephemerality were crucial to many of the works McLean did at this period. He would put objects on a piece of wood and let it float away down a stream (cat.219); he would photograph puddles, until they eventually dried up (cat.222); he would scatter wood shavings on ice (cat.223). McLean was interested not so much in the constructed physical object, in sculpture in the traditional sense, as in the process whereby a work comes into being (and disappears again). 'I liked the idea of a puddle as a sculpture, because it is not eternal, it exists only when it rains. The sun takes away sculpture because it makes another situation.'[81] In some ways these works share Boyle

MARK BOYLE **Pavement Piece** 1968 (cat.35)

Family's concerns for opening up the mind to the world about us, but in other ways they reflect McLean's own tangential approach to reality. Somewhere there is always an implied criticism or ironic comment on the accepted way of doing things or looking at them. In the 'landscape paintings' that he did in London and Scotland in 1968 and 1969, McLean did not paint from the landscape, but painted the landscape itself, by placing long lengths of photographic paper on rocks, grass or the sea and painting on them (cat. nos. 220–21). He thus poked gentle fun at the land artists who left their personal marks on the landscape by suggesting that this was perhaps not quite so radical and different from traditional landscapes as they supposed. But McLean's most sustained criticism and barbed humour were reserved for certain sculptors and for what he regarded as their pompous poses. In *People who Make Art in Glass Houses*, *Work* 1969 (cat.224) McLean parodies the apparent breakthrough made by the St Martin's pupils of Anthony Caro. As McLean put it in a famous review of an exhibition of British 1960s sculpture:

In the early sixties, under the direction of Frank (come into my office, Jock) Martin, the sculpture school at St. Martin's was making one breakthrough after another. Now, in retrospect, none of these were, in fact, major breakthroughs.

1. Put-a-sculpture-on-the-floor piece. This came immediately after take-that-sculpture-off-that-base-and-don't-ask-questions piece. There was some discussion about all that: "What do you think, Tony?" "Oh, I'll go along with that, Jeremy."

Paint-a-sculpture piece was another not-to-be-quickly-forgotten breakthrough, when everyone was rushing about

buying clever shades of paint, secret mixes, painting every sculpture in sight, calling sculptures magical names like 'Paripan', 'Dulux', 'Panfastic', without anyone thinking why they were painting up the tatty floor pieces and off-the-base works.

No problem then; all you needed was a 4-inch brush and a can of paint: 'Bitter chocolate'. 'brown sculpture'?[82]

In *Pose Work for Plinths* II 1971 (cat.226) McLean had himself photographed in various poses balanced on three differently sized plinths. The mock heroics of the poses, which in themselves are ridiculous and bear no relationship to real-life situations, are McLean's tongue-in-cheek comment on the late sculpture of Henry Moore. They also mark the beginning of a continuing critique of affected style and pose through the use of his own body, which was to include performance as well as photographs and painting.

Neither Boyle nor McLean have lived in Scotland since the 1960s and, although both have had some influence on various Scottish artists through exhibitions and performances,[83] they have not really had a following. Two other very different artists, however, Ian Hamilton Finlay and John Bellany, have contributed much to a change in the artistic climate in Scotland. Finlay's dual engagement with modernism and the classical tradition, his struggle to go beyond the former by giving it the bite and richness of the latter, what he has called 'the rejection of purity as inconsequentiality in favour of purity as commitment',[84] has promoted a greater acceptance of the importance of ideas and intellectual content in art. The *belle peinture* tradition nurtured in Scottish art schools, on the other hand, has tended to stress painterly know-how and intuition, a concentration on formal and expressive qualities.

Finlay's art is as much about words – the images and associations that they evoke – as it is about visual imagery. Indeed, much of his work depends on the interaction of the two. Words are often used in counterpoint to images in a seemingly perverse and paradoxical way – for example, a drawing of an aircraft carrier bears the inscription 'The Divided Meadows of Aphrodite' – but, in actual fact, pointing up the metaphorical nature of the image. In this respect, Finlay adopts a similar strategy, if not the same aims, as some Surrealist artists like Magritte. The seeming disparity between image and word in Finlay's work serves to make us question the fixed nature of meanings. In particular, it makes us question the idea that classical art and culture is a thing of the past and that it was simply a matter of calm grandeur and noble simplicity and a product of pure reason. Finlay insists that classical culture is still an active force today and points out that Apollo bore a bow as well as a lyre. Behind the quiet façade there are tamed forces of violence. This is a very important aspect of Finlay's work and one which has led to the greatest misunderstandings: his use of images of war and terror in pastoral and other settings. In fact, Finlay is returning to the true nature of classicism. Following Nietzsche who argued that the calm grandeur of Apollonian culture was only possible through the awareness that there was a darker, violent side of life (including human nature), which he termed Dionysian, Finlay forces us to face up to the fact that the reverse side of modern culture, even of modernism itself, from the French Revolution to today are its wars and its engines of destruction.

BRUCE MCLEAN **People who Make Art in Glass Houses, Work** 1969 (cat.224)

Thus, in his stone relief *Et in Arcadia Ego* 1976 (with John Andrew) (illustrated p. 95) Finlay replaces with a tank the tomb discovered by Arcadian shepherds in Poussin's famous painting of the same name. Instead of an elegiac meditation on mortality, Finlay returns us to a sterner and purer form of classicism by reverting to the grammatically correct rendering of the motto, which is 'I, death, am also in Arcady'. Finlay's modern metaphor for death, for the destructive force in nature, is the tank. In this way he insists on the relevance of classical ideas to our own disjointed culture.

Finlay's love of classical culture but awareness that it cannot be reconstituted, least of all in a north European country, has much in common with the German romantic notion of the north longing in vain for the south, given eloquent form by Goethe's poem 'Kennst du das Land, wo die Zitronen blühn?'. What distinguishes Finlay's work, however, from the majority of German poets and artists is his total lack of romantic *Sehnsucht*, and his emphasis on the power of wit and metaphor to unite opposites, if only temporarily. Finlay is just as conscious of the tremendous gulf between north and south, between modern and classical culture, but he does not despair of the possibility of spanning a few bridges between them.

By the early 1970s Finlay's 'neoclassical rearmament project' was well under way and his work was enjoying growing recognition.[85] It was also during this period that there emerged in Edinburgh a number of young artists who turned their back on the concerns of the Edinburgh School for paint quality and sensuous colour, and explored new ways of looking at and experiencing nature. They rejected the mimetic image, at least the traditional way in which it was used as a vehicle for personal expression and decorative rearrangement, and preferred instead a more direct, yet abstract approach. Kenneth Dingwall is one

of the oldest of these artists. His abstract paintings and constructions were first developed about 1973 when he spent a year teaching in the United States. There is no doubt that he was influenced formally by American abstract painting (Rothko, Robert Ryman and Brice Marden come most readily to mind), but his underlying aim remained the same: an attempt to articulate the constant shifts between our inner and outer worlds, between what we show to the world and what we actually feel, what we can grasp on the outside and what we gradually come to perceive beneath the surface. Dingwall's method is laborious and painstaking. He builds up a uniform, all-over paint surface, usually in grey or some other dark colour, brushstroke after brushstroke (cat.97). These are applied rhythmically, following a set pattern (in vertical rows, for example, or in overlapping arcs), that induces a sort of meditative trance. It is an act of covering, of hiding what is beneath. But, here and there, the underpainting is visible between the brushstrokes: often a red, raw like a wound.

Other contemporary Edinburgh artists have employed this repetitive, meditative element in their work in an attempt to find an analogue for their feelings. Alan Johnston's pencil marks begin by creating small structures, which in turn form larger structures spreading over the whole piece of paper or canvas (cat.171). The smallest marks themselves are an attempt to capture the feelings of being in space, of extension horizontally and vertically; when taken all together they create a landscape equivalent, nearer perhaps to some of the Japanese masters whom Johnston admires than to western artists.

Eileen Lawrence does not eschew drawing from natural objects, but she does seek to avoid imposing her personality on them. She draws things that she finds on visits to the countryside – pebbles, eggs, feathers, twigs – natural things that capture the experience of her being there, but which also represent another world outside her own self (cat.180). Lawrence tries to establish a unity between herself and the natural world, at first by a meditative emptying-out of self, in a form of ritualistic mark-making. She then incorporates the highly detailed and dispassionate drawings of these objects in the pattern of abstract marks. A harmonious and natural sequence of abstract and figurative drawings is set up which sometimes become what Lawrence, borrowing from Tibetan usage, terms prayer-sticks. They are a meditation on the natural order of things and an attempt, albeit small and isolated, to return humanity to that order.

Glen Onwin also believes passionately in that order and, increasingly in his recent work, warns of the dangers that man's actions pose to it. Since his time as a student at Edinburgh College of Art Onwin has wanted to move away from what he saw as the artificiality of traditional painting: not only the image-making, but the fact that the paint itself was an artificially manufactured product. Onwin wanted honesty and naturalness above all. So he abandoned image-making and made objects instead; he turned away from manufactured paints and began using naturally occurring minerals – in particular, salt. Salt fascinated him because of its ability to alter its physical appearance according to its water-content. Looking at the salt marshes on the south-eastern coast of Scotland, he was impressed by the natural cycle of events as the tide ebbed and flowed. Pools would be left by the ebb tide, which gradually dried out, leaving behind crystalline salt deposits. These in turn would disappear as the tide flowed back again. Onwin began to see salt (and other minerals) as natural symbols of the underlying structures of nature: structures that changed their appearances on the surface, but which were eternal beneath. He created two exhibitions, *Saltmarsh* (1975) and *The Recovery of Dissolved Substances* (1978), which looked at the 'life cycle' of salt, at its structures and how it is won from brine. Using a wide range of media and approaches, from objects, panels of encrusted salt (cat.262) to photographs, Onwin confronted the visitor with a timeless spectacle, a world that continued to operate according to its own laws. Between 1978 and 1988 he worked on a huge project which ultimately found form in another exhibition, *Revenges of Nature* (1988). What Onwin wanted to do was nothing less than to chart the birth and death of the universe. He did so through a series of panels that not so much represented as recreated aspects of natural growth and decay: the appearance of certain minerals, the first signs of life, the effects of nuclear and industrial pollution, acid rain, total destruction. He used actual minerals rather than paints, actual plants rather than depicted ones. The emphasis was on directness and materiality. This is how it was, this is how it is, this is how it will be – unless things alter.

Other artists of this generation have put the emphasis elsewhere. Robert Callender has conducted an elegy for a passing age and on decay itself in the form of old abandoned boats and parts of boats (cat.42), all fabricated by himself rather than found, but made to look deceptively real. Elizabeth Ogilvie, like Lawrence, has created a mesmeric quality in her drawings of the sea, of the patterns created by its rhythmic movements, and of the undulating shapes of the seaweed that floats in it (cat.261). Derek Roberts, on the other hand, prefers to create abstract equivalents for his feelings about nature. He uses the traditional medium of painting to achieve this, but his concerns are very close to those of his friends (cat.315). He seeks underlying unity in nature, to establish a parallel world of harmony among diversity in his own works. Repeated rhythms, grids, echoing forms and colours are some of the means he uses to establish this. Michael Docherty is particularly concerned with place and time. His work is rather like a diary that records experiences, insights, collected thoughts – not in a descriptive way, but, as with most of the artists mentioned here, in the form of abstract equivalents and found objects (cat.98).

This move away from representation, either towards a more tangential, poetic evocation of reality or towards a direct confrontation with matter itself, mirrored developments elsewhere in Britain, Europe and America. It was and is a movement with a distinctly internationalist bearing, in keeping with the general tenor of the late 1960s and 1970s. The 1980s, in contrast, have seen the growth of more national-based movements and styles that has gone hand-in-hand with a return to figurative painting. Scotland has been very much to the fore in these developments, helped by the example of two artists who established what amounted to a manifesto-position on figurative painting in the early 1960s. John Bellany and Alexander Moffat rejected not only the *belle peinture* tradition of the Edinburgh School but also what they saw as the lack of humanity in modernism. They felt that both were irrelevant to the lives of ordinary people. They wanted art to move people, to address the human condition in

JOHN BELLANY **Enigma** 1981 (cat.15)

all its glories and all its faults. The tradition with which they aimed to link up was the largely North European realist-expressionist tradition, from Bosch and Breughel, through Goya and Courbet to Munch, the German Expressionists and the artists of the *Neue Sachlichkeit*. Even while they were still at art college in Edinburgh they decided to 'take on the establishment' by showing their paintings on the railings outside the Royal Scottish Academy during the 1964 and 1965 Festivals.[86]

Bellany showed his triptych *Allegory* 1964 (cat.14) there in 1964. This is a major work by any reckoning, but for a twenty-two-year-old student it is a *tour-de-force*: a conscious attempt to take on the Old Masters at their own game, but to root it in his own experience. Bellany had grown up, the son of a fisherman, in the fishing village of Port Seton, near Edinburgh. The scene in *Allegory* is set in a busy harbour with a view of what could be the Bass Rock in the background. The immediate foreground is dominated by three enormous gutted fish, nailed up on posts to dry. Inevitably they assume the aura of a crucifixion scene; and the fish become symbolic victims of human cruelty and evil. The fishermen look on impassively but not without dignity, like figures from a painting by Piero della Francesca.

This work and others like it set the pattern for Bellany's later development. He has always based his paintings on his own experience, but has sought to give that experience universal significance and greater resonance by linking it to mythical events and characters and to religious themes. If realism is to say something forcibly it usually has recourse to symbols or it evolves into a form of expressionism by heightening form and colour. Bellany's work has taken both paths. In the 1960s and early 1970s he relied mainly on symbols, masks and allegories; in

the later 1970s and early 1980s he kept this stock vocabulary but became more extreme and wild in the way he applied his paint. This reached a crescendo in such paintings as *Enigma* 1981 (cat.15) where it is only just possible to make out the subject-matter. True to his aim of painting from personal experience, Bellany does not flinch from showing the gradual breakdown and turmoil in his own emotional life. Veiled self-portraits, a boat adrift at sea, a view of a lighthouse, signalling both haven and possible danger, can just be made out. After a period of relatively quiescent painting in the mid-1980s when he was very ill, Bellany has now regained his energy and daring and is once more tackling his paint with renewed fire.

Alexander Moffat had the same belief in the power of figurative painting to ennoble life, but developed along a different path from Bellany. He concentrated more on portraits, often choosing people who have furthered Scotland's artistic progress (cat.254). He is less personal and less Expressionist in his approach than Bellany, preserving a more objective detachment. Through his teaching at Glasgow School of Art since 1979, Moffat has done much to pass on the ideals shared by him and Bellany and so, in a curious way, to reinvigorate the Glasgow tradition of sharply delineated figure painting and hard-edged realism. Bellany's influence on a young generation of Scottish painters emerging in the late 1970s and 1980s was not confined to Glasgow. Several artists from the other three art schools in Scotland (Aberdeen, Dundee and Edinburgh) also saw him as a model or guide to help them find a specifically Scottish voice in the Neo-Expressionist/new image painting of the time.

It is never easy to distinguish groupings and trends when one is still so close in time, but one can perhaps map out some of

these recent developments. Of an older generation one should perhaps mention Will Maclean. Although he has been active as an artist since the late 1960s, it was only after his exhibition *The Ring Net* (see cat. nos. 230–34) was shown in 1978 (in Glasgow, Edinburgh and elsewhere) that he really came to prominence. This part-documentary, part-elegiac celebration of a vanishing section of the Scottish fishing industry set the tone for his subsequent work, which has largely taken the form of boxed reliefs. Like house-altars, or fetish objects, these boxes evoke the myths and symbols of fisherfolk and their precarious existence on the sea (see cat.235). In this respect he is exploring a subject-matter similar to Bellany's. Since 1981 he has been a lecturer at the Art College in Dundee, where he has exerted a considerable influence on some of his students.

Myths and symbols, whether personal or shared, have played an important role in recent Scottish painting (as elsewhere). Young artists have, for the most part, not wished simply to represent their surroundings no matter how transformed by colour and *facture*. They have wanted to reflect some of the complex layering of our modern (or rather post-modern) consciousness, the constant intrusion of memory into perception, the ability to hold several, often contradictory ideas in our minds at once, the realisation that reason is not crystal-clear and objective, but the product of a whole gamut of perhaps falsely assumed premises and prejudices. Contemporary Scottish painting is, therefore, with notable exceptions rarely utopian in its endeavours, as was much of the art of the 1960s and 1970s, but, paradoxically, it acknowledges the reality of things by exploring the realms of the imagination. This, they seem to be saying, is what reality is really like.

Some of the artists at one time or another associated with the 369 Gallery in Edinburgh have been more prepared to continue the Colourist tradition associated with the Edinburgh School and have found sufficient inspiration in their surroundings. Fionna Carlisle has a taste for the exotic and the colourful, but she rarely goes beyond it into fantasy. The exuberant rhythms of Chinese acrobats (cat.45), the sweeping curves of people sitting in a bar (cat.46), the utter richness of nature's colours are more than enough to excite her imagination. Andrew Williams is likewise an artist who finds inspiration in the sensuousness of perceived forms and colours. Indeed, his recent paintings of landscapes in the Dordogne (cat. nos. 347–48) broken up into myriad touches of thick paint, have a lushness and luxuriance reminiscent of Impressionism. Caroline McNairn, likewise, draws on aspects of her surroundings, particularly of Edinburgh, to provide the basis for her paintings. But these are composite, synthetic images, built-up of objects, places and occasionally people, that mean something to her. They do not form a narrative, but rather a collage of signs, and associated memories. McNairn pieces them together in a complex pattern of advancing and receding forms that betrays an abiding interest in the formal vocabulary of early twentieth-century French art (cat.237).

Two other artists who once showed regularly at the 369 Gallery, June Redfern and Ian Hughes, developed a more expressionist approach in their painting, influenced in part by Bellany's 'wild' pictures of the early 1980s. Redfern, typically, begins with personal experiences, but weaves into them mythic, archetypal elements and memories of Scotland (she moved to London in 1983). Her paintings always deal with the human (usually female) figure, which she treats in monumental fashion and with which she strongly identifies. Her involvement with the images she creates is expressed in a rapid and vigorous execution. Hughes, likewise, identifies very closely with the figures he paints. These are usually life's unfortunates: Kafka dying of consumption, patients lying in a hospital bed (cat.158) (Hughes used to be a psychiatric nurse), people suffering from various ailments and illustrated in a medical textbook (cat.159). Interspersed with these Hughes uses his own image, contorted into various grimaces. Hughes rarely invents his images but takes them ready made, often in the form of photographs. He reacts to them almost as if they were religious icons, 'men of sorrow', heightening the features with paint, trying to achieve an act of catharsis. He made the links between pain, sickness and religion even more obvious in a series of boxes he created in 1988, in which he mixed images of religious devotion and pictures of sick people. Hughes has taken self-identification to the point where formlessness and emotionalism threaten to dissolve the image itself.

A concern, even obsession, with the human body is a characteristic of several young Scottish painters working today. Several women have taken up the challenge of trying to create a new image of the female body, either an internalised image – what it feels like to be a woman, rather than gazed at from without (by men) – or a new conception of woman as hero. Sam Ainslie has developed the latter approach in a series of large-scale wall-hangings, in which women are seen not in passive and traditional roles, but as active forces for social progress (cat.1). Although highly abstracted and broken up into strong formal patterns, these figures are not as radically reworked from within as those by Gwen Hardie or Margaret Hunter.[87] While still at Edinburgh College of Art, Hardie, often using herself as the model, depicted the female figure in straight, frontal poses (cat.153). She avoided the traditional appeals of *contrapposto* and of an elegant, sinuous line, concentrating on the bald facts, especially the round shapes, of the body. Although attempting to paint the body more from the standpoint of how it feels, rather than how it looks, these early works still owe much to certain models provided by other artists. Balthus, Dubuffet and Fautrier, in particular, were chosen precisely because they departed from the classic view of the female body and had moved towards a more tactile, visually diffuse treatment. Hardie's move to West Berlin where she studied under Baselitz brought about a great change in her work. Baselitz encouraged her to be more conceptual, to put checks on her facility with paint, to break away from *belle peinture*. She therefore adopted various strategies to make her rethink her approach. She used a sponge instead of a brush, she made sculpture, she depicted individual parts of the body (cat.154) and especially its internal organs. This process is still under way, but it is full of the excitement of discovery. Margaret Hunter has also studied in Berlin under Baselitz. Again the effect was to move her away from relying so much on paint quality as a vehicle of expression and to be more analytical about what she was trying to achieve. She is still interested in depicting the female body but now, increasingly, she sees it in relationship with its offspring (cat.168) and with other bodies (cat.169). In an attempt to break with the European tradition of depicting the figure, Hunter has turned to primitive art for inspiration and to making ceramic sculpture.

KEN CURRIE **Glasgow Triptych** 1986 (cat.87)

Robert Maclaurin has been a friend of Hardie since they were students together at Edinburgh College of Art and shares several of her concerns, especially for monumental forms and for bold rhythmic design. However, he is not interested in the figure as material fact, but rather as psychological entity. Alone in mountainous terrain, dwarfed by smooth and symmetrical land formations, Maclaurin's figures are usually male and perhaps an alter ego. The swelling forms of the landscape suggest the female element in life, not so much as earth mother, but as 'the other', that which is different and opposite – at least for the male. In Maclaurin's paintings man is not threatened by his surroundings so much as squeezed out by their self-sufficiency (cat. nos. 217–18).

Despite attempts to go beyond the Scottish *belle peinture* tradition, Edinburgh-trained painters, in particular, have found it difficult to forget their training. In Glasgow the situation has been different. *Belle peinture* has never been so firmly entrenched in the Art School there; indeed, the alternative sharp-focus, realist tradition has never completely disappeared. But it has been Alexander Moffat's teaching and guidance there since 1979 that have done much to re-focus attention on that tradition and related movements elsewhere. His influence on Ken Currie and Peter Howson was decisive. Currie, like Moffat, believes in an art that can move people, an art that has something to say, an art that is didactic. Only a few years previously these aims would have been taboo; they would have been branded as reactionary and unmodern. Now that modernism itself is under attack, such an avowedly narrative approach can perhaps be viewed more dispassionately as a way of bringing art and life closer together once again. It should be said straight away that Currie's art is not realistic in the sense of photographic realism.[88] His work is an art of emphasis and of significant incident. It is the realism of Léger and Rivera, where figures and objects are simplified, salient characteristics heightened and the viewer is made to feel the tangible presence of what is depicted. The intention is to create maximum impact and yet still to retain a feeling of verisimilitude. *Glasgow Triptych* 1986 (cat.87) is a fine example of Currie's approach. Behind each canvas lies a main idea that Currie wants to get across. The triptych as a whole is concerned with Glasgow past, present and future and its role in the world. In the left-hand canvas we are presented with an image of Glasgow seeming to flourish, its shipbuilding industry buoyed

up by the war. But there are already signs that things are not all well – the shadow of the child's aircraft falls menacingly over the motto 'Let Glasgow Flourish'. The central canvas shows the depressed state of Glasgow in recent years. The shipyards have now largely gone and the apprentice can but listen to the tales of the older worker of what things used to be like. A band of Orangemen playing pipe and drum has replaced the din of riveting, and the bustle of work has given way to drinking in the city bar. But even here in this scene of depression there is hope. In upstairs rooms people work for the future, reading about ways of building a new society. In the right-hand canvas this theme is now dominant. The young Glasgow Communists gather to discuss the whole world situation; Glasgow's problems are seen merely as one symptom of a worldwide disorder. Everyone now has a part to play in raising the consciousness of the people. The artist (a self-portrait) sits on the right in blue cap, with Léger and Rivera as his mentors. The girl argues the case for action despite all the odds, taking her cue from Gramsci's maxim 'pessimism of the intellect, optimism of the will'. Currie is one of the few artists today who believe in utopias and their power to move people. In rejecting the elitism of modernism he still holds true to its guiding belief in the future.

Peter Howson presents no such compensating 'heaven' for present ills. He takes the drunks and dossers of the East End of Glasgow and elevates them to the status of modern heroes and martyrs (cat. nos. 156–57). They are the victims of our society, but they are not represented as broken and down. Instead he depicts them in heroic, noble poses, often defiant and proud. Howson's style is consciously ebullient and popular, the modern equivalent of Baroque. Its bulging emphatic forms, strong contrasts of light and shadow and monumental figures are meant to grab the viewer's attention. It is also a decidedly masculine world, in which aggressive, macho behaviour is an automatic response. Howson's hard men and fighters are held up as puppets, whose posing is presented as empty. In his very different way Howson attacks a male stereotype as pervasive as the traditional female image that Hardie is so intent on replacing.

Currie and Howson attempt to create meaning out of the social world that we can see and feel. Two other Glasgow artists, Steven Campbell and Adrian Wiszniewski, shun fixed meanings as a strait-jacket to the mind. They mix fact, fiction, dream and memories in images that have the absurd logic of *Alice in*

Wonderland, but also its ability to throw light on reality from the other side. We are so used to looking at things in a certain way that we no longer see them as a whole, for what they actually are. It was one of the great achievements of Dada and Surrealism to reverse this process and both Campbell and Wiszniewski owe much to its iconoclastic tradition.

Before he studied painting at Glasgow School of Art, Campbell attended an experimental course there, which included performance and installation. What he learned here, and from seeing such irreverent work as Bruce McLean's,[89] was the value not only of parody and mock seriousness but also of improvisation and the ability to change tack quickly. These are all characteristics that he took with him to painting. As early as 1982, before he went to New York, Campbell had established his basic approach: a seamless narrative or tableau which defies logical explanation, an emphasis on gesture and pose, a preference for an undefined time and place and, above all, a heightened, even dreamlike sense of reality. *Ding Dong* 1982 (cat.43) is typical of these early paintings. A monumental female figure, dressed rather like one of Velazquez's *meñinas*, holds out her left arm in a pose we cannot explain. Weights are attached by chains to both her wrists; arrows suggest they are moving to the left and the words 'ding dong', written on the canvas, suggest they are also bells. The viewer is blocked in every attempt he might make to solve the mystery of the painting. Campbell does not provide us with the necessary information, because there is none. Everything is left open and full of contradictions.

During the time he lived in New York and since then, Campbell's paintings have become more complex. He has established in them his own private world, where traditional logic, causality and probability are suspended or rather are turned on their head, because it is precisely this ingrained way of thinking that he wishes to test to breaking-point. Many of his titles point to the direction of this thought: *Two Humeians Preaching Causality to Nature* 1984, *Propagation by Electrolysis and Gesture* 1984, *Is Anaemia in Nature Caused by Disease or Lighting?* 1984, *Two Naturalist Philosophers Debating in a Garden* 1984, *Accidental Intrusion Judged by Nature's Law Guilty* 1987, *Men of Exactly the Same Size in an Unequal Room* 1987, *The Aggressiveness of Red and the Passivity of Yellow* 1987, *The Tyranny of Maths* 1988. Campbell is fascinated by science and pseudo-science, philosophy and pseudo-philosophy, and constructs absurd but somehow believable scenarios to take various ideas to their logical conclusion. Like Magritte or the young Max Ernst, Campbell delights in overturning the rationalist applecart and examining the way our minds turn and wriggle, trying to make sense of the resulting disarray (cat.44).

Adrian Wiszniewski, like Campbell, prefers the open-ended ambiguity of dreams to the cut-and-dried logic of the world as we interpret it. His method of painting, improvising as he goes along, one object suggesting another, causing him in turn to alter something else, works very much on the level of the dream. Associations rather than pre-ordained logic are the basic guidelines. Inevitably this leads to unconscious desires and fears coming to the surface in the imagery and composition. In the early works there is something akin to automatic drawing in the dense network of lines that criss-cross over the surface of the paper (cat.357). The figures that are enmeshed in them seem lost in their own dreams and longings, which are emphasised

ADRIAN WISZNIEWSKI **Bound to Love and Cherish** 1984 (cat.357)

by various symbolic objects and forms. In all Wiszniewski's inventions, whether they are figures or objects, there is a strong feeling of internal life and growth. They are never inert. Forms writhe and twist as if they were part of a general longing within nature and nature itself were but an extension of the artist's own desires (cat.358).

The Glasgow tradition of sharply focused figure painting has reasserted itself no more strongly than in the work of Stephen Conroy (cat. nos. 64–65). A great admirer of Cowie, he is a devotee of the life-room and draws as often as possible from the model. Unlike Campbell and Wiszniewski, he believes in the ordering power of reason. His paintings are meticulously planned down to the last detail; nothing is left to chance. This is very much in the classical mould. Similarly classical is the way he submits his forms to the dictates of an overall design, simplifying figures to types, and giving them a strong outline. Indeed, Conroy is very fond of presenting his figures in profile, as flat shapes disposed at ordered intervals across the canvas. The stillness and static quality of the works give them a mystery that we cannot unravel with the help of the subject-matter. Indeed, the implication is that reality itself is mysterious. In this respect, Conroy is also heir to the Surrealist tradition.

Post-modernism has made much of the classical heritage and of its continuation, often submerged and altered out of all recognition, in our own culture to-day. It denies the possibility of the *tabula rasa* and points to the survival of ancient signs and symbols. Two Scottish artists who trained at Glasgow School of Art in the 1970s, who both spent a year's study in Rome and who both now live in London, are fascinated by these images. Kate Whiteford began as a non-figurative artist, but became interested while in Rome and then while she was Artist-in-Residence at St Andrews University in the remains of ancient civilisations and, in particular, in certain symbols that recur in different cultures all over the world. One of the tenets of abstract art is its universality; perhaps such symbols hold the key to an already existing universal language, a language of signs. Whiteford now works in the area between abstraction and figuration, at the interface between basic abstract forms and symbolic images,

which, like the spiral of the shell, themselves often have a widely recurring natural form (cat. nos. 343–46). She paints in such a monumental way, often in installations and usually on large canvases, using strongly contrasting colours, often red and green, that the large designs and symbols imprint themselves very forcibly on the mind. The colours tend to vibrate and throb, leaving retinal after-images. When offered the chance to work on an even bigger scale, she grasped the opportunity and carved huge images in the turf on Calton Hill, Edinburgh, mindful of the ancient figures on the chalk uplands of Southern England.

Mario Rossi is less interested in the formal qualities of classical imagery than in the fact that it is recycled in another form, that it is merely one manifestation in a continuous process of change, decay and rebirth. His work *Charms, Capillaries and Amulets* 1987 (cat. 316) consists of nine drawings which contrast images of classical antiquity, such as Zeus and Neptune, with images of present-day reality, such as a speeding car and a power station. Just as Zeus's authority is symbolised by the thunderbolt he carries, just as Neptune's trident symbolises his sway over the oceans, so the car and the power station are modern symbols of our own domination over nature.

This essay has in the main concerned itself with the history of painting in Scotland in this century. That is not to say that much of interest could not be written about Scottish printmaking, photography and sculpture. Their history remains to be researched and written. But one should point out that all three activities are currently flourishing in Scotland. The printmaking studios in Aberdeen, Dundee, Edinburgh and Glasgow are very active, not only in providing facilities for artists to make prints, but in editioning work themselves and printing work for other publishers. *The Scottish Bestiary* 1986 was one such successful venture, which brought together in one portfolio prints by Bellany, Campbell, Howson, Knox, Bruce McLean and Redfern. Photography in Scotland was given a boost when a special department was set up in 1983 at Glasgow School of Art to teach the subject. Its first Head is the American photographer Thomas Joshua Cooper. Already several very promising young photographers have come through the course. Another impetus has been given by the success of Calum Colvin and Ron O'Donnell, both of whom work in the area of staged photography. Colvin came to photography via sculpture, which he studied at art college in Dundee. This still shows in his work, which is concerned with the ambiguities of space and its representation. Using the corner of his studio he constructs a tableau out of junk or objects bought cheaply from thrift shops. He then paints the actual set in such a way as to conjure up a two dimensional image (when seen from the right standpoint, ie the camera lens). This has led him into complex games with linear perspective, but also into questioning the whole nature of visual representation and the imagery used. In many of his works Colvin recreates a famous painting – particular favourites are pictures by Ingres – but because it is partly made up of contemporary objects, including kitsch sculpture, magazine illustrations and comics, chosen for their thematic relevance to the main image, its mystique and uniqueness is deconstructed and it becomes part of a web of images (cat. 63).

In his tableaux O'Donnell creates absurd and incongruous situations in order to point up what he sees as some of the absurdities of real life. Sometimes the intent is humorous and

KATE WHITEFORD **The Snake** 1983 (cat. 346)

lighthearted, sometimes it is critical. For example, he attempts to ridicule the idea of a controlled nuclear war, by showing a bomb exploding in a living room (*Tactical Nuclear Explosion* 1985). He comments ironically on the so-called 'north-south divide' by splitting a room into two, one half overflowing with the goods of affluence, the other half gloomy with abject poverty (*The Great Divide* 1987 (cat. 260)).

There has been a distinct increase in sculptural activity in Scotland since the mid-1970s. Although Paolozzi and Turnbull had been at the forefront of developments in Britain in the 1950s and early 1960s, Scotland, except for isolated examples,[90] did not really share in the subsequent diversification and radical departures of sculpture in the late 1960s and 1970s. With a view to improving the situation a number of initiatives took place. The Glenshee Sculpture Park was opened in 1975. The Scottish Sculpture Trust was founded in 1978 and almost immediately opened the Highland Sculpture Park (Landmark) at Carrbridge;[91] the Scottish Sculpture Workshop was opened in 1980 and has organised the Scottish Sculpture Open exhibitions every other year since 1981; the Federation of Scottish Sculptors was founded in 1982; in 1985 Cramond Sculpture Park was opened; and in 1989 sculpture workshops were opened in Glasgow and Edinburgh. The fruits of all this work are now evident. Some of the most interesting sculpture shown in the Glasgow Garden Festival in 1988 was by young Scottish artists. Looking at recent developments it is noticeable how associational values are placed at least on equal terms with purely formal values. Sculptures are seen as images (not necessarily figurative), as much as forms. David Mach, who trained at Dundee and the Royal College in London, uses (usually) large numbers of one particular object, such as magazines, books, tyres, or bottles to create a tableau or another object. In 1982 in Edinburgh he made a tank out of telephone directories; in

1986 (again in Edinburgh) he built a Parthenon out of tyres and in 1987 he created *Outside In* (see illustration p. 110), a lava flow of magazines and newspapers coming in through the windows of the Scottish National Gallery of Modern Art, bringing with it objects relevant to an art gallery situated in a park. There is not always a significant associational relationship between the objects used and the object made, neither is Mach really making any 'comment' on the consumer society (although inevitably this contributes to the aura of his pieces), but there is a necessary formal relationship between the two. Mach has an idea of what he wants to create, but he does not allow that to dictate how he uses his materials; rather he tries to achieve a balance between allowing the materials and the process to decide the final form and allowing the idea to direct the process. In this respect Mach's method is similar to traditional sculpture. As he himself has said: '... speed is essential to finding the energy of the material. That energy source is an abstract idea rather like dealing with the grain in a piece of wood or stone or when stone-carvers talk about releasing the energy inside. The materials and objects I use have a similar kind of energy.'[92] For Mach the action of making a piece is as much a part of it as the finished product; in this respect his work is similar to a performance and he likes visitors to be able to see him perform.

Mach is based in London and his work has several things in common with the young sculpture movement that emerged there in the early 1980s.[93] This 'movement' has helped create a climate receptive to associational values in sculpture; it has also brought about a renewed interest in the discrete sculptural object as opposed to the more conceptual, extended forms of sculpture common in the 1970s. Scotland has not been immune to this change of emphasis. Doug Cocker's work, for example, changed radically and dramatically in 1985. Up to that time

his sculpture had been additive and often diffuse in form; it evoked memories of places and things, but these were secondary to its formal qualities. Since 1985 Cocker has based each work on a central idea. The work is its embodiment: monumental, eidetic, immediately intelligible in its basic structure. The forms are derived from classical architecture – columns, entablatures – but made out of wood and covered with bark. Several are also made with a base that can rock back and forth, which acts as a counterbalance to the monumental stability of the classical superstructure. They are metaphors for (amongst other things) our social and political structures, for the shifting ground beneath seemingly immutable organisations.

Among the younger sculptors Linda Taylor and Tracy Mackenna should be mentioned. Taylor's work for the Glasgow Garden Festival, *Unseen Currents* 1988 (see cat. 329), was a series of taps pouring water into a dock. Instead of a handle at the top each had a sort of emblem made of copper. Mainly organic in inspiration, these delicate, linear constructions suggested the exuberance and diversity of natural forms that water makes possible. Taylor's work shows a strong concern for ecological balance. Mackenna is less interested in natural forms as such, than in creating shapes and images that give full eloquence to certain materials. Using ephemeral substances such as newspaper and cardboard or scrap-metal she makes works that are intended to bring out their essential character. The series of small discrete forms called *Objects in a Row* 1989 (cat. 212) are sometimes geometric, sometimes organic in inspiration, but in each case Mackenna directs our attention to the materials used. In a curious way the delicate and precious (in the sense of something to be cherished and cared for) nature of these small-scale works by Taylor and Mackenna points back to the roots of modern art in Scotland and to Mackintosh's plant-inspired ornaments.

Notes

1 J.D. Fergusson: *Modern Scottish Painting*, Glasgow 1943, p.31.
2 *Ibid*, p.69.
3 John Pinkerton (1758–1826) put forward the view that the Scots were largely teutonic in origin. He was violently opposed to the Celticism of Ossian. The battle between the 'Celtic' and 'Teutonic' Scots continued throughout the nineteenth century.
4 This will be more fully discussed later in the context of 1930s modernism.
5 More recently, some artists, such as Steven Campbell, have felt that they should go straight to New York, if they really wanted to make an international reputation.
6 The situation in Scotland has, however, improved out of all recognition in the last twenty years or so. There are now many more places where artists can show their work (and where they can see foreign contemporary art) and, with the founding of *Alba* in 1986, Scotland now has an art journal that makes Scottish art better known internationally.
7 Charles McKean: *The Scottish Thirties: An Architectural Introduction*, Edinburgh 1987. In

particular, p.38, note 90: 'Mackintosh is recognised as a pioneer of note in the [*RIAS*] *Quarterly* from the outset of the decade.'
8 This way of using black was central to the early work of Alexei Jawlensky (1867–1941) and Wassily Kandinsky (1866–1944), both of whom showed in Paris before the First World War.
9 The works in question were:

271 Paul Cézanne *Maison dans les Arbres*
176 Paul Gauguin *L'Esprit Veille*
261 Paul Gauguin *Poèmes Barbares*
 Auguste Herbin *Study of the Nude*
 Auguste Herbin *Arbres et Maison*
259 Henri Matisse *Les Aubergines*
 Pablo Picasso *Femme tenant une Coupe*
 Pablo Picasso *Cubist Picture*
260 Luigi Russolo *Train at Full Speed*
265 Paul Sérusier *Imploration*
267 Gino Severini *Le Boulevard*
319 Vincent Van Gogh *L'Homme à la Veste*
 Vincent Van Gogh *Le Ravin*
 Vlaminck *Le Mont Valérien*

Several of these works, including the Cézanne, Matisse, Russolo and Severini, had already been

shown at the Royal Glasgow Institute a month earlier, a fact also noted by the reviewer in *The Scotsman*, 13 December 1913.
10 See n. 9.
11 Even if Cursiter had not seen the Futurist exhibition at the Sackville Gallery in 1912, he would probably have seen the Severini show at the Marlborough Gallery, London in April 1913.
 This exhibition was on at the same time as an exhibition of contemporary Scottish art at the Grafton Gallery, which included work by Cursiter. He is likely to have attended the opening of this show since he was on the Council of the SSA and the SSA had been officially asked to submit works.
 That Cursiter was interested in recent developments in European art is without question. He himself has written that he 'was actually responsible for the Exhibition of Post Impressionists in 1913 Circumstances made it possible for me to borrow a group of pictures from the exhibition held in London in the Grafton Galleries ...' (letter to William Hardie of 22 August 1973, quoted in *Stanley Cursiter Centenary Exhibition*, catalogue published by The Pier Arts Centre, Stromness, Orkney 1987, p.11). In

another letter (of 18 November 1973) to William Hardie (quoted as above) Cursiter explains in more detail what these circumstances were: 'The "Post Impressionists" exhibition at the SSA originated in a chance introduction I got to Roger Fry and Clive Bell at the Exhibition in London. I asked if it would be possible to secure a loan of 20 or 30 works for the SSA . . .' It is (as yet) not known how the loan of the Futurist works was secured for the SSA.

12 *The Scotsman*, 13 December 1913:

Mr Stanley Cursiter, one of the younger Scottish artists, may be complimented on the step forward he has taken in his art. He has never before been so strongly represented in any exhibition as he is here. His "Studio Corner", in which a girl figures, is vigorous and realistic, but he will surprise his friends more by his life-size study of the nude, with a mirror reflection, in which the figure is satisfactorily drawn, and the colour has power and vitality. Mr Cursiter has also tried his hand at a cubist interpretation of the maze at the west end of Princes Street It is a pretty bit of patch-work, but was there ever such colour seen on the humble double-deckers and open-roofed cars, which block the way? The pretty face in the foreground is quite like Edinburgh.

Glasgow Herald, 13 December, 1913:

One of the members of the Society, Mr Stanley Cursiter, has apparently come under the spell of the new movement. In Cubist style he has painted the scene of a 'West end Crossing', the crossing being the West end of Princes Street, coloured cubes representing humanity and cable cars. Mr Cursiter is not, however, extravagantly cubistic; he depicts in conventional fashion the figure of a gracious woman typical of Princes Street beauty, and sets her in the foreground of his picture. And it is this figure, which is not designed in cubes, that focuses attention. Mr Cursiter's adventure is not to be lightly dismissed; it seems to suggest that Cubism may really have a future.

13 Titles of works shown by Cursiter at the SSA between 1906 and 1911 include: *Northern Lights, The Warning, To Odin, Sacred to a Forgotten God, 'The Lace that ran Weaves'. 'Sigurd Fafnir's Bane and Brynhild the Shield-May', and The Teasing of the Niblung, Thor goes to visit Utgard-Loki.* For an account of the Celtic Revival movement, see Lindsay Errington: 'Celtic Elements in Scottish Art at the Turn of the Century' in *The Last Romantics: The Romantic Tradition in British Art*, exhibition catalogue, Barbican Art Gallery, London 1989, pp.47–53.

14 It is interesting to note that, after he had become Director of the National Gallery of Scotland, Cursiter 'made a complete set of small watercolour sketches, on the scale of one inch to the foot, of all the pictures in the collection. With these, on a brown paper background cut to the proportions of the Gallery walls, I could carry out a complete scheme for the re-hanging of any Gallery.' (Stanley Cursiter: *Looking Back: A Book of Reminiscences*, Edinburgh 1974, p.23). Cursiter obviously had a considerable ability to analyse and paint a wide variety of styles.

15 Fergusson was never an Official War Artist but he was commissioned by the Ministry of Information to paint one work in 1918.

16 For more information on Alexander Reid (1854–1928) see the exhibition catalogue, *A Man of Influence: Alex Reid*, Scottish Arts Council 1967. The other most important Gallery in Scotland was Aitken Dott & Son, The Scottish Gallery, Edinburgh, which also showed the Colourists and dealt in French painting.

17 Quoted in T.J. Honeyman: *Three Scottish Colourists* 1950, p.105.

18 In Crozier's own copy of Alexandre Mercereau's book on *André Lhote* (Paris 1921), in the library of the Scottish National Gallery of Modern Art the following passage is underlined:

. . . la transposition, du réel dans l'abstrait lui paraît être la seule opération digne de retenir, pour le moment, le soin de l'artiste.

Il se sépare, dorénavant, de certains cubistes qu'il considère comme représentant, à l'aide de moyens abstraits, des abstractions, alors que, l'œuvre d'art étant en équilibre entre le concret et l'abstrait, l'on doit tâcher, à son avis, de représenter des réalités immédiates, sensibles, journalières, à l'aide de matériaux abstraits, ou se rapprochant à tel point de l'abstrait, sans lâcher la réalité, qu'un tout petit peu au-dessus, ce serait l'abstraction toute pure, autant que quelque chose qui se touche avec la vue puisse être abstrait. (p.30).

19 Typescript of conversation held between Douglas Hall, Keeper of the Scottish National Gallery of Modern Art, and William MacTaggart in 1968, in the archives of the Scottish National Gallery of Modern Art.

20 Matthew Justice of Dundee and William Boyd of Broughty Ferry both owned works by Segonzac. There was also a large exhibition of his work in London in 1927 and an article by Claude Roger-Marx ('Segonzac and Contemporary Painting') was published in *The Studio*, January 1929, Vol.xcvii, No.430, pp.29–34. In the above-mentioned conversation between Douglas Hall and William MacTaggart the latter mentions his interest in Segonzac: 'I remember being very, very thrilled by Segonzac.'

21 The artist responsible for this invitation was Harold Morton, who was a friend of Gillies. Letters from Morton to Munch still exist in the archive of the Munch Museet, Oslo. (Information kindly provided by Smith Art Gallery, Stirling.)

22 The SSA was justifiably proud that they had secured this exhibition of Munch's works and noted in the catalogue:

No examples of the work of Edvard Munch, the famous Norwegian artist, have hitherto been exhibited in this country, although he is represented in public collections abroad. It is due to the enterprise of this Society that the British public now has an opportunity of appraising the work of a painter who has long been the subject of controversy in Continental art circles.

It is one of the aims of the Society to procure for exhibition examples of contemporary art, and this year's loan collection should prove stimulating to public and artists alike.

23 The paintings exhibited were:

83 *Woman in Red*
84 *The Waves*
85 *Winter Landscape*
86 *Landscape*
87 *The Bathers*
88 *Bohemian Wedding*
89 *Lady in Grey*
90 *Melancholy*
91 *Landscape*
92 *The Forest*
93 *Galloping Horse*
94 *Nude*

24 'Art Interests: The Munch Pictures' in *The Scotsman*, 22 December 1931, p.11.

25 Herbert Read, 'The Scottish Society of Artists – This Year's Exhibition, from Edinburgh', a talk broadcast on BBC Radio on 28 November 1931.

26 The contents of the talk were described in *The Scotsman*, 30 November 1931 ('Scottish Painting; Hope of National Movement; Foreign Influences'). *The Scotsman* reported the talk as follows:

Professor Herbert Read, in an address broadcast

from the Edinburgh Studio of the BBC on Saturday evening, referred to the practice made by the Soceity of Scottish Artists of including the works of strangers in their exhibitions. This he thought an exceedingly wise procedure.

A national movement in art, he said, which was something they should confidently look forward to in Scotland, was never born within closed doors. Wherever in the history of art they saw the growth of a new spirit, they would find first a stirring of the soil. Foreign influences, and even foreign peoples, were the active agents in such a transformation.

Professor Read referred in particular to the inclusion in this year's exhibition, which was opened on Saturday, of 'a representative collection of the works of the greatest living Scandinavian painter', Edvard Munch, who, he said, occupied, in relation to the modern German movement, a position comparable to Cézanne's in French painting. They might say that he saved German art from the consequences of Cézanne's inventions – from being overwhelmed by a mode of expression quite foreign to the Nordic genius. He emphasised the Nordic quality of Munch's work, because he thought that Scottish artists should find it sympathetic.

When he looked round the exhibition and picked out the works which he personally found most pleasing – the paintings, for example, of the late William Crozier, whose early death they could never cease to lament, of William McTaggart [*sic*!], David Gunn, Donald Moodie, and D.M. Sutherland, and the wood sculpture of Tom Whalen – he found in them all qualities which he could relate to that northern consciousness – qualities which, thanks to Munch, were firmly established in the modern German movement. If they came to the same self-realisation in Scotland, he did not see why the promise that there was in the works of the artists he had mentioned should not go far to establish a movement in art comparable to the great Continental movements of the last fifty years.

27 In one letter, in particular, Cursiter makes his position clear:

My whole argument with Mr Davidson is whether we can claim a national or racial 'Scottish Art' or whether we have only a Scottish School in some broader Art which perhaps can be called Western European. Certainly at the present day these national or racial art boundaries have almost disappeared in European Art, and an easier classification is by the 'isms' Art in Scotland has its clearly defined Scottish accent, but I cannot find in it Scottish Art.

(*The Scotsman*, 14 December 1931, p.11.) Cursiter goes on to list all the eclectic foreign influences on Scottish artists.

28 This view was followed by T.J. Honeyman, the art dealer and later Director of Glasgow Art Gallery and Museums (see his book *Three Scottish Colourists* 1950, and particularly the introduction).

29 In particular by Wilhelm Worringer's books which split European art into Northern and Romance polarities, the former tending towards abstraction and the expression of inner feelings, the latter tending towards empathy with natural forms. Ian Finlay of the Royal Scottish Museum shows himself to have been generally influenced by these views in his book *Art in Scotland* 1948.

30 This was a reduced version of the exhibition *Twentieth Century German Art*, shown at the Burlington Galleries, London in July 1938. The Glasgow show was opened on 14 March 1939.

The Society of Scottish Artists had also attempted to take a proposed exhibition of modern German art that the Tate Gallery had planned in the early 1930s. The plan however came to nothing, probably due to the Nazis coming to power in 1933.

31 Two paintings by Soutine, *Le Groom* and *Le Petit Patissier*, were shown in the 1935 SSA exhibition. MacTaggart was President of the SSA from 1933 to 1936.

32 'What started off as appearing to be a new and exciting way of producing pictures, in the end turned out to be a dismal cul-de-sac. I did not long employ Lhote's principles in my paintings . . .' Quoted by T. Elder Dickson in *W.G. Gillies*, Edinburgh 1974, p.20.

33 *Ibid*, p.26.

34 Gillies' own description. *Ibid*, p.26.

35 In 1910 the painters Adam Bruce Thomson and D.M. Sutherland [two of Redpath's teachers] had visited France and Spain on travelling scholarships. The former brought back the news that Matisse was on everybody's lips, the latter showed in his painting the influence of the Post-Impressionists and his acquaintance with the strong, dramatic light of the Spanish sun.

George Bruce: *Anne Redpath*, Edinburgh 1974, pp.2–3.

36 Quoted by George Bruce, *ibid*, p.5.

37 The Craigmillar mural and a related painting *Church and Houses c.1934* (Paisley Art Gallery and Museum) suggest that Maxwell had also been looking at the work of such English artists as Christopher Wood and Ben and Winifred Nicholson, who all showed works in Edinburgh in the early 1930s and who were just then beginning to become quite well known.

38 Robins Millar: 'Glasgow' in *The Studio*, Vol.XCI, No.394, January 1926, pp.53–55.

39 Patrick has described this process very well in reference to the Tate Gallery's *Winter in Angus* 1935:

The castle came because I had already made a painting and an etching of Powrie Castle and I thought it would make a good subject for a big picture. But in *Winter in Angus* I created an imaginary viewpoint, up high. For the background – well I wanted a complicated background and at that time I was teaching on Fridays at Glenalmond and the background is the view from the Art Room window which I fitted in behind the Castle. I was looking for something for the foreground and I decided to put in the pigeon loft but apart from that the rest of the foreground is just invented.

Quoted in Roger Billcliffe: *James McIntosh Patrick*, London 1987, p.21. *A City Garden* 1940 (cat.275) is one of the few works by Patrick that faithfully reflect a specific motif, that out of the back window of his house in Dundee.

40 *Ibid*, p.21.

41 Robert Henderson Blyth (1919–1970) studied at Glasgow School of Art (1934–39) and Hospitalfield House, Arbroath (under Cowie in 1940). He taught at Edinburgh College of Art (1946–54) and Gray's School of Art, Aberdeen (from 1954) where he was appointed Head of Drawing and Painting in 1960.

42 *Ian Fleming: Graphic Work*. Exhibition catalogue, Peacock Printmakers, Aberdeen 1983, p.11.

43 Quoted in Cordelia Oliver: *Joan Eardley, RSA*, Edinburgh 1988, pp.24–25.

44 *Ibid*, p.32.

45 *Ibid*, p.45.

46 Adler had been evacuated to Glasgow in 1940 after the dispersal of the Polish army. He was one of a number of Polish artists who enriched the life of Scotland, and Glasgow in particular, during the war. Josef Herman was another. See Chronology

for list of events in Scotland during the war.

47 *Paul Klee 1879–1940*, National Gallery, London 1945.

48 The two interviews are featured in *Picture Post*, Vol.42, No.11, 12 March 1949 and quoted in Malcolm Yorke: *The Spirit of Place: Nine Neo-Romantic Artists and Their Times*, London 1988, p.243 and p.253.

Colquhoun: Each painting is a kind of discovery, a discovery of new forms, colour relation, or balance in composition. With every painting completed, the artist may change his viewpoint to suit the discoveries made, making his vision many-sided. Figures and objects in modern paintings may appear distorted. . . . The special forms, evolved from the relation of colour masses, line and composition, to express the painter's reaction to objects, will be the reason for a painting's existence.

MacBryde: I set out to make statements, in visual terms, concerning the things I see, and to make clear the order that exists between objects which sometimes seem opposed. I do this because it is the painter's function, generally speaking, to explore and demonstrate in his work the interdependency of forms. This leads me beneath the surface appearance of things, so that I paint the permanent reality behind the passing incident, the skeleton which is the basic support of the flesh. In doing this I perceive a 'pictorial logic' which dictates that, if a certain line or colour exists in a painting, there must be certain other lines and colours which allow the completed painting to be an organic whole.

49 The book *Cubism* by Albert Gleizes and Jean Metzinger had been published in English in 1913 and included illustrations of several works that might have stimulated McCance's interest.

50 William McCance: 'Idea in Art' *The Modern Scot*, Vol.1, No.2, Summer 1930, p.15.

51 *Ibid*, p.16.

52 *Contemporary Scottish Painting*, The Gallery, St Andrews. The exhibition included work by Percy Bliss, Cowie, Crawford, Johnstone, McCance and others.

53 The painting was altered somewhat by Johnstone in 1951 but the basic underlying structure of 1927 is still extant.

54 A.N. Whitehead: '. . . a point in time is . . . the fringe of memory tinged with anticipation.' Whether Johnstone knew these words is debatable. See Douglas Hall: *William Johnstone*, Edinburgh 1980, pp.37–38.

55 William Johnstone: *Points in Time, An Autobiography*, London 1980, pp.115–16.

56 The following drawings by Paul Nash were shown at the SSA in 1919:

331 *Passchendaele*
332 *Hill 60*
333 *Caterpillar Crater*
335 *The Landscape, Hill 60*

57 For example, *Country Life* published a series of booklets called *British Artists at the Front* in 1918. The third was devoted to Paul Nash, with introductions by John Salis and C.E. Montague. It included illustrations (in colour) of i.a. *Sunrise: Inverness Copse*, *The Field of Passchendaele*, *Crater Pools, Below Hill 60*, *Meadow with Copse, Hill 60, from the Cutting*, *The Caterpillar Crater, Landscape, Year of Our Lord, 1917*.

58 The only major exhibition of his works in Scotland in the 1930s was at Aitken Dott in Edinburgh in 1935. Johnstone writes about this in his autobiography (see n. 55, p.160):

While the exhibition was on he [George Proudfoot, who ran the Edinburgh gallery] wrote: 'A lot of people, lay and professional, have seen your pictures, but they are beyond

them. This is just about the hardest job I have undertaken.' And when it was over: 'I am sorry the exhibition met with no success and I fear that in this part of the world you can look for no future, on your present lines.' Not one picture was sold.

59 For example, Andrew Grant had bequeathed a large sum to the College in 1930 to fund two-year travel scholarships.

60 Although it should be mentioned that Edinburgh University's Fine Art Society did mount an exhibition of 'Constructive Art' at its 2nd Annual Exhibition, Minto House, Edinburgh 1937.

61 In fact, Stokes invited Ben Nicholson and Barbara Hepworth to stay with them at St Ives in August 1939.

62 Quoted in *St Ives 1939–64: Twenty-five Years of Painting, Sculpture and Pottery*, Tate Gallery, London 1985, p.179.

63 *Paul Klee 1879–1940*, exhibition organised by the Tate Gallery and held at the National Gallery, London, December 1945. The Arts Council toured part of this exhibition round the country in 1946.

64 William Gear in conversation with Malcolm Davies, published in *The Evolution of a Painter – William Gear*, magazine/catalogue, Cannon Hill Trust, Birmingham 1970–71.

65 See *Sixty Paintings for '51* exhibition. This included the large *Autumn Landscape 1950* (cat.136) that was commissioned by the Arts Council for the Festival of Britain in 1951. Gear's painting, which was purchased by the Arts Council, produced a storm of protest from the press and public, not yet prepared for this radical form of abstraction.

66 Davie had been enormously impressed by the Klee exhibition in London in 1945 and his own work had already been strongly influenced by Klee. See, for example, Davie's *Landscape with a Bridge 1945*.

67 *Alan Davie*, exhibition catalogue, Whitechapel Art Gallery, London, June–August 1958, 'Notes by the Artist', p.7.

68 William Johnstone, Principal of the Central School of Arts and Crafts, employed Davie in the Jewellery Department from 1953. Johnstone also employed Paolozzi (1949–55) to teach textile design and Turnbull (1952–61) to teach experimental design.

69 *Growth and Form*, Institute of Contemporary Arts, London, 4 July–31 August, 1951; *Parallel of Life and Art*, Institute of Contemporary Arts, London, 11 September–18 October 1953; *This is Tomorrow*, Whitechapel Art Gallery, London 1956.

70 *Seven Scottish Painters*, The Arts Council (Scottish Committee) 1955. The artists included were: Wilhelmina Barns-Graham, Robert Colquhoun, Alan Davie, William Gear, Robert MacBryde, Charles McCall and 'Scottie' Wilson.

71 The exhibition included works by Ozenfant, Rouault, Léger, Lurçat, Vuillard, Le Corbusier, Gruber, Asselin, Gischia, Laprade, Sabouraud, Fougeron, Lorjou, Montainier, Valadon, De Laboulaye, Manessier, Metzinger, Singier, Tal Coat, Bonnard, Picasso, Desnoyer, Marchand, Waroquier, Marquet, Valore, Picabia, Lhote, Eve, Gernez, Vivin, Braque, Walch, Lebasque, Bombois, Pignon, Guérin, Le Fauconnier, Camoin, Utrillo, Denis, Lapicque, Beauchamp and Séraphine.

72 It is important to note, however, that after 1955 MacTaggart painted in his studio from memory and using his sketches.

73 Quoted in George Bruce: *Anne Redpath*, Edinburgh 1974, p.43.

74 This oil painting, the only one that Kokoschka brought with him (in its then unfinished state) to Britain on the eve of war, was given to Scotland by the Czech Government in exile in 1942. Kokoschka's painting trips to Scotland both before and during the war form an interesting chapter in how Scotland has been seen and depicted by foreign artists.

[75] Quoted by T. Elder Dickson in 'Robin Philipson', essay (reprinted from *Scottish Art Review*, Vol.VIII, No.2) in exhibition catalogue, The Scottish Gallery, Edinburgh 1961, p.6.

[76] An exhibition of Julius Bissier was held at the Scottish National Gallery of Modern Art, Edinburgh, in 1965.

[77] Knox saw this exhibition in Brussels in 1959 during the year he spent abroad on a travelling scholarship.

[78] Extract from the artist's notebook, November 1969, published in *Colin Cina*, exhibition catalogue, Hatton Gallery, University of Newcastle upon Tyne 1971.

[79] Of course, a number of darts fell on areas of ocean. The Boyle Family have not yet 'cracked' how they are going to reproduce water, but they are actively pursuing it.

[80] Mark Boyle: 'Beyond Image: Boyle Family', in exhibition catalogue *Beyond Image: Boyle Family*, Hayward Gallery, London 1986–87, p.18.

[81] Quoted by Nena Dimitrijevič in exhibition catalogue *Bruce McLean*, Whitechapel Art Gallery, London 1982, p.11.

[82] Bruce McLean: 'Not even crimble crumble', review of *British Sculpture Out of the Sixties*, ICA, London 1970, in *Studio International*. McLean later enlarged a photograph of this review and exhibited it alongside *People who Make Art in Glass Houses, Work*.

[83] Boyle's reliefs have probably had a general influence on Glen Onwin, although their aims are very different. Bruce McLean had exhibitions and gave performances in Edinburgh and Glasgow in 1980, which may well have influenced Steven Campbell and Adrian Wiszniewski, then studying at Glasgow School of Art.

[84] From a letter written by Finlay to Yves Abrioux, September 1983, quoted in Yves Abrioux: *Ian Hamilton Finlay: A Visual Primer*, Edinburgh 1985, p.168.

[85] The Scottish National Gallery of Modern Art held a retrospective exhibition of Finlay's work in 1972.

[86] In 1963 they had hung their paintings on the railings in Castle Terrace.

[87] Ainslie has taught at Glasgow School of Art for the past few years, where she has been a strong force for change, particularly with her female students.

[88] Although Currie's work has been influenced by the film-making he did in the mid-1980s, it was more the strong contrasts of light and shade, the sense of capturing someone in a significant pose and 'frame' that he retained, rather than any desire for photographic realism.

[89] Bruce McLean had a solo exhibition at the Third Eye Centre, Glasgow, in 1980: *New Works and Performance/Actions Positions*.

[90] Rory McEwen and Gavin Scobie, for example.

[91] Landmark is now closed.

[92] David Mach in *The Vigorous Imagination: New Scottish Art*. Exhibition catalogue, Scottish National Gallery of Modern Art, Edinburgh 1987, p.86.

[93] Sculptors such as Tony Cragg, Bill Woodrow, Anish Kapoor, Antony Gormley, Richard Deacon and Alison Wilding.

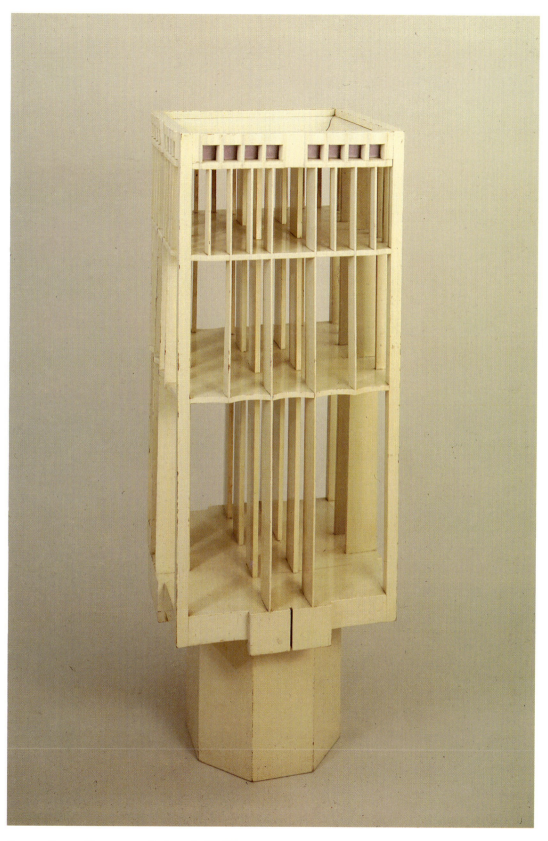

CHARLES RENNIE MACKINTOSH **Bookcase for Nitshill,
Glasgow** 1904 (cat.213)

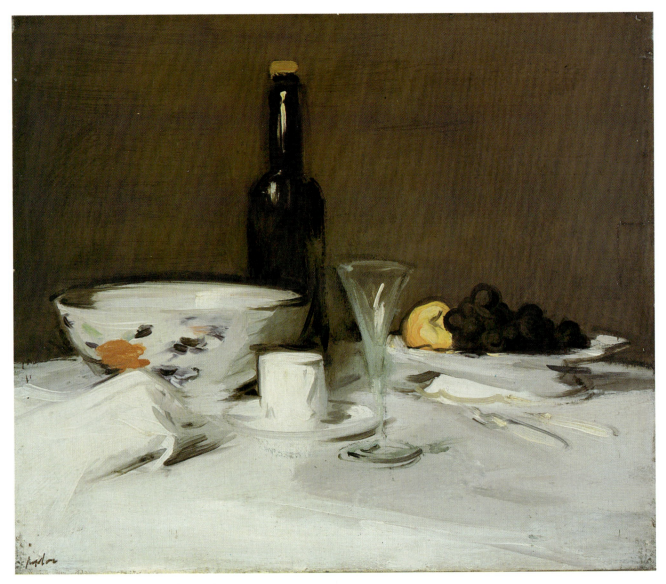

S.J. Peploe **The Black Bottle** *c.*1905 (cat.282)

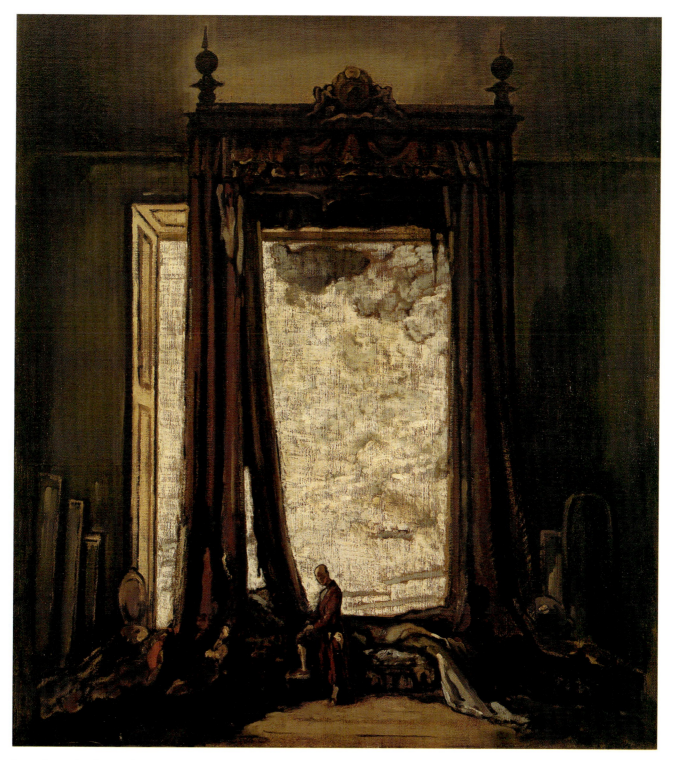

JAMES PRYDE **Lumber: A Silhouette** 1921 (cat.307)

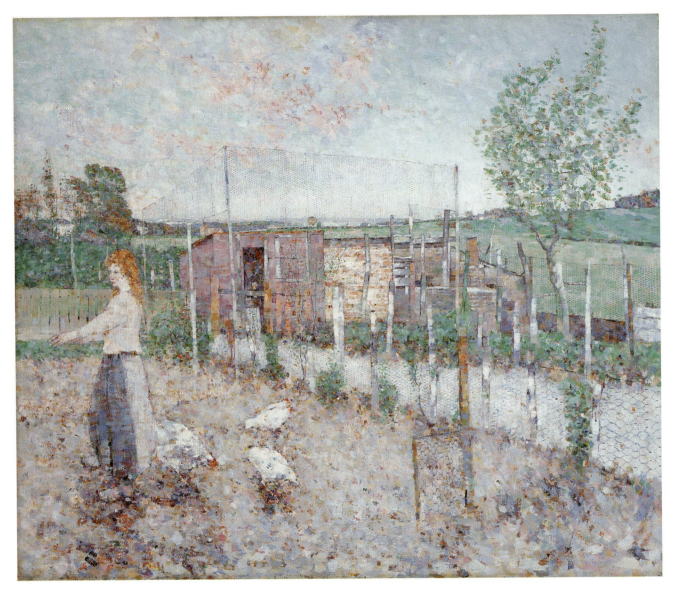

John Quinton Pringle **Poultry Yard, Gartcosh** 1906 (cat. 303)

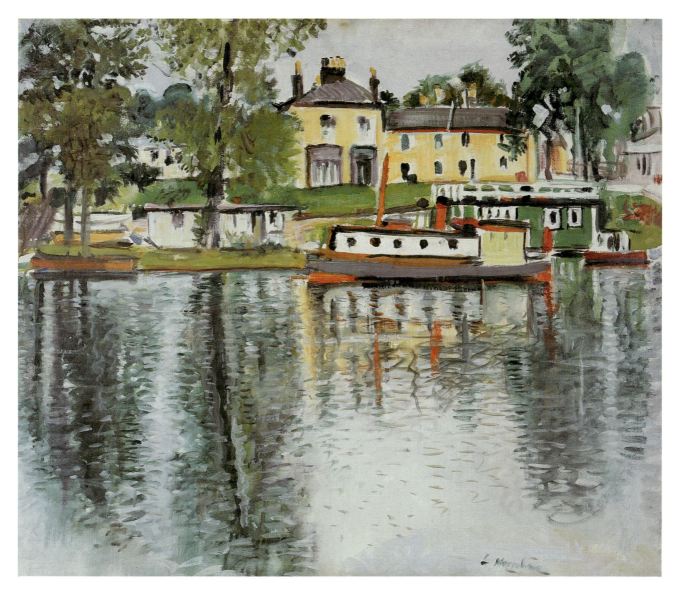

LESLIE HUNTER **Reflections, Balloch** 1929–30 (cat.160)

J.D. Fergusson **La Terrasse, le Café d'Harcourt** *c.*1908–9 (cat.114)

S.J. PEPLOE **Verville-les-Roses** 1910–11 (cat.286)

STANLEY CURSITER **The Regatta** 1913 (cat.90)

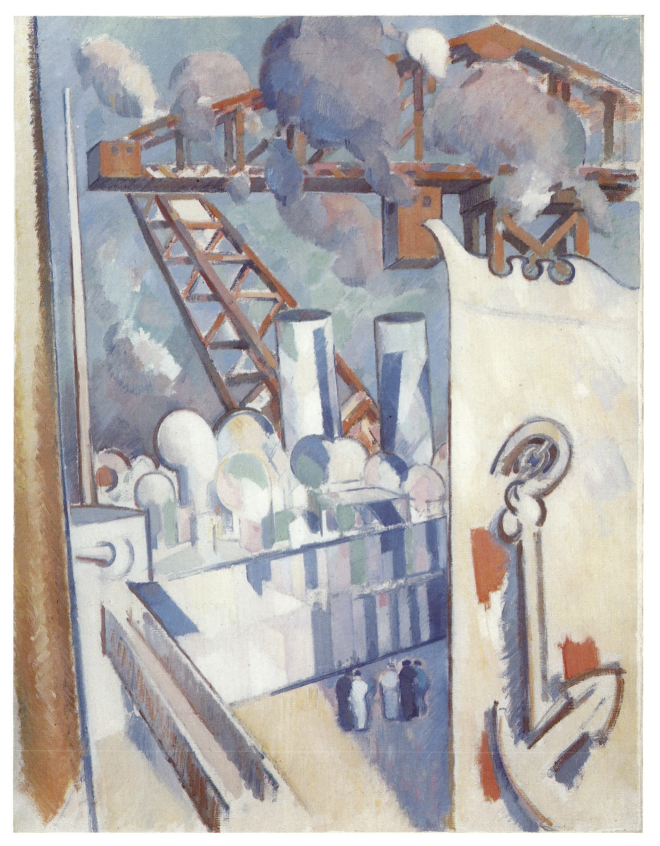

J.D. Fᴇʀɢᴜssᴏɴ **Portsmouth Docks** 1918 (cat.118)

F.C.B. Cadell **The Model** (cat. 36)

F.C.B. Cadell **Lady in Black: Miss Don-Wauchope** 1921 (cat.37)

S.J. Peploe **Still Life with Melon** *c.*1919–20 (cat.289)

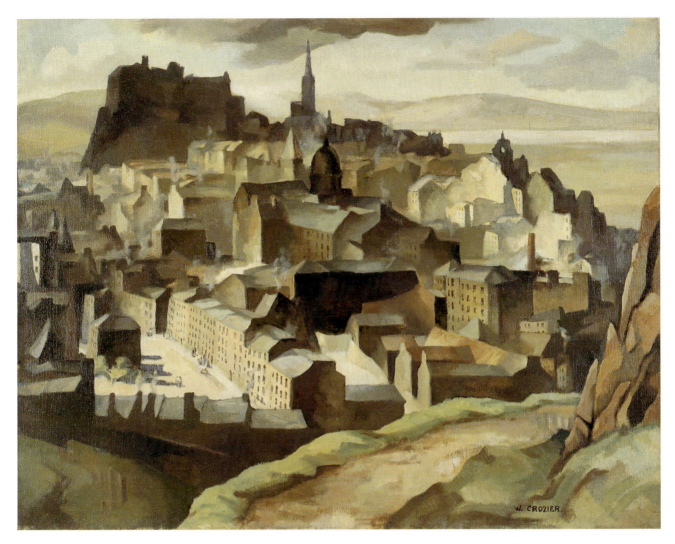

WILLIAM CROZIER **Edinburgh (from Salisbury Crags)** 1927 (cat.82)

WILLIAM McCANCE **Portrait of Joseph Brewer** 1925 (cat.197)

JAMES COWIE **Portrait of the Artist's Daughter, Ruth** 1932–33 (cat.68)

WILLIAM McCANCE **Heavy Structures in a Landscape Setting** 1922 (cat.194)

WILLIAM CROSBIE **Heart Knife** 1934 (cat.77)

WILLIAM JOHNSTONE **A Point in Time** 1929/37 (cat.174)

WILLIAM GILLIES **In Ardnamurchan** *c.*1936 (cat.149)

JOHN MAXWELL **View from a Tent** 1933 (cat.242)

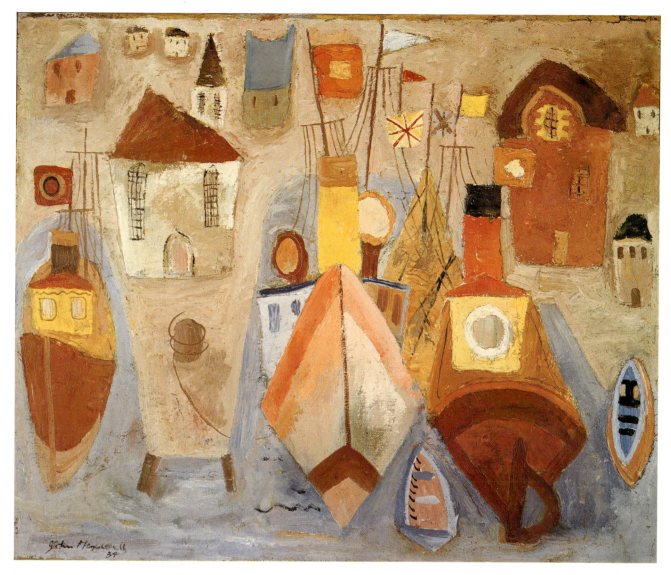

JOHN MAXWELL **Harbour with Three Ships** 1934 (cat.246)

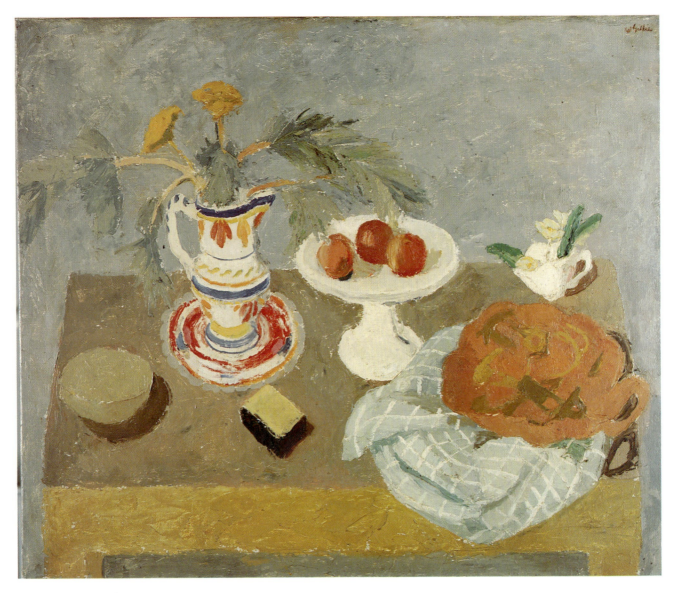

WILLIAM GILLIES **Still Life with Breton Pot** 1942 (cat.142)

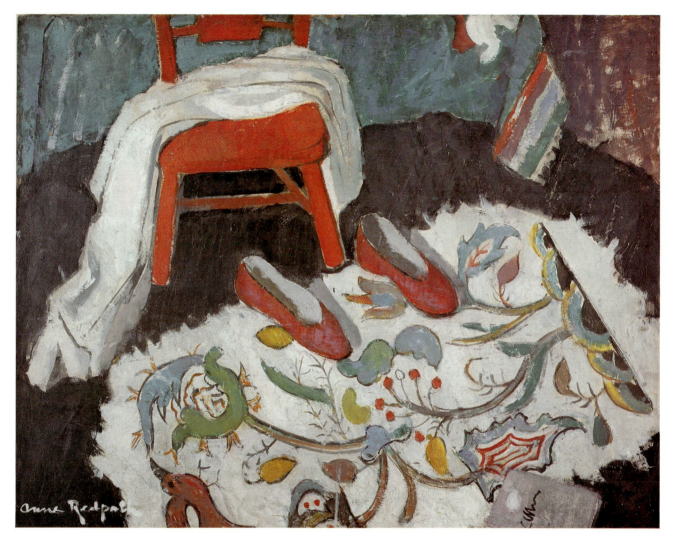

ANNE REDPATH **The Indian Rug** *c.*1942 (cat.309)

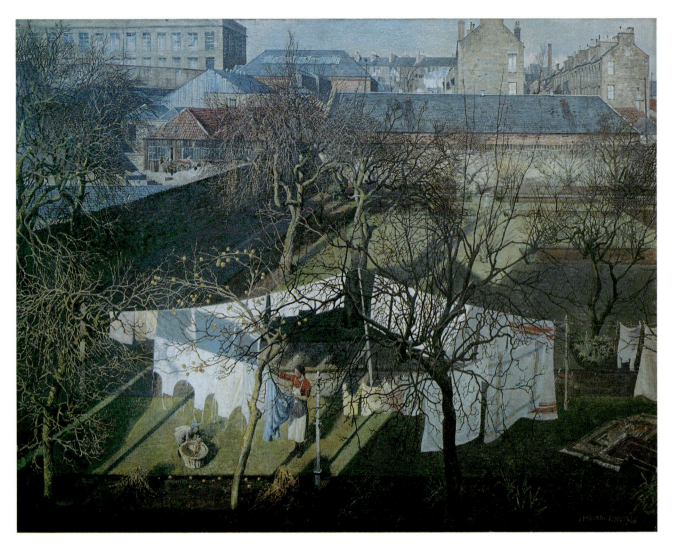

JAMES McINTOSH PATRICK **A City Garden** 1940 (cat.275)

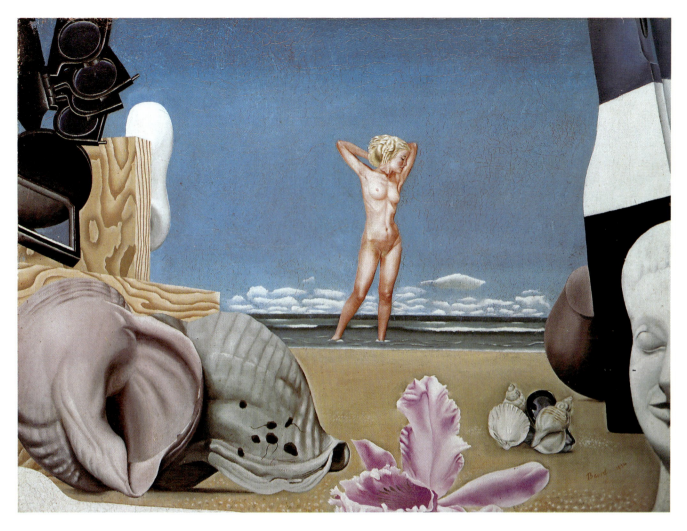

Edward Baird **The Birth of Venus** 1934 (cat.7)

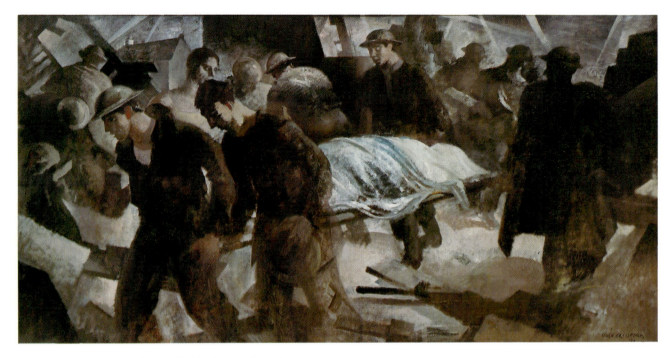

HUGH ADAM CRAWFORD **Tribute to Clydebank** 1941 (cat.76)

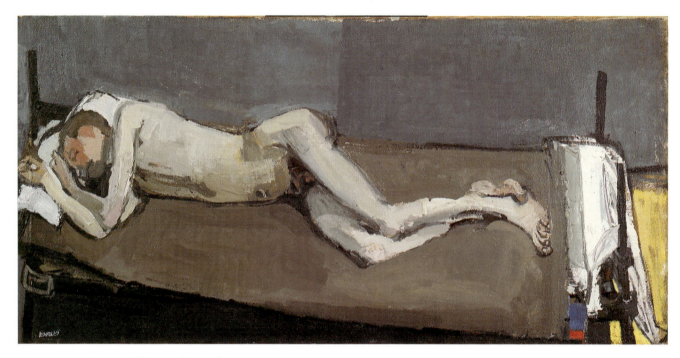

JOAN EARDLEY **Sleeping Nude** 1955 (cat.103)

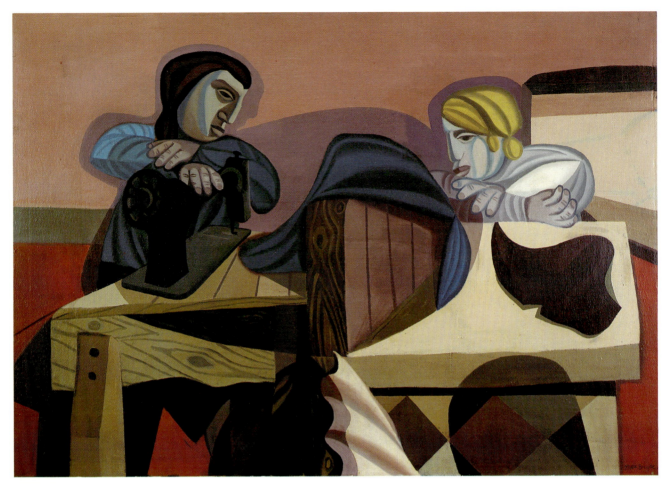

Robert MacBryde **Two Women Sewing** (cat.189)

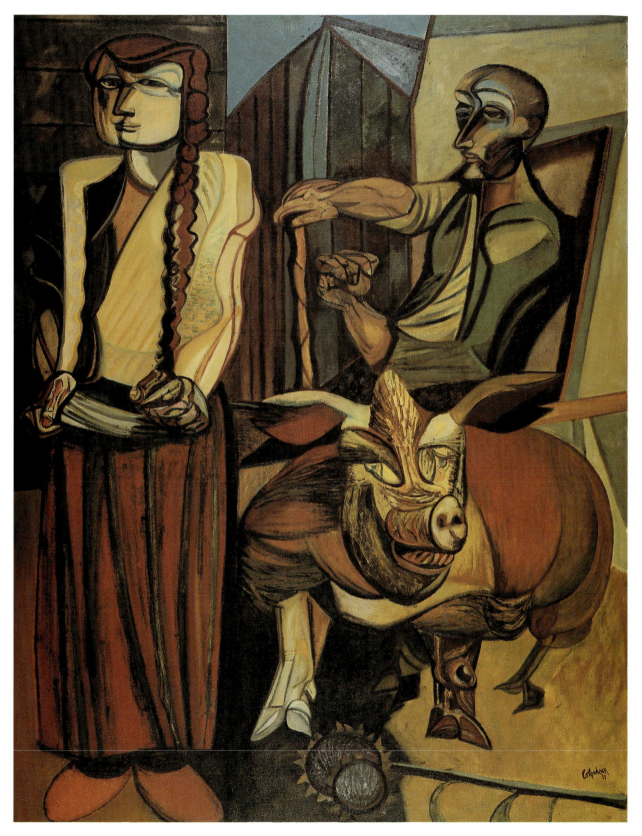

ROBERT COLQUHOUN **Figures in a Farmyard** 1953 (cat.53)

CHARLES RENNIE MACKINTOSH
Le Fort Maillert 1927 (cat.216)

BASIL SPENCE **Design for A.G. Lockhead, Princes Street,
Edinburgh** 1930s (cat.323)

MARGARET MELLIS
Construction in Wood 1941 (cat.252)

ALASTAIR MORTON **Untitled** 1939 (cat.255)

WILLIAM GEAR **Autumn Landscape Sept. 1950** 1950 (cat.135)

WILLIAM TURNBULL **Pegasus** 1954 (cat.334)

EDUARDO PAOLOZZI **Table Sculpture (Growth)** 1949 (cat.266)

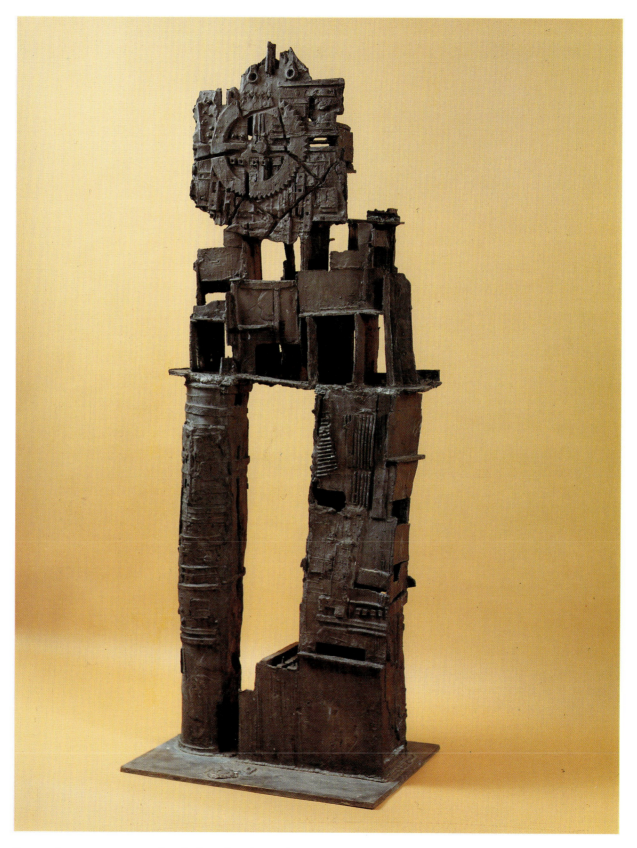

EDUARDO PAOLOZZI **His Majesty the Wheel** 1958–59 (cat.271)

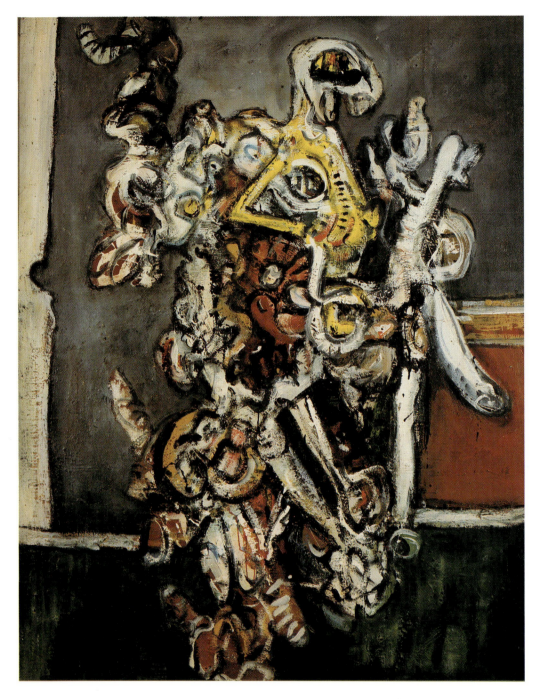

ALAN DAVIE **Woman Bewitched by the Moon, No.2** 1956 (cat.96)

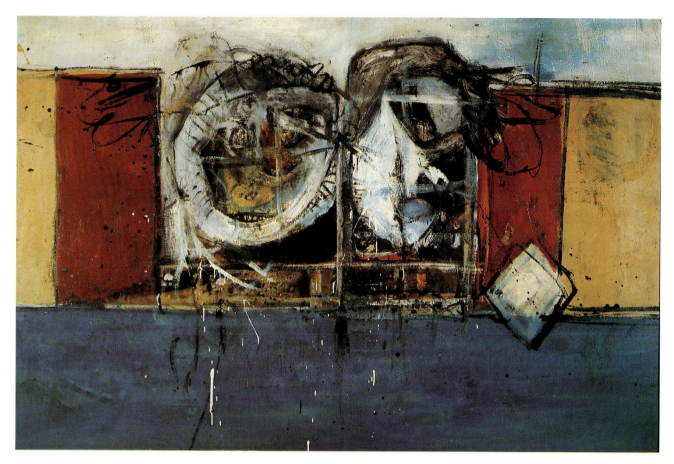

Alan Davie **Seascape Erotic** 1955 (cat.94)

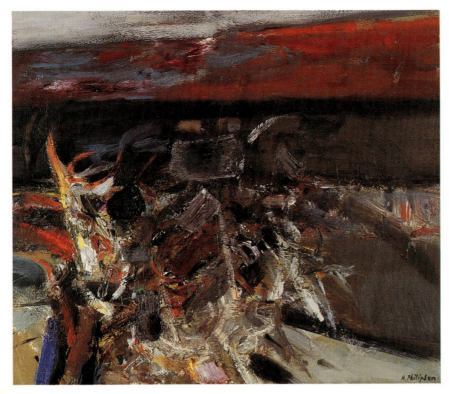

ROBIN PHILIPSON **Burning at the Sea's Edge** 1961 (cat.301)

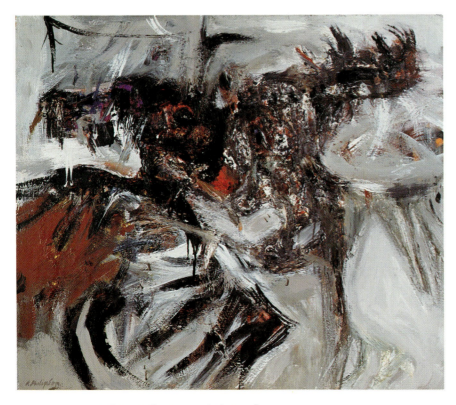

ROBIN PHILIPSON **Fighting Cocks, Grey** 1960 (cat.300)

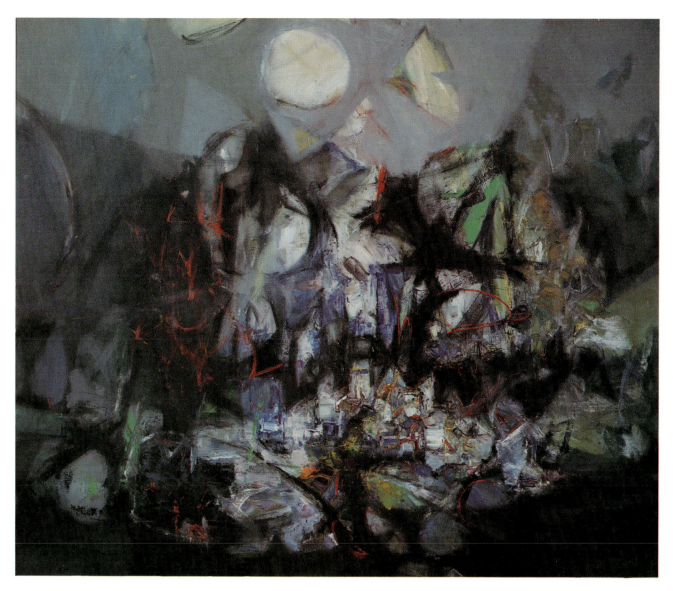

JOHN HOUSTON **Village under the Cliffs** 1962 (cat.155)

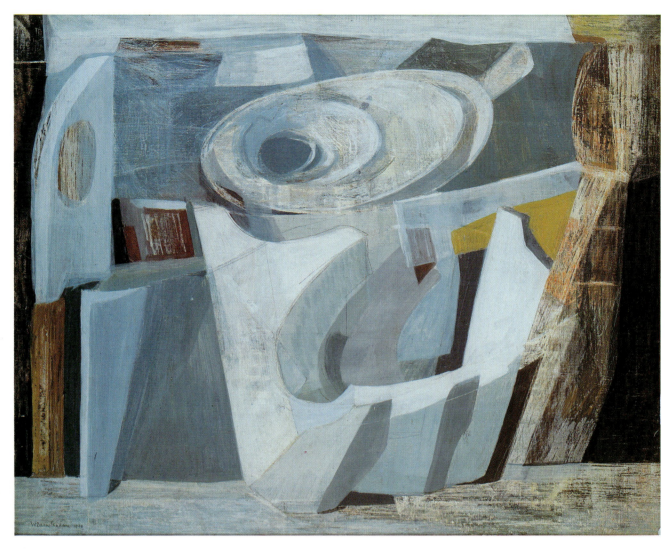

WILHELMINA BARNS-GRAHAM **Glacier (Vortex)** 1950 (cat.11)

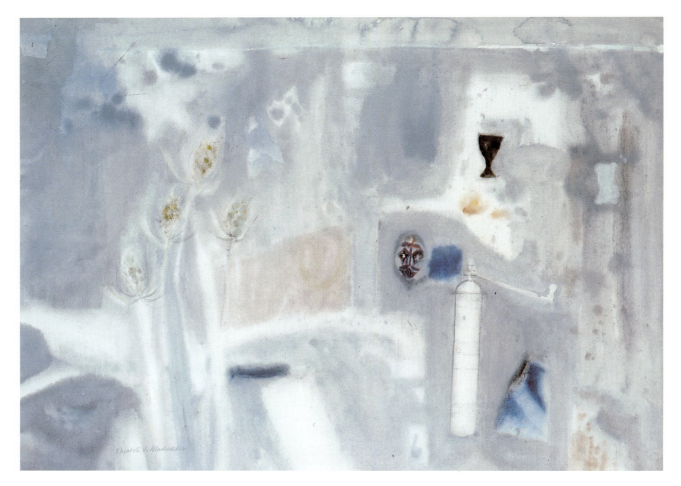

Elizabeth Blackadder **Easter Egg, Teazles and Grey Table** *c.*1961–62 (cat.21)

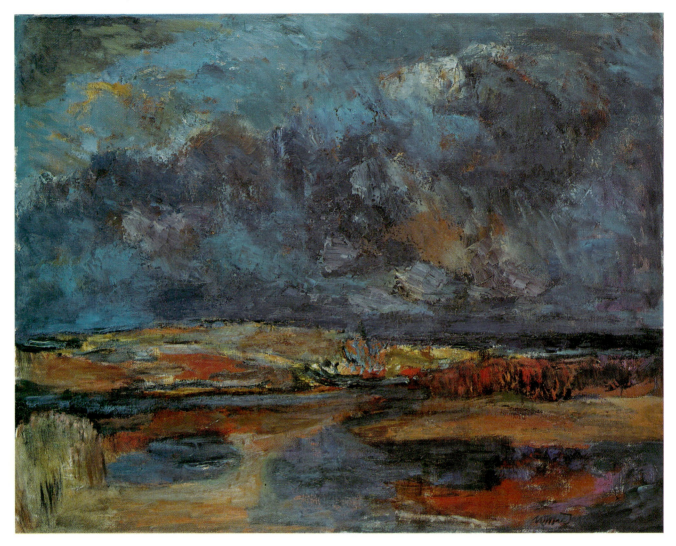

WILLIAM MACTAGGART **The Wigtown Coast** 1968 (cat.241)

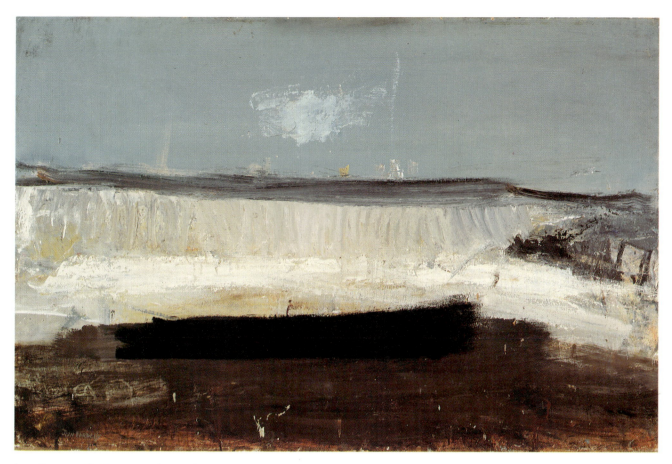

JOAN EARDLEY **The Wave** 1961 (cat.104)

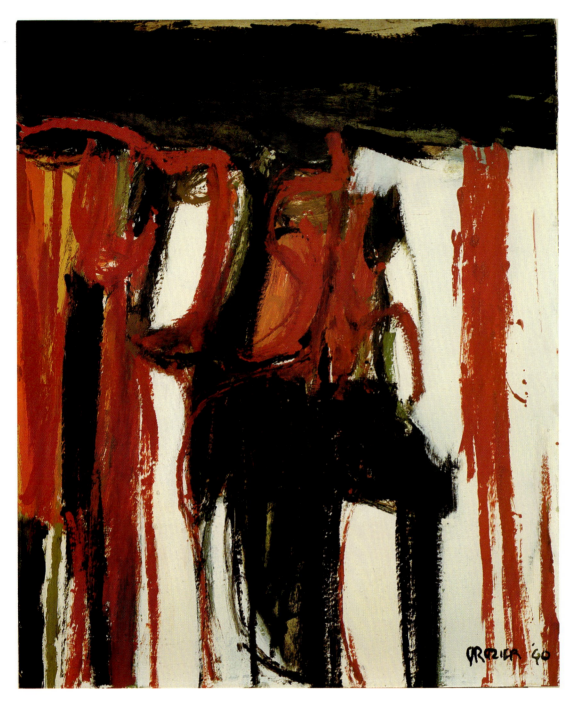

WILLIAM CROZIER **Burning Field, Essex** 1960 (cat.86)

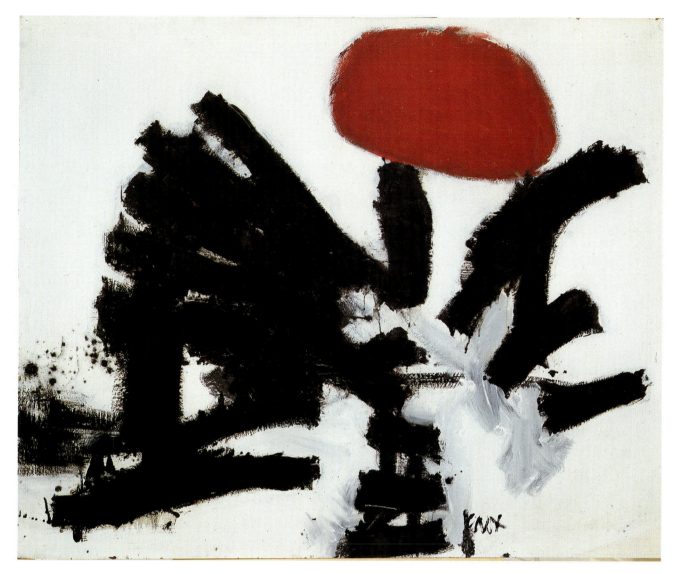

JOHN KNOX **Aftermath** *c.*1961 (cat.178)

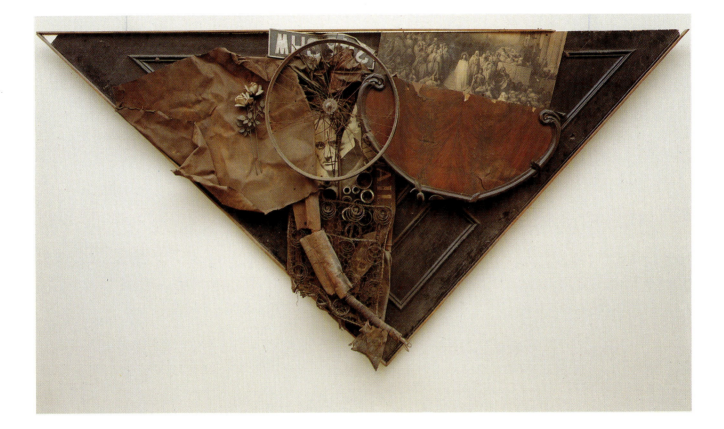

Mark Boyle 'Mine Eyes Have Seen the Glory' *c.*1963 (cat.32)

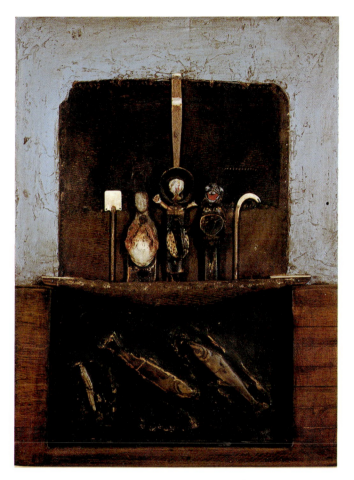

Will Maclean **Bard McIntyre's Box** 1984 (cat.235)

Ian Hamilton Finlay with Jim Nicholson **Homage to Modern Art** 1972
(cat.126)

Ian Hamilton Finlay with John Andrew **Et in Arcadia Ego** 1976 (ex cat.)

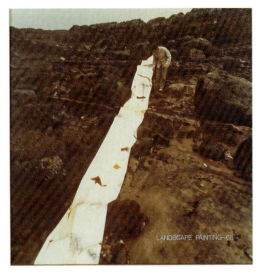

BRUCE MCLEAN **Landscape Painting '68** 1968
(cat.220)

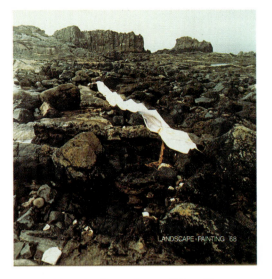

BRUCE MCLEAN **Landscape Painting '68** 1968
(cat.221)

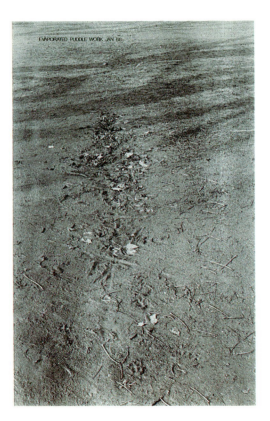

BRUCE MCLEAN **Evaporated Puddle Work January '68**
1968 (cat.222)

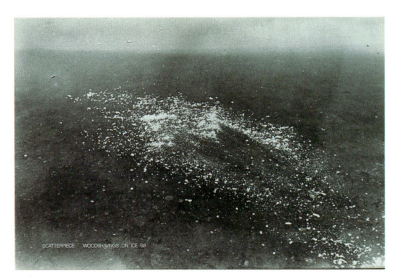

BRUCE MCLEAN **Scatterpiece Woodshavings on Ice '68**
1968 (cat.223)

JOHN McLEAN **Escalator** 1988 (cat.228)

EILEEN LAWRENCE **Naples, Serpent, Fascine** 1983–84 (cat.180)

GLEN ONWIN **Salt Room Crystal** 1977 (cat.262)

John Bellany **Allegory** 1964 (cat.14)

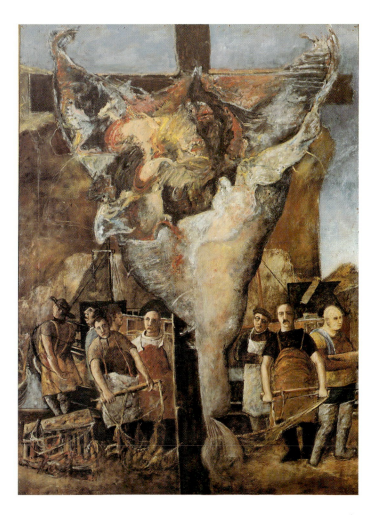

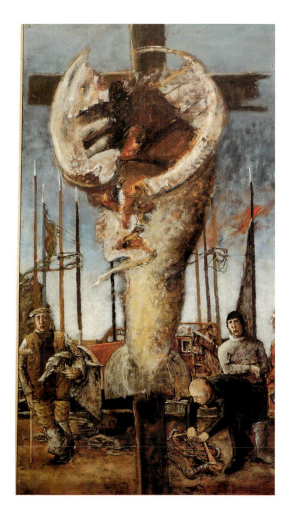

JUNE REDFERN **My Baby Moon** 1983 (cat.308)

CAROLINE MCNAIRN **Looking Outside** 1987 (cat.237)

ANDREW WILLIAMS **Dordogne Landscape I** 1988 (cat.347)

FIONNA CARLISLE **Theresa's Place** 1984 (cat.46)

STEVEN CAMPBELL **Elegant Gestures of the Drowned**
after Max Ernst 1986 (cat.44)

ADRIAN WISZNIEWSKI **Kingfisher** 1987 (cat.358)

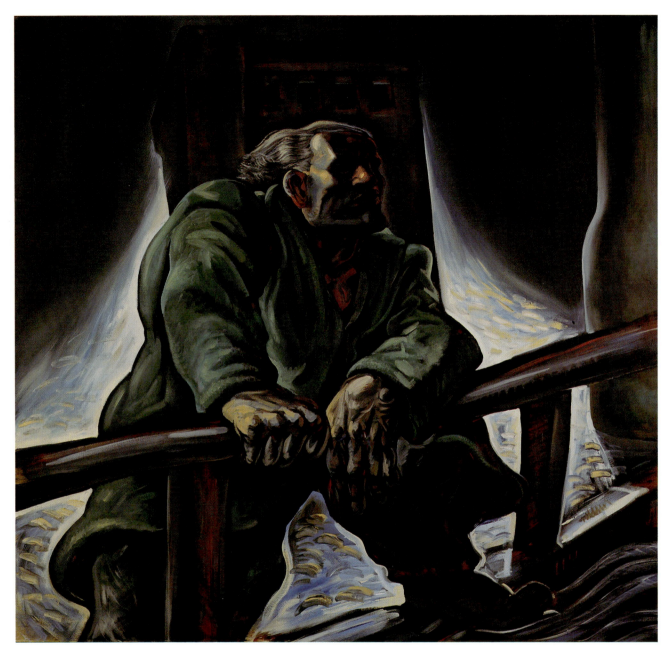

PETER HOWSON **Heroic Dosser** 1987 (cat.156)

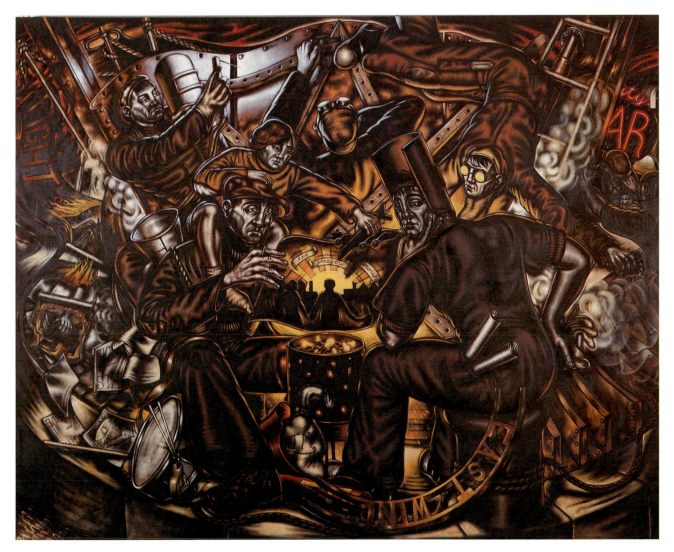

Ken Currie **Template of the Future** (from **Glasgow Triptych**)
1986 (cat.87)

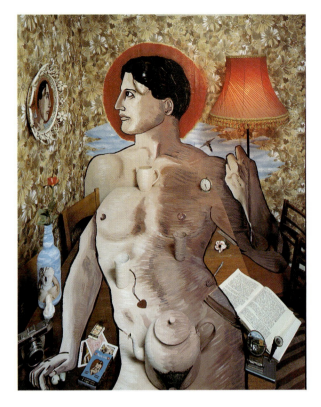

CALUM COLVIN **Narcissus** 1987 (cat.63)

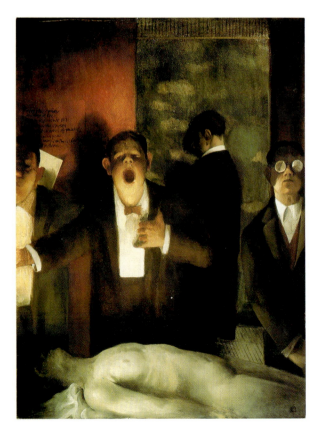

STEPHEN CONROY
Healing of a Lunatic Boy 1986 (cat.64)

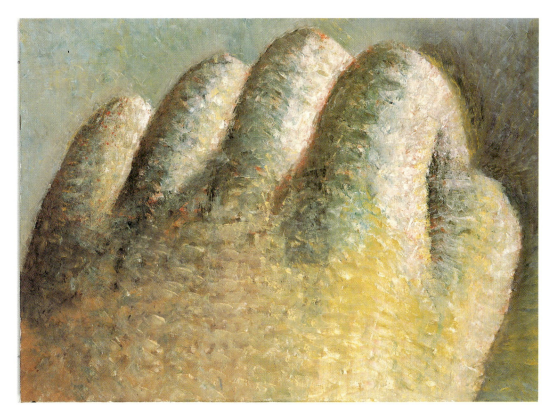

GWEN HARDIE **Fist** 1986 (cat.154)

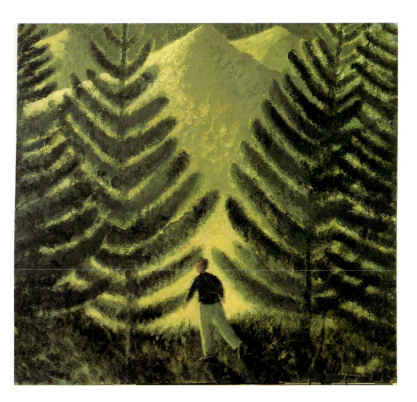

ROBERT MACLAURIN **Among the
Turkish Wilderness** 1988 (cat.217)

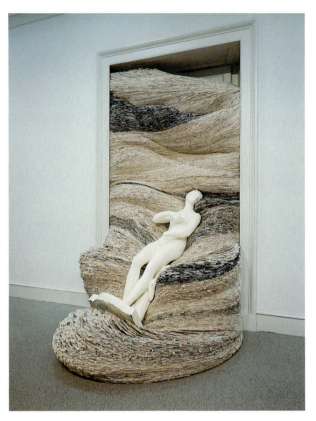

DAVID MACH **Outside In** 1987
(Work produced for the exhibition
The Vigorous Imagination, Scottish National
Gallery of Modern Art, Edinburgh)

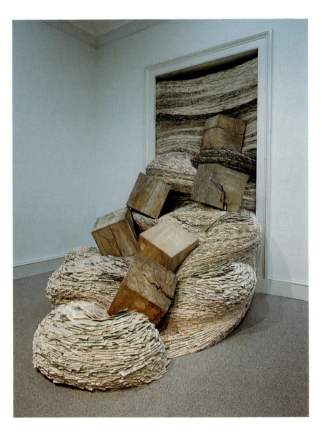

Tracy Mackenna **Objects 8, 9, 10 in a Row** 1989 (cat.212)

Linda Taylor **Three Drawings for
'Unseen Currents'** 1988 (cat.329)

KATE WHITEFORD **Red Spiral** 1986 (cat. 343)

Biographies and Catalogue

Dimensions are in centimetres, height before width, before
depth (sculpture and reliefs). With works on paper, paper size
is given in each case.

b.r. = bottom right, t.l. = top left, b.c. = bottom centre, etc.

GMA. . . .(. . .) = Scottish National Gallery of Modern Art, Accession no. and date.

Paintings and sculptures are listed before watercolours and drawings; prints follow.

Abbreviations

ACGB	Arts Council of Great Britain
ACNI	Arts Council of Northern Ireland
ARA	Associate of the Royal Academy
ARE	Associate of the Royal Society of Painter-Etchers and Engravers
ARSA	Associate of the Royal Scottish Academy
CAC	City Art Centre, Edinburgh
ECA	Edinburgh College of Art
EIF	Edinburgh International Festival
FMG	Fruitmarket Gallery, Edinburgh
GAGM	Glasgow Art Gallery and Museums
GI	Royal Glasgow Institute of the Fine Arts
GSA	Glasgow School of Art
GSLA	Glasgow Society of Lady Artists
ICA	Institute of Contemporary Arts, London
NGS	National Galleries of Scotland, Edinburgh
RA	Royal Academy, London
RCA	Royal College of Art, London
RDG	Richard Demarco Gallery, Edinburgh
RE	Royal Society of Painter-Etchers and Engravers
ROI	Royal Institute of Oil Painters
RSA	Royal Scottish Academy, Edinburgh
RSBA	Royal Society of British Artists
RSW/RSSPW	Royal Scottish Society of Painters in Watercolour
SAC	Scottish Arts Council
SMAA	Scottish Modern Arts Association
SNGMA	Scottish National Gallery of Modern Art, Edinburgh
SNPG	Scottish National Portrait Gallery, Edinburgh
SPG	Scottish Photography Group
SSA	Society of Scottish Artists
SSWA	Scottish Society of Women Artists
TEC	Third Eye Centre, Glasgow
TRAC	Talbot Rice Art Centre, University of Edinburgh
WAC	Welsh Arts Council

Sam Ainslie b.1950

Ainslie was born in North Shields, Tyne and Wear. She attended an Arts Foundation course at the Jacob Kramer College of Art, Leeds, from 1972–73 and from 1974–77, studied art at Newcastle upon Tyne Polytechnic. In 1975 she spent six weeks in Japan studying Sukiya architecture; the use of natural materials in Japanese art was to be an important influence on her work. Ainslie's wall-hangings of the late 1970s incorporate canvas, cotton bindings and wood in ways which suggest Japanese costumes. In 1977 she moved to Edinburgh to study tapestry at the College of Art. There, the Japanese influence eroded as Ainslie turned to using brighter colours and abstract shapes, employing canvas materials which she overlaid and sewed together. In 1983 she produced a 30 foot-long tapestry for the General Accident Headquarters in Perth and in 1984 made five 20 foot-long banners for the opening of the SNGMA at its new building in Edinburgh. Ainslie's *Banner for Greenham* (1985) signalled a move away from primarily decorative hangings to a politically engaged art expressing ideas about the role of women in contemporary society. Since 1985, Ainslie has continued to work on this theme, depicting stylised female bodies which are constructed from pieces of canvas woven together and painted with acrylics. An exhibition of her work was held at TEC in 1986. She currently teaches at GSA.

Bibliography

Edinburgh, TRAC: *Three Artists* (exhibition catalogue 1979)
Glasgow, TEC: *Why I choose Red: Sam Ainsley* (exhibition catalogue 1987)

1

I **Warrior Woman V: The Artist**
 1986
 Acrylic on canvas with cotton
 binding 381 × 142.5 cm
 GMA 3026 (1987)

Craigie Aitchison b.1926

The son of The Lord Justice Clerk of Scotland, Aitchison spent his early life in Dunbartonshire and on the Island of Arran where the family owned a holiday house. The Scottish landscape and the Aitchison family's involvement with the Church (his grandfather was a minister) would later find form in his paintings. Around 1950, Aitchison moved to London to study law at the Middle Temple, but he soon turned instead to painting, attending the Slade School of Art from 1952–54. In 1955 he won a British Council scholarship to study in Italy; there, the quality of light and the landscape profoundly affected his work as did early Italian art with its simplified depiction of events. On his return to London, Aitchison found a style of radically abbreviated forms and strong pastel colouring to which he remains faithful. He began exhibiting in London from 1954, and had three one-man shows at the Beaux-Arts Gallery in 1959, 1960 and 1964. His paintings normally feature just one or two simple elements, such as a bird, a vase or a tree, set squarely in the centre of the canvas. Extraneous detail is rigorously edited out, colours are rarely modulated but flatly applied and worked deep into the weave of the canvas. The paintings are never signed on the front so as not to upset the austere balance of the composition. Aitchison's choice of subject-matter is also highly selective, being principally animals, plants and, from 1963, portraits which evoke a pre-industrial age of innocence. He has also produced an important series of crucifixions and nativities. Aitchison lives and works in London.

Bibliography

SAC: *Craigie Aitchison* (exhibition catalogue 1975)
London, Serpentine Gallery: *Craigie Aitchison* (exhibition catalogue 1981)
London, Albemarle Gallery: *Craigie Aitchison, Paintings 1982–87* (exhibition catalogue 1987)

2 **Still Life No.4** 1974
 Oil on canvas 76.2 × 63.5 cm
 GMA 1501 (1975)

2

Donald Bain 1904–1979

The son of a textile designer, Donald Bain was born in Kilmacolm, Renfrewshire. In 1918 his family moved to Harrogate and subsequently to Liverpool before settling in Matlock, Derbyshire. In 1920 Bain met the 'Glasgow Boy' painter W. Y. MacGregor, who introduced him to the work of Peploe and Fergusson. In 1928 Bain visited Paris where he was particularly struck by the paintings of Matisse. It was only in 1940 that he returned to live in Scotland, taking up residence in Glasgow where he worked in the shipyards. He immediately contacted Fergusson and became involved in the New Scottish Group from its formation in

1942. His work of this period owes much to Fergusson and to Hunter, being brightly coloured and depicting still lifes and landscapes. In 1946, he returned to France where he remained until 1948, exhibiting at the major Salons on the Côte d'Azur and in Paris. Bain's paintings of the mid-1940s share the concerns of contemporary French landscape artists for a Cézannesque tightly co-ordinated structure, bright colour and rich paint texture. In 1948 Margaret Morris, Fergusson's wife, commissioned Bain to design the decor for a ballet production of *A Midsummer Night's Dream*. A one-man exhibition in Glasgow in 1952 and a sprinkling of shows throughout the 1950s failed to keep him in the public eye, as ill-health severely curtailed his production. A touring exhibition shown in major Scottish cities in 1972–73 and a Queen's Jubilee medal for services to the Arts awarded in 1977 served to revive interest in Bain, then resident in a tenement block in the Springburn area of Glasgow and largely forgotten.

Bibliography

William MacLellan: *Donald Bain*, Glasgow 1950
Crieff Williamson: 'Donald Bain, Scottish Painter', *The Studio*, Vol.CXLIII, No.708 March 1952
Dundee Art Gallery: *Donald Bain* (exhibition catalogue 1972)
Glasgow Print Studio Gallery: *Donald Bain Memorial Exhibition* (exhibition catalogue 1980)

3 **Jazz** 1943
Inscribed b.c.: 'D. Bain/43'
Watercolour on paper
27 × 20.3 cm
GMA 1593 (1976)

4 **A Glade in Angus** 1944
Inscribed b.r.: 'D. Bain/44'
Black and coloured chalk on paper
25.5 × 20.3 cm
GMA 1594 (1976)

5 **Boulevard, Paris** 1946
Inscribed b.r.: 'D. Bain/46'
Black chalk and watercolour on paper 18 × 14.3 cm
GMA 1596 (1976)

6 **Passageway St Paul de Vence** 1947
Inscribed b.l.: 'D. Bain/47'
Pastel, watercolour and charcoal on paper 29.1 × 27.2 cm
GMA 1598 (1976)

3

Edward Baird 1904–1949

Baird was born in Montrose and was educated at the Montrose Academy. From 1923–27 he attended GSA, graduating with the Newbery Medal awarded to the best student of the year. He also won a travelling scholarship which enabled him to spend a year in Italy. The meticulous detail of early Renaissance painting would profoundly affect Baird's style. He then returned to Montrose, remaining there until his death in 1949. From 1938–40 he taught at Dundee College of Art, but otherwise kept to his studio, spending lengthy periods on each painting, often extensively reworking the compositions and leaving many unfinished. In the early 1930s he incorporated Surrealist elements in his pictures, which are close to those of Nash and Wadsworth. Continual ill-health forced him to remain in Montrose during the war, where he concentrated chiefly on portraiture. Baird's aloofness from the art world and his early death meant that he remained virtually unknown until an exhibition organised by the SAC in 1968.

Bibliography

SAC: *Edward Baird and William Lamb* (exhibition catalogue 1968)
Montrose Public Library: *Edward Baird* (exhibition catalogue 1981)

7 **The Birth of Venus** 1934
Inscribed b.r.: 'Baird 1934'
Oil on canvas 51 × 69 cm
Private Collection

[colour illustration page 71]

8 **LDV** 1939
Oil on canvas 91.5 × 71 cm
Scottish Arts Council Collection

9 **Unidentified Aircraft** 1942
Inscribed b.l.: 'Edward Baird/1942'
Oil on canvas 71 × 91.5 cm
Glasgow Museums and Art Galleries

10 **Portrait of Walter Graham**
Oil on canvas 92.1 × 71.7 cm
Dundee Art Galleries and Museums

8

10

Wilhelmina Barns-Graham
b.1912

Wilhelmina Barns-Graham has worked in oils, gouache, collage and line drawings but is best known for her painted reliefs. Her work has alternated between figurative and abstract. Born in St Andrews in 1912, she began painting abstract forms at an early age, using col-

oured chalks on paper. After some parental opposition and a struggle with ill-health, she enrolled at ECA where she studied from 1932–37. Among her teachers were Gillies, Maxwell and Moodie, and her fellow students included William Gear, Margaret Mellis, Denis Peploe, Charles Pulsford and Norman Reid. From 1936–40 she rented a studio in Edinburgh. In 1940 Barns-Graham, taking up an Andrew Grant Travelling Scholarship went to St Ives in Cornwall. Hubert Wellington, Principal of ECA, suggested the move because he thought her work in sympathy with the artists working there. In St Ives Borlase Smart became a supporter and friend and she met, among others, Nicholson, Hepworth and Gabo. She joined the Newlyn Society of Artists and the St Ives Society of Artists in 1942, and became a founder-member of the Penwith Society in 1949. A visit to Switzerland in 1948 resulted in a series of drawings and paintings of glaciers which were to influence her work for many years. She wrote in 1965 of the glaciers: 'This likeness to glass and transparency combined with solid rough ridges made me wish to combine in a work all angles at once, from above, through and all round, as a bird flies, a total experience.' From 1948–49 she worked on large gouaches and also began to work on small abstract white reliefs, usually hardboard with some added colour. During an Italian government travelling scholarship in 1955 she met Poliakoff and on the return journey through Paris visited the studios of Brancusi and Arp. She taught at Leeds School of Art from 1956–57 and from 1961–63 she had a studio in London. In the late 1970s she produced a series of works reflecting the movement of waves, and more recently Orkney has become a source of inspiration. In 1960 Barns-Graham inherited a house in St Andrews since when she has divided her time between Scotland and Cornwall.

Bibliography

Edinburgh, The Scottish Gallery: *W. Barns-Graham* (exhibition catalogue 1956; Introduction by Alan Bowness)
St Andrews, Crawford Centre for the Arts: *W. Barns-Graham Paintings and Drawings* (exhibition catalogue 1982; Introduction by William Jackson)
London, The Tate Gallery: *St Ives Twenty-Five Years of Painting, Sculpture and Pottery* (exhibition catalogue 1985)
Edinburgh, CAC: *W. Barns-Graham Retrospective 1940–1989* (exhibition catalogue 1989)

11 **Glacier (Vortex)** 1950
Inscribed b.l.: 'W. Barns Graham 1950'
Oil and pencil on canvas
56 × 71 cm
Private Collection

[colour illustration page 86]

12 **March 1957 (Starbotton)** 1957
Inscribed b.l: 'Barns Graham '57'
Oil on canvas 63.5 × 76.5 cm
GMA 2778 (1983)

13 **White Rocks, St Mary's, Scilly Isles** 1953
Inscribed b.r.: 'W. Barns-Graham 1953'
Oil, ink and chalk on paper
49.8 × 76.2 cm
GMA 1697 (1977)

12

John Bellany b.1942

Bellany was born in the fishing village of Port Seton and although his father and both grandfathers were fishermen, he chose instead to study painting, attending ECA from 1960–65. In 1962, he was awarded an Andrew Grant Scholarship enabling him to travel to Paris where he particularly admired Gustave Courbet's paintings. Bellany was attracted to an art that had clear social references, in contrast to the *belle peinture* tradition still strong at ECA. In 1963, he and Alexander Moffat showed their paintings at EIF in the open-air at Castle Terrace, repeating the performance the following two years outside the RSA. Bellany's work of the mid-1960s drew inspiration from Port Seton's fishing industry but by the late 1960s he was working more complex symbolism into this theme. A visit to the Max Beckmann retrospective in London in 1965 and a trip to East Germany in 1967 where he visited Buchenwald concentration camp deeply affected this move towards a dark, richly personal symbolism in which fish, birds and animals are introduced as representatives of death, guilt and sexual obsession. The claustrophobic paintings of the early 1970s gave way around 1973 to the use of acid tones and broader brushwork; the works became less descriptive and more idiosyncratic in the macabre use of symbolism as humans were given fish-heads or transformed into birds. By 1982, Bellany was applying paint so aggressively and freely that the works approached abstraction. Since then, Bellany's symbolism has remained arcane, but more calmly rendered. During the 1980s he has produced a large body of watercolour portraits, many done in the wake of serious illnesses suffered in 1984 and 1988. A series executed after surgery in 1988 was exhibited at the SNGMA in 1989. Bellany has been given numerous one-man exhibitions throughout Europe and the USA. He currently lives and works in London.

Bibliography

Birmingham, Ikon Gallery: *John Bellany: Paintings 1972–1982* (exhibition catalogue of touring show 1983)
Edinburgh, SNGMA: *John Bellany* (exhibition catalogue 1986)
London, National Portrait Gallery: *John Bellany* (exhibition catalogue 1986)
London, Fischer Fine Art Ltd: *John Bellany* (exhibition catalogue 1986)

14 **Allegory** 1964 (Triptych)
Inscribed b.l. left panel: 'John Bellany '64'
Oil on hardboard 212.4 × 121.8; 213.3 × 160; 212.5 × 121.8 cm
GMA 3359 (1988)

[colour illustration pages 100–1]

15 **Enigma** 1981 (Triptych)
Inscribed l.l., left panel: 'Bellany'
Oil on canvas
173 × 91.5; 173 × 153; 173 × 91.5 cm
The Artist

16 **Flowers** 1989
Oil on canvas
213.5 × 206.5 cm
The Artist

17 **Self Portrait** 1988
Inscribed t.l.: 'John Bellany "Self
portrait"/12th May 1988' and b.r.:
'Bellany 88'
Pencil and watercolour on paper
77 × 57 cm
The Artist

17

Elizabeth Blackadder b.1931

Elizabeth Blackadder was born in Falkirk.
From 1949–54 she studied art at Edin-
burgh University and ECA. Her teachers
included Penelope Beaton, Robert
Henderson Blyth, Philipson, MacTaggart,
but it was William Gillies who had the
greatest impact on her work. In 1954
she was awarded a Carnegie Travelling
Scholarship and visited Yugoslavia,
Greece and Italy. She was impressed by
Byzantine architecture and mosaics
which have influenced much of her later
work. During a post-graduate scholar-
ship year 1954–55 she spent nine
months in Italy where she studied work
of the early Italian School and saw the
work of contemporary artists such as
Morandi and Sironi. In 1956 she married
fellow student John Houston and began
teaching part-time at ECA. Blackadder
has travelled widely with her husband to
most European countries, the USA and

to Japan. Her travels have provided a rich
fund of images. Elizabeth Blackadder's
subjects include landscapes, flowers, cats,
portraits, and still lifes. Commissions
have included tapestries, stained glass
and lithographs. She has worked in oil
but is at her most experimental in water-
colour. In 1978 she began a series of deli-
cately observed watercolours of flowers
from her garden. Her still-life paintings
have as their starting point the upward-
tilted picture space of Anne Redpath.
They show objects arranged with great
care on the surface of her studio table,
which is brought vertical to the picture
plane. Blackadder was elected ARSA in
1963, ARA in 1971, RSA in 1972 and
RA in 1976. She has had regular solo
shows at the Mercury Gallery, London
since 1965 as well as shows throughout
Britain, Italy, Canada, New York, Ger-
many and Brazil. She lives in Edinburgh
and taught at ECA until 1986.

Bibliography

SAC: *Elizabeth Blackadder* (exhibition catalogue
1981: Text by William Packer)
Judith Bumpus: *Elizabeth Blackadder*, Oxford 1988

18 **Untitled** 1967–68
Bears initials of artist and symbol of
Dovecot Studios c.r.
Tapestry in wool 137 × 244 cm
*GMA 1105 (presented by Mrs John
Noble, 1968)*

19 **Homesteads, Hadrian's Wall**
Inscribed b.r.: 'E.V. Blackadder'
Pen and black ink, black chalk and
pencil on paper 50.5 × 66.7 cm
*GMA 1888 (Dr R. A. Lillie Bequest,
1977)*

20 **Houses and Fields, Mykonos** 1962
Inscribed b.l.: 'Elizabeth V.
Blackadder'
Watercolour on paper
68.6 × 99 cm
GMA 839 (1963)

21 **Easter Egg, Teazles and Grey
Table** c.1961–62
Inscribed b.l.: 'Elizabeth V.
Blackadder'
Pencil and watercolour on paper
68 × 99.7 cm
*Private Collection (on loan to
SNGMA)*

[colour illustration page 87]

18

Douglas Percy Bliss 1900–1984

Born in Karachi, Bliss was educated at
Watson's College, Edinburgh and Edin-
burgh University, where he took an MA
in 1922. He then studied painting at the
Royal College of Art under Sir William
Rothenstein and, as a post-graduate in
1922–24, wood-engraving with Sir
Frank Short. In 1927 Bliss shared a
group exhibition at St George's Gallery,
London with Edward Bawden and Eric
Ravilious. He wrote *A History of Wood
Engraving* (published in 1928) and
became the London art critic of *The Scots-
man*. Bliss taught part-time at Hornsey
School of Art 1932–40 and at Black-
heath 1934–40. He had one-man shows
at Reid and Lefevre, London, in 1930,
1939 and 1947 and one at the Leger
Galleries in 1938. In 1934 he was elec-
ted a member of the Society of Wood
Engravers. Bliss regularly exhibited at
the New English Art Club and the Royal
Academy. During this period he illus-
trated twelve books and published well
over a hundred essays in e.g. *The Listener,
The Print Collector's Quarterly, Art World*
and *The Studio*. Bliss served in the RAF
1941–45, where he met Iain Macnab,
and spent 1945–46 teaching part-time
at Harrow School of Art. Bliss is remem-
bered in Scotland for his work as Director
of GSA from 1946–64. Bliss used his
'retirement' to continue his painting and
write a book on his friend Edward Baw-
den (published 1979). During the last
decade there has been a new appreci-
ation of his contribution to the revival of
wood engraving in the 1920s.

Bibliography

Albert Garrett: *A History of British Wood Engraving*, Tunbridge Wells 1978
London, Blond Fine Art: *Douglas Percy Bliss, watercolours and wood engravings: Clifford Webb, watercolours, wood engravings and coloured woodcuts* (exhibition catalogue 1980)
London, Alpine Gallery: *Douglas Percy Bliss. Paintings, watercolours and wood engravings* (exhibition catalogue 1980; presented by Robin Garton)

22 **Morayshire Crofter** c.1928
Inscribed b.r.: 'Douglas P. Bliss' and b.l.: 'Morayshire Crofter'
Wood engraving 10.4 × 15.7 cm
GMA 2082 (1979)

22

Muirhead Bone 1876–1953

Born in Partick, an industrial suburb of Glasgow, and apprenticed to an architectural practice, he was encouraged by Archibald Kay, his secondary school art master, to study at GSA under F. H. Newbery, at evening classes. Accompanying his journalist father through the city's closes, Bone sought in his prints to emulate the Dutch masters. His first set of Glasgow etchings of 1898 also drew upon the prints of Meryon and Whistler. These prints introduced him to London circles in 1898 where he exhibited at the New English Art Club. In 1901, following his series of etchings for the International Exhibition in Glasgow and the illustration of a monograph, Bone moved to London. In 1902 he had his first solo show at the Carfax Gallery, London and in 1904 became a founder-member of the Society of Twelve. His architectural compositions, recording the development of London, in the manner of Piranesi, and the publication of a *catalogue raisonné* of his prints in 1909 by Campbell Dodgson brought Bone public recognition.

Bone served as an Official War Artist from 1916 and his strong draughtsmanship was particularly suited to the lithographic medium. He served as a Trustee of the Tate Gallery 1920–27, supporting the radical contributions of young artists such as Epstein. He moved to Oxford in the 1930s, was knighted in 1937 and served as a War Artist to the Admiralty 1939–46. Latterly Bone illustrated books by his brothers James and David.

Bibliography

C. Dodgson: *Etchings and Drypoints of Muirhead Bone (1898–1907)*, London 1909
C. Dodgson: 'The Later Drypoints of Muirhead Bone (1908–16)', *Print Collector's Quarterly*, February 1922, pp.173–200
M. Bone: 'From Glasgow to London', *Artwork*, 1929, pp.143–64
St Andrews, Crawford Centre for the Arts: *Muirhead Bone. Portrait of the Artist* (exhibition catalogue 1986; Essay by Peter Trowles)

23 **Moonlight, Auxerre**
Inscribed b.r.: 'Muirhead Bone'
Black chalk on paper
35.5 × 25.4 cm
GMA 681 (Sanderson Bequest to NGS 1943, transferred to SNGMA)

24 **A Baroque Monastery**
Inscribed b.l.: 'Muirhead Bone'
Brush drawing on paper
28 × 38.5 cm
GMA 939 (Sir Alexander Maitland Bequest, 1965)

25 **An Italian Town by Night**
Chalk on paper 24 × 18 cm
GMA 940 (Sir Alexander Maitland Bequest, 1965)

26 **Glasgow Exhibition 1901**
Inscribed b.r.: 'Muirhead Bone to Joe Cameron' and b. l.: 'Glasgow Exhibition 1901'
Etching and drypoint
31.5 × 21.6 cm
GMA 94 (transferred from NGS)

27 **Glasgow International Exhibition 1901 – The Russian Section**
Etching 12.6 × 9.1 cm
GMA 95A (transferred from NGS)

28 **T. & R. Annan & Sons, 1901 International Exhibition**
Etching 13.8 × 8.2 cm
GMA 90 (transferred from NGS)

29 **Glasgow International Exhibition – View of Main Pavilion 1901**
Etching 7 × 13 cm
GMA 93 (transferred from NGS)

30 **Glasgow Art Gallery at the 1901 Exhibition**
Inscribed b.r.: 'Muirhead Bone'
Etching 12.1 × 27.5 cm
The Artist's Family

31 **Trees and Cottage**
Drypoint 16 × 11.6 cm
GMA 91 (transferred from NGS)

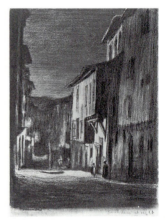

25

Mark Boyle b.1934 and Family

Mark Boyle was born in Glasgow and from 1950–53 served in the Army. From 1955–56, he studied law at Glasgow University before pursuing a variety of jobs (labourer, waiter, clerk) and becoming involved in theatre shows and Performance Art in the early 1960s. From 1963 he staged exhibitions and events in Glasgow, Edinburgh and London including shows at the Traverse Theatre, Edinburgh (1963, 1964) and at the ICA, London (1965). In 1964, Boyle and his companion Joan Hills (b.1936, Edinburgh) made their first replica of a section of ground surface. This was the start of a project 'The Journey to the Surface of the Earth' launched in 1969, the aim

of which was to duplicate 1000 randomly selected portions of the earth's surface. Darts were thrown at a map to pinpoint proposed sites, a T-square would be thrown to mark the precise section to be duplicated, normally a 6 × 6 foot area. Projects within this scheme have involved the reproduction of sections of pavement in West London where Boyle and Hills lived until recently. The Boyle children, Sebastian (b.1962) and Georgina (b.1964) also take part in these projects. A plastic substance 'Epikote' is spread over the ground's surface, allowed to dry and peeled away, carrying with it the imprint of the ground together with the surface debris. A fibreglass cast is made which is then painted to provide an exact duplicate of the original surface. Parallel projects have included the recording of sensory data such as smell and sounds at randomly selected sites. Boyle explained in 1966: 'I have tried to cut out of my work any hint of originality, style, superimposed design, wit, elegance or significance. The aim is to produce as objective a work as possible'. From 1967–68 he collaborated with leading contemporary Rock musicians Jimi Hendrix and Soft Machine, lighting their stage shows. Since 1970, the Boyle family's earth-surface studies have been widely exhibited throughout the world and were accorded a central position in the British Pavilion at the 1978 Venice Biennale. Major shows have been held at the Institute of Contemporary Art, Boston, at the San Francisco Museum of Modern Art (both 1982) and at the Hayward Gallery, London in 1986.

Bibliography

London, ICA: *Journey to the Surface of The Earth* (exhibition catalogue 1969)
David Thompson: *Journey to The Surface of The Earth: Mark Boyle's Atlas and Manual*, London 1970
Høvikødden, Henie-Onstad Foundation: *Boyle Family Archives*, Oslo 1985
London, Hayward Gallery: *Beyond Image: Boyle Family* (exhibition catalogue 1986)

32 **'Mine Eyes Have Seen the Glory'** *c.*1963
Mixed media 150 × 297.5 cm
Sean Hignett

[colour illustration page 92]

33 **Drawer Piece** 1963
Mixed media 46 × 29 × 7 cm
Sean Hignett

34 **Frame Relief** *c.*1963
Inscribed on frame b.r.: 'Mark Boyle'
Mixed media 49 × 35.2 × 5.5 cm
John and Halla Beloff Collection

35 **Pavement Piece** 1968
Painted fibreglass
247 × 244 × 19 cm
GMA 1304 (1974)

33

34

Francis Campbell Boileau Cadell

1883–1937

Born in Edinburgh, Cadell's early artistic talent was encouraged by family friend and 'Glasgow Boy', Arthur Melville. On his advice Cadell studied at the Académie Julian and other studios in Paris 1899–1902. From 1906–8 the Cadell family lived in Munich. Cadell's first solo exhibition at Doig, Wilson and Wheatley, Edinburgh in 1908 consisted mainly of landscapes in watercolour and oil. In 1910 Cadell painted a set of impressionistic Venetian compositions. In 1912 he became a founder-member of The Society of Eight which exhibited annually in Edinburgh, his base, and began his lifelong annual visits to Iona. He served in the trenches from 1915 and used his war experiences for the 'Jock and Tommy' drawings which were published in 1916. He went to Iona upon leaving the army in 1919 and in 1920 S. J. Peploe joined him on the island for the first of many shared painting trips. The year 1920 also saw a marked change in Cadell's work, which became more brilliant in hue and hard-edged in form. This provoked a charge of 'Bolshevism in colour' from the art establishment. Cadell exhibited alongside Peploe and Hunter at the Leicester Galleries, London in 1923 and in 1924 they also exhibited at the Galerie Barbazanges, Paris together with J. D. Fergusson. Cadell visited the South of France in 1923 and 1924, where he depicted the sunlit streets and harbours in a Fauve manner. On the one hand Cadell painted sensuous, painterly renderings of landscapes, interiors and figures but in contrast he also introduced a design element which dominated his studio still lifes and some of his portraits of elegant women. Cadell was an immensely popular man but apart from a handful of patrons he never achieved wide recognition within his lifetime. He was elected RSA in 1936 and died the following year. A memorial exhibition was held at the NGS in 1942.

Bibliography

Obituary: *The Scotsman*, 7 December 1937
T. J. Honeyman: *Three Scottish Colourists: Peploe, Hunter, Cadell*, London 1950
SAC: *Three Scottish Colourists. Cadell: Hunter: Peploe* (catalogue of touring exhibition 1969–70; Foreword by T. J. Honeyman, Essay by William Hardie, Catalogue and Biography by Ailsa Tanner)
Tom Hewlett: *Cadell, A Scottish Colourist*, London 1988

36 **The Model**
Inscribed b.r.: 'F.C.B. Cadell'
Oil on canvas 127.2 × 101.6 cm
GMA 3 (transferred from NGS)

[colour illustration page 58]

37 **Lady in Black: Miss Don-Wauchope** 1921
Inscribed b.l.: 'F.C.B. Cadell'
Oil on canvas 74.9 × 62.2 cm
GMA 3350 (Mr and Mrs G. D. Robinson Bequest, through the NACF, 1988)

[colour illustration page 59]

38 **Still Life (The Grey Fan)**
Inscribed b.r.: 'F.C.B. Cadell'
Oil on canvas 66 × 49.3 cm
GMA 1311 (1974)

39 **Aspidistra and Wine on Table**
Oil on board 76.2 × 60.9 cm
GMA 3351 (Mr and Mrs G. D. Robinson Bequest, through the NACF, 1988)

40 **The Shed, Iona**
Inscribed b.c.: 'F.C.B. Cadell'
Oil on board 36.5 × 44 cm
GMA 1893 (Dr R. A. Lillie Bequest, 1977)

41 **Melancholy Portrait of a Poet**
Inscribed b.r.: 'F.C.B. Cadell'
Charcoal on paper 55.8 × 37.7 cm
GMA 1891 (Dr R. A. Lillie Bequest, 1977)

38

Robert Callender b.1932

Born in Mottingham, Kent, Callender studied at South Shields Art School from 1948–49. He came to Edinburgh in 1951, attending Edinburgh University from 1951–54 and the College of Art from 1954–59. In 1959 he received an Andrew Grant Scholarship enabling him to study at the British School in Rome. Callender's first solo exhibition came in 1963 at the 57 Gallery which presented further shows in 1965 and 1967. He was Director of the Gallery from 1966–69 and President of the SSA from 1969–73. In the 1960s, Callender took to constructing works from cardboard. Neither paintings nor sculptures in any traditional sense, they are more akin to theatrical stage designs, being composed of painted layers of board arranged in three-dimensional space. In the 1970s and 1980s, and alongside his activities as a painter, Callender has taken to reconstructing objects (frequently sailing boats) in cardboard and painting these to produce replicas of uncanny realism. Since 1980 he has used balsa-wood, paper and card in making miniature models. Callender has had several one-man shows, including those at TEC in 1986, the Serpentine Gallery, London in 1981 and TRAC in 1985.

Bibliography

London, Mayor Gallery: *Robert Callender, Constructions* (exhibition catalogue 1986)
Edinburgh, TRAC: *Sea Salvage* (exhibition catalogue 1989)

42 **Abandoned Red Rudder** 1983
Cardboard stiffened with polystyrene insulation board covered with glue size and newsprint and painted with acrylic over oil paint 300 × 61.3 × 6.5 cm
GMA 2953 (1985)

42

Steven Campbell b.1953

Campbell was born in Glasgow where, after leaving school, he spent seven years working as a maintenance engineer and fitter in a steelworks. In 1978 he enrolled at GSA. While he was initially involved in Performance Art activities, he soon took up painting and in 1982 won a Fulbright Scholarship which enabled him to travel to New York. There he held two solo exhibitions in 1983, at Barbara Toll Fine Arts and at the John Weber Gallery. These were the first of many one-man shows throughout the USA and Europe. He remained in New York until 1986 before returning to Glasgow where he now lives. Campbell's paintings are characterised by a surreal and highly esoteric symbolism. His tweed-clad, mainly male cast of characters roam the countryside and become embroiled in bizarre, nonsensical occurrences. Birds, beasts and men compete in a hostile garden environment, performing strange rituals which defy nature's logic. The precise, arcane titles which Campbell gives his works are often at odds with the painted image, recalling Max Ernst's exploitation of the gulf between word and image. This cultivation of the absurd also has parallels in the stories of P. G. Wodehouse (a writer Campbell greatly admires). The settings in Campbell's paintings resemble a theatre stage with its claustrophobic sense of space and tipped-up perspective. The characters too, wide-eyed and earnest, recall actors from a second-rate play. Campbell works quickly, painting directly onto the canvas, inventing and changing elements as he progresses.

Bibliography

London, Riverside Studios and Edinburgh, FMG: *Steven Campbell: New Paintings* (exhibition catalogue 1984)
London, Marlborough Fine Art: *Steven Campbell: Recent Paintings* (exhibition catalogue 1987)
New York, Marlborough Gallery Inc.: *Steven Campbell: Recent Work* (exhibition catalogue 1988)

43 **Ding Dong** 1982
Oil on paper laid down on canvas 213.8 × 153 cm
Private Collection

44 **Elegant Gestures of the Drowned after Max Ernst** 1986
Oil on canvas 238.8 × 264 cm
GMA 3296 (1987)

[colour illustration page 104]

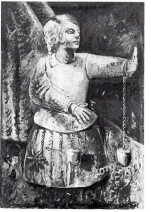

43

Fionna Carlisle b.1954

Carlisle was born in Wick and studied at ECA from 1972–76. She was awarded an Andrew Grant Post-Graduate Scholarship from 1976–77. Since her first one-woman exhibition at the 369 Gallery, Edinburgh in 1978, she has had five further shows at the Gallery. Her paintings have featured in numerous group exhibitions in Scotland and London. In the late 1970s, Carlisle's work was Matisse-like in the use of flat areas of colour and black contour lines. During the 1980s her preferred imagery of groups of women has been rendered with more vigorous brushwork and the colour has become more strident. Carlisle has lived on the island of Crete since 1984.

Bibliography

Edinburgh, 369 Gallery (exhibition catalogues 1980, 1982, 1983, 1986)

45 **Chinese Acrobats** 1983
Acrylic on paper 128 × 151 cm
Private Collection

46 **Theresa's Place** 1984
Inscribed b.r.: 'Fionna Carlisle '84'
Acrylic on paper 182 × 197.5 cm
GMA 2985 (1986)

[colour illustration page 103]

Alexander Carrick 1882–1966

Born in Musselburgh, Carrick trained as a stone carver in the studio of Birnie Rhind in Edinburgh. He trained as a sculptor at ECA and the Royal College of Art, London, and joined the staff of ECA in 1914. Following military service 1916–18, Carrick resumed his teaching of stone and marble carving at ECA and became ARSA 1918. The SMAA purchased his bronze *Jock* 1919 in 1920 (now CAC). Carrick's training brought him into close contact with architects and he used this awareness of the relationship of sculpture to architecture in his major monumental commissions during the inter-war years. These included the following: the *Animal Wall* extensions 1923 at Cardiff Castle for the 4th Marquis of Bute; the War Memorials at Ayr, Berwick-upon-Tweed, Dornoch, Forres, Fraserburgh and Killin; the carved exterior figures of *Justice* and *Courage* and the interior bronze reliefs to the *Royal Artillery* and the *Royal Engineers* 1924–27 for the Scottish National War Memorial; the *Wallace* statue of 1928 for the Esplanade façade wall of Edinburgh Castle; the 1932 figurative relief of *Geology* for King's Buildings, University of Edinburgh; an exterior carved stone relief of *Christ and the Woman of Samaria at the Well* 1934 for the cloister of the Reid Memorial Church, Edinburgh; carved pediment of 1936 for the Sheriff Court House, Edinburgh; the carving of Reid Dick's designs for St Andrew's House, Edinburgh, 1936; and the two bronze figures of *Safety* and *Security* for the Caledonian Insurance Co. (now Guardian Royal Exchange) building, St Andrews Square, Edinburgh. Carrick is remembered as the inspired teacher of a generation of Scots sculptors including Whalen, Lorimer, Elisabeth Dempster, Mary S. Boyd, Murray McCheyne, and George Mancini. He was Head of Sculpture at ECA from 1928–c.1942. He exhibited at the RSA, GI, RA.

Bibliography

Alexander Carrick's business papers are lodged with the National Monuments Record of Scotland, Edinburgh
Photocopies of the Carrick collection press cuttings, SNGMA archive
The Studio, Vol.LXXXVIII, No.379, October 1924, p.225

47 **Felicity** 1934
Inscribed on base: 'A. Carrick/1934'
Bronze 89.5 × 27 × 19 cm
Royal Scottish Academy

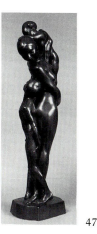

47

Ian Cheyne 1895–1955

Born in Broughty Ferry and educated at Glasgow Academy, Cheyne studied at GSA under Maurice Greiffenhagen. He exhibited at the SSA 1921–23 and 1926–28, at the RSA, GI, and Redfern and Cooling Galleries in London. Cheyne served as Treasurer for the Society of Artist-Printmakers. Although originally a painter, colour woodcuts of Scottish, Spanish and French landscapes became his prime interest. He resided in Bearsden, Glasgow and exhibited in the Scottish section of the 1949 *Exposition Internationale de la Gravure Contemporaine* at the Petit Palais, Paris. Cheyne's colour woodcuts have an Art Deco quality in their use of flat planes and curved forms combined with the perspective found in Japanese woodcuts.

Bibliography

Grant M. Waters: *Dictionary of British Artists working 1900–1950*, Eastbourne 1975
London, Garton and Cooke: *British Colour Woodcuts and Related Prints* (exhibition catalogue 35, Spring 1986)

48 **Beeches in Glen Lyon**
Inscribed b.l.: 'Beeches in Glen Lyon' and b.r.: 'Ian Cheyne'
Coloured woodcut 32.4 × 29.9 cm
GMA 203 (transferred from NGS)

Colin Cina b.1943

Colin Cina was born in Glasgow where
he attended the School of Art from
1961–63. He then settled in London fol-
lowing a post-graduate course at the
Central School of Art from 1963–66.
In 1966 he was awarded a Peter
Stuyvesant Foundation Bursary enabling
him to travel in the USA for three
months. There, the paintings of con-
temporary American colour-field artists
such as Barnett Newman and Joseph
Albers were to influence him strongly. In
the mid-1960s Cina was combining geo-
metric abstraction with Surrealist
imagery in works close to Pop art, these
featured in a group exhibition *The New
Generation* at the Whitechapel Art Gal-
lery, London in 1966. From 1967–68 he
eliminated extraneous references to con-
centrate on abstract painting, often using
unusually shaped angular canvases.
During the 1970s Cina returned to paint-
ing on rectangular surfaces, giving them
a unified surface colouring transected by
sharp vertical and angled lines (these he
called the 'MH' series). Since the early
1980s Cina has reintroduced fragments
of quasi-Surrealist imagery into his
painting, lively geometric shapes 'jump-
ing' out of the picture plane in works
reminiscent of Malevich and Kandinsky.
Cina has had numerous one-man exhibi-
tions, including two at the Serpentine
Gallery, London, in 1970 and 1980. He
is currently Head of Fine Art at Chelsea
School of Art.

Bibliography

Newcastle upon Tyne, Hatton Gallery: *Colin Cina*
 (exhibition catalogue 1971)
Glasgow, TEC: *Colin Cina: Paintings and Drawings
 1966–75* (exhibition catalogue 1975)

49 **MH/37** 1973
 Acrylic on canvas
 228.6 × 274.4 cm
 GMA 1298 (1974)

49

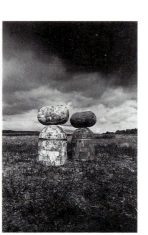

Doug Cocker, *Silver Kiss/Rough Touch*, 1986

Doug Cocker b.1945

Cocker was born in Perthshire and
studied at Duncan of Jordanstone College
of Art, Dundee from 1963–68. In 1966
he won an SED scholarship enabling him
to travel to Greece and Italy and in 1968
won a Greenshields Fellowship, travel-
ling to New York and again to Greece.
From 1972–81 he lived in Northampton,
England, returning to Scotland to
become lecturer at Gray's School of Art,
Aberdeen. Until the early 1970s Cocker
made sculptures in metal, but from
around 1975 took to making box con-
structions incorporating wood and col-
lage elements. By 1980, their coded
meanings were becoming increasingly
complex as texts and found objects were
added. From the early 1980s Cocker
branched out into larger quasi-
architectural works designed for outdoor
exhibition. Like his boxes, these were pre-
cisely machined structures made from
wood; a series was also designed for
interior wall-mounting. In 1985 he
began making much larger works out of
rough wooden logs and inspired by
classical architecture. Cocker was elected
ARSA in 1984 and Chairman of the Fed-
eration of Scottish Sculptors in 1985. An
important one-man show was held at
TEC in 1985.

Bibliography

Glasgow, TEC: *Doug Cocker: Sculpture and Related
 Works 1976–1986* (exhibition catalogue 1986)

Robert Colquhoun 1914–1962

Robert Colquhoun was born in
Kilmarnock, Ayrshire. In 1933 he
obtained a scholarship to GSA where he
met Robert MacBryde who became his
lifelong friend and companion. He
studied under Hugh Adam Crawford and
Ian Fleming. His artistic heroes at this
time were the Post-Impressionists,
Braque, Picasso and Wyndham Lewis.
From 1937–39 scholarships from the
School of Art enabled Colquhoun and
MacBryde to travel to France and Italy.
From 1940–41 Colquhoun served as an
ambulance driver in the RAMC.
Invalided out of the Army in 1941, Col-
quhoun went to London together with
MacBryde. They moved into a studio in
Bedford Gardens which they shared with
John Minton. Through Peter Watson,
publisher of *Horizon*, they met and
became friends with other artists of the
Neo-Romantic group. Colquhoun
experimented with landscape in the
manner of his new friends but soon
turned back to the angularities of Wynd-
ham Lewis. Jankel Adler, the Polish artist
and friend of Klee, moved into Bedford
Gardens in 1943. He encouraged Colqu-
houn to forget landscape and con-
centrate on the figure alone set within a
shallow picture space. In 1942 the
Lefevre Gallery exhibited the work of
both Roberts in their *6 Scottish Artists*
show. In 1943 Colquhoun had his first
one-man show there (to be followed by
others in 1944, 1946, 1947 and 1951).

The period 1944–46 saw Colquhoun at the peak of his powers painting such outstanding works as *The Woman with Leaping Cat* 1945–46, and *Woman with Birdcage* 1946. The figures in these paintings have an underlying feeling of desolation and detachment which runs throughout Colquhoun's work. In 1946 he began to experiment with monotypes and also visited Ireland. From 1947 his fortunes began to decline partly as a result of his roisterous life-style. Evicted from their London studio, Colquhoun and MacBryde moved to a studio in Lewes, Sussex, belonging to Frances Byng Stamper and Catherine Lucas, owners of Miller's Press. They made lithographs and drawings for the Press and Colquhoun painted a series of women and goats. During an Italian trip in 1949 he made drawings of the puppet plays in Modena and of the Siena Palio which were badly received when they were exhibited in London. From 1949–54 'the Roberts' lived at Tilty Mill, Dunmow in Essex. Here Colquhoun concentrated on animal painting. There was little work and very little money. Some commissions came for stage designs. Colquhoun and MacBryde provided designs for costumes and sets for Léonide Massine's Scottish ballet *Donald of the Burthens* (produced at Covent Garden in 1951), and in 1953 Colquhoun made designs for a production of *King Lear* at Stratford. Another commission was from the Arts Council for a large canvas for their Festival of Britain exhibition *Sixty Paintings for 51*. In 1958 Bryan Robertson organised a retrospective exhibition of Colquhoun's work at the Whitechapel Art Gallery, London for which Colquhoun painted eleven oils. The show was quite well received and 'the Roberts' visited Spain on the proceeds. Back in London, Colquhoun's health declined and he died of heart disease in 1962.

Bibliography

London, Whitechapel Art Gallery: *Robert Colquhoun* (exhibition catalogue 1958)

London, Mayor Gallery: *Robert Colquhoun and Robert MacBryde* (exhibition catalogue 1977; Text by Richard Shone)

Edinburgh, CAC: *Robert Colquhoun* (exhibition catalogue 1981; Text by Andrew Brown)

London, Barbican Art Gallery: *A Paradise Lost. The Neo-Romantic Imagination in Britain 1935–55* (exhibition catalogue 1987; Edited by David Mellor)

Malcolm York: *The Spirit of the Place. Nine Neo-Romantic Artists and their Times*, London 1988

50 **Seated Woman and Cat** 1946
Inscribed b.l.: 'Colquhoun 46'
Oil on canvas 97 × 76 cm
Arts Council Collection, London

51 **The Dubliners** 1946
Inscribed b.r.: 'Colquhoun'
Oil on canvas 76.2 × 61 cm
GMA 842 (1963)

52 **Woman in Green** 1949
Inscribed t.l.: 'Colquhoun'
Oil on canvas 103.3 × 51.4 cm
Aberdeen Art Gallery and Museums

53 **Figures in a Farmyard** 1953
Inscribed b.r.: 'Colquhoun/53'
Oil on canvas 185.4 × 143.5 cm
GMA 1306 (1974)

[colour illustration page 75]

54 **Study of a Male Nude** *c.*1937–38
Inscribed l.r.: 'Colquhoun'
Conté crayon on paper
52.7 × 38 cm
GMA 2476 (1982)

55 **Robert MacBryde** 1939
Inscribed b.r.: 'Colquhoun' and b.l. on mount: 'Robert: a head study: 1939. R. Colquhoun'.
Pen and sepia ink on paper
28.5 × 22.5 cm
Scottish National Portrait Gallery

56 **Sacha**
Inscribed b.r.: 'Colquhoun' and b.l.: 'Sacha'
Pencil on paper 30.3 × 21 cm
GMA 2111 (1979)

57 **Self Portrait**
Inscribed b.r.: 'Colquhoun'
Pencil on paper 26.6 × 23 cm
GMA 2110 (1979)

58 **The Spectators** 1947
Inscribed t.l.: 'Colquhoun 47'
Watercolour on paper
69.3 × 52.5 cm
GMA 2746 (1983)

59 **Man and Goat** 1945
Inscribed b.r.: 'Colquhoun 45'
Carbon drawing 55.5 × 45 cm
GMA 2782 (1983)

60 **Woman and Goat** 1948
Colour lithograph 39.1 × 28.4 cm
GMA 3310 (1987)

61 **Head of a Woman** 1949
Inscribed b.r.: 'Colquhoun 49'
Monotype 47.5 × 40.8 cm
GMA 2786 (1983)

62 **Man with Duck** 1954
Inscribed b.r.: 'Colquhoun 54'
Monotype 72.5 × 53 cm
GMA 2787 (1983)

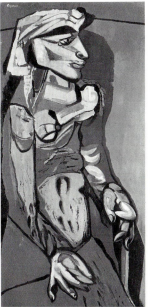

52

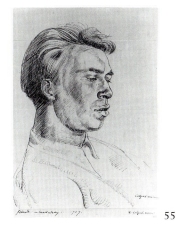

55

Calum Colvin b.1961

Born in Glasgow, Colvin studied at Duncan of Jordanstone College of Art, Dundee from 1979–83. He was initially in the painting department, then moved to sculpture and subsequently concentrated on photography. All three elements are very much evident in Colvin's work which defies classification under any single heading. From 1983–85 he studied photography at the Royal College of Art in London where he initially continued his interest in traditional documentary photography. But gradually he began building installations of junk objects which he photographed *in situ* using large-format cameras. He painted onto the objects, at first representing figures by a single black outline and then incorporating colour and layering objects in highly sophisticated and complex ways. His 'Constructed Narratives' are composed over a period of several days, painted over to give a bizarre and highly ambiguous reading of three-dimensional space, and photographed. The installations are then destroyed. The objects are carefully chosen for their kitsch value and for their iconographic significance; Scottish symbols recur in such forms as kilt-clad 'Action Men' and cans of McEwans beer. Each element within the whole composition is selected to construct an open-ended narrative dealing with male desire, fantasy and hero-worship.

Bibliography

London, The Photographer's Gallery: *Constructed Narratives: Photographs by Calum Colvin and Ron O'Donnell* (exhibition catalogue 1986)
Edinburgh, SNGMA: *The Vigorous Imagination* (exhibition catalogue 1987)
Interview, *Alba*, August 1987 pp.40–41

63　**Narcissus** 1987
Cibachrome print 101 × 76 cm
GMA 3047 (1987)

[colour illustration page 108]

Stephen Conroy b.1964

Stephen Conroy was born in Helensburgh and studied painting at GSA from 1982–87. In 1986, just before commencing his post-graduate year, he was awarded First Prize for painting at the Royal Academy's British Institute Fund Awards. That same year he had a one-man exhibition of commissioned work at Dumbarton District Council. Unlike the majority of his contemporaries who prefer loose brushwork and violent colour, Conroy works in the classical tradition, meticulously planning each painting with detailed preparatory drawings and compositional studies. Employing chiaroscuro and compressing his subjects into a shallow pictorial space, Conroy evokes a claustrophobic Edwardian world in which communication between the figures is minimal and highly enigmatic. Memories of Degas, Seurat, Sickert and Cowie permeate these very formal paintings. Conroy lives and works near Glasgow.

Bibliography

Edinburgh, SNGMA: *The Vigorous Imagination* (exhibition catalogue 1987)
London, Marlborough Fine Art: *Stephen Conroy. Living the Life* (exhibition catalogue 1989)

64　**Healing of a Lunatic Boy** 1986
Inscribed b.r.: 'C'
Oil on canvas 123.8 × 93.5 cm
GMA 3039 (1987)

[colour illustration page 108]

65　**The Enthusiasts** 1987
Inscribed b.c.: 'Conroy'
Charcoal, pastel and oil on paper
58 × 76 cm
GMA 3040 (1987)

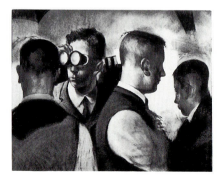

65

James Cosgrove b.1939

Born in Glasgow, Cosgrove joined the Army in 1955 as a cartographic draughtsman. He then worked ten years as a telecommunications officer for a telephone exchange before deciding to study art. He studied in the Prints and Textile Department of GSA from 1967–71, mainly producing screen-prints. On graduating, he worked as a member of staff in the same department, becoming its Head in the mid-1970s. In 1982 he took over as Head of First Year studies. In 1980 Cosgrove had a one-man show of drawings at Glasgow Print Studio, and in 1986 had a solo exhibition of paintings at Corners Gallery, Glasgow. He has also exhibited ceramics and sculptures, but concentrates primarily on painting. He lives and works in Glasgow.

66　**Potted Head** 1989
Inscribed l.r.: Cosgrove/89'
Acrylic on canvas 122 × 122 cm
The Artist

67　**P410** 1989
Inscribed l.r.: 'Cosgrove/89'
Acrylic on canvas 122 × 122 cm
The Artist

66

James Cowie 1886–1956

Cowie was born on a farm near the small hamlet of Cuminestown in Aberdeenshire. In 1906 he began studying for a degree in English literature at Aberdeen University but found himself increasingly attracted to the visual arts, eventually passing teacher-training examinations in drawing and becoming art master at Fraserburgh Academy in 1909. From 1912–14 he studied at GSA and was subsequently appointed art master at Bellshill Academy, near Glasgow, a post he was however unable to occupy for long as war had broken out. A conscientious objector, from 1916–18 he worked for the Pioneer Corps near Edinburgh. From 1918–35 he resumed teaching at Bellshill, where the pupils inspired many of Cowie's works. His exquisite line-drawing technique, coupled with a meticulous approach to detail and composition, marked Cowie out from the majority of his Scottish contemporaries who shared a preference for more painterly qualities. During the 1920s he showed paintings regularly at the annual exhibitions in Glasgow and Edinburgh but it was not until 1935 that he held his first one-man show, at the McLellan Galleries in Glasgow. That same year he was appointed Head of Painting at Gray's School of Art, Aberdeen, before becoming Warden of the Patrick Allan Fraser School of Art at Hospitalfield House, Arbroath, in 1937. He retired from a lifetime's teaching in 1948. The stiff formality of Cowie's paintings of the 1920s and 1930s, products of elaborate preparatory studies in the manner of the Old Masters, gave way in the 1940s to an interest in Surrealism. Paul Nash in particular inspired Cowie to take liberties with perspective and to incorporate picture-within-a-picture devices into his works to highly idiosyncratic effect. His passion for centralising compositions around plaster-cast figures, often enigmatically placed in landscapes, contains echoes not only of Nash, but also of de Chirico, and once again marks Cowie out as a painter of considerable individuality.

Bibliography

ACGB, Scottish Committee, *James Cowie, Memorial Exhibition* (exhibition catalogue 1957)
Richard Calvocoressi: *James Cowie*, Edinburgh 1979
Cordelia Oliver: *James Cowie*, Edinburgh 1980

68 **Portrait of the Artist's Daughter, Ruth** 1932–33
Inscribed b.r.: 'J. Cowie'
Oil on canvas 131 × 63.5 cm
The Artist's Daughter

[colour illustration page 63]

69 **Portrait Group** 1932/*c*.1940
Oil on canvas 101.6 × 127.3 cm
GMA 1325 (1975)

[colour illustration back cover]

70 **Study for Male Student**
(at right of Portrait Group)
Crayon, pastel and pencil on paper
56 × 33.7 cm
GMA 1326 (1975)

71 **Study for Portrait of Ruth** 1932
Pastel and pencil on paper
33 × 22.5 cm
The Artist's Daughter

72 **Reclining Nude with Crossed Arms**
Pastel and pencil on paper
53 × 36 cm
The Artist's Daughter

73 **Still Life with Jug**
Pencil on paper 29.5 × 34.3 cm
GMA 1329 (1975)

74 **Studio Still Life**
Pencil, crayon and chalk on paper
40.3 × 33 cm
GMA 1330 (1975)

75 **Student with Plaster Cast**
Inscribed u.r.: 'J. Cowie'
Crayon and chalk on paper
50.5 × 36.2 cm
GMA 1388 (1975)

75

Hugh Adam Crawford
1898–1982

Born in Busby, Lanarkshire, Crawford studied at GSA 1919–23 under Maurice Greiffenhagen and David Forrester Wilson. In 1924–25 he studied part-time at Central School of Arts and Crafts and St Martin's School of Art, London. He joined the staff of GSA in 1925. Crawford is remembered as a highly gifted teacher of such painters as Colquhoun, MacBryde, Merlyn Evans, and Eardley. In 1934 he married the artist Kathleen Mann, then Head of Embroidery at Glasgow. During the 1930s Crawford painted a series of strong portraits of his wife and friends, including Jack Coia the Glasgow architect. It was for Coia that he designed the exterior murals on the Roman Catholic chapel at Bellahouston and other mural work within the 1938 Glasgow Empire Exhibition. He was Head of Painting at Glasgow until 1948, Head of Gray's School of Art, Aberdeen 1948–54 and Principal of Duncan of Jordanstone College of Art, Dundee 1954–64. Crawford had a particular interest in the work of Piero della Francesca and Cézanne. The *Tribute to Clydebank* of 1941 meshes the quiet dignity of the former with the dynamic of the moment. Crawford's mural work included commissions for John Brown's shipyard and Scottish Brewers, Glasgow.

Bibliography

Glasgow Art Club: *Hugh Adam Crawford RSA* (retrospective exhibition catalogue 1971; Introduction by Emilio Coia)
SAC at ECA: *Painters in Parallel* (exhibition catalogue 1978; Introduction and Catalogue by Cordelia Oliver)
Glasgow, TEC: *Crawford and Company Selected Works 1928–1978* (exhibition catalogue 1978; Catalogue by Cordelia Oliver)

76 **Tribute to Clydebank** 1941
Inscribed b.r.: 'HUGH CRAWFORD/41'
Oil on canvas 107 × 213.5 cm
Royal College of Physicians & Surgeons of Glasgow

[colour illustration page 72]

William Crosbie b.1915

Crosbie was born in Hankow (China), where his father, a Scot, was employed as a marine engineer. In 1926 the family returned to Glasgow where William Crosbie passed exams in chartered accountancy and then spent several months working as a salesman. But he soon decided against a career in commerce and in 1932 entered GSA. In 1935 he was awarded a travelling scholarship enabling him to spend a year in Paris where he studied with Fernand Léger and took drawing lessons with the sculptor Aristide Maillol. During this period, Crosbie adopted a style clearly indebted to Léger and to French Surrealism. After Paris, he travelled extensively in Greece, Turkey and Egypt, only returning to Britain on the eve of war. For two years he served with the Merchant Navy, then acted as an ambulance driver for the Civil Defence. During the 1940s and 1950s Crosbie became best known as a mural artist, producing large-scale works for the 1938 Glasgow Empire Exhibition, Glasgow Police Headquarters (1940), Kelvinhall, Glasgow (1951) and many other public buildings. Since 1940 he has had many one-man exhibitions in Glasgow and Edinburgh, a major retrospective being held at the Scottish Gallery, Edinburgh, in 1980. Crosbie lived in Glasgow until 1979 when he moved to Petersfield in Hampshire. However, he still retains the use of a studio in Glasgow and spends several months of each year in Scotland.

Bibliography

Edinburgh, The Scottish Gallery: *William Crosbie* (exhibition catalogue 1980)

77 **Heart Knife** 1934
Inscribed b.l.: 'Crosbie '34'
Oil on canvas 60.3 × 43 cm
GMA 1714 (1978)

[colour illustration page 64]

78 **Machine and End** 1948
Inscribed b.l.: 'Crosbie'
Oil on board 23 × 102 cm
Ewan Mundy Fine Art, Glasgow

79 **Post Mortem**
Inscribed t.r.: 'Crosbie'
Oil on board 59.5 × 100 cm
Scottish Arts Council Collection

80 **Untitled**
Inscribed b.r.: 'Crosbie'
Gouache, watercolour and ink on paper 37.5 × 27.5 cm
Ewan Mundy Fine Art, Glasgow

79

William Crozier 1897–1930

Crozier was born in Edinburgh. From 1903–9 he attended George Heriot's School where he gained a bursary. A playground accident invalided him for nine months. On his recovery he worked for a time with the North British Rubber Company, but his condition made a career in business impossible. Crozier had always been interested in art and about 1915 he enrolled at ECA. An RSA student, he was awarded the Chalmers Bursary and ultimately a Carnegie Travelling Scholarship. This enabled him to travel to France and Italy. Like so many young Scottish artists he studied in Paris with André Lhote. With MacTaggart he made frequent winter visits to France and then travelled on to Italy, where, an Italian speaker, he studied both art and people. Crozier exhibited at the RSA from 1920 and the SSA from 1922. At the 1928 RSA exhibition he won the Guthrie Award, given to the most outstanding younger exhibitor, for *The Cello Player*, a rare figure piece. Also in 1928 his *From the Mound* was bought by the SMAA. He was elected ARSA in 1930.

William Crozier is best known for his landscapes of France and Italy, and in particular for his beautifully constructed, subdued views of Edinburgh. His talents also extended to etching and illustration. A haemophiliac, he died at the age of thirty-three. He was described in his *Scotsman* obituary as 'one of the best and most interesting of the younger school of Scottish painters. His achievement was definitely an individual one'. A gifted, scholarly and sensitive painter, he had a strong influence on the early career of William MacTaggart with whom he shared a studio in Frederick Street, Edinburgh.

Bibliography

Obituary: The Scotsman, 20 December 1930, p.10
Annual Report, RSA, Edinburgh 1930
H. Harvey Wood: *Sir William MacTaggart*, Modern Scottish Painters, Three, Edinburgh 1974

81 **Italian Landscape** 1927
Inscribed b.l.: 'CROZIER'
Oil on board 45.5 × 61 cm
Cyril Gerber Fine Art, Glasgow

82 **Edinburgh (from Salisbury Crags)** 1927
Inscribed b.r.: 'W. CROZIER'
Oil on canvas 71.1 × 91.5 cm
GMA 7 (transferred from NGS)

[colour illustration page 61]

83 **Landscape**
Inscribed b.l.: 'W. CROZIER'
Oil on canvas 41.2 × 45.7 cm
GMA 9 (Anna Blair Bequest to NGS 1952, transferred to SNGMA)

84 **The Slopes of Fiesole, Tuscany** 1930
Inscribed b.l.: 'W. CROZIER/30'
Oil on board 60 × 45 cm
The Fine Art Society plc

85 **Tuscan Landscape** 1930
Inscribed l.r.: 'W. CROZIER'
Oil on board 55 × 41 cm
The Fine Art Society plc

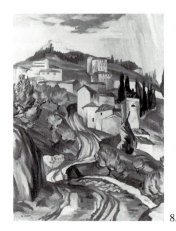

84

William Crozier b.1930

Crozier was born in Yoker, Scotland, and studied art at Glasgow School of Art from 1949–53. He then worked for two years as a theatre decorator. Since 1955 he has lived in Paris, Dublin, Malaga and London, and has taught at Bath Academy of Art, Corsham, Central School of Arts and Crafts, London and Winchester School of Art where he was Head of Fine Art until 1987. He retired to devote himself full-time to painting. In the late 1950s, Crozier developed a powerful abstract idiom loosely based on the study of landscape motifs. From 1957–70 the Drian Galleries, London, held eight one-man shows of his work and from 1959 Crozier's work featured in several one-man and group shows at Arthur Tooth & Sons, London, figuring alongside painters such as Appel, Jorn and Mathieu. Other exhibitions include those at RDG in 1968 and 1983, at the Serpentine Gallery, London in 1978 and at the Scottish Gallery, Edinburgh, in 1985. During the 1980s, Crozier has returned to more easily recognisable depictions of landscape, often employing a brightly coloured palette.

Bibliography

Interview, *Artlog* No.6, 1979, with I. Kirkwood
Edinburgh, The Scottish Gallery: *William Crozier, Paintings* (exhibition catalogue 1985)

86 **Burning Field, Essex** 1960
Inscribed b.r.: 'CROZIER '60'
Oil on hardboard 91.4 × 76.2 cm
GMA 816 (1962)

[colour illustration page 90]

Ken Currie b.1960

Born in North Shields to Scottish parents, Ken Currie moved with his family to Glasgow when just three months old. He studied social science at Paisley College of Technology from 1977–78 and then from 1978–83 attended GSA, where he studied painting under Alexander Moffat. He won several awards including a Cargill Scholarship in 1983 and a SAC Young Artists Bursary in 1985. At GSA he spent considerable time working on film productions and initially intended making a career in films: from 1983–85 he was film director/producer at Cranhill Community Arts Project, Glasgow. Currie's socialist convictions persuaded him that films could have more relevance to contemporary issues than could painting. But during 1985 he became disenchanted with the expense and problems involved in film-making and returned to painting, planning a major series of works which would chart key moments in Scottish labour history. Following the completion of *Glasgow Triptych* (1986, SNGMA) he was commissioned to paint a series of murals for The People's Palace in Glasgow. Between 1986–87 he executed the eight paintings which depict scenes from Scottish labour history beginning with the *Massacre of the Calton Weavers of 1787*, which was unveiled at the bicentenary of the event. In 1988 he was accorded solo exhibitions at TEC and at the Raab Gallery, Berlin. Inspired by the art of Léger, Rivera and the German Neue Sachlichkeit group, Currie has produced a substantial body of work demonstrating that a politically motivated art of Socialist Realism can be relevant in the 1980s.

Bibliography

Glasgow, TEC: *Ken Currie* (exhibition catalogue 1988; Text by Julian Spalding and the artist)

87 **Glasgow Triptych** 1986
1. **Template of the Future**
2. **The Apprentices**
3. **Young Glasgow Communists**
Each inscribed b.r.: 'Ken Currie'
Oil on canvas 1. 214 × 272.3 cm;
2. 217.6 × 277.8 cm;
3. 207 × 278.1 cm
GMA 3012 (1987)

[colour illustration of 1. page 107]

Stanley Cursiter 1887–1976

Born in Kirkwall, Orkney, he served an apprenticeship as a chromolithographic designer before embarking upon full-time study at ECA. He was an enthusiastic follower of Post-Impressionism and the Futurist works shown in London in 1912 and at SSA in 1913. As a response he painted a series of Futurist pictures in 1913. Sketchbooks of this period reveal Cursiter's fascination with the design of such compositions. This intellectual appreciation of design, style and technique was brought to the fore during his keepership at the SNPG and informed his subsequent pioneering work in art education and picture restoration as Director of the NGS from 1930–1948. Cursiter primarily painted oil and watercolour landscapes in the South of France and Orkney; society and group portraits; and executed a wide range of subjects through lithography. The foundation of a SNGMA was proposed by Cursiter as a means of stimulating new design and pride in Scottish art. He helped organise the major show of Scottish art at the RA in 1939 and during the war years mounted an adventurous series of exhibitions of child art and contemporary art from abroad at NGS. In 1948 he was appointed King's Painter and Limner in Scotland and retired from NGS to his native Orkney where he devoted himself to landscape painting and recording Orcadian life in articles. Cursiter wrote the following books: *Peploe: An Intimate Memoir of an Artist and his Work* (1947); *Scottish Art at the Close of the Nineteenth Century* (1949); *Looking Back: A Book of Reminiscences* (1974).

Bibliography

A. Eddington: 'The Paintings and Lithographs of Stanley Cursiter', *The Studio*, Vol.LXXXII, No.340, July 1921, pp.21–25
Stromness, Orkney, Pier Arts Centre: *Stanley Cursiter Centenary Exhibition* (exhibition catalogue 1987; Text by Howie Firth, William Hardie and Ian MacInnes)
Obituary: *The Scotsman*, 23 April 1976

88 **The Ribbon Counter** 1913
Inscribed b.r.: 'Stanley Cursiter 1913'
Oil on canvas 48 × 48 cm
Private Collection

89 **Princes Street on Saturday
Morning** 1913
Inscribed b.l.: 'Stanley Cursiter'
Oil on canvas 51 × 61 cm
James Holloway

90 **The Regatta** (or **The Yachting
Race**) 1913
Oil on canvas 60 × 50 cm
GMA 3034 (1987)

[colour illustration page 56]

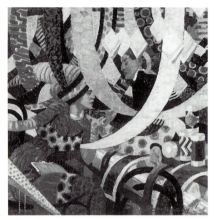

88

Alan Davie b.1920

Davie was born in Grangemouth into an
artistically minded family; his father was
a painter and etcher. He entered ECA in
1937 where he studied under John Max-
well. Davie complemented his facility for
painting with experiments in textile
design, pottery and jewellery-making. He
received the Guthrie Award at the RSA
in 1942. While serving in the Royal
Artillery from 1940 to 1946, his chief
concerns were writing poetry and, par-
ticularly, playing jazz, from which he
initially earned his living after the war.
His painting of the period, which brought
him his first one-man show in Grant's
Bookshop, Edinburgh in 1946, displayed
the influence of Klee and Picasso, and a
growing affinity for primitive art and
culture. In 1947 he married an artist-
potter, Janet Gaul, and accepting a
travelling scholarship from ECA,
embarked upon an extensive journey
through Europe. In Venice, he met Peggy
Guggenheim who, in addition to pur-
chasing one of his paintings, introduced

him to the early work of American
Abstract Expressionists, including Pol-
lock and Rothko. Returning to London in
1948, he concentrated on making and
selling gold and silver jewellery to
finance his experiments in paint and
other media. The first of his many one-
man shows at Gimpel Fils Gallery,
London occurred in 1950. During the
subsequent decade he attained consider-
able international acclaim, including
solo exhibitions in New York and at the
Whitechapel Art Gallery, London, in
1958. Between 1956 and 1959 he held
the Gregory Fellowship in Painting at the
University of Leeds. Davie's abstract
painting of the 1950s bears undoubted
parallels with contemporaneous develop-
ments in America (Pollock and Gorky)
and Europe (Jorn, Appel and
Alechinsky), with its expressionistic
handling of paint, bold use of colour and
complex subject-matter. However, what
distinguished Davie was a highly devel-
oped personal philosophy which viewed
art as a ritualistic process geared to the
attainment of spiritual enlightenment.
He expressed these ideas through an
elaborate range of symbols appropriated
from non-Western cultures: he had
become interested in Zen Buddhism and
oriental mysticism from the middle of the
1950s. Since the 1960s he has con-
solidated his international reputation –
he was awarded the prize for the best
foreign painter at the VII Bienal at São
Paulo, Brazil, in 1963, and the first prize
at the International Print Exhibition at
Cracow in 1966 – and has exhibited
extensively throughout the world. His
recent works are less expressionistic in
character and more formally coherent
with the pictographic symbols, now fre-
quently derived from Indian manuscripts
and mythology, more clearly delineated.
He lives in Hertfordshire, Cornwall and St
Lucia in the Caribbean.

Bibliography

Michael Horovitz: *Alan Davie*, London 1963
Alan Bowness: *Alan Davie*, London 1967
Edinburgh, RSA: *Alan Davie, Paintings* (exhibition
 catalogue 1972)
London, Gimpel Fils: *Alan Davie, Major Works of the
Fifties* (exhibition catalogue 1987)

91 **Jingling Space** 1950
Oil on board 122 × 152.5 cm
GMA 3308 (1987)

92 **Phantom** 1951
Oil on masonite 122 × 122 cm
The Artist

93 **Blue Triangle Enters** 1953
Oil on board 152.4 × 190.5 cm
The Artist

94 **Seascape Erotic** 1955
Oil on board 160 × 241 cm
GMA 1084 (1968)

[colour illustration page 83]

95 **Articulated Masks** 1956
Oil on board 152.5 × 122 cm
The Artist

96 **Woman Bewitched by the Moon,
No.2** 1956
Oil on board 152.5 × 122 cm
GMA 3309 (1987)

[colour illustration page 82]

93

95

Kenneth Dingwall b.1938

Born in Devonside, Clackmannanshire, Dingwall studied at ECA from 1955–59. He was Andrew Grant Post-Graduate Scholar from 1959–60, lived in Greece from 1961–62 and then took up a teaching post at ECA in 1963. From 1973–74 he was Visiting Professor at the Minneapolis College of Art and Design, USA and it was at this time that he made his first abstract colour-field paintings. Inspired by American painters such as Robert Ryman, Dingwall's paintings of the 1970s contain rich surface texture and subtle modulations of colour. During the mid-1970s he produced a series of small Minimalist wooden constructions which he painted a uniform colour. Dingwall has had solo exhibitions at the Scottish Gallery, Edinburgh in 1969, the Graeme Murray Gallery, Edinburgh 1977, the SAC Gallery, Edinburgh 1977, and at the Peter Noser Galerie, Zurich in 1987. In 1988 he was appointed Professor at the Cleveland Institute of Art, Ohio.

Bibliography

Edinburgh, SAC Gallery: *Kenneth Dingwall* (exhibition catalogue 1977)

97 **Grey Surface** 1979
Acrylic on canvas 160 × 213.5 cm
GMA 2135 (1980)

Michael Docherty b.1947

Born in Alloa, Docherty studied painting at ECA from 1964–68. He was awarded an Andrew Grant Scholarship in 1968 and spent the following year travelling in France and Spain. He began exhibiting in 1967 and held his first one-man show at RDG in 1970. Docherty has worked extensively with found objects – metal cans, buckets, wood – onto which he paints. The objects are chosen for their special relevance to a particular location (for example film-reel cans from New York) and form a kind of diary of Docherty's travels.

Bibliography

SAC: *Scottish Art Now* (exhibition catalogue 1982)

98 **An Object Fixed in Time** 1977
Wood, hardboard and plaster
54.5 × 40.5 × 5.7 cm
GMA 2013 (1978)

98

Pat Douthwaite b.1939

Born in Glasgow, Douthwaite began studying modern dance and mime with Margaret Morris in 1947. Morris's husband, the painter J. D. Fergusson, encouraged Douthwaite to paint, but otherwise she underwent no formal art education. In 1958 she held her first solo exhibition at the 57 Gallery in Edinburgh and later that year moved from Glasgow to Suffolk, where she joined a group of expatriate Scottish artists, including Crozier, Colquhoun and MacBryde. During the 1960s Douthwaite travelled widely in Europe, Africa and the Far East. In 1968 she returned to live in Scotland but subsequently settled in York. Since 1958 she has held numerous solo exhibitions in Britain, including a series of shows at RDG and retrospectives at the RCA, London in 1982 and at TEC in 1988. Douthwaite has worked extensively on series of paintings, such as those based on the aviator Amy Johnson and on the painter Gwen John. The tortured, twisted figures recall the works of Egon Schiele and evoke a similar sense of anguish and neurosis.

Bibliography

Glasgow, TEC: *Pat Douthwaite* (exhibition catalogue 1988)

99 **Death of Amy Johnson** 1976
Inscribed t.r.: 'Douthwaite 76'
Oil on canvas 152.5 × 152.5 cm
GMA 1645 (1977)

99

John Duncan 1866–1945

Born in Dundee, Duncan began evening studies at Dundee Art School from the age of eleven. He was a newspaper illustrator for the *Dundee Advertiser* and *The Wizard of the North* and went on to do similar work for three years in London. He studied in Antwerp and Düsseldorf and after a period in Dundee with George Dutch Davidson, he visited Rome, where he was profoundly influenced by Michelangelo and the Italian Primitives. Duncan then moved to Edinburgh where he became involved with the architectural schemes of the Celtic movement leader, Patrick Geddes. French Symbolism and the Pre-Raphaelites provided the iconography for *The Evergreen* magazine, Duncan's murals for Geddes's home at Ramsay Gardens and the adjacent Halls

of Residence. Duncan accompanied Geddes to the USA in 1899 and in 1902–4 he returned to teach art as an Associate Professor of Chicago University. He moved back to Edinburgh and his Torphichen Street home became a centre for Celtic Revival artists and intellectuals. Duncan executed large murals, oils and tempera paintings illustrating scenes from Celtic literature, history paintings, Symbolist compositions, Iona landscapes, church murals and stained glass.

Bibliography

Edinburgh, NGS: *John Duncan* (exhibition catalogue 1941; Essay by Stanley Cursiter)
Obituary: *The Scotsman*, 24 November 1945
London, Barbican Art Gallery: *The Last Romantics: The Romantic Tradition in British Art* (exhibition catalogue 1989; Essay 'Celtic Elements in Scottish Art at the Turn of the Century' by Lindsay Errington; Catalogue entry by John Christian)

100 **Sleeping Woman and Putto**
Inscribed b.l.: 'J.D.'
Watercolour and pencil on paper
23 × 35 cm
Private Collection (on loan to the SNGMA)

Joan Eardley 1921–1963

Born at Warnham, Sussex, Eardley was educated at Blackheath, Goldsmith's School of Art, London and GSA 1940–43 under Hugh Adam Crawford. In 1943 she graduated with the Diploma prize for drawing and painting and the prize for portraiture. Van Gogh, Vuillard and Bonnard influenced her early draughtsmanship and choice of domestic interiors. Henry Moore and early Italian Renaissance masters brought a sculptural weight and humanity to the figure compositions. Six months of 1947 were spent at the Patrick Allan-Fraser School of Art, Hospitalfield, near Arbroath, under the tutorship of James Cowie. In January 1948 she took up her post-Diploma scholarship at GSA, won the travelling scholarship, and was elected SSA. The sketches and compositions executed in France and Italy during 1948–49 were shown at her first solo exhibition at GSA upon her return in

1949. During the early 1950s Eardley worked among the run-down Glasgow tenements recording street life through photography and chalk sketches that were translated into larger works. In 1951 she began to paint the landscape and the sea at Catterline, a fishing village on the north-east coast of Scotland and five years later she took up semi-permanent residence there. The later gestural weather studies in chalk had much of the force of the Abstract Expressionists but never became totally abstract. The oils included collaged layers of earth and vegetation under thick sweeps of paint. Eardley was elected ARSA 1955 and in 1956 had a solo show at St George's Gallery in London. She was elected RSA in the spring of 1963 but died of cancer at Killearn Hospital, outside Glasgow, on 16 August 1963.

Bibliography

William Buchanan: *Joan Eardley*, Edinburgh 1976
Douglas Hall: *Joan Eardley: All the works in the collection*, Scottish Artists in the SNGMA, No. 3, Edinburgh 1979
Cordelia Oliver: *Joan Eardley RSA*, Edinburgh 1988
Fiona Pearson: *Joan Eardley 1921–1963*, Edinburgh 1988

101 **Street Kids** *c.*1949–51
Inscribed b.r.: 'JOAN EARDLEY'
Oil on canvas 101.6 × 73.7 cm
GMA 887 (1964)

102 **The Kitchen Stove** *c.*1950
Inscribed b.r.: 'EARDLEY'
Oil on hardboard 95.5 × 79 cm
GMA 2801 (1984)

103 **Sleeping Nude** 1955
Inscribed b.l.: 'EARDLEY'
Oil on canvas 73.7 × 152.4 cm
GMA 897 (Presented by Mrs Irene Eardley, 1964)

[colour illustration page 73]

104 **The Wave** 1961
Inscribed b.l.: 'JOAN EARDLEY'
Oil on board 121.9 × 188 cm
GMA 791 (1962)

[colour illustration page 89]

105 **Boats on the Shore** *c.*1963
Oil on hardboard 101.6 × 115.6 cm
GMA 1036 (R. R. Scott Hay Bequest, 1967)

106 **Italian Peasant Sitting on the Ground** 1948–49
Inscribed b.r.: 'JOAN EARDLEY'
Black chalk on paper
52.7 × 48.7 cm
GMA 2224 (1980)

107 **And Old Woman Sewing** *c.*1950
Black crayon on paper
56.1 × 44.3 cm
GMA 2024 (1978)

108 **Two Seated Children**
Black chalk, pastel and watercolour on paper 30 × 17.3 cm
GMA 3193 (Presented by the artist's sister, Mrs P. M. Black, 1987)

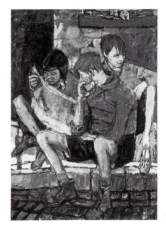

101

David Shanks Ewart

1901–1965

Ewart was born in Glasgow. He spent a year in business before going to GSA, where he studied under Maurice Greiffenhagen and F. H. Newbery. He graduated in 1924 with a Diploma and a travelling scholarship, which he used to study in Italy and France. He returned to Glasgow in 1926 and made considerable impact in the GI exhibition of that year with his painting *The Emigrants*. He exhibited regularly at the RSA (where he won the Guthrie Award in 1926 and the Lauder Award in 1927), at the GI, and also occasionally at the RA. He was made an ARSA in 1934. He lived all his life in Glasgow, but from 1946 until his

death spent several months of each year in the USA painting portraits of American industrialists and their wives.

109 **The Return** 1927
Inscribed b.r.: 'DAVID S. EWART 1927'
Oil on canvas 127 × 76.5 cm
GMA 2222 (1980)

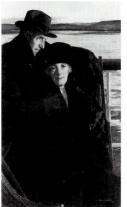

109

John Duncan Fergusson

1874–1961

Fergusson was born in Leith, educated at the Royal High School, Edinburgh and Blair College, Linlithgow. He abandoned medical studies in order to devote himself to painting. Encouraged by the example of Whistler and the Glasgow Boys, Fergusson made regular visits to Paris from the mid-1890s, where he studied the Impressionists and frequented the life-classes at the Académie Colarossi. S. J. Peploe shared some of his painting vacations in Scotland and France. Fergusson also visited Spain and Morocco. His first solo exhibition was at the Baillie Galleries, London in 1905. Two years later Fergusson settled in Paris where he painted in the Fauve manner, taught at the Académie de la Palette and was befriended by Dunoyer de Segonzac. In 1908 he began to sculpt, carving directly in wood and stone, in a Cubist manner. John Middleton Murry and Michael Sadler appointed Fergusson visual arts editor of *Rhythm* in 1911 and the arts journal bore a design based upon his female nude composition of the same

title. Fergusson was inspired by contemporary dance and music in Paris and sought to emulate the sense of vitality, movement and sensuous line through a series of nude studies. Four works were shown at the *Post-Impressionist and Futurist Exhibition* at the Doré Galleries, London, in 1913, the year that he met the dancer, Margaret Morris, later to become his wife. They moved to London from Antibes at the outbreak of war and in 1918 Fergusson undertook a series of studies of ships and submarines at Portsmouth. In 1923 he had his first solo exhibition in Scotland and in 1924 and 1925 was shown with Peploe, Hunter and Cadell in Paris and London. In 1926 and 1928 Fergusson was shown in New York. The French government purchased a painting from the exhibition *Les Peintres Ecossais* at Galerie Georges Petit, Paris, 1931. During the 1930s Fergusson was President of the Groupe des Artistes Anglo-Américains in Paris. In 1939 he moved to Glasgow and was a founder-member of the New Art Club in 1940, from which emerged the New Scottish Group in 1942. He was art editor of *Scottish Art and Letters* and author of *Modern Scottish Painting* (1943). His first retrospective exhibition opened in Glasgow in 1948.

Bibliography

SAC: *J. D. Fergusson, Memorial Exhibition* (exhibition catalogue 1961; Text by A. Maclaren Young)
Margaret Morris: *The Art of J. D. Fergusson*, Glasgow 1974
SAC: *Colour, Rhythm and Dance. Paintings and drawings by J. D. Fergusson and his circle in Paris* (exhibition catalogue 1985; Essays by Elizabeth Cumming, Sheila McGregor and John Drummond)

110 **Bar at Public House** *c.*1900
Oil on canvas 31.7 × 23.4 cm
University of Stirling

111 **Self Portrait** *c.*1902
Oil on canvas 50.8 × 56.4 cm
Scottish National Portrait Gallery

112 **Jean Maconochie**
Oil on canvas 61 × 50.5 cm
Robert Fleming Holdings Limited

113 **Dieppe, 14 July 1905: Night** 1905
Oil on canvas 76.8 × 76.8 cm
GMA 1713 (1978)

[colour illustration front cover]

114 **La Terrasse, le Café d'Harcourt**
*c.*1908–9
Oil on canvas 108.6 × 122 cm
Private Collection

[colour illustration page 54]

115 **Twilight Royan** 1910
Oil on board 26 × 34 cm
GMA 1897 (Dr R. A. Lillie Bequest, 1977)

116 **Rhythm** 1911
Oil on canvas 162.8 × 114.3 cm
University of Stirling

117 **Damaged Destroyer** *c.*1918
Oil on canvas 73.6 × 76.2 cm
Glasgow Museums and Art Galleries

118 **Portsmouth Docks** 1918
Oil on canvas 76.2 × 68.6 cm
University of Sterling

[colour illustration page 57]

119 **Eastre (Hymn to the Sun)** 1924
Polished brass 43 × 21 × 23 cm
GMA 1263 (1972)

120 **In the Patio: Mrs Margaret Morris Fergusson** 1925
Oil on canvas 71 × 61 cm
GMA 3352 (Mr and Mrs G. D. Robinson Bequest, through the NACF, 1988)

121 **The Log Cabin Houseboat, Bourne End** 1925
Oil on canvas 76.2 × 66 cm
GMA 974 (1966)

119

122 **Tin Openers** c.1918–20
Conté crayon and watercolour on
paper 48 × 35 cm
GMA 1351 (1974)

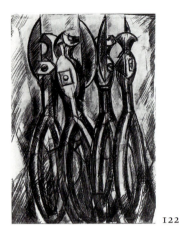

122

Ian Hamilton Finlay b.1925

Finlay was born in the Bahamas to Scot-
tish parents. The family returned to Scot-
land when he was a child. Following a
brief period at GSA, Finlay was called up
and saw service in Germany. After the
war he became a shepherd in the
Orkneys, took a variety of agricultural
labouring jobs and in the 1950s began
writing short stories, poems and plays
(some were published in *The Glasgow
Herald* and others broadcast by the BBC).
By the late 1950s his poems were becom-
ing increasingly formal, being concerned
with the sound and shape of individual
words rather than with constructing
meaning through sentences. His poems
of the early 1960s, some of which con-
tain only one word, have since been
hailed as forerunners of 'concrete'
poetry. In 1961, Finlay and Jessie
McGuffie founded The Wild Hawthorn
Press with the aim of publishing works
by contemporary artists and writers.
From 1962–68 the Press issued a period-
ical *Poor. Old. Tired. Horse* as a forum for
debate on contemporary art and liter-
ature. In 1966, he and his wife Sue

Finlay, whom he had met in 1964,
moved into an isolated farmhouse at
Stonypath near Dunsyre in the Pentland
Hills and over the years, transformed the
garden (they later renamed it 'Little
Sparta') into a living homage to the
classical tradition. Bristling with sculp-
tures and stone inscriptions, it is con-
ceived as an antidote to the mainstream
Modern Movement or, as Finlay has put
it, 'Certain gardens are described as
retreats when they are really attacks'.
Finlay's interest in classical and
neo-classical imagery has found form
during the 1970s and 1980s in sculp-
tures, drawings and posters which play
on the metaphorical potency of classical
iconography, often in unusual and ambi-
guous ways. He has frequently combined
the imagery of the French Revolution
and Nazi symbolism (both extreme
examples of classicism) within the con-
text of Arcadian nature to provide an
equivocal interpretation of the forces of
Terror. Much of Finlay's *œuvre* aspires to
a dead-pan 'style-less' quality and is
executed by various collaborators. He
has become a highly controversial figure
in the art world, provoking both commit-
ted support and heavy-handed criticism.
He has woven this breadth of response
into his art, the written explanations and
justifications assuming an important part
in the meaning of the work, and forming
part of an overall anti-establishment
strategy. Finlay has had many one-man
shows, including those at the SNGMA in
1972 and at the Serpentine Gallery,
London in 1977.

Bibliography

Cambridge, Kettle's Yard: *Ian Hamilton Finlay: Col-
laborations* (exhibition catalogue 1977)
Francis Edeline: *Ian Hamilton Finlay*, Paris 1977
Christopher McIntosh: *Coincidence in the work of Ian
Hamilton Finlay*, Edinburgh 1980
Yves Abrioux: *Ian Hamilton Finlay: A Visual Primer*,
Edinburgh 1985

IAN HAMILTON FINLAY (with Sue
Finlay, Nicholas Sloan, Dave Pater-
son and Wilma Paterson)

123 **Nature Over Again After
Poussin** 1979–80
11 black and white photographs,
each in halves mounted separately
on perspex.
Accompanying flute music
Each half print: 49.5 × 29.2 cm
GMA 2293 (1981)

IAN HAMILTON FINLAY (with
Edward Wright)

124 **Star/Steer** 1966
Screenprint 56.9 × 44.3 cm
GMA 1484 (1975)

IAN HAMILTON FINLAY

125 **Seams** 1969
Screen print 43.5 × 56.2 cm
GMA 1386 (1975)

IAN HAMILTON FINLAY (with Jim
Nicholson)

126 **Homage to Modern Art** 1972
Screenprint 76.2 × 53.9 cm
GMA 1357 (1975)

[colour illustration page 94]

EX. CAT.
IAN HAMILTON FINLAY (with John
Andrew)

Et in Arcadia Ego 1976
Stone 20 × 28 × 7.5 cm
GMA 1583 (1976)

[colour illustration page 95]

Ian Fleming b.1906

Born in Glasgow, Fleming attended GSA
from 1924–29. He studied lithography
and colour woodcut with Chika Macnab,
as his craft options. His post-Diploma
studies of 1928–29 consisted of engrav-
ing in the studio of Charles Murray. The
first three months of a travelling scholar-
ship were spent in London at the RCA
with Robert Sargent Austin and Malcolm
Osborne, copying Dürer. Fleming then
continued his travels to Paris, the South
of France and Spain. Upon his return in
1931 he completed his important line-
engraving *Gethsemane* which was later
purchased by the French government.
He taught at GSA from 1931–48 and
began etching c.1935. Fleming moved
from factual landscape engraving to a
more atmospheric use of drypoint. He
was a permanent member of the Council
of the Society of Artist-Printmakers and
took sketching trips within Scotland with
fellow member William Wilson, both
men working in the landscape and com-
pleting their compositions from memory.
Elected ARSA in 1947, Fleming taught

at Hospitalfield 1948–54. As Principal of Gray's School of Art, Aberdeen from 1954–72 Fleming developed printmaking in the Design and Fine Art Departments. A watercolourist and printmaker, Fleming has consistently experimented in his landscapes with the juxtaposition of light and shade, views into the sun and sweeping arcs of light. In the 1970s he began the mixed-media print series of *Creation* and *Comment* which introduced texts into semi-abstract compositions reflecting the human dilemma. Fleming was elected RSA in 1956 and was appointed Chairman of Peacock Printmakers in 1974. He continues to be active within both organisations.

Bibliography

Aberdeen Art Gallery: *Great Scottish Etchers* (exhibition handsheet 1981; Introductory text by Ian Fleming, Catalogue by Anne Whyte)
Aberdeen Art Gallery: *Ian Fleming: Graphic Work* (catalogue of a Peacock Printmakers exhibition 1983; Autobiographical Essay by the Artist)

127 **The Two Roberts** 1937–38
Inscribed b.l.: 'Ian Fleming. 38'
Oil on canvas 102 × 125 cm
Glasgow School of Art

128 **Gethsemane** 1931
Inscribed b.r.: 'Ian Fleming'
Engraving 48.2 × 37 cm
GMA 2545 (1982)

129 **Glasgow School of Art**
Inscribed b.r.: 'Ian Fleming' and b.l.: 'Glasgow School of Art'
Etching 37.9 × 28.5
GMA 2835 (1984)

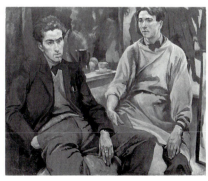

128

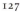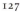

127

Frank Morley Fletcher

1866–1949

Born at Whiston in Lancashire, Fletcher studied art at the Atelier Cormon in Paris. He exhibited at the principal London galleries from 1888, also at the Paris Salons and in the USA. He was a member of the Council of International Society of Sculptors, Painters and Gravers, 1903–09. Fletcher first came to prominence as Head of the Art Department of University College, Reading, 1898–1906, where he trained E. S. Lumsden. Fletcher painted portraits but his main concern was the promotion of colour wood-block printing in the Japanese manner. He taught this process at ECA from his appointment as Director in 1908. His staff included the etchers Lumsden and Mabel Royds who also taught colour woodcut. In 1916 Fletcher published *Wood-block Printing*. He left Edinburgh for California in 1923 and became a naturalised American citizen in 1926.

Bibliography

Grant M. Waters: *Dictionary of British Artists working 1900–1950*, Eastbourne 1975
London, Garton and Cooke: *British Colour Woodcuts and Related Prints* (exhibition catalogue 35, Spring 1986)

130 **Girl Reading**
Inscribed b.r.: 'Morley Fletcher'
Coloured woodcut 24.7 × 20.6 cm
GMA 266 (transferred from NGS)

Annie French 1872–1965

Born in Glasgow, Annie French studied at GSA under F. H. Newbery. Her book illustrations, greetings-card designs and pen and watercolour compositions upon vellum were similar in their art nouveau style to the work of her near contemporary, Jessie M. King. Annie French took over King's post in the GSA Department of Design in 1909. In 1914 she married the artist George Wooliscroft Rhead (1854–1920) and settled in London. The SNGMA holds an illustration for Christina Rossetti's poem 'Goblin Market', two fairy-tale studies and a drawing of Princess Melilot of 1941, all presented by Stanley Cursiter.

Bibliography

London, Barbican Art Gallery: *The Last Romantics: The Romantic Tradition in British Art* (exhibition catalogue 1989; Catalogue entry by John Christian)

131 **The Ugly Sisters**
Inscribed b.r.: 'ANNIE FRENCH'
Pen and watercolour heightened with gold on vellum
23.5 × 21.5 cm
GMA 708 (Presented by the Artist to NGS 1943, transferred to SNGMA)

131

William Gear b.1915

Gear was born in Methil, Fife and attended ECA from 1932–36. He subsequently won a scholarship to study history of art at the University of Edinburgh from 1936–37 and then spent a year travelling in Europe, studying with Fernand Léger in Paris for several months. On his return to Scotland in 1938, he enrolled at Moray House Training College, Edinburgh and exhibited his works for the first time at the RSA and SSA. In 1940, Gear joined the Royal Signals Corps and travelled widely in Europe and the Middle East, occasionally finding time during his Army work to paint and exhibit, holding one-man shows in Siena and Florence in 1944. From 1946–47 he worked in Germany with the Monuments, Fine Arts and Archives Section of the Central Commission for whom he mounted exhibitions, including one of *Modern Prints* confiscated by the Nazis from the Berlin museum. He befriended the artist Karl Otto Götz and they both later became members of the COBRA movement. This group, which was officially formed in 1948, linked artists of the Northern European countries who had a common interest in informal abstraction and folk art. Following a one-man exhibition in Hamburg in 1947, Gear moved to Paris where he remained until 1950. He became a leading member of the Ecole de Paris, alongside such artists as Atlan, Soulages and Poliakoff. He developed a style using bright colours and strong compositional black lines, producing works which are often close to stained-glass designs. Although often untitled and apparently abstract, many of the paintings of this period were based on landscapes, figures and plants. Gear exhibited extensively at the Paris Salons and in 1948 had one-man shows at the Galerie Arc en Ciel in Paris and at Gimpel Fils in London. He participated in several of the major COBRA exhibitions, including the 1949 show in Amsterdam and the 1951 show in Luik. In 1950, Gear settled in England, first in Buckinghamshire before moving to Kent. Amid great controversy, an abstract work Gear exhibited at the 1951 Festival of Britain was awarded a major Purchase Prize. During the 1950s and the 1960s he had several one-man exhibitions in Britain

and participated in many major group shows on the continent. The expressive works of the late 1940s gave way to more delicately composed works in the 1950s. From 1958 he was Curator of the Towner Art Gallery, Eastbourne before being appointed Head of Fine Art at Birmingham College of Art in 1964. He still lives and works in Birmingham. For some years, Gear fell into relative obscurity, but recent retrospective exhibitions in Paris, London, Edinburgh and Munich have highlighted the significant contribution he made to European abstract painting.

Bibliography

London, Gimpel Fils Gallery: *William Gear* (exhibition catalogue 1961)
ACNI: *William Gear: Paintings 1948–68* (exhibition catalogue of touring show 1968)
Paris, Galerie 1900–2000: *William Gear: Cobra Abstractions 1946–1949* (exhibition catalogue 1988)
Munich, Karl & Faber: *William Gear* (exhibition catalogue 1988)

132 **Landscape March 1949** 1949
Inscribed b.r.: 'Gear 49'
Oil on canvas 73.7 × 92.7 cm
GMA 1300 (1974)

133 **Interior Aug. 1949** 1949
Oil on canvas 73 × 60 cm
GMA 3297 (1987)

134 **Coucher du Soleil Jan.-Feb. 1950** 1950
Oil on canvas 54 × 73 cm
GMA 3298 (1987)

135 **Autumn Landscape Sept. 1950** 1950
Inscribed b.r.: 'Gear 50'
Oil on canvas 97.2 × 69 cm
GMA 1301 (1974)

[colour illustration page 78]

136 **Marine Finistère No.2. August 1950** 1950
Oil on canvas 65.4 × 54.6 cm
GMA 3299 (1987)

137 **Autumn Landscape** 1951
Inscribed b.c.: 'Gear 50'
Oil on canvas 183.2 × 127 cm
Laing Art Gallery, Newcastle upon Tyne (Tyne and Wear Museums Service)

138 **White Interior Dec. 1954** 1954
Inscribed b.r.: 'Gear '54'
Oil on canvas 81.3 × 100.3 cm
GMA 890 (1964)

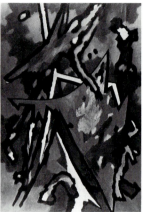

137

William Gillies 1898–1973

Gillies was born in Haddington, East Lothian. He attended ECA for two terms in 1916 before being called up for war service. Gillies resumed his studies at the College of Art in 1919 and in 1922 was one of the founder members of the 1922 Group, a number of young artists who exhibited together in Edinburgh from 1923–28. A travelling scholarship awarded in 1924 enabled him to study for one year in Paris with the Cubist painter André Lhote. On his return, Gillies taught art for a year at Inverness Academy, but took up a post at ECA the following year. He would remain on the staff there for the next forty years, becoming Head of Painting in 1946 and Principal in 1960, only retiring in 1966. From 1925 Gillies adopted a Cubist idiom based on Lhote's, but gradually shrugged this off, turning instead to a more naturalistic treatment in his paintings of still lifes and Scottish landscapes. The Munch retrospective held in Edinburgh in 1931 affected his work, provoking an expressionist use of brushwork and colour. Towards the end of the 1930s the more controlled styles of Bonnard and Braque surfaced in Gillies's painting:

forms were simplified and the perspective in his still lifes tipped up to give geometry to the compositions. In 1939 Gillies moved from Edinburgh to the village of Temple (Midlothian) where the surrounding landscape furnished the principal motifs of his post-war work. He was elected to the RSA in 1947 and knighted in 1970. In 1963 he was made President of the RSW; much of Gillies's freshest work from the 1920s onwards was done in this medium. His first one-man show came in 1948 at the French Institute in Edinburgh, and a major touring retrospective exhibition organised by the SAC was held in 1970. Much of Gillies's output was bought by Dr R. A. Lillie who bequeathed some 300 pictures to the NGS; most of these are now in the SNGMA collection.

Bibliography

SAC: *W. G. Gillies: Retrospective Exhibition* (exhibition catalogue 1970)

T. Elder Dickson: *W. G. Gillies*, Edinburgh 1974

SAC: *William Gillies and the Scottish Landscape* (exhibition catalogue 1980)

139 **Near Durisdeer** *c.*1932
Inscribed b.r.: 'W. Gillies'
Oil on canvas 63.4 × 76 cm
GMA 1747 (Dr R. A. Lillie Bequest, 1977)

140 **Poppies and Cretonne Cloth** 1937
Oil on canvas 100 × 80 cm
GMA 1820 (Dr R. A. Lillie Bequest, 1977)

141 **The Harbour** *c.*1938
Inscribed b.r.: 'W. Gillies'
Oil on canvas 76.5 × 91.5 cm
GMA 1766 (Dr R. A. Lillie Bequest, 1977)

142 **Still Life with Breton Pot** 1942
Inscribed t.r.: 'W. Gillies'
Oil on canvas 74.5 × 89 cm
GMA 1840 (Dr R. A. Lillie Bequest, 1977)

[colour illustration page 68]

143 **The Peebles Train** 1950s
Inscribed b.r.: 'W. Gillies'
Oil on canvas 46 × 57 cm
GMA 1811 (Dr R. A. Lillie Bequest, 1977)

144 **Fields and River** *c.*1959
Inscribed b.r.: 'W. Gillies'
Oil on canvas 63 × 86 cm
GMA 1755 (Dr R. A. Lillie Bequest, 1977)

145 **On the Tyne, The Long Cram, Haddington** 1927
Inscribed b.r.: 'W. Gillies 1927'
Watercolour on paper
40.8 × 48.7 cm
GMA 1765 (Dr R. A. Lillie Bequest, 1977)

146 **Skye Hills from Near Morar** *c.*1930
Watercolour on paper 38 × 56 cm
GMA 1833 (Dr R. A. Lillie Bequest, 1977)

147 **A Pool** 1932
Inscribed b.l.: 'W. Gillies'
Watercolour and black chalk on paper 27.7 × 38 cm
GMA 1819 (Dr R. A. Lillie Bequest, 1977)

148 **The Dark Pond** *c.*1934
Inscribed b.l.: 'W. Gillies'
Watercolour on paper
50.5 × 63.5 cm
GMA 1818 (Dr R. A. Lillie Bequest, 1977)

149 **In Ardnamurchan** *c.*1936
Inscribed b.r.: 'W. G. Gillies'
Watercolour on paper 51 × 63 cm
GMA 1723 (Dr R. A. Lillie Bequest, 1977)

[colour illustration page 66]

150 **Suilven, Wester Ross** 1937
Inscribed b.r.: 'W. G. Gillies 1937'
Watercolour on paper
50.7 × 63.4 cm
GMA 1856 (Dr R. A. Lillie Bequest, 1977)

151 **March, Moorfoot** 1951
Inscribed b.r.: 'W. Gillies 1951'
Black wash on paper 61.5 × 52 cm
GMA 1806 (Dr R. A. Lillie Bequest, 1977)

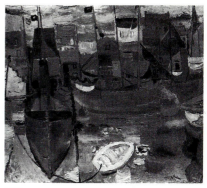

141

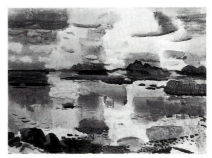

146

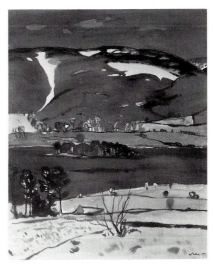

151

Alan Gouk b.1939

Born in Belfast, Alan Gouk moved to
Glasgow in 1944 and from 1957–59
studied architecture part-time at GSA;
he also began work as an architect's
assistant. Between 1959–60 he lived in
London, studying architecture, again
part-time, at Regent Street Polytechnic
while also working in the architecture
department of the LCC. Gouk returned to
Edinburgh to read psychology and phil-
osophy at the University from 1961–64.
He only began painting in 1961, evolv-
ing a style indebted to American Abstract
Expressionism, especially to the paintings
of Hans Hofmann. From 1964–67 he
worked as Fine Arts Exhibition Officer for
the British Council and it was only in
1967 when he was appointed Lecturer at
St Martin's School of Art, London that he
could devote himself fully to painting.
During the 1970s, Gouk was one of a
number of painters e.g. Gillian Ayres,
John McLean, Geoff Rigden, whose
central concern was the physical quality
of the paint itself – its consistency and the
ways in which brushstrokes abutted or
bled into one another. From the mid-
1970s he abandoned acrylics for oils,
using increasingly thick, creamy paint.
By 1981 the brushstrokes were broad
and linear and the paint a heavy
impasto. Gouk has explained that 'in
physical terms the thing I hate most in
painting is flatness'. He lives in London
where he is Head of Advanced Painting
and Sculpture at St Martin's School of
Art. Gouk has also written extensively in
contemporary art journals.

Bibliography

Edinburgh, FMG: *Four Abstract Artists* (exhibition
 catalogue 1977)
London, Smith's Galleries: *Alan Gouk* (exhibition
 catalogue 1986)

152 **Sun, Waning Moon, under
 Venus** 1988
 Oil on canvas 198 × 480 cm
 The Artist

Gwen Hardie b.1962

Hardie was born in Fife and from 1979–
84 studied painting at ECA. In 1984 and
1985 she won DAAD scholarships to
study in West Berlin where she still lives.
In her first months there she received tui-
tion from Georg Baselitz who encouraged
her to change from a studied, precise
depiction of the human figure to a more
liberated, dynamic representation.
Hardie produced a series of works based
on analysis of elements of her own body:
her hands, head and breasts. These were
large paintings in which the paint was
applied with a sponge in a conscious
effort to hinder bravura technique and
concentrate instead on bold surface and
colour effects. *Venus with Spikes* of 1986
signalled a radically new approach in
Hardie's work, in which the female form
is schematically represented as a trans-
parent shape inhabited by primary bodily
organs. These large, colourful works
were exhibited in 1987 at a major solo
exhibition at FMG which followed pre-
vious exhibitions at Main Fine Art,
Glasgow (1984) and the Paton Gallery,
London (1986). Hardie's work also fea-
tured in the group exhibition *The
Vigorous Imagination* at the SNGMA in
1987.

Bibliography

Edinburgh, FMG: *Gwen Hardie: Paintings and Draw-
ings* (exhibition catalogue 1987)

153 **Self Portrait V** 1984
 Oil on paper 96.5 × 76.2 cm
 Private Collection

154 **Fist** 1986
 Oil on canvas 158 × 220.5 cm
 GMA 3038 (1987)

 [colour illustration page 109]

John Houston b.1930

Born in Buckhaven, Fife, John Houston
studied at ECA from 1948–54. Munch
had a great influence on his early work,
and he much admired the work of
Morandi and Sironi in Italy when he was
awarded a travelling scholarship in

1953–54. On his return to Edinburgh he
joined the staff of ECA where he still
teaches. In 1956 he married fellow
student Elizabeth Blackadder, and with
her has travelled widely to keep in touch
with art developments throughout the
world. In 1957 he helped to start the 57
Gallery, Edinburgh and held his first one-
man show there in 1958. In 1964 he
was elected ARSA, and also won the
Guthrie Award at the RSA and the
Cargill Prize at the GI. A member of the
RSSPW and the SSA he was elected
RSA in 1972. He has had solo shows at
the Scottish Gallery, Edinburgh since
1960 and at the Mercury Gallery,
London since 1966, among many others.
He has taken part in mixed exhibitions
throughout Scotland, in London, Nice,
Warsaw, New York, Canada and Japan.
He lives in Edinburgh. A powerful colour-
ist, there is an affinity with Nolde in
Houston's atmospheric landscapes, evok-
ing the effects of light and weather over
vast areas of water and sky.

Bibliography

SAC/WAC: *Edinburgh Ten 30. The work of ten Edin-
 burgh artists 1945–75* (exhibition catalogue 1975)
Cardiff, Oriel 31: *The Scottish Show* (exhibition cata-
 logue 1988: Text by James Holloway and Duncan
 Macmillan)

155 **Village under the Cliffs** 1962
 Inscribed b.r.: 'John Houston 1962'
 Oil on canvas 152.5 × 183 cm
 *Private Collection (on loan to the
 SNGMA)*

 [colour illustration page 85]

Peter Howson b.1958

Born in London, Howson moved to Scot-
land in 1962 at the age of four. From
1975–77 he attended GSA before taking
various jobs (including a period in the
Scottish Infantry) and travelling in
Europe. From 1979–81 he resumed his
studies at GSA. In 1981 Howson shared
an exhibition with Scott Kilgour at the
Speakeasy Gallery in Edinburgh and
participated in exhibitions at the 369
Gallery, Edinburgh and at Valar Fine Art
Gallery in Glasgow. From 1982–83 he
executed a series of murals at the Fel-

tham Community Association, London, in which he portrayed aspects of contemporary life. In the bold use of black contour, the bright colouring and the socially involved subject-matter, these works recall Orozco, Beckmann and Léger. In 1985, Howson was Artist-in-Residence at the University of St Andrews and from this date he exhibited widely throughout Britian, with paintings included in the major group shows *New Image Glasgow* (TEC 1985) and *The Vigorous Imagination* (SNGMA 1987). His work chronicles Glasgow's working-class male population, an overtly masculine world of footballers, boxers, body-builders and pub-goers. This vividly Glaswegian imagery is given theatrical quality through Howson's frequent depiction of dark settings illuminated by strong artifical light, evoking a sense of both melancholy and irony.

Bibliography

London, Feltham Community Association: *Wall Murals* (exhibition catalogue 1982; Text by D. Howell)
London, Angela Flowers Gallery: *Peter Howson* (exhibition catalogue 1987; Text by Waldemar Januszczak)

156 **Heroic Dosser** 1987
Oil on canvas 213.5 × 213.5 cm
GMA 3460 (Presented anonymously through the British American Arts Association, 1989)

[colour illustration page 106]

157 **Heroic Dosser** 1986
Inscribed b.r.: 'HOWSON '86'
Monotype with crayon and oil on paper 104.5 × 75.7 cm
GMA 3013 (1987)

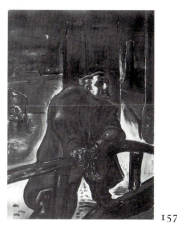

157

Ian Hughes b.1958

Born in Glasgow, Hughes attended Duncan of Jordanstone College of Art, Dundee from 1976–80. From 1981–87 he worked with the mentally ill, initially in the Art Therapy Department at Stobhill Hospital, Glasgow and from 1983 at the Royal Edinburgh Psychiatric Hospital. The experience gained in the company of the patients has powerfully affected Hughes's work which evokes despair, agony and pain. His first solo exhibition came in 1985 at the 369 Gallery, Edinburgh where he showed *The Anatomy Lesson*, an installation of paintings and a mock operating table. In 1987 an exhibition of Hughes's paintings based on a photograph of Franz Kafka took place at the same gallery and that year he also featured in the exhibition *The Vigorous Imagination* held at the SNGMA. In June 1988 he began a nine-month period as Artist-in-Residence at the SNGMA which was followed in February 1989 by an exhibition of works produced during his residency. These haunting new works comprised large oil paintings and also a series of greatly enlarged photographs (some of mental patients, some of himself) which Hughes had over-painted to dramatic effect. In the paintings he painstakingly reproduced elements from Old Master pictures which were then half-obliterated with gushing blood-like paint. Additionally, he produced a series of boxes containing photographs culled from medical textbooks, combined with religious imagery and glutinous paint. While being deeply distressing and shocking, Hughes's work has, nonetheless, a profoundly human resonance. During 1989, he has exhibited in France, Germany and Poland and has had works acquired by several major museums.

Bibliography

Edinburgh, 369 Gallery: *Kafka: Paintings from Photographs* (exhibition catalogue 1987)
Edinburgh, SNGMA: *Ian Hughes: Works 1988* (exhibition catalogue 1989)

158 **Apperception I** 1987
Inscribed b.r.: 'Ian Huges 87'
Oil on canvas 153 × 153 cm
GMA 3048 (1987)

159 **General Paralysis of the Insane** 1988
Oil on photograph on board
132.2 × 122 cm
Private Collection

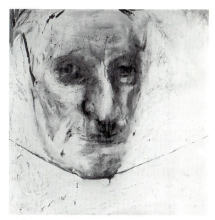

158

George Leslie Hunter

1879–1931

Hunter's family emigrated to California from his native Rothesay in 1892, leaving the young Hunter in San Francisco upon their return to Scotland in 1899. His natural gift for draughtsmanship gained him employment as an illustrator. He worked a passage east and across to Paris in 1904, acknowledged the importance of Post-Impressionist developments and foresaw the end of the illustrative tradition of his heroes Steinlen and Forain. Upon his return to San Francisco in 1906, Hunter amassed paintings and studies for his first solo exhibition but everything was destroyed in the great earthquake. He returned to Glasgow within the year and continued his self-education as a fine artist. Alexander Reid became Hunter's dealer and gave him his first solo exhibition in 1913, in Glasgow. He worked in Lanarkshire during the war as a farm labourer. At this time Whistler, McTaggart, Cézanne, Van Gogh and Gauguin were his mentors in their use of light, colour, line and form. The exploration of these qualities dominated Hunter's mature work. His deep

appreciation of the work of Matisse was expressed in the still lifes, portraits and Loch Lomond houseboat studies of his last decade. The largest part of his output remained his pen and ink sketches. He showed with Peploe and Cadell at the Leicester Galleries, London in 1923 and they were joined by Fergusson for the group exhibitions of 1924 at the Galerie Barbazanges, Paris and 1925 at the Leicester Galleries, London. Hunter's first solo show in London was in 1928 at Reid and Lefevre and in 1929 he also showed at the Ferargil Galleries, New York. At the Galerie Georges Petit, Paris group exhibition of 1931, *Les Peintres Ecossais*, the French government purchased a Loch Lomond picture. His planned move to London from Glasgow in 1932 never took place.

Bibliography

T. J. Honeyman: *Introducing Leslie Hunter*, London 1937

T. J. Honeyman: *Three Scottish Colourists, S. J. Peploe, F. C. B. Cadell, Leslie Hunter*, London 1950

SAC: *Three Scottish Colourists. Cadell: Hunter: Peploe* (catalogue of touring exhibition 1969–70; Foreword by T. J. Honeyman, Essay by William Hardie, Catalogue and Biography by Ailsa Tanner)

160 **Reflections, Balloch** 1929–30
Inscribed b.r.: 'L. Hunter'
Oil on canvas 63.5 × 76.2 cm
GMA 18 (Presented by Mr W. McInnes to NGS 1933, transferred to SNGMA)

[colour illustration page 53]

161 **Still Life of Fruit Dish and Rose in a Glass** 1930–31
Inscribed b.r.: 'L. Hunter'
Oil on canvas 49.5 × 59.7 cm
GMA 20 (transferred from NGS)

162 **Still Life, Stocks**
Oil on canvas 56 × 45.8 cm
GMA 1910 (Dr R. A. Lillie Bequest, 1977)

163 **Still Life of Gladioli**
Oil on canvas 81.9 × 66.7 cm
GMA 1348 (1975)

164 **Still life of Apples on a Plate with a Knife**
Inscribed b.l.: 'L. Hunter'
Pen and ink on paper
21.2 × 26.6 cm
GMA 717 (K. Sanderson Bequest to NGS 1943, transferred toSNGMA)

165 **Juan les Pins**
Inscribed b.r.: 'L. Hunter'
Brush, ink and crayon on paper
31.3 × 39.3 cm
GMA 1907 (Dr R. A. Lillie Bequest, 1977)

166 **A Hilly Landscape**
Inscribed b.r.: 'L. Hunter 21'
Brush and ink on paper
16.8 × 27 cm
GMA 718 (Presented by Mr W. Dodd to NGS 1948, transferred to SNGMA)

167 **Venice** 1922
Inscribed b.l.: '22/L. Hunter'
Pen and black ink on paper
22.8 × 33 cm
GMA 1912 (Dr R. A. Lillie Bequest, 1977)

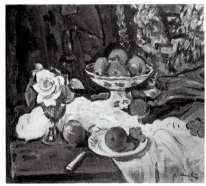

161

164

Margaret Hunter b.1948

Born in Irvine, Ayrshire, Margaret Hunter studied at GSA from 1981–85. Various awards enabled her, during 1985–86, to study at the Hochschule der Künste in Berlin under Georg Baselitz. Since then she has divided her time between Berlin and Fairlie, on the west coast of Scotland. In 1986 she had solo shows in Berlin and Ayr and in 1988 at the 369 Gallery in Edinburgh, the Vanessa Devereux Gallery in London, and the Galerie Werkstatt in Berlin. She has taken part in mixed shows in Britain, Germany, Italy, Poland and the USA. From student days Margaret Hunter's theme has been the female form defined in terms of an expressive gestural brushwork. Life in Berlin, her interest in primitive art and ethnography, allied with the influence of Baselitz and current German art has had a liberating and expansive effect on her work both technically and in subject-matter. Her early interest in Mother/Child symbolism has extended to other more complex human relationships expressed by means of a vigorous, stabbing application of paint.

Bibliography

Edinburgh, 369 Gallery: *Ideas and Images* (exhibition catalogue 1988)

168 **Precious Belonging** 1988
Acrylic on collage on board
122.1 × 92.1 cm
GMA 3419 (1988)

169 **Whisper . . .** 1988
Acrylic on paper 134.7 × 100.4 cm
GMA 3418 (1988)

168

George Innes 1913–1970

Born in Glasgow, Innes spent four years studying at GSA. In 1936 he exhibited with the painter J. L. Forsyth at the McLellan Galleries, Glasgow and in 1938 he showed four stone carvings at the Glasgow Empire Exhibition. In 1939 Innes volunteered for the Army and during his service his hands were badly burned. Thereafter, carving became difficult and he executed relatively few works. Immediately after the war his work became strongly influenced by Henry Moore, being composed of heavy, simplified volumes in the manner of Pre-Columbian sculpture. From about 1947 he adopted a very literal Cubist style, reducing figures to rigidly geometrical arrangements of carved facets. While he continued carving until his death in 1970, he spent the latter part of his life in almost total obscurity.

Bibliography

T. S. Halliday and George Bruce: *Scottish Sculpture: A Record of Twenty Years*, Dundee 1946

170 **Seated Figure** *c.*1950
White sandstone
53.4 × 30.5 × 30.5 cm
Kirkcaldy Museum and Art Gallery

170

Alan Johnston b.1945

Born in Scotland, Johnston attended ECA from 1967–70. From 1970–72 he studied at the Royal College of Art in London, concentrating on life drawing. He then spent a period in Germany, working first in Donaueschingen and then near Düsseldorf. There he began a series of Minimalist drawings done with a hard graphite pencil, many of which were done on handmade Japanese paper. A group of these drawings was exhibited at Johnston's first one-man show at the Konrad Fischer Gallery, Düsseldorf. He returned to Scotland in 1973, settling in Edinburgh. There he worked on a series of drawings based on the length of the Megalithic Yard. These were hieratic, vertical forms of varying width, in which tone was carefully built up and modulated through fine hatchwork pencil marks. The series was shown at the Von der Heydt Museum, Wuppertal in 1974, and the exhibition also included a number of pencil works drawn directly onto the Gallery walls. Johnston has since had numerous one-man shows, several of which were held at the Graeme Murray Gallery, Edinburgh. Johnston's interest in Zen Buddhism and the relation between Man and Nature has informed his entire *œuvre* which tends toward the quiet and discreet. Recently he has worked on large canvases and has produced several sculptures. In the 1980s, his work has been widely exhibited in Britain, Japan, Iceland and in New York.

Bibliography

Wuppertal, Von der Heydt Museum: *Alan Johnston, Grey Marks in the Village* (exhibition catalogue 1974)
Oxford, Museum of Modern Art: *Alan Johnston* (exhibition catalogue 1978)
Stromness, Orkney, Pier Arts Centre: *Alan Johnston* (exhibition catalogue, touring show 1978–88)

171 **From the Mountain to the Plain**
1978
Four untitled drawings
Pencil on paper 187.3 × 39.5 cm
GMA 2012 (1978)

171

William Johnstone 1897–1981

The son of a farmer, Johnstone was born in Denholm, Roxburghshire. In 1902 the family took over a farm near Selkirk and Johnstone left school at an early age to help his parents with the work. In 1912 he met the painter Tom Scott and a friendship evolved; during the following years Scott encouraged Johnstone to paint. After a spell of farming work for the Labour Corps in 1918, Johnstone entered ECA, studying there from 1919–23. He then taught evening classes at ECA from 1923–25. In 1925 he was awarded a Carnegie Travelling Scholarship which took him to Paris. There Johnstone frequented drawing classes at the Grande Chaumière and at the Académie Colarossi and studied also with the Cubist painter André Lhote. In 1927 he married an American sculptor, Flora MacDonald, then studying with Antoine Bourdelle. While elements of Lhote's Cubism emerge in Johnstone's work immediately after 1925, by the late 1920s biomorphic, Surrealist forms were becoming dominant. The Johnstones returned to Selkirk in 1927, but lack of

recognition and financial problems encouraged them to part the following year for California where Flora Mac-Donald's family lived. After a series of casual jobs, and a teaching post at the California School of Art, Johnstone and his wife returned to Scotland in 1929. He then took teaching posts at Selkirk and Galashiels where he gave evening classes. In 1931 the Johnstones left Scotland for London where William had secured a teaching job at a school. During the 1930s he taught at a number of institutions, including Regent Street Polytechnic, the Royal College of Needlework and Hackney School of Art. In 1935 Johnstone had his first one-man show at the Wertheim Gallery, London, and in the autumn, a second show at Aitken and Dott, Edinburgh. In London he met and socialised with many of the leading avant-garde figures of the day, including T. S. Eliot and Wyndham Lewis, and also illustrated books for Ezra Pound and Hugh MacDiarmid. In 1938 Johnstone became Principal of Camberwell School of Art and Crafts, a position he held until 1946. From 1947–60 he was Principal at the Central School of Arts and Crafts, London. After the war, Johnstone's work became more geometric, moving away from the rounded forms of his 1930s biomorphic paintings. He retired in 1960 to become a full-time sheep-farmer in the Scottish Borders. In 1970 he settled in Crailing near Jedburgh where he commenced a series of reliefs, using a spatula to apply thick plaster onto board surfaces. His oil paintings and ink drawings became more informal, approaching Chinese and Japanese calligraphy. Major Johnstone exhibitions were held at the SNGMA in 1973 and at the Hayward Gallery, London, in 1980.

Bibliography

William Johnstone: *Child Art to Man Art*, London 1941
William Johnstone: *Creative Art in Britain*, London 1950
Douglas Hall: *William Johnstone*, Edinburgh 1980
William Johnstone: *Points in Time: An Autobiography*, London 1980
London, Hayward Gallery: *William Johnstone* (exhibition catalogue 1980)

172 **Painting, Selkirk, Summer 1927**
1927–38/51
Oil on canvas 101.6 × 101.6 cm
GMA 1100 (1969)

173 **Ode to the North Wind** 1929
Oil on canvas 71.1 × 91.4 cm
Dundee Art Galleries and Museums

174 **A Point in Time** 1929/37
Inscribed b.r.: 'JOHNSTONE'
Oil on canvas 137.2 × 243.8 cm
GMA 1254 (Presented by Hope Montagu Douglas Scott, 1971)

[colour illustration page 65]

173

Jessie Marion King 1875–1949

Born at New Kilpatrick, Dunbartonshire, King studied at Glasgow University and at GSA, where she won a travelling scholarship for study in Italy. In 1898 she won a Queen's prize in the South Kensington National Art Competition 'for excellence in the design honours exhibition'. One year later she was working on book-cover design in Germany and by 1902 she was teaching that subject at GSA. She exhibited work at the *Turin International Decorative Art Exhibition*, and began exhibiting at the RSA in 1902. King excelled in the field of outline illustration, in the manner of Burne-Jones, Beardsley and her 'Spook' contemporaries at GSA. Her first solo exhibition was at the Bruton Street Galleries, London in 1905. King also designed fabrics, wallpaper, jewellery, costumes, and interiors. In 1908 she married E. A. Taylor, the painter and designer. They moved first to Manchester and in 1911 to Paris, where they ran the Shealing Atelier. Taylor also acted as Paris correspondent for *The Studio*. The presence of the Russian Ballet, especially Bakst, in Paris and the popularity of the craft of batik dyeing inspired King towards a greater freedom of style, and use of colour, and a larger scale. The Taylors played an active part in the café society which included S. J. Peploe, J. D. Fergusson, Anne Estelle Rice, John Middleton Murry and Katherine Mansfield. On the outbreak of war the Taylors headed back to Scotland and set up a small artists' community in Kirkcudbright but retained a studio in Paris until 1928. Jessie King's later work includes ceramic painting and brightly coloured watercolours of Arran.

Bibliography

SAC: *Jessie M. King 1875–1949* (catalogue of touring exhibition 1971; Selection and Catalogue by Cordelia Oliver)

175 **Princess Melilot**
Inscribed b.r.: 'JESSIE M. KING' and b.l.: 'PRINCESS MELILOT'
Pen and ink on parchment laid on board 32.4 × 21.2 cm
GMA 720 (K. Sanderson Bequest to NGS 1943, transferred to SNGMA)

176 **Design for one Wall of a Child's Nursery**
Watercolour and gouache on card 35.5 × 62 cm
GMA 1673 (1977)

177 **The Fisherman Watched over by the Mermaids**
Inscribed b.r.: 'JESSIE M. KING'
Pen and ink and watercolour heightened with silver paint, on vellum laid on board 37.9 × 50.3 cm
GMA 1672 (1977)

176

John Knox b.1936

John, or 'Jack' Knox, as he prefers to be called, was born on the west coast of Scotland in Kirkintilloch. From 1953–57 he studied at GSA, winning a travelling scholarship in 1958 which enabled him to study in Paris with the painter André Lhote. In 1959 he visited a major exhibition of American Abstract Expressionist painting in Brussels which deeply influenced his own work of the early 1960s. By 1965 he had adopted a style more related to Pop art, using bright colours in witty, obsessively detailed depictions of banal objects. Domestic kitchen appliances and particularly food have remained one of his favourite sources of subject-matter. In 1971 an exhibition of Knox's work was held at the Serpentine Gallery, London. During the 1970s he worked on a series of table-top still lifes of great simplicity which made clear reference to seventeenth-century Dutch painting. Wedges of cheese or cake were rendered with Magritte-like dead-pan humour, behind which an uncertain sense of menace is often present. In 1983 a one-man exhibition organised by the SAC was shown in several Scottish venues. From 1965–81 Knox taught at Duncan of Jordanstone College of Art, Dundee and since 1981 has been Head of Painting at GSA.

Bibliography

SAC: *Scottish Art Now* (exhibition catalogue 1982)
Cordelia Oliver: *Jack Knox: Paintings and Drawings 1960–83*, Glasgow 1983

178 **Aftermath** c.1961
Inscribed b.r.: 'Knox'
Oil on hardboard 104.1 × 129.6 cm
GMA 1168 (1971)

[colour illustration page 91]

William Lamb 1893–1951

Born in Montrose, Lamb studied at the local North Links School before serving an apprenticeship as a monumental sculptor to his brother James from c.1906–12. He attended art evening classes at Montrose Academy and in 1912 moved to work at an Aberdeen granite merchants, continuing his studies at Gray's School of Art. He fought in the trenches in the war and lost the use of his right hand. He began using his left hand during his convalescence in Aberdeen and 1918–21 attended the art classes of John A. Myles and Lena Gaudie at Montrose Academy, moving to full-time study at ECA with Percy Portsmouth and David Foggie, 1921–22. Lamb studied in Paris 1922–24 at the Ecole des Beaux-Arts under Boucher and set off for a 3000 mile bicycle tour of France and Italy. In 1924 he returned to Montrose where he set up a studio. He exhibited *The Cynic* at the 1925 Paris Salon and works at the RA and RSA. Lamb won the RSA Guthrie Award for *Ferryden Fishwife* in 1929. He was elected ARSA in 1931. In 1932 he modelled heads of the Royal Family and in 1945 set up a stone-carving business. Lamb modelled strong expressionistic sculptures of fisherfolk that drew upon Meunier and Barlach. A portrait head of MacDiarmid has the strength of line of German wood-carving and painting of the 1930s, as do Lamb's carved works. His entire output of drawings, watercolours, etchings, bronzes, stone- and wood-carvings, and plasters are housed in the William Lamb Memorial Studio, Montrose.

Bibliography

T. S. Halliday and George Bruce: *Scottish Sculpture. A record of twenty years*, Dundee 1946
Montrose Festival and SAC: *Baird. Lamb* (exhibition catalogue 1968; Introduction by James Morrison)
Norman K. Atkinson: *William Lamb 1893–1951. Catalogue of the contents of the William Lamb Memorial Studio*, Montrose 1979

179 **The Daily News** c. 1930
Inscribed on folds of newspaper: 'W. LAMB/ARSA' and on base: 'LAMB'
Bronze 56 × 28 × 35 cm
GMA 1104 (1969)

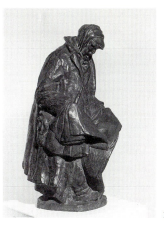

179

Eileen Lawrence b.1946

Eileen Lawrence was born in Leith and studied at ECA from 1963–68. She held her first solo exhibition at the 57 Gallery, Edinburgh, in 1969. Lawrence lived in London (1969–72) and in Wuppertal, Germany (1972–73), before returning to Edinburgh. In her watercolours and drawings she has concentrated on depicting the primary forms of nature – eggs, shells, feathers, twigs – paying particular attention to what is specific and individual to each item. These elements are painted onto richly textured hand-made paper in a precise geometrical order of balanced horizontals and verticals. She has produced a series of prayer sticks and scrolls (the employment of the scroll format reflects Lawrence's interest in Eastern philosophies) in which feathers and twigs are depicted in alternating combinations, rather like musical phrases. Her work was principally monochromatic until a trip to Turkey in 1985 provoked the use of brighter colours.

Bibliography

London, Fischer Fine Art Ltd: *Eileen Lawrence: Recent Work* (exhibition catalogues 1980 and 1985)
Bath Festival: *Eileen Lawrence* (exhibition catalogue 1986)

180 **Naples, Serpent, Fascine** 1983–84
Inscribed b.r.: 'E E M Lawrence 1983–4' and b.l.: 'Naples, Serpent, Fascine'
Watercolour, oil, sand on collage of

handmade paper on paper
183 × 165 cm
GMA 2958 (1985)

[colour illustration page 98]

Hew Lorimer b.1907

Lorimer was born in Edinburgh, the son of Sir Robert Lorimer the architect. Educated privately and at Loretto, Musselburgh, Lorimer began studies at Magdalen College, Oxford in 1928 but after a short stay at Blois, France, transferred to ECA where he studied architecture, then sculpture under the new Head of Sculpture, Alexander Carrick. Lorimer and Tom Whalen belonged to a group of young sculptors who were encouraged by Carrick and taught the methods of direct stone-carving. Lorimer and Whalen went to Paris, Florence and Rome on Andrew Grant Travelling Scholarships c.1933 and in 1934–35 an Andrew Grant Fellowship enabled Lorimer to work with Eric Gill at Piggotts. Gill introduced Lorimer to the writings of Ananda Coomeraswami; his belief that the artist is the humble collaborator in God's continuing Act of Creation has remained central to Lorimer's work. A subsequent tour of the Romanesque churches of France and the acquisition in 1930 by NGS of Bourdelle's: *Vierge d'Alsace* inspired Lorimer to model his columnar *Mother and Child* 1931–46, an idea developed into the *Lady of the Isles* 1956 for South Uist. Lorimer spent the war years as exhibition and publicity officer for the British Council, helping to mount a series of remarkable exhibitions of European and Chinese art at the National Gallery of Scotland. In the two decades following the war Lorimer collaborated with the carver Maxwell Allen on major monumental religious and secular commissions. In 1953 he executed the figures for the façade of the National Library of Scotland and supervised the work of Elizabeth Dempster on the reliefs.

Bibliography

St Andrews, Crawford Centre for the Arts: *The Lorimers* (St Andrews Festival exhibition catalogue 1983; Essay by Hew Lorimer)
Edinburgh, TRAC: *Hew Lorimer Sculptor* (exhibition catalogue 1988; Essay by Duncan Macmillan)

181 **Science** 1953
Maquette for figure on façade of National Library of Scotland.
Caen stone 75 × 26 × 15 cm
The Artist

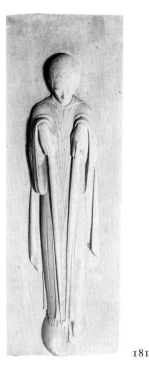

181

Ernest Stephen Lumsden

1883–1948

Born in Edmonton, London, Lumsden intended to go to sea but his health broke down. He began to study art under Morley Fletcher at Reading in 1898. In 1903 he was at the Académie Julien in Paris and he studied the work of Velazquez on a trip to Madrid the following year. In 1905 Lumsden, like McBey, taught himself to etch from Lalanne's *Treatise on Etching* and in 1907 two of his etchings were hung in the Paris Salon. His first solo exhibition of topographical etchings of Reading, Ludlow and France (which looked to Whistler, Rembrandt and Meryon) was held at the Arcade Studio, Reading in 1908. In the same year Morley Fletcher, then Principal of ECA, invited him north to take up a teaching post. He exhibited in Stockholm in 1909 and travelled to Berlin and Amsterdam. In 1910 he had an exhibition at Dowdeswell's in London and visited Canada, Tokyo, China and Korea. In 1912 Lumsden left teaching and travelled to India. He revisited India in 1913–14 with his wife and ex-colleague, Mabel Royds. In order to undertake war service, Lumsden lived in India 1917–19. The three sets of Indian prints (etching and aquatint) were his highest achievement, incorporating a fine sense of composition and use of line. His sympathetic rendering of scenes in towns, monasteries and villages, with particular reference to Benares, Jodhpur, Kashmir and Ladak near the Tibetan border, celebrated the traditional way of life. Upon his return to Edinburgh Lumsden etched portraits and Spanish scenes (1923); published *The Art of Etching* (1925); illustrated James Bone's *The Perambulator in Edinburgh* (1926) and etched Indian themes following his 1927 visit to India. In 1929 he became President of the Society of Artist Printmakers, moving the focus from the west of Scotland to Edinburgh. He was elected RSA in 1933. Lumsden moved to Raeburn's studio in Queen Street, Edinburgh in 1927, where he painted portraits, taught, wrote and etched until his death.

Bibliography

M. C. Salaman: 'The Etchings of E. S. Lumsden RE. (Catalogue 1905–21)', *Print Collector's Quarterly*, VIII 1921, p.91
J. Copley: 'The Later Etchings of E. S. Lumsden'. *Print Collector's Quarterly*, XXIII, p.211 (with chronological list 1905–35 by E. S. Lumsden)
Unpublished typescript from artist's daughter, SNGMA archive.
Obituary: *The Times*, 2 October 1948

182 **James McBey**
Inscribed b.c.: 'Lumsden imp'
and b.l.: '49.50'
Etching 29.3 × 34.3 cm
GMA 407 (K. Sanderson Bequest to NGS 1943, transferred to SNGMA)

183 **Elder Street, Edinburgh** 1939
Inscribed b.c.: 'Lumsden/imp to W. Wilson 8.vi.39'
Etching and drypoint
28.1 × 25.8 cm
GMA 2557 (1982)

183

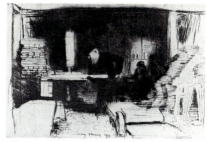

185

the etching boom declined, McBey took to painting in oil and watercolour and to doing fine pencil drawings. He visited New York on the occasion of his 1929 exhibition of paintings at the Knoedler Gallery. He made a series of New York etchings and portrait etchings of American collectors including H. H. Kynett, who bequeathed a comprehensive collection of McBey's graphic work to Aberdeen Art Gallery in 1960. In 1931 McBey married Marguerite Loeb of Philadelphia and returned to London. The McBeys then visited Spain and Tangier, where they bought a second home and it was there that McBey died in 1959.

James McBey 1883–1959

Born in Foveran, Newburgh, near Aberdeen, McBey left Newburgh School at fifteen to work in the North of Scotland Bank, Aberdeen. A keen amateur artist he attended evening classes at Gray's School of Art and in 1902 taught himself etching from Maxine Lalanne's *Treatise on Etching*. McBey constructed his own press and on business trips to Kirkcaldy and Edinburgh executed small etchings, two of which were sent to the RSA in 1905. In 1906 he sent two etchings to the GI and in 1907 a painting to the Aberdeen Artists' Society. In 1910 he left banking, painted and etched in Amsterdam and Spain and in 1911 moved to London where the Goupil Gallery gave him his first solo exhibition, which was an enormous success. McBey travelled to Morocco with Kerr Lawson in 1912. He enlisted in 1916 and his etchings of the Somme led to his appointment as War Artist with the British Expeditionary Force in Egypt. *Dawn: The Camel Patrol Setting Out* of 1919 was based upon this experience. McBey also painted portraits in oil of King Feisal and T. E. Lawrence. In 1924 he visited Venice and produced three sets of etchings. The composition of McBey's etchings and drypoints revealed a study of McTaggart, Rembrandt, Goya, Bone and Whistler. Martin Hardie, Keeper at the Victoria and Albert Museum Print Room, was a keen supporter and published a catalogue raisonné of his graphic work in 1925. As

Bibliography

Martin Hardie: *James McBey. Catalogue Raisonné 1902–1924*, London 1925
M. C. Salaman: *The Etchings of James McBey*, London 1929
E. Blaikley: 'With McBey in the Desert', *The Studio*, Vol.cxxv, No.598, 1943, pp.19–22
M. Hardie and Charles Carter (eds): *James McBey, Etchings and Drypoints, from 1924*, Aberdeen 1964
Nicholas Barker (ed): *The Early Life of James McBey. An Autobiography, 1883–1911*, Oxford 1977

184 **The Ford** 1913
Inscribed b.r.: 'James McBey' and b.l.: 'XL'
Etching 27.7 × 17.5 cm
GMA 419 (1961)

185 **The Carpenter of Hesdin** 1917
Inscribed b.r.: 'James McBey' and b.l.: 'II'
Drypoint 23.5 × 34.3 cm
GMA 414 (transferred from NGS)

186 **The Moonlight Attack Jelil** 1920
Inscribed b.r.: 'James McBey' and b.l.: 'XLVII'
Drypoint 29.2 × 43.1 cm
GMA 415 (transferred from NGS)

187 **New York** 1930
Inscribed b.r.: 'James McBey' and b.l.: 'XXIII'
Etching and drypoint
31.7 × 45.7 cm
GMA 416 (George H. Hunter-Foulis Bequest to NGS 1958, transferred to SNGMA)

Robert MacBryde 1913–1966

Robert MacBryde's career was inextricably linked with that of his close friend and companion Robert Colquhoun, but his work is very different in outlook. Where Colquhoun's work has an undercurrent of tragic emotion, MacBryde was more concerned with making pictures. His subjects were mostly still lifes, with some figure painting, and, while Colquhoun was the better draughtsman, MacBryde had arguably a finer sense of colour. MacBryde was born at Maybole in Ayrshire. After five years working in a factory, in 1932 he entered GSA, where he met Robert Colquhoun. The two rapidly became inseparable, so much so that when Colquhoun was awarded a travelling scholarship, the School found money for an award to MacBryde so that they could travel together. After their scholarship years in France and Italy from 1937–39, 'the Roberts' returned to Ayrshire, where they stayed until Colquhoun's call-up in 1940. MacBryde, exempt from military service on health grounds, followed his friend to Edinburgh and Leeds while actively campaigning for his release. Like Colquhoun, MacBryde's work after the move to London in 1941 came under the influence of Wyndham Lewis and Jankel Adler. His work was also included in the Lefevre Gallery's *6 Scottish Artists* show of 1942. He had his first and only solo show there in 1943. By the mid-1940s his work became more decorative, the forms flattened and his palette lighter. Like Colquhoun he worked on lithographs and monotypes for Miller's Press in Lewes

from 1947 and from 1948 collaborated with him on Massine's ballet *Donald of the Burthens* (produced at Covent Garden in 1951). In 1951 he was commissioned to design murals for the Orient liner *SS Oronsay*, and by the Arts Council to paint a large canvas for its Festival of Britain exhibition *Sixty Paintings for '51*. Devastated by Colquhoun's death, Mac-Bryde moved to Dublin, where he was run over by a car and killed in 1966.

Bibliography

London, Mayor Gallery: *Robert Colquhoun and Robert MacBryde* (exhibition catalogue 1977; Text by Richard Shone)
Edinburgh, CAC: *Robert Colquhoun* (exhibition catalogue 1981; Text by Andrew Brown)
London, Barbican Art Gallery: *A Paradise Lost: The Neo-Romantic Imagination in Britain 1935–55* (exhibition catalogue 1987; Edited by David Mellor)
Malcolm York: *The Spirit of the Place. Nine Neo-Romantic Artists and their Times*, London 1988

188 **Chess Player** *c.*1950
Inscribed b.r.: 'MacBryde'
Oil on canvas 76.2 × 50.8 cm
GMA 2772 (Alan F. Stark Bequest, 1983)

189 **Two Women Sewing**
Inscribed b.r.: 'MacBryde'
Oil on canvas 100.3 × 143.5 cm
GMA 1588 (1976)

[colour illustration page 74]

190 **Still Life – Fish on a Pedestal Table**
Inscribed b.l.: 'MacBryde'
Oil on canvas 61.3 × 50.9 cm
GMA 946 (1966)

EX. CAT.
Still Life with Cucumber
Oil on canvas 40.5 × 53 cm
GMA 3306(1987)

191 **Robert Colquhoun** 1939
Inscribed b.r.: 'MacBryde'
Black chalk on paper
27.3 × 15.7 cm
Scottish National Portrait Gallery

192 **Woman with a Drum** 1949
Inscribed b.r.: 'MacBryde'
Colour lithograph 50 × 32 cm
GMA 3312 (1987)

193 **Still Life with Lamp**
Colour lithograph 39.2 × 53.6 cm
GMA 3313 (1987)

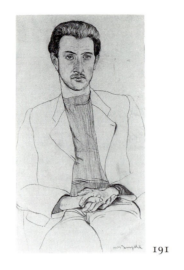

191

Robert MacBryde, *Still Life with Cucumber*

William McCance 1894–1970

William McCance was born at Cambuslang near Glasgow and attended Hamilton Academy and then GSA. He married a fellow student, Agnes Miller Parker and together they moved to London in 1920. He worked as an illustrator and teacher but simultaneously produced a series of paintings, drawings, prints and a few sculptures close to the style of Wyndham Lewis and the Vorticists. These near abstract works with their emphasis on crisply rendered machine imagery are quite unlike anything produced by contemporary Scottish artists. From 1923–26 he was art critic of *The Spectator*, but also contributed articles to other art journals. In 1928 McCance and Miller Parker

exhibited works at the St George's Gallery in London and in 1930 featured in a show of the Neo Society at the Godfrey Phillips Gallery, London. In 1935 his paintings were shown in James Whyte's Gallery in St Andrews in an exhibition of modern Scottish art. In 1930 McCance left London for Newtown, Montgomeryshire to become Controller of the Gregynog Press, designing and illustrating high-quality, limited edition books. In 1933, the McCances moved to a converted windmill near Albrighton in the Midlands and in 1936 to Hambledon, Berkshire, where he continued writing art columns for a number of newspapers, including *Picture Post*. In 1943 McCance succeeded Robert Gibbings as lecturer in typography and book-production at Reading University. In 1955 he and his wife separated and from 1960 he returned frequently to Scotland, eventually settling in Girvan where he remarried. His first solo exhibition was in 1960 at Reading Art Gallery and he had a major retrospective shown at Dundee, Glasgow and Edinburgh in 1975. McCance's involvement from the mid-1920s in illustration and journalism no doubt contributed to his reduced production of paintings and a consequent drift into obscurity. Furthermore, he rarely exhibited. He counts, however, as one of the most inventive British artists of the 1920s.

Bibliography

Dundee, City Art Gallery: *William McCance (1894–1970)* (exhibition catalogue 1975)

194 **Heavy Structures in a Landscape Setting** 1922
Inscribed b.r.: 'W. McCance '22'
Oil on irregularly shaped canvas
max. 68 × max. 82 cm
Mrs Margaret McCance

[colour illustration page 64]

195 **Conflict** *c.*1922
Inscribed t.r.: 'W. McCance '22'
Oil on canvas 87.5 × 100.5 cm
Glasgow Museums and Art Galleries

196 **Mediterranean Hill Town** 1923
Inscribed t.r.: 'W. McCance '23'
Oil on canvas 92.1 × 61 cm
Dundee Art Galleries and Museums

197 **Portrait of Joseph Brewer** 1925
Inscribed t.l.: 'W. McCance 1925'
Oil on canvas 71 × 61 cm
GMA 3446 (1989)

[colour illustration page 62]

198 **Standing Figure** 1931
Bronze 36 × 10 × 10 cm
Mrs Margaret McCance

199 **The Bell** 1931
Inscribed on rim of bell:
'WMcCANCE. MCMXXXI'
Bronze 32 × 10 × 10 cm
Mrs Margaret McCance

200 **Heavy Structures in a Landscape
Setting** c.1922–24
Ink and wash on paper
18 × 22.9 cm
GMA 3432 (1988)

201 **Head of an American (Joseph
Brewer)** 1925
Inscribed b.l.: 'W. McCance 1925'
Charcoal on paper 40.5 × 33 cm
Mrs Margaret McCance

202 **Portrait of Agnes Miller Parker**
1925
Inscribed t.r.: 'W. McCance 1925'
Black crayon on paper 33 × 38 cm
GMA 3433 (1988)

203 **Study for Colossal Head** 1926
Inscribed b.c.: 'W. McCance 1926'
Charcoal on paper 53.6 × 37.6 cm
GMA 3439 (1988)

204 **View of LMS Wolverhampton**
c.1935
Charcoal on paper 36.3 × 50.5 cm
Mrs Margaret McCance

205 **Industrial Midlands** c.1935
Charcoal on paper 36 × 50.4 cm
Mrs Margaret McCance

206 **Mediterranean Hill Town** 1923
Inscribed b.r.: 'W. McCance 1923'
Linocut 24.4 × 16.9 cm
GMA 3431 (1988)

207 **Greetings Card** 1930
Wood engraving on card
14.5 × 9.5 cm
Mrs Margaret McCance

208 **Initial letters for 'The Fables of
Esope'** 1932
Wood engraving
Three sheets mounted together
Each inscribed b.r.: 'W. McCance
1932'
56 × 40.6 cm
Mrs Margaret McCance

209 **The Fables of Esope** 1932
Book bound in Welsh natural
sheepskin 31.5 × 23 cm
Mrs Margaret McCance

210 **Greetings Card** 1935
Inscribed b.r.: 'Design x-35'
Wood engraving on card
13 × 10 cm
Mrs Margaret McCance

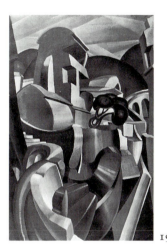

196

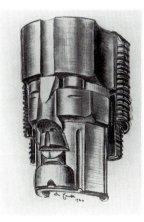

203

Rory McEwen 1932–1982

McEwen was born into a landed family at
Polwarth, Berwickshire and was edu-
cated at Eton and Cambridge. For five
years he worked as a professional musi-
cian before turning full-time painter in
1951. His highly detailed watercolour
studies of botanical specimens were
exhibited in one-man shows at Durlacher
Bros, New York, in 1962 and 1964.
After the second show, McEwen pro-
duced a series of abstract paintings in
acrylics and by 1965 had begun painting
directly onto glass and acrylic sheet.
These were enlarged and developed into
free-standing sculptures incorporating
glass, perspex, metal and even polarised
light, built into coloured box construc-
tions. They were exhibited at RDG dur-
ing the 1969 EIF, and some of the
smaller models were later mass-
produced. In 1971, McEwen went on an
extended trip to India which rekindled
his interest in botanical illustration. Dur-
ing the 1970s he added collage elements
and broadened his technique. A retro-
spective of his paintings of flora and fauna
was held at Inverleith House, Edinburgh
in 1988.

Bibliography

Edinburgh, RDG: *Rory McEwen* (exhibition cata-
logue 1969)
Tokyo, Nihonbashi Gallery: *Rory McEwen* (exhibi-
tion catalogue 1980)
Edinburgh, Royal Botanic Garden: *Rory McEwen:
The Botanical Paintings* (exhibition catalogue
1988)

211 **Untitled** 1968
(Grey Plate Glass Series No. 4)
Grey plate glass and metal
203 × 51 × 25.5 cm
GMA 1086 (1968)

211

Kirsty McGhie b.1959

McGhie was born in Edinburgh and from 1980–85 studied at GSA in the Fine Art, Murals and Stained Glass Department. In 1985 she won an SED scholarship which enabled her to travel to Japan. Since 1983 she has exhibited at numerous venues in Scotland, having a one-woman show at the Collective Gallery, Edinburgh in 1985. McGhie uses an unusual range of materials, many of which are intended for the manufacturing industries – plastics, wax, resin, wire netting. In 1987 she won an SAC Artists in Industry Scholarship and that same year began teaching in the Sculpture Department at ECA as a visiting lecturer.

Bibliography

Glasgow, Collins Gallery: *Shape + Form. Six Sculptors from Scotland* (exhibition catalogue of touring show 1988–89)

EX. CAT.
Tina 1986
Mixed media 74 × 60 × 36 cm
Private Collection

Kirsty McGhie, *Tina*, 1986

Tracy Mackenna b.1963

Mackenna was born in Oban and studied sculpture at GSA from 1981–86. Between 1986 and 1987 she lived and worked in Hungary as a guest of the Artists' Collective Studio, Budapest. Since 1987 she has exhibited widely in Britain and abroad, having one-woman shows at the Collective Gallery, Edinburgh, in 1986, at the Young Artists' Club, Budapest, in 1987 and most recently at the Glasgow Print Studio in April 1989. Mackenna uses waste and manufactured materials – paper, cardboard, and, in particular, steel – which she assembles into self-contained sculptural objects. Mackenna formerly designed these for placement on the ground but much of her recent work is wall-mounted. She is co-founder and Director of Glasgow Sculpture Studios.

Bibliography

Glasgow Print Studio: *Tracy Mackenna: Sculpture* (exhibition catalogue 1989)

212 **Objects 8, 9, 10 in a Row** 1989
Metal and elastic bands
11.5 × 9; 9.5 diameter;
9 × 12.5 cm
GMA 3458 (1989)

[colour illustration page 111]

Charles Rennie Mackintosh

1868–1928

Mackintosh was born and educated in Glasgow where in 1884 he started an apprenticeship with the architect John Hutchison. At the same time he began attending evening classes in architecture at GSA. In 1889 he moved to the firm of Honeyman and Keppie as a draughtsman. At GSA Mackintosh won an impressive number of prizes including a travelling scholarship to Italy, France and Belgium awarded in 1891. On his return to Glasgow he met the sisters Frances and Margaret Macdonald (he married the latter in 1900), who, together with Herbert MacNair, would form the Glasgow Four group to create a specifically Scottish variant of the European Art Nouveau style. In 1896 Mackintosh won the competition to design a new building for the GSA. Realised between 1897 and 1902, it stands as one of the first European buildings of the Modern Style. Mackintosh designed Hill House, Helensburgh in 1902 and made significant alterations to Hous'hill, Glasgow, the following year. In 1904 he became a partner in the firm of Honeyman and Keppie; that same year saw the opening of the Willow Tea Rooms, Glasgow, for which Mackintosh had designed the furnishings and fittings. He was very concerned with detail, designing not only buildings, but also interior decoration schemes, furniture, wallpapers, textiles and cutlery.

From 1901 a number of articles on Mackintosh's work began appearing in continental art reviews and he was indeed to have an enormous influence on architects and designers in Germany, Austria and France, notably among the Vienna Secessionists (he exhibited with them in 1901) and later on the Bauhaus group. In Britain, fame came to him much later. The Mackintoshes moved away from Glasgow in 1914, living initially in Suffolk before settling in Chelsea. There he concentrated chiefly on furniture and fabric designs, the alterations made in 1916 to a house in Northampton being one of few returns to the field of architecture. From 1923–27 they moved to Port Vendres in the South of France where Mackintosh devoted much of his time to watercolour painting. His return to England in 1927 was brought about by ill-health; he died the following year. Mackintosh counts not only as one of the great British architects, but also as one of the most influential artists and designers of this century.

Bibliography

Thomas Howarth: *Charles Rennie Mackintosh and the Modern Movement*, London, 2nd ed. 1977
Roger Billcliffe: *Architectural Sketches – Flower Drawings by Charles Rennie Mackintosh*, London 1977
Roger Billcliffe: *Mackintosh Watercolours*, London 1978
Patrick Nuttgens (ed.): *Mackintosh and his Contemporaries*, London 1988
Roger Billcliffe: *Charles Rennie Mackintosh: The Complete Furniture, Furniture Drawings and Interior Designs*, London, 3rd ed. 1988

213 **Bookcase for Nitshill, Glasgow** 1904
Wood, painted white with inlays of coloured enamel 122 × 46 × 46 cm
GMA 3447 (1989)

[colour illustration page 49]

214 **The Fort** c.1924–26
Inscribed b.r.: 'C.R. MACKINTOSH'
Watercolour on paper
45 × 45.2 cm
Hunterian Art Gallery, University of Glasgow, Mackintosh Collection

215 **Slate Roofs** c.1924–27
Inscribed b.r.: 'C. R. MACKINTOSH'
Watercolour on paper
37 × 27.5 cm
Glasgow School of Art

216 Le Fort Maillert 1927
Inscribed b.r.: 'C. R. MACKINTOSH
1927'
Watercolour on paper
35.8 × 28.5 cm
Glasgow School of Art

[colour illustration page 76]

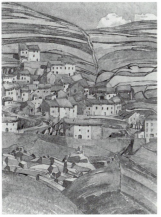

215

Robert Maclaurin b.1961

Born and brought up in Yorkshire,
Robert Maclaurin studied at ECA from
1979–83. In 1983 he was awarded an
Andrew Grant Scholarship and also
made his first visit to Turkey. After a
post-graduate year 1983–84 he travelled
on scholarships to France, Holland and
Italy. He spent 1984 in Istanbul on a
Turkish Government Scholarship. His
association with Turkey continues to this
day. He has been awarded bursaries and
grants by the British Council and the
SAC. He began to exhibit in 1983 and
his first solo show was at the Edinburgh
University Staff Club in 1984. Since then
his work has been shown throughout
Scotland, in London, Bath, Cambridge,
Munich and New York. Among his other
solo shows have been those at the
Bedlam Theatre, EIF 1984, the Mercury
Gallery, Edinburgh 1987, St Catherine's
College, Cambridge 1988 and the 369
Gallery, Edinburgh and Turberville
Smith, London 1989. The artist now
lives and works in Edinburgh.
Maclaurin's work concerns the essential
loneliness and vulnerability of the indi-
vidual, and is characterised by a large

human figure set against a dramatic
landscape backdrop. In more recent work
the figure has shrunk, and appears dwar-
fed before the strongly geometric shapes
of the landscape behind. Educated in the
Edinburgh tradition of *belle peinture*,
Maclaurin aims to produce a rich surface
texture in the large areas of strong single
colour he uses for each landscape fea-
ture. In his smaller paintings, brushwork
provides this variety, but in his larger
work Maclaurin has recently begun to
introduce secondary colours often
applied with rags to enliven the picture
surface.

Bibliography

Edinburgh, 369 Gallery and New York, Art in
 General: *An Exchange* (exhibition catalogue
 1987–88)

217 Among the Turkish Wilderness
1988
Inscribed b.r.: 'R. Maclaurin '88'
Oil on canvas 153 × 168 cm
GMA 3420 (1988)

[colour illustration page 109]

218 Under the Armenian Bridge 1988
Inscribed b.r.: 'R. Maclaurin'
Oil on canvas 168 × 153 cm
GMA 3421 (1988)

Bruce McLean b.1944

Born in Glasgow, McLean studied at GSA
from 1961–63. From 1963–66 he won
a place on the post-graduate sculpture
course at St Martin's School of Art in
London, where Antony Caro and Wil-
liam Tucker were professors. They based
the course around formalist concerns for
arranging metal girders, wood, fibreglass
etc. in balanced compositions on the
floor. McLean, like his contemporary at
the School Barry Flanagan, found this
approach tedious and pretentious and set
about undermining what he saw as the
pompous, bombastic aspect of con-
temporary sculpture. He lambasted the
serious classroom view of sculpture: 'The
St Martin's sculpture forum would avoid
every broader issue, discussing for hours
the position of one piece of metal in rela-
tion to another. Twelve adult men with
pipes would walk for hours around sculp-

ture and mumble'. At the School he
made a number of performances
intended to bring humour back into
sculpture, denying the studio-orientated
approach to art and becoming instead
the art object himself. In 1965 he con-
ducted a performance which involved
waving in the direction of Charing Cross
Station, and throughout the 1960s he
produced variations on related themes,
subverting the traditional view which
saw the aim of art as being the produc-
tion of tangible objects. In 1966 he
began teaching at Croydon School of Art
before taking a post at Maidstone College
of Art. In the mid-1960s McLean made
a series of witty sculptures from rubbish
he found on the streets and which he
tastefully arranged to ape Caro's works.
He had a one-man exhibition in Düs-
seldorf in 1969 and took part in the
major international survey of con-
temporary art shown in Bern and
London, *When Attitudes Become Form*, in
which he exhibited a group of postcards.
In 1971 McLean held his first solo exhibi-
tion in London, at the Situation Gallery,
under the title *There's a Sculpture on my
Shoulder*; slides of famous modern sculp-
tures were projected onto the wall above
his shoulder. In 1972 he had a one-day
show at the Tate Gallery, *King for a Day*,
exhibiting 1000 booklets, each of which
contained proposals for new sculptures.
Ironically, the establishment was taking
McLean very seriously, so for a while he
gave up art, concentrating instead on
performances with the group he formed
in 1971 at Maidstone, Nice Style. From
the late 1970s McLean took to working
in more traditional idioms, producing
paintings and prints which owe a debt to
Matisse. In 1981 he had a major one-
man show at the Kunsthalle, Basel, and
another in 1982 at the Whitechapel Art
Gallery, London. Despite his great inter-
national success, McLean still enjoys
undermining the pomposity of art, mock-
ing himself as much as he does the art he
practises. He currently lives and works in
London.

Bibliography

Saint-Etienne, Musée d'Art et d'Industrie: *Bruce
 McLean* (exhibition catalogue 1981)
London, Whitechapel Art Gallery: *Bruce McLean*
 (exhibition catalogue; Text by Nena Dimitrijevic
 1982)
Edinburgh, The Scottish Gallery: *Bruce McLean*
 (exhibition catalogue 1986)

219 **Floataway Piece Beverley Brook Barnes '67** 1967
Black and white photograph with letraset 47.5 × 69 cm (including frame)
Private Collection

220 **Landscape Painting '68** 1968
Colour photograph with letraset 33 × 33 cm (including frame)
Private Collection

[colour illustration page 96]

221 **Landscape Painting '68** 1968
Colour photograph with letraset 33 × 33 cm (including frame)
Private Collection

[colour illustration page 96]

222 **Evaporated Puddle Work January '68** 1968
Black and white photograph with letraset 66 × 44.5 cm (including frame)
Private Collection

[colour illustration page 96]

223 **Scatterpiece Woodshavings on Ice '68** 1968
Black and white photograph with letraset 45 × 65.5 cm (including frame)
Private Collection

[colour illustration page 96]

224 **People who Make Art in Glass Houses, Work** 1969
Two black and white photographs, one with letraset
Each 122 × 90.7 cm
GMA 2223 (1980)

225 **Fallen Warrior Piece** 1969
Black and white photograph with letraset
60 × 91 cm
Private Collection

226 **Pose Work for Plinths II** 1971
12 black and white photographs mounted on board
73.7 × 67.6 cm
Private Collection

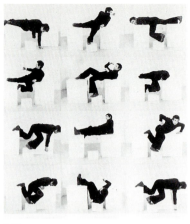

226

John McLean b.1939

McLean was born in Liverpool to Scottish parents. He was educated at Kerrimuir, Arbroath and at St Andrews University where he studied art from 1957–62. He then moved to London to study history of art at the Courtauld Institute from 1963–68. McLean's paintings are abstract designs composed of bands of colour arranged in a balanced sequence. He uses acrylic paints and often works on a large scale. From 1966 McLean taught at a number of art colleges in the London area, including Chelsea School of Art, University College and the Slade School of Art. A one-man show of McLean's work was held at TRAC in 1975 and he has shown extensively in galleries in Britain and the USA. He taught in Canada in 1981 and at the Boston Museum School of Art in 1982. Since 1987 he has lived in New York.

227 **Bright Lights** 1988
Acrylic on canvas 79 × 223.4 cm
Francis Graham-Dixon Gallery, London

228 **Escalator** 1988
Acrylic on canvas 185.7 × 89 cm
Francis Graham-Dixon Gallery, London

[colour illustration page 97]

229 **Greengage** 1988
Acrylic on canvas 170.3 × 104 cm
Francis Graham-Dixon Gallery, London

Will Maclean b.1941

Maclean was born in Inverness into a family of fishermen. He studied from 1961–67 at Gray's School of Art, Aberdeen, and then at Hospitalfield, Arbroath. He won a scholarship to the British School in Rome in 1967 before working as a ring-net fisherman off the coasts of Scotland. He exhibited his paintings widely in the late 1960s and 1970s, with one-man shows at the 57 Gallery in Edinburgh in 1968 and at RDG in 1970. In 1973, the Scottish International Education Trust commissioned Maclean to undertake a visual study of Scottish ring-net fishing. This was to prove an obsession for Maclean who produced some 400 drawings and diagrams documenting this fast-disappearing fishing technique. The entire project was shown at TEC in 1978 and was subsequently acquired by the SNGMA. Maclean taught art at Bell-Baxter High School, Cupar, Fife, before becoming lecturer at Duncan of Jordanstone College of Art, Dundee in 1981. From 1974 until the present, he has worked on an unusual series of sculptures and constructions composed of driftwood, found objects and sculpted elements. These are fitted into box-like frames and painted. Their inspiration frequently comes from Scotland's seafaring culture as fish-bones, hooks and miscellaneous objects are carefully arranged in bizarre tableaux evoking Scotland's pre-industrial fishing traditions.

Bibliography

Angus Martin with illustrations by Will Maclean: *The Ring-Net Fishermen*, Edinburgh 1981
London, Claus Runkel Fine Art Ltd: *Will Maclean: Sculptures and Box Constructions 1974–1987: A Catalogue Raisonné*, London 1987

230 Works from **The Ring Net**
(Scottish Ring-Net Fishing)
1973–76

230 **Method Double Anchor and
Sweeplines**
Watercolour, ink and letraset on
paper 61.5 × 48.6 cm
GMA 2130 (1979)

231 **Net Needles**
Ink, watercolour and letraset on
paper 42.9 × 42 cm
GMA 2130 (1979)

232 **Three Fish**
Inscribed b.r.: 'Herring Dec '73'
Pen, ink and wash on paper
25.1 × 31.6 cm
GMA 2130 (1979)

233 **Two Fish**
Watercolour and ink on paper
25.1 × 31.6 cm
GMA 2130 (1979)

234 **One Fish**
Inscribed l.r.: 'W. J. Maclean '73'
Pen and ink on paper
25.1 × 31.6 cm
GMA 2130 (1979)

235 **Bard McIntyre's Box** 1984
Inscribed b.r. on front of box:
'W. J. MacLean 84'
Mixed media 60 × 45.8 × 7.3 cm
GMA 2973 (1986)

[colour illustration p. 93]

233

Iain Macnab 1890–1967

Macnab was born in the Philippines, but
his family moved to Kilmacolm in 1894.
He studied accountancy in Glasgow and
served in the Army 1914–17. Early
desires to be a sculptor foundered on his
being invalided out of the Army. Macnab
studied at GSA in 1917, Heatherley
School of Fine Art, London in 1918 and
in Paris the following year. He returned
to become Joint Principal of the
Heatherley School 1919–25. In 1923 he
was elected ARE (RE in 1935). He
opened the Grosvenor School of Modern
Art in 1925 in Warwick Square, London.
He brought together a brilliant group of
teachers which included Claude Flight,
Blair Hughes-Stanton, Frank Rutter,
Graham Sutherland and R. H. Wilenski.
In 1926 he turned from etching to wood-
engraving under the influence of Noel
Rooke. Macnab taught and influenced a
whole generation of wood-engravers,
among them Winifred and Alison
McKenzie, who, in turn, taught wood-
engraving at St Andrews and Dundee.
His teaching led to a Fellowship of the
RCA in 1932, membership of the Society
of Wood Engravers, and the publication
of *The Student's Book of Wood Engraving* in
1938. The Grosvenor School closed in
1940 and in 1941 Macnab joined the
RAF. He relinquished the post of Director
of Art Studies at Heatherley in 1953, and
in 1959 took office as President of the
ROI. Macnab served as a Governor of the
Federation of British Artists in 1959 and
Chairman of the Imperial Arts League in
1962. He is remembered for his stylised
wood-engravings of Spain, Corsica and
the South of France and for his book
illustrations. He produced his last wood
engraving in 1961, of Ronda, Spain.

Bibliography

Albert Garrett: *Wood Engravings and Drawings of Iain
Macnab of Barachastlain*, Tunbridge Wells 1973
London, Blond Fine Art: *Iain Macnab and his circle*
(exhibition catalogue 1979)

236 **The Waterfront, Calvi, Corsica**
1930
Inscribed b.r.: 'IAIN MACNAB'
and b.c.: 'WATERFRONT CALVI'
and b.l.: 7/40
Wood engraving 25.3 × 20.2 cm
GMA 2084 (1979)

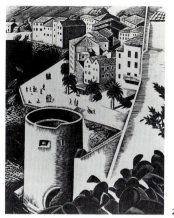

236

Caroline McNairn b.1955

Born in Selkirk, Caroline McNairn
studied art at Edinburgh University from
1972–78. Her first solo show was in
1980 at Calton Studios, Edinburgh. Since
then she has had solo shows at the 369
Gallery, Edinburgh (in 1981, 1984 and
1987), at Trevelyan College, University
of Durham, 1986 and the Le Cadre Gal-
lery, Hong Kong, 1987. She has taken
part in group exhibitions since 1977 and
her work has been seen throughout Scot-
land, in Cambridge, London, Santa Fé,
Hong Kong, Chicago and New York. In
her work Caroline McNairn seeks to con-
tain within a bold and simple composi-
tion a complex of opposing images,
shapes, colours and textures. From the
easy, decorative mood of her early days
her work has grown bolder and more
powerful as it has grown in scale. Mc-
Nairn's images, once purely formal, have
also become more expressive. They are
those of the city dweller and of the Edin-
burgh inhabitant in particular. In a
recent series of paintings a large human
figure stands sentinel in a side panel,
silent counter in emotional and composi-
tional terms to the complicated push and
pull of the other side. McNairn is perhaps
at her best working in pastel where the
more rapid working method and relative
ease of making changes is more
sympathetic to her task of extending to
the limits the opposing elements in her
work.

Bibliography

London, Warwick Arts Trust: *Scottish Expressionism*
(exhibition catalogue 1984)
Edinburgh, 369 Gallery: *Caroline McNairn* (exhibition catalogue 1987)
Edinburgh, 369 Gallery and New York, Art in General: *An Exchange* (exhibition catalogue 1987-8)

237 **Looking Outside** 1987
Inscribed b.r.: 'Caroline McNairn 87'
Oil on canvas 182.9 × 182.9 cm
The Artist

[colour illustration page 102]

William MacTaggart

1903–1981

MacTaggart was born at Loanhead, grandson of William McTaggart RSA. Ill-health limited his studies at ECA from 1918 to part-time, interspersed with trips to France, throughout the 1920s. His contemporaries at ECA, William Gillies and William Crozier, studied with André Lhote in Paris, and by sharing a studio in Edinburgh, first with Crozier and then with Gillies, MacTaggart learnt about contemporary movements in French art. In 1921 MacTaggart sent work to the RSA, joined the SSA in 1922 and became a founder-member of the 1922 Group. His Post-Impressionist landscape style owed much to the Scottish Colourists Peploe and Hunter, but also to Derain and Marchand. In 1924 MacTaggart had his first solo show at Cannes and met Matthew Smith at Cassis, in the South of France. He joined the Society of Eight in 1927 and in 1929 had his first Scottish show at Aitken Dott's, Edinburgh. Two years later the SSA brought a large body of work by Edvard Munch to Scotland and these together with the influence of Kirchner, Jawlensky, Nolde and Soutine served to strengthen the expressionist tendencies in his art. MacTaggart was elected President of the SSA in 1933, began to teach at ECA and in 1937 married Fanny Aavatsmark, the Norwegian organiser of the Munch exhibition. During the war years he was honorary exhibition organiser of the Council for the Encouragement of Music and the Arts. 1947–52 the MacTaggarts made annual visits to Orry-la-Ville outside Paris. The 1952 Rouault retrospective in Paris inspired his more expressive late work. The forms within his flower paintings, still lifes, landscapes and seascapes merged into masses of glowing colour set within dark grounds or shapes. MacTaggart served as a member of the EIF Council from 1948, and on the ACGB Scottish Committee 1953–62. He was President of the RSA 1959–69, and was knighted in 1963. MacTaggart had a retrospective exhibition at the SNGMA in 1968 and was elected RA in 1973.

Bibliography

Edinburgh, SNGMA: *Sir William MacTaggart*
(retrospective exhibition catalogue 1968; Introduction by H. Harvey Wood, Text by Douglas Hall)
H. Harvey Wood: *W. MacTaggart*, Edinburgh 1974

238 **Snow near Lasswade** *c.*1928
Inscribed b.l.: 'W. MacTaggart YR'
Oil on board 51 × 61 cm
GMA 1087 (1968)

239 **The Old Mill, East Linton** 1942
Inscribed b.r.: 'W. MacTaggart YR'
Oil on canvas 51 × 76.5 cm
GMA 1922 (Dr R. A. Lillie Bequest, 1977)

240 **Poppies against the Night Sky**
*c.*1962
Inscribed b.r.: 'W. MacTaggart'
Oil on hardboard 76.2 × 63.5 cm
GMA 1046 (R. R. Scott Hay Bequest, 1967)

241 **The Wigtown Coast** 1968
Inscribed b.r.: 'W. MacTaggart '68'
Oil on canvas 86.2 × 111.5 cm
GMA 2740 (1983)

[colour illustration page 88]

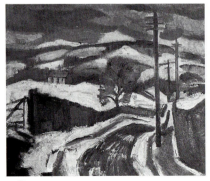

238

David Mach b. 1956

David Mach was born in Methil, Fife and from 1974-79 studied at Duncan of Jordanstone College of Art, Dundee. From 1979–82 he followed a post-graduate course in the Sculpture Department at the Royal College of Art in London and thereafter settled in the capital. At the RCA he built his first works out of mass-produced items, namely books. At a huge second-hand bookshop in Hay-on-Wye, Mach built a *Rolls Royce* car using thousands of old books. He repeated the process to produce an *Eiffel Tower* (which he exhibited at his post-graduate show in 1982) and a *Reclining Nude* shown at his one-man exhibition at the Lisson Gallery, London in 1982. In 1983 he used old car-tyres to fashion an enormous *Polaris Submarine* which was commissioned as part of *The Sculpture Show* at the Hayward Gallery, London. Ten thousand tyres were required to make a *Parthenon*, constructed in Edinburgh's Princes Street Gardens during the spring of 1986. That same year, Mach used 30 tons of magazines and furniture in his largest work to date, *Fuel for the Fire*, exhibited at the Riverside Studios, London. Mach made another work using magazines and newspapers for the SNGMA in 1987 for *The Vigorous Imagination* exhibition. Each work requires careful planning and may take up to three weeks to build with the aid of a team of helpers. Mach's work, while being 'figurative' in the sense that it depicts recognisable objects, belongs also to the realm of Performance Art in that the audience can observe the work's construction. In a process which suggests comparison with an orchestra or a circus (an analogy the artist readily accepts), Mach travels the world giving performances and then moving on. He remarks: 'If it's a good idea then it shouldn't matter how long it lasts, five minutes or forever'. Much of his work cannot be bought or owned since it is dismantled after being exhibited; instead it is hired for the given period of the exhibition. His use of the waste-products of Western consumer society (magazines, books, bottles, toys, tyres) is an essential part of the meaning of the work, an ironic comment on today's ersatz culture.

Bibliography

Rotterdam, Galerie t'Venster: *David Mach, Master Builder* (exhibition catalogue 1983; Text by Tom Bendham)

London, Riverside Studios: *David Mach: Fuel for the Fire* (exhibition catalogue 1986; Text by Mel Gooding)

London, Tate Gallery: *David Mach: 101 Dalmatians* (exhibition catalogue 1988)

EX. CAT.
Dying for it 1989
Glass bottles, water, dye and emulsion paint
GMA 3469 (1989)

David Mach, *Dying for it*, 1989

John Maxwell 1905–1962

Maxwell was born in Dalbeattie, Kirkcudbrightshire where his father ran the local cinema. From 1921–26 he attended ECA, winning a post-graduate scholarship in his final year. In 1927 he travelled to Spain and Italy and also studied in Paris at the Académie Moderne under Léger and Ozenfant. The influence of these Purist painters was to be negligible, however, since Maxwell's temperament favoured the visionary art of Klee and Chagall. In 1929 Maxwell was appointed to the staff of ECA. He assisted the College Principal, Gerald Moira, with a large mural for St Cuthbert's Church, Edinburgh and in 1934–35 executed murals for Craigmillar School, Niddrie. In Italy, Maxwell had been impressed by early Renaissance wall-paintings, and their stiff, hieratic aspect reappears in his own Craigmillar mural. However, his watercolours and oil paintings, with their rich impasto, have a poetic, dream-like quality closer to Chagall. Maxwell retired from teaching in 1943, returning to Dalbeattie to concentrate on his own work. He was very self-critical and frequently destroyed works. He was elected ARSA in 1945 and RSA in 1949. At the invitation of his close friend William Gillies, Maxwell returned to ECA in 1955, taking the post of Senior Lecturer in Composition. Ill-health dogged his later years – he died at Dalbeattie at the age of fifty-seven. The ACGB organised Maxwell exhibitions in 1954 (shared with Gillies) and in 1960. A retrospective was held at the SNGMA in 1963.

Bibliography

ACGB: *W. G. Gillies and John Maxwell* (exhibition catalogue 1954)

ACGB (Scottish Committee): *Watercolour Paintings by John Maxwell RSA* (exhibition catalogue 1960)

Edinburgh, SNGMA: *John Maxwell* (exhibition catalogue 1963)

David McClure: *John Maxwell*, Edinburgh 1975

242 **View from a Tent** 1933
Inscribed b.r.: 'John Maxwell/1933'
Oil on panel 76.2 × 91.5 cm
GMA 977 (1966)

[colour illustration page 66]

243 **Three Figures in a Garden** 1934
Inscribed b.r.: 'John Maxwell 34'
Oil on plyboard 101.5 × 127 cm
Joanna Drew

244 **Still Life with Stuffed Birds** 1934
Inscribed b.r.: 'John Maxwell 34'
Oil on canvas 91.5 × 61 cm
GMA 2475 (1982)

245 **Fish Market** 1934
Inscribed b.l.: 'John Maxwell 1934'
Oil on canvas 71.5 × 96 cm
GMA 1926 (Dr R. A. Lillie Bequest, 1977)

246 **Harbour with Three Ships** 1934
Inscribed b.l.: 'John Maxwell/34'
Oil on canvas 71.3 × 87.7 cm
GMA 3342 (George & Isobel Neillands Bequest, 1988)

[colour illustration page 67]

247 **Ventriloquist** 1952
Inscribed b.r.: 'John Maxwell/52'
Oil on canvas 68.6 × 55.9 cm
GMA 3347 (George & Isobel Neillands Bequest, 1988)

248 **Phases of the Moon** 1958
Tapestry in wool 182.8 × 243.8 cm
(Commissioned by the Scottish Committee of the Arts Council, woven by the Edinburgh Tapestry Company)
Scottish Arts Council Collection

249 **Figures in a Garden** 1937
(or **Strange Garden**)
Inscribed l.r.: 'John Maxwell/1937'
Watercolour, pen and ink on paper
34.3 × 49.9 cm
GMA 870 (Presented by Mr Hubert Wellington, 1963)

250 **Requiem for a Decayed Affection** 1937
Inscribed l.r.: 'John Maxwell/1937'
Watercolour, pen and ink on paper
51 × 63.5 cm
GMA 1324 (Sir David Milne Bequest, 1974)

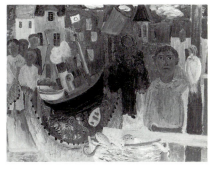

245

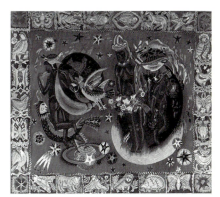

248

Margaret Mellis b.1914

Born in Wu-Kung-Fu in China to Scottish parents, Mellis came to Britain at the age of one. From 1929–33 she attended ECA where she was taught by Peploe. In 1933 Mellis won a travelling scholarship enabling her to study in Paris for one year with the painter André Lhote. Following her travels in Spain and Italy, she returned to ECA where she held a Fellowship from 1935–37. In 1938 she moved to London where she married the writer and painter Adrian Stokes. They moved to St Ives in Cornwall the next year, becoming central figures in the emerging St Ives group. Under the influence of Ben Nicholson and the Russian sculptor Naum Gabo, who lived close by, Mellis adopted a Constructivist idiom, making geometric reliefs from plywood sheets. After her divorce from Stokes she remarried and between 1948–50 lived in the South of France, returning again to painting. In 1950 she settled once more in England and now lives and works at Southwold, Suffolk, where she continues to produce wood constructions, often using driftwood and found objects.

Bibliography

Stromness, Orkney, Pier Arts Centre: *Margaret Mellis 1940–80* (exhibition catalogue 1982)
London, Redfern Gallery: *Margaret Mellis 1940–1987* (exhibition catalogue 1987)

251 **White Still Life** 1939
Oil on canvas 63.3 × 76.4 cm
Private Collection

252 **Construction in Wood** 1941
Wooden relief with inscribed pencil lines 36.4 × 37.3 cm
GMA 2745 (1983)

[colour illustration page 77]

253 **White Painting (with Red, Blue, Violet and Ochre)** 1964
Oil on hardboard 116.8 × 101.6 cm
GMA 1499 (1975)

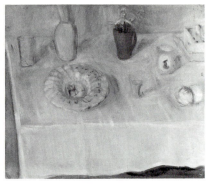

251

Alexander Moffat b.1943

Moffat was born in Dunfermline and studied drawing and painting at ECA from 1960–64. He worked in an engineering factory in Edinburgh from 1964–66 and as a photographer from 1966–74. In 1963 Moffat and his close friend John Bellany exhibited their paintings in the open air at Castle Terrace, Edinburgh and the following two years, showed work outside the RSA. From 1968–78, Moffat was Chairman of the 57 Gallery, Edinburgh. He is principally a portraitist; before 1967 he employed earth colours but later adopted a brighter palette. Max Beckmann's figure paintings influenced Moffat's use of sharp black contour lines and high-key colour: he organised a small Beckmann show at the 57 Gallery. Another influence has been the work of R. B. Kitaj. An exhibition of Moffat's portraits was held at the SNPG in 1973. In 1981–82 TEC organised a travelling show of his portraits of Scottish poets. A smaller show of portraits of young artists was shown at SNGMA in 1988. Since 1979, Moffat has taught at GSA where he is now Senior Lecturer. His teaching has been very influential on the new generation of Glasgow painters. His writings on art have appeared in many art reviews and he has selected several exhibitions of contemporary painting.

Bibliography

Edinburgh, SNPG: *A view of the Portrait: Portraits by Alexander Moffat* (exhibition catalogue 1973)
Glasgow, TEC: *Seven Poets: an Exhibition of Paintings and Drawings by Alexander Moffat* (exhibition catalogue 1981)

254 **Gwen Hardie** 1987
Oil on canvas 152 × 122 cm
GMA 3454 (1989)

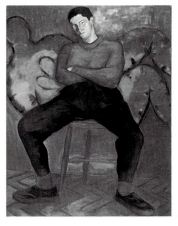

254

Alastair Morton 1910–1963

Morton was born in Carlisle where his father, James Morton, headed a firm of textile manufacturers and conducted research into colour dyes. In 1926 the Morton family moved to Edinburgh where branches of the firm were based. Alastair Morton joined the company, Morton Sundour, at the age of twenty-one, having studied mathematics for a year at Edinburgh University and spent a brief period at Oxford University. In 1928 James Morton founded Edinburgh Weavers with the object of producing contemporary textile designs; Alastair Morton joined the company in 1932 and was soon its Artistic Director. In 1932 the family moved back to the Carlisle area and from about 1935 Alastair Morton began his involvement with leading British artists of the Modern Movement, including Ben Nicholson and Barbara Hepworth. During the late 1930s he commissioned them and other Constructivist artists to design fabrics for Edinburgh Weavers. From 1936 Morton produced his own Constructivist-inspired paintings, exhibiting them at group shows from 1937 onward.

Bibliography

Jocelyn Morton: *Three Generations of a Family Textile Firm*, London 1971

Edinburgh, SNGMA: *Alastair Morton and Edinburgh Weavers: Abstract Art and Textile Design 1935–46* (exhibition catalogue 1978)

255 **Untitled** 1939
Gouache and pencil on paper
51 × 35.6 cm
GMA 2001 (1978)

[colour illustration page 77]

256 **Untitled** 1940
Pencil on paper 37.2 × 25.5 cm
GMA 1527 (1976)

257 **Untitled** 1940
Gouache, watercolour and pencil
on paper 35.6 × 51 cm
GMA 2002 (1978)

255

and religious subjects. Murray's first solo exhibition was held at the Leicester Galleries, London in 1946 and another followed at Batley Art Gallery in 1950. A memorial exhibition was held at Temple Newsam House, Leeds in 1955.

Bibliography

Ernest I. Musgrave: 'Charles Murray 1894–1954', *The Studio* Vol.CXLIX, No.747, June 1955, pp.180–83
Leeds, Temple Newsam House: *Charles Murray Memorial Exhibition* (exhibition catalogue 1955; Catalogue and Foreword by E. I. Musgrave)
Edinburgh, The Merchant Company Hall: *Charles Murray 1894–1954* (EIF exhibition catalogue 1977; Text by Sir John Rothenstein; Biography and Catalogue by Emilio Coia)

258 **The Adoration of the Magi**
Inscribed b.r.: 'Charles Murray'
Etching 39 × 25 cm
GMA 452 (transferred from the NGS)

259 **Borghese Gardens** 1924
Inscribed b.r.: 'Chas. Murray'
Etching 23.4 × 29.2 cm
GMA 2560 (1982)

shown at many photography exhibitions in Britain, and had a one-man show at Stills Gallery, Edinburgh, in 1985. In 1987 he created the tableau for *The Great Divide* at the SNGMA as part of its exhibition *The Vigorous Imagination*.

Bibliography

London, The Photographers Gallery: *Constructed Narratives: Photographs by Calum Colvin and Ron O'Donnell* (exhibition catalogue 1986)
Edinburgh, SNGMA: *The Vigorous Imagination* (exhibition catalogue 1987)

260 **The Great Divide** 1987
Colour photograph 183 × 305 cm
GMA 3046 (1987)

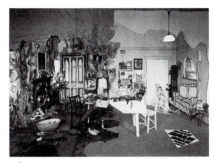

260

Charles Murray 1894–1954

Born in Aberdeen, Murray studied at GSA c.1908–11. Murray served with the White Army in Russia 1918–20 and, upon his return to Glasgow, won a Prix de Rome for etching in 1922. He studied at the British School in Rome from 1922–25. Murray's use of extenuated, mannerist forms, curved lines and dynamic compositions gave his prints of the late 1920s an extraordinary intensity. These traits and the interest in the drama of the subject were passed on to the post-graduate Ian Fleming in c.1928 in his print-making classes at GSA. A breakdown in health in 1930 brought Murray's etching career to a temporary close. In 1935, following his marriage and move to Pinner, he began once more and painted oil and gouache landscapes

Ron O'Donnell b.1952

O'Donnell was born in Stirling where from 1970–76 he was a trainee photographer at the University. Since 1976 he has worked as a technical photographer in the Civil Engineering Department of Edinburgh University. During the 1970s and early 1980s, O'Donnell photographed the decaying interiors of old-fashioned shops and slum dwellings. Around 1984, he began making alterations to the interiors of disused buildings, adding Surrealist-inspired motifs – Egyptian frescoes were painted over the peeling wallpaper of a tenement interior; a cardboard nuclear mushroom-cloud appears in the middle of a sitting room. Unlike Calum Colvin (with whom O'Donnell was shown in an exhibition *Constructed Narratives* at the Photographers Gallery, London 1985), O'Donnell prefers to adapt existing interiors rather than create entirely new settings. He has

Elizabeth Ogilvie b.1946

Born in Aberdeen, Elizabeth Ogilvie studied sculpture at ECA from 1964–69 under Eric Schilsky. From 1969–70 she spent a post-graduate scholarship year working on white plaster reliefs. The constraints of this medium led her towards two-dimensional work, and to her favoured medium of monochromatic drawing on paper. Her first solo show was in 1974 at the 57 Gallery, Edinburgh. Also in that year she discovered, with Robert Callender, the Point of Stoer in Sutherland. Here she found in the bleak solitude of the seascape a major source of inspiration. Sea images were the subject of a solo show in 1976, also at the New 57 Gallery, and the sea has remained her subject ever since. Other solo shows have been *Watermarks* (with Robert Callender) 1980, and in 1981, *New Work* at the Serpentine Gallery, London. In this exhibition, for the first

time, she showed images drawn on scrolls and across folding screens, evidence of her interest in the art of the Far East. In 1984 she began to use seaweed as a metaphor for the moving surface of the sea (*Sea Papers*, TRAC). Since then her restrained and austere work has acquired a greater sense of freedom with the use of washes, collaged handmade paper and scrim. She has also used transparent acetate, for example in her first book, of Haiku poems. Some of her recent work is on a giant scale e.g. 24 feet across. St Kilda, the home of her maternal grandfather, has provided a new source of imagery. Elizabeth Ogilvie has won several SAC Awards and was President of the SSA from 1981–83. She lives and works in Leith and is currently a lecturer at ECA.

Bibliography

SAC: *Watermarks* (exhibition catalogue 1980)
Edinburgh, TRAC: *Sea Papers* (exhibition catalogue 1984)
Edinburgh, TRAC: *Sea Sanctuary* (exhibition catalogue 1988)

261 **Sea Sanctuary** 1989
 Seaweed, graphite, ink, charcoal, acetate and acrylic on handmade paper 244 × 366 cm
 The Artist

261

Glen Onwin b.1947

Onwin was born in Edinburgh where from 1966–71 he studied painting at ECA. Towards the end of his studies there, he began incorporating natural chemical substances into his works, applying, for example, salt onto papier-

maché sheets. In March 1973 he discovered a vast salt marsh on the east coast near Dunbar, consisting of hundreds of pools of evaporating salt-water. Onwin was immediately struck by the constantly changing nature of the marsh as the tide altered the shape and size of the pools and as the plant life died wherever the salt formed deposits. He made a series of photographs of the site and evoked a sense of natural decay in drawings and constructions onto which he applied wood, glass, wax and salt itself. Onwin created a rich symbolism of salt as both life-giving force and destroying substance. These works were featured in a 1975 SAC touring exhibition and further works developing the theme of elemental decomposition were shown in 1978 at the Arnolfini Gallery, Bristol and elsewhere in an exhibition entitled *The Recovery of Dissolved Substances*. During the 1980s he has introduced a great variety of natural substances and objects such as leaves, sulphur, ash and earth into his work. While, during the 1970s, Onwin produced work in a variety of different formats and types, recently he has concentrated on flat surfaces onto which he applies natural debris and which he coats with a great variety of materials in a process more akin to alchemy than to traditional picture-making. His interest in natural decay and decomposition has led on to a searching investigation into human-induced pollution.

Bibliography

Glen Onwin: *Saltmarsh*, Edinburgh 1974
Edinburgh, SAC: *Glen Onwin Saltmarsh* (exhibition catalogue 1975; Text by David Brown)
London, ICA: *Essential For Life . . . The Recovery of Dissolved Substances* (exhibition catalogue 1978; Essay by David Brown)
Glen Onwin: *The Recovery of Dissolved Substances*, Bristol 1978
Edinburgh, FMG: *Revenges of Nature: Glen Onwin* (exhibition catalogue 1988)

262 **Salt Room Crystal** 1977
 Salt and zinc on wood (three panels) Each panel
 191.8 × 91.3 cm
 GMA 2114 (1979)

[colour illustration page 99]

Eduardo Paolozzi b.1924

Born in Leith, Paolozzi was the son of Italian immigrants. With the outbreak of World War II, he was interned for three months and then in 1943 began evening classes at ECA. Following service in the Royal Pioneer Corps, Paolozzi attended the Slade School of Art, initially at Oxford and then in London. From 1945 he fell under the spell of French Dada and Surrealist art, producing a series of Dada-inspired collages in which photographs of human figures and machine parts are combined. Following his first solo exhibition at the Mayor Gallery, London, in 1947, Paolozzi moved to Paris where he met many of the leading avant-garde artists, including Dubuffet and Giacometti. He began incorporating illustrations from contemporary advertisements and comic-strips into collages which were to prove seminal in the evolution of British Pop Art. Inspired by Giacometti, Paolozzi also produced a number of enigmatic sculptures, some of which were exhibited at the Hanover Gallery, London, in 1950 alongside works by William Turnbull and Kenneth King. In the early 1950s, Paolozzi became one of the central figures of the Independent Group, a proto-Pop gathering of artists and critics centred around London's ICA. Just as Paolozzi had incorporated junk motifs into collages, so in the 1950s he employed a parallel technique in his bronze sculptures, pressing found objects and machine parts into loosely anthropomorphic clay figures, giving them a rich encrusted surface comparable to works produced by the French *Art Brut* movement. Paolozzi taught textile design at the Central School of Art and Design, London from 1949–55 and sculpture from 1955–58 at St Martin's School of Art, London. In 1960 he represented Britain at the Venice Biennale. That same year, he was appointed Visiting Professor at the Staatliche Hochschule für Bildende Kunst, Hamburg, precipitating a move to Germany where he has since held a variety of posts. In 1968 he was appointed Lecturer in Ceramics at the RCA. The Tate Gallery held a major Paolozzi retrospective in 1971. During the 1970s and 1980s Paolozzi won a number of major public commissions which include the large entrance doors of Glasgow University's Hunterian

Museum, 1976, mosaics for Tottenham Court Road Tube Station, London, 1980, and a variety of large-scale works in Germany. Paolozzi divides his time between homes in Munich (where he is Professor of Sculpture at the Akademie der Bildenden Künste) and London. He was made Queen's Sculptor in Ordinary for Scotland in 1986 and knighted in 1988.

Bibliography

Diane Kirkpatrick: *Eduardo Paolozzi*, London 1970
Uwe Schneede: *Eduardo Paolozzi*, London 1971
London, Tate Gallery: *Eduardo Paolozzi* (exhibition catalogue 1971)
ACGB: *Paolozzi* (catalogue of touring exhibition 1976)
Edinburgh, RSA: *Eduardo Paolozzi Recurring Themes* (exhibition catalogue 1984)
Winfried Konnertz: *Eduardo Paolozzi*, Cologne 1984

263 **Sea Horse (Horse's Head)** 1946
Inscribed on base: 'Eduardo Paolozzi/Gabrielle KEILLER/SLADE 1947'
Bronze 69 × 46 × 34 cm
Private Collection (on loan to SNGMA)

264 **Paris Bird** 1948–49
Stamped on base: '6/6 EDUARDO PAOLOZZI'
Bronze 33.5 × 34.5 × 15.5 cm
GMA 3303 (1987)

265 **Two Forms on a Rod** 1948–49
Bronze 51 × 65 × 32.5 cm
GMA 3398 (1988)

266 **Table Sculpture (Growth)** 1949
Stamped on edge of table: '3/6 EDUARDO PAOLOZZI'
Bronze 81.2 × 60.3 × 39 cm
GMA 3399 (1988)

[colour illustration page 80]

267 **Krokodeel** 1956
Bronze 94 × 60 × 20 cm
GMA 3400 (1988)

268 **Icarus** 1957 (first version)
Bronze 134.6 × 72 × 32 cm
GMA 824 (Presented by the Artist and Messrs. Lund Humphries in memory of Mr E. C. Gregory, 1962)

269 **Icarus** 1957 (second version)
Bronze 143.5 × 60 × 35 cm
Private Collection (on loan to SNGMA)

270 **Large Frog** 1958 (new version)
Inscribed on base: '5/6'
Bronze 72 × 82 × 82 cm
Private Collection (on loan to SNGMA)

271 **His Majesty the Wheel** 1958–59
Bronze 183 × 70 × 50 cm
GMA 3449 (1989)

[colour illustration page 81]

264

Alistair Park 1930–1984

Park was born in Edinburgh where from 1949–52 he studied at the College of Art, his final year being provided for by an Andrew Grant Post-Graduate Scholarship. After National Service from 1953–55, Park taught part-time at ECA and then, from 1957–63, was art teacher at an Edinburgh secondary school. In 1963 he was awarded the post of lecturer at Bradford College of Art, moving to Newcastle upon Tyne's College of Art in 1967 and lecturing there until his death in 1984. Park began exhibiting at an early age, having one-man shows at the 57 Gallery, Edinburgh, in 1957 and 1958. During the 1960s he exhibited extensively throughout Britain. From the figurative work of the late 1950s to the abstract paintings of the 1960s, Park's work showed a very natural evolution. Explaining his work in 1963, Park wrote: 'I was interested in elementary images which have usually resolved into forms with human connections. In late paintings, these human images have been appearing in the forms of squares and circles and ovoids. It was an obvious step to move into the non-figurative world.' The RDG showed Park's work in many group exhibitions and in several one-man shows, the last being in 1983.

Bibliography

Edinburgh, CAC: *Alistair Park* (exhibition organised by RDG, catalogue 1983)

272 **Female Nude** 1959
Inscribed b.l.: 'Alistair Park '59'
Oil on canvas 110.4 × 85.5 cm
Private Collection (on loan to SNGMA)

272

Agnes Miller Parker 1895–1980

Born in Irvine, Ayrshire and educated at
Whitehill Higher Grade School, Glasgow,
Parker trained at GSA 1914–18 where
she was awarded the Haldane Scholar-
ship. She married fellow artist William
McCance. Parker taught at GSA 1918–
20. In 1920 she and her husband moved
south, and she taught at Gerrards Cross
from 1920–28. She was a partly self-
taught wood-engraver but also studied in
1926 with Gertrude Hermes and Blair
Hughes-Stanton. She and McCance went
on to run the Gregynog Press in Mid-
Wales in 1930. In 1931 Parker illus-
trated *The Fables of Esope* for Gregynog,
among other commissions. The springing
forms, fine cross-hatching and subtle use
of light in her compositions were charac-
teristics sustained throughout her career.
She also did work for the Golden Cock-
erell Press and the Limited Editions Club
of New York. In 1933 she became a
member of the Society of Wood
Engravers and later an Associate of the
Royal Society of Painter-Etchers and
Engravers. She separated from McCance
in 1955 and subsequently moved to
Glasgow and, finally, the island of Arran.

Bibliography

Albert Garrett: *A History of British Wood Engraving*,
 Tunbridge Wells 1978
Edinburgh, SAC: *Graven Images* (exhibition cata-
 logue 1979)
London, Society of Wood Engravers: *Engraving Then
 and Now* (catalogue of the retrospective 50th
 exhibition 1987)

273 **Herte and Dogges** 1931
 Inscribed b.l.: 'Herte and Dogges
 10/12' and b.r: 'A Miller Parker.
 1931'
 Wood engraving 10.8 × 12.7 cm
 GMA 466 (transferred from NGS)

273

James McIntosh Patrick b.1907

James McIntosh Patrick, the son of an
architect, was born in Dundee. From an
early age he showed great technical dex-
terity in both watercolour and oil-
painting. In 1924 he enrolled at GSA
where he won a host of prizes and a post-
Diploma scholarship. From his student
days onwards, McIntosh Patrick con-
centrated on minutely detailed
panoramic views of the landscape and
this preference has remained a constant
feature of his work. While he did execute
oil paintings as a student, his early talent
was for etching. This inclination was
encouraged when in 1928 he signed a
substantial contract with a London
dealer for editions of prints. When the
print market slumped in the 1930s, he
diversified, taking a part-time post at
Dundee College of Art in 1930, making
illustrations for postcards and journals
and turning to oil-painting. From 1928
he exhibited paintings at the RA in
London and these were favourably
received by the press. The Fine Art
Society began selling his works from
1934; the Tate Gallery bought an oil in
1935. McIntosh Patrick's landscape
paintings, which recall Breughel's, show
a meticulous attention to detail, a high
viewpoint and a crisp directional light
source. The motifs were generally of agri-
cultural rather than wild nature and
were mainly found within a twenty-mile
radius of McIntosh Patrick's Dundee
home. After war service in the
Camouflage Corps, he took to painting *en
plein air*, having previously composed
views in the studio after outdoor
sketches. The super-realist detail
remained constant, however. He was
elected ARSA in 1949 and RSA in
1957. Important one-man exhibitions
were held at Dundee City Art Gallery in
1967 and at Dundee, Aberdeen and
Liverpool in 1987. McIntosh Patrick lives
and works in Dundee.

Bibliography

Dundee, City Art Gallery: *McIntosh Patrick* (exhibi-
 tion catalogue 1967)
Roger Billcliffe: *James McIntosh Patrick*, London 1987

274 **Sidlaw Village, Winter** 1936
 Inscribed b.l.: 'J. McIntosh
 Patrick/36'

Oil on canvas 71 × 91 cm
Private Collection

275 **A City Garden** 1940
 Inscribed b.r.: 'J. McIntosh
 Patrick '40'
 Oil on canvas 71 × 91.4 cm
 Dundee Art Galleries & Museums

 [colour illustration page 70]

276 **The Green Belt** c.1938
 Inscribed t.l.: 'Design for L.T.P.B.
 Poster "Harrow Weald" J M
 Patrick'
 and b.c.: 'THE GREEN BELT'
 Pencil, ink and watercolour on card
 23 × 31 cm
 GMA 2146 (1980)

277 **Stobo Church** c.1936
 Inscribed b.r.: 'J. McIntosh Patrick'
 Etching 16.4 × 25.4 cm
 GMA 2559 (1982)

278 **Happy Scenes of Cheer Again** 1938
 Poster 98 × 57 cm
 The Artist's Family

279 **Longer Days are Here Again** 1938
 Poster 98 × 57 cm
 The Artist's Family

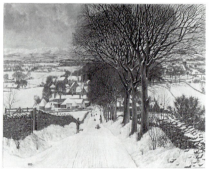

274

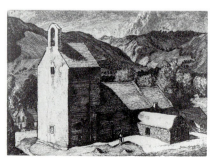

277

HAPPY SCENES
OF CHEER AGAIN

278

Samuel John Peploe 1871–1935

Born in Edinburgh and apprenticed to a legal firm, Peploe attended evening classes at ECA from 1891–94. His determination to paint led him to Paris in 1894 where he studied under Bouguereau at the Académie Julian and won a medal at the Académie Colarossi. In 1894 he painted landscapes on Barra with R. C. Robertson and commenced a series of figure subjects which paid homage to Manet and Hals. In the following year he visited Amsterdam, won the RSA life-class medal and in 1896 began exhibiting with the GI. His first solo exhibition was at Aitken Dott (The Scottish Gallery) in 1903. In 1904 he painted in Brittany with J. D. Fergusson and in 1905 he moved into Raeburn's former studio in Queen Street, Edinburgh. This coincided with a lighter painting style in the manner of W. Nicholson, Lavery and Sargent. Peploe married and moved to Paris in 1910 where he contributed six drawings to the avant-garde art review *Rhythm*. During 1910–12 he experimented with Fauve colour theories and the inter-relationship of shape and colour in landscapes and still lifes. These were shown at the New Gallery, Edinburgh upon his return from France in 1913. In 1920 Cadell invited Peploe to paint on Iona. The French government purchased an Iona landscape at the group show of Scottish painters at the Galerie Barbazanges, Paris in 1924. Peploe was also shown in group exhibitions at the Leicester Galleries,

London in 1923 and 1925. During the last decade of his life Peploe's mature style consisted of finely balanced compositions, painted on a chalky ground with dry outlines and a sculptural sense of form. The work ranged from an almost monochromatic purity in his still lifes to the vivid colour of his Mediterranean landscapes and the rich greens of the Scottish countryside. Peploe was elected RSA in 1927 and had a solo show at the Kraushaar Gallery, New York in 1928. The French government purchased a Cassis landscape from the exhibition *Les Peintres Ecossais* held at the Galerie Georges Petit, Paris, in 1932. Ill-health curtailed his year of teaching at ECA in 1933. Memorial exhibitions were held at Aitken Dott, Edinburgh in 1936, the McLellan Galleries, Glasgow in 1937 and the NGS in 1941.

Bibliography

Glasgow, McLellan Galleries: *Memorial Exhibition* (exhibition catalogue 1937; organised by Reid & Lefevre and Pearson and Westergaard; Foreword by E. A. Taylor)
Stanley Cursiter: *Peploe*, London 1947
T. J. Honeyman: *Three Scottish Colourists. S. J. Peploe. F. C. B. Cadell. Leslie Hunter*, London 1950
SAC: *Three Scottish Colourists. Cadell: Hunter: Peploe* (catalogue of touring exhibition 1969–70; Foreword by T. J. Honeyman, Essay by William Hardie, Catalogue and Biography by Ailsa Tanner)
Edinburgh, SNGMA: *S. J. Peploe 1871–1935* (catalogue of EIF exhibition 1985; Essay and Catalogue by Guy Peploe)

280 **Self Portrait**
Oil on panel 50 × 30 cm
GMA 1950 (Dr R. A. Lillie Bequest, 1977)

281 **Man Laughing** *c.*1901–5
Oil on panel 71.1 × 50.8 cm
GMA 33 (Presented by the Trustees of Mr G. Proudfoot to NGS 1946, transferred to SNGMA)

282 **The Black Bottle** *c.*1905
Inscribed b.l.: 'peploe'
Oil on canvas 50.8 × 61 cm
GMA 26 (Presented by Mr J. W. Blyth to NGS 1939, transferred to SNGMA)

[colour illustration page 50]

283 **The Green Blouse** *c.*1905
Inscribed b.l.: 'Peploe'
Oil on wood 50.8 × 50.2 cm
GMA 28 (1941)

284 **Game of Tennis, Luxembourg Gardens** *c.*1906
Oil on board 15.5 × 23 cm
GMA 1944 (Dr R. A. Lillie Bequest, 1977)

285 **Boats at Royan** 1910
Oil on canvas 27 × 35.5 cm
GMA 1949 (Dr R. A. Lillie Bequest, 1977)

286 **Verville-les-Roses** 1910–11
Oil on cardboard 35.6 × 27 cm
GMA 909 (1965)

[colour illustration page 55]

287 **Ile de Bréhat** *c.*1912
Inscribed b.l.: 'peploe'
Oil on board 33.5 × 41.5 cm
GMA 1941 (Dr R. A. Lillie Bequest, 1977)

288 **Still Life** *c.*1913
Inscribed b.r.: 'peploe'
Oil on canvas 54.6 × 46.4 cm
GMA 32 (Presented by Mr A. J. McNeill Reid to NGS 1946, transferred to SNGMA)

289 **Still Life with Melon** *c.*1919–20
Inscribed b.l.: 'peploe'
Oil on canvas 46 × 40.5 cm
GMA 1951 (Dr R. A. Lillie Bequest, 1977)

[colour illustration page 60]

290 **Roses** *c.*1921
Inscribed b.l.: 'peploe'
Oil on canvas 50.8 × 61 cm
GMA 27 (Presented by the Rev. H. G. R. Hay-Boyd to NGS 1941, transferred to SNGMA)

291 **Landscape, South of France** 1924
Inscribed b.r.: 'peploe'
Oil on canvas 51 × 56 cm
GMA 1103 (1969)

292 **Landscape at Cassis** 1924
Inscribed b.r.: 'peploe'
Oil on canvas 57.2 × 45.8 cm
GMA 866 (G. Binnie Bequest, 1963)

293 **Iona Landscape, Rocks** *c.*1927
Inscribed b.l.: 'peploe'
Oil on canvas 39.7 × 46 cm
GMA 1942 (Dr R. A. Lillie Bequest, 1977)

294 **Still Life with Plaster Cast** *c.*1931
Inscribed b.l.: 'peploe'
Oil on canvas 58.4 × 54.6 cm
GMA 31 (K. Sanderson Bequest to NGS 1943, transferred to SNGMA)

295 **Head of Young Girl**
Inscribed l.l.: 'peploe'
Pastel on paper 31.5 × 24.5 cm
GMA 1940 (Dr R. A. Lillie Bequest, 1977)

296 **Figures**
Oil and black chalk on paper
17 × 21.5 cm
GMA 1938 (Dr R. A. Lillie Bequest, 1977)

297 **Quayside, Cassis**
Inscribed b.c.: 'peploe'
Black crayon on paper
15 × 22.2 cm
GMA 1936 (Dr R. A. Lillie Bequest, 1977)

298 **In Cassis Harbour**
Inscribed t.l.: 'PEPLOE'
Black crayon on paper
15 × 22.2 cm
GMA 728 (transferred from NGS)

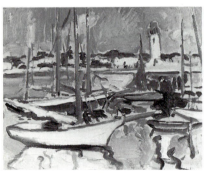

285

287

William Watson Peploe

1869–1933

Eldest son of the banker Robert Luff Peploe and his second wife Anne Hickock Watson, W. W. Peploe's career has been overshadowed by that of his younger brother S. J. Peploe. He was a bank manager with the Commercial Bank of Scotland in Stockbridge, Edinburgh. In *c.*1894 and during the following summers R. C. Robertson, S. J. Peploe and W. W. Peploe painted together on Barra. In 1910 when S. J. Peploe married Margaret Mackay and moved to Paris, 'Willie' published a volume of poetry *The Heart of a Dancer*, dedicated to S. J. Peploe: 'dearest brother and friend in love and memory'. The fin-de-siècle titles of the poems include 'Fleur du Mal', 'Hebridean' and 'Kimono'. Willie Peploe's black and white drawings satirised the Aubrey Beardsley school and the fashion for Japanese art. In 1918 he produced two tiny abstract colour sketches. However, these seem not to have led to any other works in this manner. The Peploe family have suggested that these were another manifestation of his playfulness.

Bibliography

Stanley Cursiter: *Peploe*, London 1947

EX. CAT.
Souvenir of the Red Triangle 1918
Watercolour and ink on card
8.9 × 14 cm
GMA 1295 (1973)

W.W. Peploe, *Souvenir of the Red Triangle*, 1918

Robin Philipson b.1916

Born at Broughton-in-Furness, Lancashire, Philipson went to school in Whitehaven, Cumberland. When he was fourteen his family moved to Gretna. Philipson attended Dumfries Academy and then ECA from 1936–40. In 1940, he joined the King's Own Scottish Borderers, serving in India for six years. He joined the staff of ECA in 1947. While early influences on his painting included the Edinburgh painters Gillies and Maxwell, after the war Kokoschka's expressive, painterly style deeply affected his work. In the early 1950s he began a series of paintings depicting cock-fights, a theme he would continue into the following decade. In 1948 he was elected SSA. His paintings were included in a 1952 touring exhibition of *Young Contemporary Painters* organised by the SAC, and in 1954 and 1958 he was given one-man shows at the Scottish Gallery in Edinburgh. These exhibitions were both dominated by paintings from the cock-fighting series which verge on informal abstraction in the versions produced around 1960. In 1960 and 1962 two solo shows were held at Roland, Browse and Delbanco in London. In 1962, Philipson was elected RSA. During the 1960s he again worked in series, first on the theme of Kings and Queens and subsequently on the themes of World War I soldiers, crucifixions and cathedral interiors. Common to each work was an aggressive handling of paint, a jewel-like colouration and a tendency towards abstraction, though the subject is never entirely lost. In the 1970s Philipson searched for greater clarity of design in series which made repeated references to animals, frequently zebras. In 1973 he was elected President of the RSA, a post he held for ten years, and in 1976 he was knighted. In 1982 he retired as Head of the School of Drawing and Painting at ECA. His recent work demonstrates a renewed interest in facture, heavy impasto contrasting with large areas of flat paint. The wide variety of techniques and approaches adopted by Philipson from serene figurative watercolours to aggressively semi-abstract oils denotes an artist never content to adopt a formula.

Bibliography

Edinburgh, The Scottish Gallery: *Robin Philipson* (exhibition catalogue 1961; Essay by T. Elder Dickson)
Dunfermline, Carnegie Festival: *Robin Philipson* (exhibition catalogue 1970)
Maurice Lindsay: *Robin Philipson*, Edinburgh 1976
Edinburgh, The Scottish Gallery: *Robin Philipson* (exhibition catalogue 1983)

299 **Woman in Ecstasy** *c.*1955
Inscribed b.r.: 'R. Philipson'
Oil on canvas 208 × 105.5 cm
Private Collection (on loan to SNGMA)

300 **Fighting Cocks, Grey** 1960
Inscribed b.l.: 'R. Philipson'
Oil on canvas 63 × 75.8 cm
GMA 788 (1961)

[colour illustration page 84]

301 **Burning at the Sea's Edge** 1961
Inscribed b.r.: 'R. Philipson'
Oil on canvas 63.5 × 76.2 cm
GMA 1054 (R.R. Scott Hay Bequest, 1967)

[colour illustration page 84]

299

Valerie Pragnall b.1942

Pragnall was born in Worthing and in her twenties pursued a variety of jobs in London and Paris. She came to Glasgow in 1972 and from 1981–85 studied in the Mural and Stained Glass Department at GSA. Pragnall's sculptures are created from natural materials such as branches, twigs and moss, often weaving them together into nest-like containers; many are site-specific, designed for a particular location. She frequently makes allusion to themes of fertility, growth and survival, incorporating enlarged seed forms into her works. Pragnall was Artist-in-Residence at the 1988 Glasgow Garden Festival and recently produced a work for the Cramond Sculpture Centre near Edinburgh. Since 1985, her work has featured in many group shows in Glasgow and Edinburgh. She lives and works in Glasgow.

Bibliography

Glasgow, Collins Gallery: *Shape + Form: Six Sculptors from Scotland* (exhibition catalogue 1988)

EX. CAT.
Tree Pods 1988
Wood
The Artist

EX. CAT.
Storm 1989
Scots pine
The Artist

John Quinton Pringle

1864–1925

John Quinton Pringle was a lone figure among his Scottish contemporaries. Free from the need or desire to earn his living from painting, he very much followed his own course. His subjects included scenes of Glasgow and its backyards, landscapes sometimes with figures, and portraits sometimes in miniature. His craftsmanship is evident in the fine and vivid surface texture of his paintings, achieved through the delicate application of dabs of colour in his characteristic square brushstrokes. Born in the East End of Glasgow, Pringle started to paint at an early age. From 1869–74 the family lived at Langbank near Glasgow where the father was stationmaster. Langbank was a favourite sketching ground for Glasgow artists, and the young Pringle learnt by watching them. Returning to Glasgow, he was apprenticed to an optician. Meanwhile he continued his home studies. His tutors were copies of *Art Journal* and the *Magazine of Art*, and the works of art on show in the Glasgow galleries. He was an apt pupil with a good visual memory. The artists Pringle most admired were the Pre-Raphaelites, Bastien-Lepage (whose square brushstrokes he was to adopt) and the Glasgow Boys. He went to evening school from 1883–85 and won a bursary which allowed him to attend evening classes at GSA. This he did from 1886–95. Pringle was an outstanding pupil and F. H. Newbery, then Head of the School, thought highly of his work. He won several prizes, including, in 1891, the South Kensington National Competition Gold Medal for Life-Drawing. Among his fellow students were Charles Rennie Mackintosh and, from 1892, Muirhead Bone. In 1896 F. H. Newbery and William Davidson (who commissioned Windyhill from Mackintosh) asked Pringle to paint miniatures of their children. After setting up shop in 1896 at 90 Saltmarket, Pringle was more concerned with business but continued to paint in the back room. In the *Poultry Yard, Gartcosh* 1906 and *Tollcross* 1908, he produced work akin to the Neo-Impressionists, although the most he had seen of their work was the paintings of Le Sidaner shown at the GI. In 1910 he made his only trip to the continent – a ten-day trip to Caudebec in Normandy. His sister, Margaret, who had kept house for him, died in 1911 and his life became more difficult. He had more work in the shop than he could manage, and from 1911–20 he painted only watercolours. He resumed oil painting on a visit to Whalsay, in Shetland, in 1921. A retrospective show was organised at GSA in 1922. Visitors were surpised at the range and quality of Pringle's work. *Muslin Street Bridgetown* 1895–96 was bought for the SMAA. In failing health, Pringle was persuaded to give up the shop in 1922 to concentrate on painting.

During the few years until his death he made painting trips to Ardersier in Inverness-shire, to Bewdley in Worcestershire (during which trip he made a pilgrimage to see the Pre-Raphaelite collection at Birmingham City Art Gallery), to Ireland and another trip to Whalsay.

Bibliography

Elizabeth Johnston: 'John Quinton Pringle (1864–1925)', *Scottish Art Review*, Vol.IX, No.2, 1963, p.4

Glasgow, GAGM: *John Quinton Pringle 1864–1925. A Centenary Exhibition* (exhibition catalogue 1964; Text by James Meldrum and Alasdair Auld)

SAC: *John Quinton Pringle 1864–1926* (exhibition catalogue 1981; Text by James Meldrum and David Brown)

302 **Study of a Head: Man with Drinking Mug** 1904
Inscribed b.l.: 'JOHN Q PRINGLE/04'
Oil on canvas 31 × 25.8 cm
GMA 2028 (Presented by James Meldrum, 1978)

303 **Poultry Yard, Gartcosh** 1906
Oil on canvas 62.3 × 75.6 cm
GMA 37 (Presented by James Meldrum to NGS 1948, transferred to SNGMA)

[colour illustration page 52]

302

James Pryde 1866–1941

James Ferrier Pryde was born in Edinburgh where his father was Headmaster of Queen's Street Ladies College. The lofty tenements and grey terraces of Edinburgh's Old and New Towns were to have a lasting effect on Pryde as a painter. Pryde grew up with a love of the theatre. His parents were friends of Henry Irvine and Ellen Terry and when times were hard in the 1890s Pryde toured unsuccessfully as an actor with Edward Gordon Craig. He studied at the RSA School and in Bouguereau's studio in Paris but did not find either a productive experience. In 1890 he moved to London and from 1894 he collaborated with his brother-in-law William Nicholson, under the name of the 'Beggarstaff Brothers'. The partnership lasted until *c*.1898 and was highly successful, producing posters for, among others, Henry Irvine. Their novel technique of using cut-out paper silhouettes effected a revolution in the development of poster design. Early in the 1900s Pryde won some notice as a portraitist; among his sitters were Irvine, Ellen Terry and Lady Ottoline Morrell. He exhibited with the International Society of Painters becoming an Associate in 1901 and its Vice-President in 1921. As a painter Pryde's most fruitful period was from 1905–25. His often very large canvases have something of the theatre about the huge architecture and undersized figures, reminiscent of Velázquez, Piranesi, Daumier, Guardi and Hogarth, as well as something of the streets of Edinburgh. About 1909 Pryde began a sequence of paintings inspired by Mary Queen of Scots's bed at Holyrood Palace in Edinburgh. He painted twelve of these, with a thirteenth interrupted by his death. Lady (Annie) Cowdray, among others, saw and admired his work and from 1910–22 she bought several important works by Pryde. She commissioned him to produce more, and eighteen works in all were to hang along the side walls of the Library at Dunecht, the Cowdray family home in Aberdeenshire. From 1925 until his death Pryde produced very little work although he designed sets for Paul Robeson's *Othello* in 1930. His health ruined by alcohol, he was unable even to be present at his retrospective show at the Leicester Galleries, London,

in 1933. He died in Kensington in 1941. In 1949 the ACGB organised a memorial exhibition of his work shown in Edinburgh, Brighton and London.

Bibliography

London, Leicester Galleries: *The Art of James Pryde* (exhibition catalogue 1933; Text by H. Granville Fell)

Derek Hudson: *James Pryde 1866–1941*, London 1949

ACGB: *A Memorial Exhibition of Works by James Pryde 1866–1941* (exhibition catalogue 1949; Text by Derek Hudson)

London, Redfern Gallery: *James Pryde* (exhibition catalogue 1988; Text by John Synge)

304 **The Doctor** *c*.1908
Oil on canvas 85.5 × 72 cm
The Trustees of the Tate Gallery, London

305 **The Derelict**
Oil on canvas 153.5 × 141 cm
The Viscount Cowdray

306 **The Red Bed**
Oil on canvas 68 × 62.9 cm
City of Edinburgh Art Centre

307 **Lumber: A Silhouette** 1921
Oil on canvas 182.9 × 152.4 cm
GMA 1521 (1975)

[colour illustration page 51]

306

June Redfern b.1951

Born in Fife, Redfern studied drawing and painting at ECA from 1968–72. She then taught art at a comprehensive school in Leith. The experience of teaching greatly affected Redfern's work as she moved from using images found in magazines to painting her immediate surroundings in a broadly realist manner. Works from this period were shown at her solo exhibition *Real Lives* held at TEC in 1981. Following the show, Redfern became disillusioned with her previous work and took to making collages from fragments of paintings, sticking them on to silver backgrounds. After a brief period as part-time tutor at Preston Polytechnic (1982–83) she was appointed to the staff at Cardiff College of Art in 1983. A year earlier Redfern had returned to oil painting, adopting a bold expressionist use of brushwork and colour to produce strong, highly dramatic works. These recall contemporary German and Italian painting. In 1985 Redfern gave up her post at Cardiff to become Artist-in-Residence at the National Gallery, London. The paintings produced over the six-month period formed the basis of an exhibition at the Gallery in 1986. Redfern has shown regularly at the 369 Gallery, Edinburgh, and has also had numerous solo exhibitions, including those at the AIR Gallery, London, in 1984 and at TEC in 1985. In 1986 she was guest artist at the University of Minnesota, USA. She has since been visiting tutor at a variety of art colleges in Britain.

Bibliography

Glasgow, TEC: *June Redfern: To the River* (exhibition catalogue 1985)
London, National Gallery: *June Redfern: Artist in Residence* (exhibition catalogue 1986)

308 **My Baby Moon** 1983
Oil on canvas 190.5 × 214 cm
GMA 2797 (1983)

[colour illustration page 102]

Anne Redpath 1895–1965

Born in Galashiels, Redpath was the daughter of a textile designer. Educated in Hawick, she studied at ECA under Henry Lintott and Robert Burns from 1913–17. Redpath qualified as an art teacher at Moray House College of Education. In 1919 she won a travelling scholarship which took her to Brussels, Bruges, Paris, Florence and Siena. The painting *Girl in a Red Cloak* of 1921 with its flat silhouette against a gold ground and embossed with naïve decoration, incorporated aspects that Redpath was to develop throughout her career. Following her marriage in 1920 Redpath moved first to Northern France, then to the Riviera, with her husband James Beattie Michie, an architect with the Imperial War Graves Commission. She returned to settle in Hawick in 1934 and resumed her career as a painter. At the time of her first solo exhibition at Gordon Small's Gallery, Edinburgh, in 1947, Redpath was painting landscapes and still-life interiors in white and grey, but was moving towards a brighter palette inspired by Matisse, Gauguin, oriental manuscripts and Far Eastern textiles. Redpath visited Paris in 1948 and moved to Edinburgh in 1949. She was elected RSA in 1951. A visit to Spain, also in 1951, inspired Redpath to adopt a new expressive handling of paint and to inject a sense of drama into sombre compositions of peasant figures, hill towns and church interiors. The paintings of Tréboul in Britanny of *c.*1953 recall Christopher Wood. A trip to Corsica in 1954 heralded a brilliant use of colour, and a delight in the organic nature of rocks, buildings, plants and jewel-encrusted altarpieces. She suffered a serious illness in 1955 which recurred in 1959 and limited her output. Having learnt to paint with her left hand and regained the use of her right, Redpath went to the Canary Islands in 1959, Portugal in 1961 and Holland in 1962. In these last works red, brown, blue and purple paint is scumbled, scraped and piled upon the canvas until buildings, rocks and water, flowers and cloth or holy relic and screen became a unified, vibrant whole.

Bibliography

T. Elder Dickson: 'Anne Redpath', *The Studio*, Vol.CLIX, No.803, March 1960, pp.86–89
George Bruce: *Anne Redpath*, Edinburgh 1974
ACGB, (Scottish Committee): *Anne Redpath. Memorial Exhibition* (exhibition catalogue 1965)
Edinburgh, SNGMA: *Anne Redpath 1895–1965. All the works in the collection* (exhibition catalogue 1975)

309 **The Indian Rug** *c.*1942
Inscribed b.l.: 'Anne Redpath'
Oil on plywood 74 × 96.5 cm
GMA 932 (1965)

[colour illustration page 69]

310 **Landscape at Kyleakin** late 1950s
Inscribed b.r.: 'Anne Redpath'
Oil on board 71.2 × 91.5 cm
GMA 814 (1962)

311 **Playa de San Cristoba** 1960
Inscribed b.l.: 'Anne Redpath'
Oil on canvas 63.5 × 76.2 cm
GMA 1065 (R.R. Scott Hay Bequest, 1967)

312 **White Tulips** 1962
Inscribed b.l.: 'Anne Redpath'
Oil on board 61 × 91.5 cm
GMA 1964 (Dr R.A. Lillie Bequest, 1977)

313 **Red and White Roses** *c.*1958
Inscribed b.l.: 'Anne Redpath'
Watercolour on paper
53.3 × 58.4 cm
GMA 1114 (Tertia Liebenthal Bequest, 1970)

310

Alan Reiach b.1910

Reiach was born in London to a Scottish father and Polish mother. He came to Edinburgh in 1922 and from 1928–32 was apprenticed to the architect Robert Lorimer. From 1928–35 Reiach took morning and evening classes in the Architecture Department of ECA; there he won many prizes including an Andrew Grant Scholarship. From 1935, he travelled extensively in the USA, Europe and the USSR, studying architecture. This experience formed the basis for his influential book *Building Scotland* (1940), written with Robert Hurd, in which a simple functional style in harmony with Scottish vernacular was advocated. From 1944–47 Reiach was on the Clyde Valley Regional Planning Committee and from 1947–54 taught architecture at ECA. He continued practising, however, designing many schools and churches in the early 1950s. In 1940 and from 1949–56 he produced plans for a Gallery of Modern Art for Scotland, to be built in Edinburgh, but the proposals were not taken up. His firm was commissioned to design the Veterinary Field Stations at Penicuik and at Liverpool in the early 1960s. Reiach retired in 1975 but remained a consultant until 1980.

Bibliography

Alan Reiach and Robert Hurd: *Building Scotland: A Cautionary Guide*, Edinburgh 1940 (2nd, revised ed. 1944)
Charles McKean: *The Scottish Thirties: an Architectural Introduction*, Edinburgh 1987

314 Model, plans and elevations of proposed **Museum of Modern Art for Scotland** 1940, York Buildings site, Queen Street, Edinburgh
Model made by Stanley Cursiter (Director of the NGS 1930–48)
Archive of SNGMA

Derek Roberts b.1947

Born in Berwick-upon-Tweed, Northumberland, Roberts studied at ECA from 1966–71. He has since lived in a farmhouse on the northern edge of the Pentland Hills, to the west of Edinburgh. He has worked extensively in watercolour, oils, ink and pastel, composing complex configurations of form and colour into harmonious abstract paintings which are an analogue of the nature that surrounds him. Solo exhibitions of Roberts's work have been held at the New 57 Gallery, Edinburgh in 1977, at TRAC in 1986 and at CAC in 1985.

Bibliography

SAC: *Scottish Art Now* (exhibition catalogue 1982)
Edinburgh, CAC: *Derek Roberts: Summer Shadows, Winter Footpaths* (exhibition catalogue 1985)
Newcastle upon Tyne, Laing Art Gallery: *Four Seasons: Paintings by Derek Roberts* (exhibition catalogue 1988)

315 **Summer Shadows** 1984
Oil on sized flax 142 × 121.5 cm
GMA 2972 (1986)

315

Mario Rossi b.1958

Mario Rossi was born in Glasgow where from 1975–79 he studied sculpture at the School of Art. From 1979–81 he followed a post-graduate sculpture course at the RCA. Rossi was Gulbenkian Scholar at the British School in Rome between 1982–83. Although he trained as a sculptor, and continues to make bronzes, Rossi is perhaps better known for his paintings. These invoke a Surrealist view of the world, bringing disparate images together and juxtaposing these in unusual ways. Much of this imagery is derived from classical sources – urns, sculptural fragments, Ionic capitals. These led to a series of paintings entitled 'The Archaeologist' exhibited at CAC in 1984. The theme was developed in a group of charcoal drawings depicting archaeological fragments and motifs from contemporary industrial landscapes. Rossi's work has figured in numerous group shows including *New Image Glasgow* at TEC in 1985 and *The Vigorous Imagination* at SNGMA in 1987. Rossi was Artist-in-Residence at Trinity College, Cambridge in 1988–89. He currently lives and works in London.

Bibliography

Glasgow, TEC: *New Image Glasgow* (exhibition catalogue 1985)
Edinburgh, SNGMA: *The Vigorous Imagination* (exhibition catalogue 1987)

316 **Charms, Capillaries and Amulets: Suite No. 2** 1987
Suite of nine permanently framed drawings. Indian ink and bleach on paper with iron frames. Each frame 61.5 × 48.7 cm
GMA 3044 (1987)

316

Mabel Royds 1874–1941

Mabel Alington Royds was born in Bedfordshire in 1874. In 1889 she won a scholarship to the Royal Academy Schools in London but preferred instead to enrol at the Slade School of Art, where she studied under Henry Tonks. In Paris at the turn of the century she worked alongside Sickert, sometimes even on his paintings. After several years in Canada, Mabel Royds moved to Edinburgh. She joined the staff of ECA, where Frank Morley Fletcher was then Principal; among her friends and colleagues were J. D. Fergusson and S. J. Peploe. In 1913 she married the etcher and portrait painter E. S. Lumsden. Their honeymoon took them to Paris, Florence and Rome, then on to Port Said and Bombay. They returned to India in 1914, and in 1916 set off on a trek into the Himalayas. Their travels, particularly in India, provided the Lumsdens with a rich source of material for their work. Returning to Edinburgh in 1917, Royds resumed her post at ECA. She painted a ceiling for the Episcopal Church in Hamilton, Lanarkshire, but is best known for her colour woodcuts. Her development in this medium was influenced by Morley Fletcher's Japanese methods of colour woodblock printing. She exhibited regularly at the SSA, the Society of Artist Printmakers and Graveur Printers in Colour. Her work was reproduced in various publications of the 1920s and was praised for its expressive and decorative line, and for its rich and unusual sense of colour. Her subjects include many scenes of India and Tibet, highly decorative flower-pieces, religious scenes, children and ducks.

Bibliography

'Modern British Woodcuts and Lithographs by British and French Artists' (The Studio, Special Number) London 1919
Herbert Furst, ed.: The Modern Woodcut, London 1924
Malcolm C. Salaman, ed.: Fine Prints of the Year 1923, London 1924

317 **Drooping Tulips**
Inscribed b.r.: 'M. A. Royds'
Coloured woodcut 23 × 18.4 cm
GMA 529 (transferred from NGS)

Benno Schotz 1891–1984

Schotz was born in Arensburg, Estonia, where his father was a watchmaker. In 1911 he went to Darmstadt in Germany to study engineering, moving on to Glasgow (where he had relatives) in 1912 and attending Glasgow Technical College. Following his examinations, Schotz began work as a draughtsman at the Clydesdale shipping firm of John Brown and Co., while in the evenings he studied at GSA. After a visit to the Ivan Mestrović exhibition at the Victoria and Albert Museum, London, in 1915, Schotz decided to become a sculptor. He modelled portrait busts in the evenings after work and began exhibiting these in 1917 at the GI. In 1920 he was elected President of the Society of Painters and Sculptors, Glasgow, and in 1923 became a full-time sculptor. Schotz had one-man shows at Alex Reid's Gallery, Glasgow, in 1926 and 1929, and at Reid and Lefevre's London gallery in 1930 and 1938. He was elected ARSA in 1933, RSA in 1937 and appointed Head of Sculpture and Ceramics at GSA in 1938. During the 1920s and 1930s his busts were inspired by Rodin, but late in the 1930s and more particularly from the 1940s, Schotz adopted a modelling technique indebted to Epstein. This involved building up the surface with small pellets of clay and leaving a rough, variegated finish. During the 1940s Schotz also produced several stylised wood-carvings which are closer to mainstream modernism. He was an influential figure in the Glasgow Jewish community, organising exhibitions of Jewish art in 1942 and 1951 and helping war refugees. In 1949 he executed a series of Stations of the Cross for St Matthew's Church, Glasgow and in 1958 made a large altar cross for St Paul's Church in Glenrothes. During the 1960s and concurrent with his portraiture, Schotz made a number of near-abstract bronzes whose heavily encrusted surfaces recall volcanic rock formations. He retired from teaching in 1961. Major Schotz exhibitions were mounted by the SAC in 1962, at the RSA Diploma Galleries in 1971 and at Kelvingrove Art Gallery, Glasgow, in 1978. He died at the age of ninety-three and was buried in Jerusalem.

Bibliography

Glasgow, Alex Reid and Lefevre: New Sculpture by Benno Schotz (exhibition catalogue 1929)
SAC: Benno Schotz Retrospective Exhibition (exhibition catalogue 1971)
Glasgow, GAGM: Benno Schotz, Portrait Sculpture (exhibition catalogue 1978)
Benno Schotz: Bronze in my Blood, Edinburgh 1981

318 **The Lament** 1943
Lignum vitae
91.5 × 30.5 × 21.5 cm
GMA 1216 (1971)

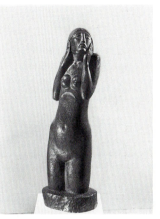

318

Gavin Scobie b.1940

Born in Edinburgh, Scobie studied painting at ECA from 1958–62. From 1963–74 he worked as an art teacher at an Edinburgh school. His earliest sculptures date from 1966 and develop from the formal minimalist tradition of Judd, Turnbull and King. These featured in Scobie's first one-man show at RDG in 1972. That same year he won the Invergordon Sculpture Prize and in 1974 left his teaching job to take up sculpture full-time, moving to Ross-shire. From 1973 he produced works employing long pieces of aluminium balanced in precarious harmony and intended for outdoor display. A touring show of these works was organised by the SAC in 1974. In 1975 Scobie took to cutting and welding Cor-ten steel, a material which develops its own natural rust patina. In 1976 he was awarded the commission for a 3 metre-long sculpture,

to be erected at Eden Court Theatre, Inverness. Its unveiling in 1977 coincided with a one-man show at the Inverness Art Gallery. In 1977 Scobie began a series of bronze 'books', consisting of hinged 'pages' which open to reveal sculptural elements enclosed within. Since 1983 he has worked principally in terracotta. A major retrospective was held at TRAC in 1984.

Bibliography

SAC: *Gavin Scobie; sculpture* (catalogue of touring exhibition 1974)
Duncan Macmillan: *Gavin Scobie*, Edinburgh 1984

319 **Eve** 1975
 Cor-ten steel
 205.5 × 111.5 × 102 cm
 GMA 1562 (1976)

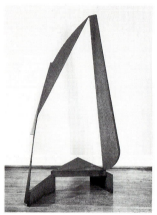

319

Jozef Sekalski 1904–1972

Jozef Sekalski was born in Turek in Poland. After studying medicine for three years he enrolled in the Faculty of Fine Art at Wilno University. From 1929–34 he studied painting under Ludomir Slendzinski, lettering with Bonawentura Lenart and engraving with Jerzy Hoppen, whose assistant he became during his final year. After graduating he spent three years painting church murals and then, in 1937, became head of an artists' and designers' studio in Lødz. During this time he visited Vienna and Italy. In 1940 he escaped from German-occupied Poland to Hungary. In Budapest he held a one-man exhibition of prints; his eye-witness account of the burning of Warsaw sold out within a day. On the proceeds of this he travelled on through Zagreb, to Italy and France. Here he enlisted in the Polish Army under French command. He was captured in the Ardennes and marched to Saxony whence he escaped, finally reaching Britain in 1942. He joined the Polish troops in Scotland, based near Dundee. During the latter days of the war Sekalski settled in St Andrews, where he became one of an important group of wood-engravers which included Alison and Winifred McKenzie and Annabel Kidston. From 1944–45 he became involved in illustrating and designing for the Polish Library and Publishing House in Glasgow. In 1945 he produced illustrations for F. C. Anstruther's *Old Polish Legends* and in 1946 for Jan Rostorowski's poems *The Fourteen Hours of the Night*. He also designed Christmas cards and book-plates for friends. In 1949 he became an Associate of the Royal Society of Painter-Etchers and Engravers and in 1950 was elected SSA. He exhibited both paintings and wood-engravings at the RSA and the RA. From 1957 he was lecturer in printmaking at Duncan of Jordanstone College of Art, Dundee.

Bibliography

Albert Garrett: *A History of British Wood Engraving*, Tunbridge Wells 1978
Michael Gill and Robert Fraser: *Jozef Sekalski*, Dundee 1976
Dundee, Art Gallery: *Jozef Sekalski ARE SSA 1904–1972* (exhibition catalogue 1978; Text by Gerald Deslandes)

320 **Bombing Raid** 1943
 Inscribed b.r.: 'Josef Sekalski' and b.l.: '1943'
 Wood-engraving 13 × 10 cm
 GMA 2334 (1981)

321 **St Monance** 1951
 Wood-engraving on japan paper
 14.1 × 19.4 cm
 GMA 2357 (1981)

Ian McKenzie Smith b.1935

McKenzie Smith was born in Montrose and from 1953–58 studied painting at Gray's School of Art, Aberdeen. He also attended courses at Hospitalfield School of Art, Arbroath, in 1957 and 1958, winning a travelling scholarship in 1958. With Jack Knox, McKenzie Smith went to Paris where he was particularly attracted by the Egyptian and Japanese sections at the Louvre. McKenzie Smith's paintings of the early 1960s are close to American colour-field abstraction but during the 1970s an Oriental sense of finesse and balance takes over (like Davie, he was interested in Zen philosophy). In 1968 he was appointed Director of Aberdeen Art Gallery and Museums, a position he still holds. From this date subtle references to landscape became more apparent; hard edges were softened and colours muted. He has had several one-man shows, including those at the 57 Gallery, Edinburgh in 1959 and 1963 and at the Scottish Gallery in 1965 and 1971. He was elected ARSA in 1973, RSA in 1987 and President of the RSW in 1988.

Bibliography

SAC: *Scottish Art Now* (exhibition catalogue 1982)

322 **Summer** (Canna) 1963
 Oil on canvas 66.8 × 82 cm
 GMA 868 (1963)

322

Basil Spence 1907–1976

Spence was born in Bombay, India but came to Edinburgh as a child. He studied architecture at ECA and from 1931 began a loose partnership with his co-student, William Kininmonth; Spence nevertheless remained freelance. His 1934 flat-roofed house for Dr John King at Easter Belmont and a garage at Causewayside (both Edinburgh) were among the first examples of modernist architecture to be constructed in Britain. In his later buildings Spence reverted to more traditional steep-pitched roofs and incorporated details from Scottish vernacular architecture. Spence was awarded the commissions for three Pavilions at the 1938 Glasgow Empire Exhibition, including the ICI Building and the Scottish Pavilion, for which he also designed furniture and fittings. He also designed the *Scottish Everyday Art* (1936) and *Enterprise Scotland* (1947) exhibitions at the Royal Scottish Museum. In 1951 he won the competition to design a new cathedral for the city of Coventry; this was consecrated in 1962. From the 1950s his firm designed numerous churches, airports, schools, housing estates and industrial buildings throughout Britain: these include the University of Sussex complex and the Headquarters of the Scottish Widows Fund and Life Assurance Society, Edinburgh, completed in the year of Spence's death. He was elected ARSA in 1952, ARA in 1953 and RA in 1960. Spence was President of The Royal Institute of British Architects from 1958–60.

Bibliography

Charles McKean: *The Scottish Thirties: an Architectural Introduction*, Edinburgh 1987

323 **Design for A. G. Lockhead, Princes Street, Edinburgh** 1930s
Inscribed b.l.: 'A.G. Lockhead, Princes Street'
Gouache, black chalk and pencil on paper 57.5 × 77 cm
Royal Commission on the Ancient and Historical Monuments of Scotland: Basil Spence Collection

[colour illustration page 76]

324 **Design for a House, Comiston, Edinburgh** 1933
Inscribed b.r.: 'KININMONTH & SPENCE/16 RUTLAND SQ/EDINBURGH'
Gouache, black chalk and pencil on paper 57.5 × 77 cm
Royal Commission on the Ancient and Historical Monuments of Scotland: Basil Spence Collection

325 **Design for a Garage, Causewayside, Edinburgh** 1933
Inscribed b.r.: 'B.S. Kininmonth & Spence Architects/16 Rutland Square/Edinburgh, Feb 1933'
Gouache, black chalk and pencil on paper 77 × 57.5 cm
Royal Commission on the Ancient and Historical Monuments of Scotland: Basil Spence Collection

326 **Design for a Garage, Causewayside, Edinburgh** 1933
Gouache, black chalk and pencil on paper 57.5 × 77 cm
Royal Commission on the Ancient and Historical Monuments of Scotland: Basil Spence Collection

327 **Designs for Highland Home Industries** 1930s
Gouache, black chalk and pencil on paper 77 × 57.5 cm
Royal Commission on the Ancient and Historical Monuments of Scotland: Basil Spence Collection

328 **Design for Cleghorns, Leather goods manufacturers, Edinburgh** 1930s
Gouache, black chalk and pencil on paper 57.5 × 77 cm
Royal Commission on the Ancient and Historical Monuments of Scotland: Basil Spence Collection

EX. CAT.
Dining chair for the King house, Easter Belmont, Edinburgh 1934
Beech 83 × 49.5 × 52 cm
Private Collection (on loan to SNGMA)

EX. CAT.
Model and Sketches for **Gribloch, Kippen, Stirlingshire** 1937–38
Private Collection (on loan to Glasgow University Archives)

326

Basil Spence, *Dining chair for the King house, Easter Belmont, Edinburgh*, 1934

Thomas Tait 1882–1954

Tait was born in Paisley and studied architecture at Paisley School of Art, GSA and at the Royal Academy Schools, London. He was apprenticed to Sir John Burnet's Glasgow-based firm of architects, later becoming Burnet's personal assistant, his chief assistant and in 1920 a partner. With Burnet, Tait was involved in the design of many London buildings including Kodak House, Kingsway and the Lloyds Bank Headquarters. With Burnet, too, Tait designed numerous War Memorials for the Imperial War Graves Commission. In 1932 Tait, Burnet and Lorne were commissioned to design the Infectious Diseases Hospital, Hawkhead and in 1933 Tait won the competition for the St Andrew's House buildings, Edinburgh (completed 1939). He was controlling architect of the 1938 Glasgow Empire Exhibition, making the overall plan and designing several of the pavilions including the remarkable central tower.

Bibliography

Bruno Sicomor: *Life and Works of Thomas Smith Tait* (unpublished thesis 1982)

EX. CAT.

Model of Tower for 1938 Empire Exhibition, Glasgow 1988
Mixed media
Glasgow Museums and Art Galleries

[illustration of actual tower page 174]

Linda Taylor b.1959

Taylor was born in Stranraer, Galloway and studied drawing and painting at ECA from 1976–80. Since graduating, she has worked primarily as a sculptor. In 1980 she won an Andrew Grant Travelling Scholarship and in 1983 was awarded a Young Artist's Bursary by the SAC. Taylor first exhibited at the 1981 show *Contemporary Abstraction* at FMG and has since had one-woman shows at the Collective Gallery, Edinburgh in 1985 and at the Graeme Murray Gallery, Edinburgh 1987. Taylor's work also featured in the touring group exhibition *The Unpainted Landscape* in 1987. A large sculpture in copper, *Unseen Currents*, was shown at the Glasgow Garden Festival in 1988.

Bibliography

Edinburgh, FMG: *Contemporary Abstraction* (exhibition catalogue 1981)
Edinburgh, SAC/Graeme Murray Gallery: *The Unpainted Landscape* (exhibition catalogue 1987)

329 **Unseen Currents** 1988
3 drawings (Nos. 3,9,11) for Glasgow Garden Festival Sculpture
Each watercolour and pencil on paper 42 × 29.5 cm
GMA 3462 (1989)

[colour illustration page 111]

330 **Pine** 1986–88
Mixed media
GMA 3457 (1989)

Murray Macpherson Tod

1909–1974

Murray Tod trained at GSA 1927–31 and was a contemporary of Ian Fleming. He went on to study at the Royal College of Art where he received his Diploma in 1935. Tod subsequently took up a scholarship at the British School in Rome. He was a frequent exhibitor at the RSA. Tod painted as well as etched landscapes and townscapes in Scotland, Italy and Spain. There is a slight hint of caricature in his work together with a lightness of touch. In 1947 Tod was elected ARE and RE in 1953. From the late 1940s he suffered from muscular dystrophy.

Bibliography

Obituary: *The Scotsman*, 15 August 1974
Kenneth M. Guichard: *British Etchers 1850–1940*, London 1977
Aberdeen, Art Gallery: *Great Scottish Etchers* (exhibition catalogue 1981; Foreword by Ian Fleming; Catalogue by Anne Whyte)

331 **The Pond**
Inscribed b.c.: 'M. Macpherson Tod'
Etching 21.6 × 28 cm
GMA 567 (transferred from NGS)

William Turnbull b.1922

William Turnbull was born in Dundee where his father was an engineer in the shipyards. From an early age Turnbull was passionately interested in drawing and when he left school at the age of fifteen, he pursued evening courses at the art college, enabling him to gain a position as a magazine illustrator. In 1941 he became a pilot in the RAF. From 1946–48 he studied at the Slade School in London, where he found his preference for European avant-garde art was not welcomed. A trip to Paris in 1947 pursuaded him to settle there in 1948; his fellow Scots Paolozzi and Gear had moved there in 1947. In Paris he met the artists whose work was to influence him profoundly: Giacometti and Brancusi.

Turnbull's sculptures of this period show a great debt to Giacometti in the depiction of thin, wiry, loosely anthropomorphic forms. In 1950 he returned to London and shared an exhibition at the Hanover Gallery with Paolozzi and Kenneth King, exhibiting twelve sculptures, most of which had been made in Paris. In 1952 his work formed part of an exhibition *New Aspects of British Sculpture* at the Venice Biennale, featuring alongside works by Moore, Butler, Paolozzi, Armitage and others. But unlike their sculptures, Turnbull's work had a cool, detached economy which would separate him from his contemporaries' more anguished, angular works. Also in 1952, Turnbull had a one-man show at the Hanover Gallery, London in which he showed a number of painted sculptures. In the mid-1950s he began making sculptures from different, complementary materials such as wood, stone and bronze; these elements were stacked one on top of the other to produce primitive, totemic structures. These balanced, heavy forms recall both prehistoric sculpture (such as Stonehenge) and the works of Brancusi. From the late 1950s Turnbull's work became increasingly abstract; he worked particularly with long cylindrical timbers, matching them with elements of bronze and stone of complementary form, texture and colour. Late in the 1950s he also came into contact with American colour-field painting and was among the first European artists to make similar experiments. His sculptures of the 1960s were more crisp in their definition of form – tall, hard-edged shapes made of steel (and often painted) which articulate and envelop space in contrast to the dense, monolithic work of the 1950s. These 1960s sculptures were thoroughly contemporary in their emphasis on machine-like clarity and economy of means. Since 1970 his work has referred back again to tribal and totemic forms, in particular to Cycladic art. The rich colours and textures of the 1950s sculptures have reappeared in his 1980s bronzes which also show a renewed interest in figurative references; sleek balanced shapes are given human character by the discreet suggestion of bodily form. Turnbull's work features in many of the world's principal museums of modern art. He has had numerous one-man shows including a major

retrospective at the Tate Gallery, London in 1971.

Bibliography

London, The Tate Gallery: *William Turnbull: Sculpture and Painting* (exhibition catalogue 1971; Text by Richard Morphet)
London, Waddington Galleries: *William Turnbull: Sculptures* (exhibition catalogue 1987)

332 **Horse** 1946
Inscribed b.: 'Turnbull 46'
Bronze 71.1 × 35.5 × 25.4 cm
Waddington Galleries, London

333 **Horse** 1954
Bronze 66 × 25.4 × 67 cm
The Artist

334 **Pegasus** 1954
Inscribed on base: 'Turnbull 54 1/4'
Bronze 88.9 × 44.5 × 73.7 cm
Waddington Galleries, London

[colour illustration page 79]

335 **Female Figure** 1955
Inscribed on heel: 'T55/3/4'
Bronze 120.7 × 41.9 × 34.9 cm
Waddington Galleries, London

336 **Idol 2** 1956
Bronze 164.5 × 43.2 × 50.2 cm
Waddington Galleries, London

337 **Totemic Figure** 1957
Inscribed on base: 'T57/4/4'
Bronze 153.7 × 43.2 × 35.5 cm
Waddington Galleries, London

338 **Aphrodite** 1958
Inscribed b.: 'T 58'
Bronze 109.5 × 73.7 × 50.2 cm
Waddington Galleries, London

339 **Source** 1958
Bronze 125.8 × 54.6 × 9 cm
Waddington Galleries, London

340 **Paddle Venus 2** 1986
Inscribed on base: 'T/3/4 86'
Bronze 198.1 × 36.2 × 30.5 cm
Waddington Galleries, courtesy of the Artist

341 **Head** 1987
Inscribed on base: 'T/5/6 87'
Bronze 90.2 × 26.7 × 22.2 cm
Waddington Galleries, courtesy of the Artist

338

340

Cecile Walton 1891–1956

Born in Glasgow, Cecile Walton was the daughter of the painter E. A. Walton. The family moved to Chelsea in the 1890s, where she began to draw and paint at an early age. Her inspiration came from the Pre-Raphaelites and Jessie M. King rather than from her father's contemporaries, Whistler, Melville, Lavery and Guthrie. When her father moved back to Edinburgh she found a mentor in John Duncan, who introduced her to the work of the French Symbolists. In 1908–9 she studied in Paris and when she returned took up book illustration. In 1911 her illustrations for Hans Christian Andersen were published. Walton's illustrative line drawings in the tradition of Jessie M. King remained her strength throughout her career. Cecile Walton was close to Mary Newbery, daughter of F. H. Newbery, Head of GSA. At the Newbery summer cottage at Walberswick, Suffolk, she met Eric Robertson and the couple married in 1914. In 1919 she began to exhibit with the Edinburgh Group. After the breakdown of her marriage, Walton visited Vienna in 1923 with Dorothy Johnstone. She returned to Edinburgh and devoted herself to work on murals, illustration, design, and latterly for the theatre. Her final home was in Kirkcudbright.

Bibliography

Edinburgh, CAC: *The Edinburgh Group* (exhibition catalogue 1983; Catalogue and Text by John Kemplay)
London, Barbican Art Gallery: *The Last Romantics: The Romantic Tradition in British Art* (exhibition catalogue 1989)

Tom Whalen 1903–1975

Born in Leith, Whalen trained as a ship-wright. His natural gift as a wood-carver led him to ECA where from c.1928–31 he trained with wood-carver Thomas Good and the Head of the Sculpture Department, Alexander Carrick. Whalen was the first holder of the Andrew Grant Fellowship during which he executed a bronze fountain group of *Mother and Child* for Prestonfield School, Edinburgh. He won the RSA Carnegie Travelling Scholarship to France and Italy and had his first solo exhibition at the Cooling Gallery, London in 1932. During the 1930s his carvings in wood and stone were influenced by Mestrovič, Gill, Milles and medieval sculpture, and his modelled figures in bronze by contemporary French sculpture. Whalen executed a large body of work for the 1938 Empire Exhibition in Glasgow including reliefs for the ICI Pavilion and the Garden Club, monumental figures for the Scottish Pavilion (North) and bronzes for the Palace of Art quadrangle. Carved relief work for churches, public buildings, and power stations dominated his output over the next two decades but he also fulfilled private commissions for carved figures in wood, alabaster and stone. In

1951 he modelled monumental reliefs on the theme of 'Coal' for Basil Spence's Festival of Britain Pavilion of Industry, Kelvingrove, Glasgow. The broad, rounded, semi-abstract figures of women and clowns and his experiments with glass were peculiar to him. He was a Fellow of ECA, a member of the SSA and the GI and was elected RSA in 1954.

Bibliography

T. S. Halliday and George Bruce: *Scottish Sculpture. A Record of twenty years*, Dundee 1946
Hamilton, Saltire Society Festival: *Tom Whalen* (exhibition catalogue 1973; Foreword by Esme Gordon)

342 **Europa and the Bull** 1943
Inscribed on base:
'T. Whalen/1943'
Plaster 58 × 46.5 × 27 cm
Royal Scottish Academy, Edinburgh

342

Kate Whiteford b.1952

Whiteford was born in Glasgow and studied drawing and painting at GSA from 1969–73. From 1974–76 she was at Glasgow University studying history of art. A British Council Scholarship to Rome in 1977 enabled her to see the frescoes at Pompeii and Herculaneum; their classical iconography and limited colour-range would greatly influence Whiteford's painting. She began exhibit-

ing in 1974 and her first solo exhibition came in 1978 at the Stirling Art Gallery. Her early work is minimal and non-figurative but, from about 1980, Whiteford began incorporating classical lettering and archaeological imagery into her work. Roman urns and columns together with Celtic and Pictish signs were employed to create a symbolism suggestive of ancient myths and cultures. Since 1978 she has lived in London, but returned to Scotland in 1982–83 to take the post of Artist-in-Residence at St Andrews University. There she took a keen interest in the Pre-Roman archaeological remains of ancient Celtic civilisations. From 1984–85 she was Artist-in-Residence at the Whitechapel Art Gallery, London. The titles of her solo exhibitions *Rites of Passage* (TEC 1984) and *Puja: Ritual Offerings to the Gods* (Riverside Studios, London 1986) also evoke themes of myth and rite. Since 1983, much of Whiteford's work has been large-scale, executed in a limited but bright colour range, and created for particular gallery spaces. In 1987, on Calton Hill, Edinburgh, she produced three vast land-works reminiscent of prehistoric images such as the Cerne Abbas Giant. These were composed of white stone chippings laid in a shallow trench and describing fish and spiral motifs.

Bibliography

St Andrews, Crawford Centre for the Arts: *Votives and Libations in Summons of the Oracle* (exhibition catalogue 1983)
Glasgow, TEC: *Kate Whiteford: Rites of Passage* (exhibition catalogue 1984)
London, Riverside Studios: *Puja: Ritual Offerings to the Gods* (exhibition catalogue 1986)

343 **Red Spiral** 1986
Acrylic on paper 157.5 × 120.6 cm
GMA 3459 (1989)

[colour illustration page 112]

344 **The Peacock** 1983
(from the series 'Symbol Stones')
Acrylic on paper 151.9 × 114.4 cm
GMA 3442 (1989)

345 **The Arc** 1983
(from the series 'Symbol Stones')
Acrylic on paper 151.3 × 114.4 cm
GMA 3443 (1989)

346 **The Snake** 1983
(from the series 'Symbol Stones')
Acrylic and pencil on paper
152 × 115 cm
GMA 3444 (1989)

344

Andrew Williams b.1954

Andrew Williams was born in Barry, South Wales. From 1972–77 he studied art and art history at Edinburgh University and at ECA. Since graduating, he has exhibited widely in Britain and abroad; four one-man shows have been held at the 369 Gallery, Edinburgh. From 1979–80 he worked in the South of France where he administered the Karolyi Foundation at Vence. In 1984 he worked in New York. Williams applies paint with bold, thick brushstrokes in works allied to contemporary European figurative art. His preferred theme is the male figure, often athletes and body-builders, although recently he has turned to landscapes.

Bibliography

Edinburgh, 369 Gallery: *Andrew Williams* (exhibition catalogue 1986)

347 **Dordogne Landscape I** 1988
Oil on canvas 66 × 81.5 cm
The Artist

[colour illustration page 103]

348 **Dordogne Landscape II** 1988
Oil on canvas 66 × 81.5 cm
The Artist

Scottie Wilson 1889–1972

Robert (Scottie) Wilson was born in Glasgow of working-class parents. He had little formal education. In 1906 he enlisted in the Army and served in India, South Africa and France. About 1930–31 he went to Canada and opened a junk shop in Toronto. He collected old fountain-pens in order to salvage the gold nibs and it was with one of these that he began to draw. Scottie did not paint a real world, but a magical two-dimensional one. From the closely hatched black ink lines, coloured in with crayon, there emerged totemic images of castles, flowers, birds, trees, streams and the brooding bulbous-nosed, start-eyed faces of his 'Greedies' and 'Evils'. Douglas Duncan of the Picture Loan Society in Toronto admired his work and put on his first exhibition in 1943. In 1945 Scottie returned to London and settled in Kilburn. He exhibited at several London galleries as well as in Paris, Basel and New York, but he preferred to exhibit in an old bus. His work was admired by the Surrealists and was included in the Paris *Exposition Internationale du Surréalisme* 1947. In 1952 Scottie went to Paris to meet Dubuffet, who admired his work and had shown it in his *Art Brut* exhibition in 1949. There he also met Picasso who was full of praise, but Scottie was unimpressed. In the early 1960s he began painting on plates, and in 1964 the Royal Worcester Porcelain Company commissioned some designs from him. His other commissions included tapestries for the Aubusson factory in France and the Edinburgh Tapestry Company, and a mural for a bank in Zürich.

Bibliography

London, Brook Street Gallery: *Scottie Wilson* (exhibition catalogue 1966; Text by Mervyn Levy)
London, Barbican Art Gallery: *Aftermath: France 1945–54* (exhibition catalogue 1982)
George Melly: *'It's all writ out for you'. The Life and Work of Scottie Wilson*, London 1986

349 **A Whispering Paradise** 1951
Inscribed b.r.: 'SCOTTIE'
Coloured crayon with ink on black paper 90.2 × 152.4 cm
GMA 1997 (Presented by Mr & Mrs Robert Lewin, 1978)

350 **Design with Fish**
Inscribed b.c.: 'SCOTTIE'
Coloured crayon and ink on paper
35.6 × 26 cm
GMA 895 (1964)

351 **Peaceful Village** 1963
Inscribed b.r.: 'SCOTTIE'
Royal Worcester Porcelain
49 × 40 cm
GMA 1677 (Presented by Mr & Mrs Robert Lewin, 1978)

350

William Wilson 1905–1972

Born in Edinburgh, Wilson served an apprenticeship in the stained-glass studio of James Ballantine, Edinburgh. His etching and engraving as a student at ECA won him the 1932 RSA Travelling Scholarship to France, Germany, Spain and Italy. In 1934 he received an Andrew Grant Fellowship which, together with the RSA Guthrie Award the same year, enabled him to study engraving at the RCA and contemporary stained-glass in Germany. In the 1930s he was also Secretary to the Society of Artist-Printmakers. Wilson's etchings and engravings of landscapes in Germany, Italy, France and Scotland move from an appreciation of Mantegna and Italian Primitive art, with their use of fine line and perspectival recession, towards a darker expressive style. His dramatic landscapes and Fife harbours have a lyrical intensity and brooding mood. In 1937 Wilson opened his own stained-glass studio in Edinburgh and established a nationwide reputation. The series of windows made in 1938 for the Caledonian Insurance Company (now Guardian Royal Exchange), St Andrew Square, Edinburgh reveals a German influence in its strong expressive figurative style. Wilson proposed and executed work for cathedrals and churches in Britain and overseas. He has been acclaimed by his fellow etcher Ian Fleming as the master of Scottish twentieth-century print-making. The SNGMA holds a large collection of his graphic work. Wilson was also a fine watercolour painter. He was elected SSA in 1930, ARSA in 1939, RSW in 1946, RSA in 1949. In 1961 he lost his sight.

Bibliography

SSA: *Annual Exhibition* (exhibition catalogue 1959; section showing his stained-glass)
N. McIsaac: 'William Wilson' *Scottish Arts Review* Vol.VII, No.2, 1959 p.20
H. J. Barnes: *Prospect* 1960, p.23

352 **A Castle near Verona** 1932
Inscribed b.l.: 'A Castle Near Verona'; b.c.: '1–20' and b.r.: 'W. Wilson 1932'
Etching 26.7 × 31.4 cm
GMA 581 (Transferred from NGS)

353 **North Highland Landscape** 1934
Inscribed b.r.: 'W. Wilson 1934,/to E.S. Lumsden' and b.l.: 'North Highland Landscape'
Etching 40.6 × 51.4 cm
GMA 596 (Transferred from NGS)

354 **The Harrow**
Inscribed b.r.: 'W. Wilson ImpJC' and b.l.: '15/15'
Etching 42 × 52 cm
GMA 2247 (1980)

355 **St Monance**
Inscribed b.r.: 'W. Wilson ImpJC' and b.l.: '13/15'
Etching 25 × 29 cm
GMA 2244 (1980)

356 **Scottish Coastal Village with Jetty**
Etching 41.5 × 45.4 cm
GMA 2276 (1980)

353

Adrian Wiszniewski b.1958

Of Polish extraction, Adrian Wiszniewski
was born in Glasgow where from 1975–
79 he attended the Mackintosh School of
Architecture and, from 1979–83, GSA.
Between 1982–84 he won a series of
scholarships including a Cargill Scholar-
ship in 1983 and a grant from the Mark
Rothko Memorial Trust Fund in 1984.
He held his first one-man shows in 1984
at the Compass Gallery in Glasgow and
at the AIR Gallery in London. By 1985
his works had been bought by the Tate
Gallery, London and by the Museum of
Modern Art, New York. In 1986 he
moved from Glasgow to the village of
Alnmouth in Northumberland. From
1986–87 he was Artist-in-Residence at
the Walker Art Gallery, Liverpool, hold-
ing a one-man show there in 1987.
Wiszniewski's paintings depict an
Arcadian world populated by awkward-
looking young men, many of whom are
covert self-portraits. Wiszniewski
executed much of his early work in
charcoal on paper, but since 1985–86 he
has concentrated on large-scale oil-
paintings. The densely worked, patterned
surfaces of the early work have given
way to greater clarity of design while the
imagery has remained obscure, suggest-
ing an arcane symbolism of suppressed
sexual desire. Melancholy young men
struggle to comprehend their unfathom-
able environment in a reconstructed
world that recalls de Chirico and the
Surrealists.

Bibliography

Liverpool, Walker Art Gallery: *Adrian Wiszniewski*
 (exhibition catalogue 1987)

357 **Bound to Love and Cherish** 1984
 Charcoal on paper 201 × 287 cm
 GMA 3043 (1987)

358 **Kingfisher** 1987
 Inscribed b.r.: 'a. wiszniewski
 1987' and b.c.: 'KINGFISHER'
 Acrylic on canvas
 213.5 × 213.5 cm
 GMA 3042 (1987)

 [colour illustration page 105]

Chronology

1819
Foundation of the Royal Institution for the Encouragement of the Fine Arts, Scotland, in Edinburgh (Royal Charter granted 1827).

1826
Royal Scottish Academy founded in Edinburgh (Royal Charter granted 1838)

1827
Venus and Ascanius by Henry Howard (1759–1847) purchased by the Royal Institution, Edinburgh and 'intended as the commencement of a gallery of modern pictures'.

1854
Glasgow Art Gallery and Museum founded.

1859
National Gallery of Scotland founded.

1861
Royal Glasgow Institute of the Fine Arts founded to provide annual exhibitions of the work of living artists.

1870
Paisley Museum and Art Gallery founded.

1873
Dundee Art Gallery and Museum founded.

1876
Greenock: Maclean Museum and Art Gallery founded.

1878
Royal Scottish Society of Painters in Watercolour founded (Royal Charter granted 1888).

1879
GI opened own gallery in Sauchiehall Street.

1882
Glasgow Society of Lady Artists founded by eight former students of Glasgow School of Art.

1885
Aberdeen Art Gallery founded.
F. H. Newbery appointed Director of GSA.
Gray's School of Art, Aberdeen founded.

1888
Glasgow International Exhibition.

1889
Alexander Reid opened gallery in Glasgow, dealing in Barbizon, Impressionist and Post-Impressionist works.

1891
Society of Scottish Artists founded.

1891–94
Peploe at RSA school, L'Académie Julian and L'Académie Colarossi, Paris.

1892
Decorative Art studios opened at GSA and first woman joined staff to teach embroidery.
Duncan of Jordanstone College of Art, Dundee founded.

1896
Mackintosh won competition to design new building for GSA (working for the Glasgow architectural firm, Honeyman and Keppie).

1897
Building work began on GSA.

***c.*1897**
Foundation stone laid for new Glasgow Art Gallery at Kelvingrove.
Fergusson at L'Académie Colarossi, Paris.

1899
East wing of GSA opened.
Cadell at L'Académie Julian, Paris and Fergusson in Morocco.

1900
Mackintosh's work exhibited at the Vienna Secession.
Fergusson and Peploe in Paris.

1901
Glasgow International Exhibition at Kelvingrove and opening of Art Gallery.

1902
Scottish section at Turin Decorative Art Exhibition designed by Mackintosh. Exhibits included work by the Macdonald sisters, Mackintosh, Herbert McNair, Phoebe Traquair, Anne Macbeth, F. H. Newbery and his wife Jessie Newbery; Mackintosh's *Haus eines Kunstfreundes* project featured.

1903
Parliamentary paper published suggesting the establishment of an Art College in Edinburgh on the lines of Glasgow.

1904
Twenty-five paintings, two sets of etchings and four lithographs by Whistler shown at the RSA.
Peploe and Fergusson painted in Brittany.
Mackintosh became partner of Honeyman and Keppie and designed interiors and furniture for Miss Cranston's house, Hous'hill at Nitshill, Glasgow; and Willow Tea Rooms.

1905
G. F. Watts memorial exhibition at RSA.

1906
Fergusson visited Paris-Plage and Le Touquet.
Hunter's work destroyed in San Francisco earthquake; returned to Scotland as illustrator, Glasgow.
The National Galleries of Scotland Bill.
Maurice Greiffenhagen became Master in Charge of the Life Department, GSA.
Three works by Bourdelle at GI.

1907
Foundation of the Scottish Modern Arts Association '. . . to assist in the enriching of Scottish Public Art Collections'.
Fergusson settled in Paris and visited Normandy.

Peploe visited Paris-Plage and Paris.
Rodin elected Hon. RSA.
St Peter's Roman Catholic Church, Falcon Avenue, Edinburgh, begun; architect Robert Lorimer. Canon John Gray subsequently commissioned works for interior by Brangwyn, John Duncan and Glyn Philpot; supported in this enterprise by André Raffalovich.

1909
West wing of GSA opened. Mackintosh took part in second *Kunstschau* exhibition in Vienna.

1910
Peploe moved to Paris and visited Royan with Fergusson.
Cadell visited Venice.
James McBey visited Holland.

1911
Scottish Exhibition of National History, Art and Industry, Glasgow; Mackintosh designed tea

S.J. Peploe and J.D. Fergusson at Paris-Plage, *c.*1906–7

West façade of Glasgow School of Art, designed by Charles Rennie Mackintosh, completed in 1909

room for Miss Cranston.
Edgar Degas elected Hon. RSA; RSA building remodelled to give more exhibition space; RSA annual show included sculpture by Rodin and Bourdelle, German and Italian painting and American architectural designs.
The periodical *Rhythm* launched by J. Middleton Murry and Fergusson.
McBey's first London exhibition at Goupil Gallery established his reputation, with best proofs going to Victoria and Albert Museum and twenty-eight prints purchased by the French government.

1912
Edinburgh Tapestry Company founded at the Dovecot Studios, Edinburgh.
Peploe returned to live in Edinburgh and Cadell took his first trip to Iona.
Society of Eight founded by P. W. Adam, David Allison, Cadell, James Cadenhead, John Lavery, Harrington Mann, James Paterson and A. G. Sinclair. Twice yearly shows held at New Gallery, Shandwick Place, Edinburgh.
McBey visited Morocco.
SSA invited to send to forthcoming show in Munich.

1913
GI included works by Futurists, Matisse, Cézanne, Fry and Grant.
RSSPW exhibited in Prague.
SSA showed two Italian Futurist paintings, recent works by Picasso, Matisse, Vlaminck and Herbin; plus works by Gauguin, Sérusier, Cézanne and Van Gogh.
Stanley Cursiter painted a series of 'Futurist' works.

1914
Hunter visited Paris and met Fergusson.
Fergusson returned to London.
Mackintosh moved to Walberswick and subsequently settled in Chelsea in 1915.
RSA included contemporary Belgian sculpture.

1915
Victoria and Albert Museum loaned sixteen works by Rodin to RSA.
GI included six works by Mestrovič.

1915–17
Fergusson spent three months annually in Edinburgh.

1916
RSA included range of historical Scottish sculpture.
Bone and McBey became Official War Artists.

1917
Peploe elected ARSA.
Rowand Anderson became first President of the newly founded Institution of Scottish Architects.
D'Arcy Wentworth Thompson's *On Growth and Form* published. Wentworth Thompson appointed Professor of Natural History at University of St Andrews.

1918
Fergusson painted war pictures in Portsmouth Docks.
MacTaggart, Gillies and Crozier all studied at ECA.

James Pryde, **Madonna of The Ruins**, lunette in the library of Dunecht House, Aberdeenshire. 6.5m wide

RSA and GI included works by Serbian sculptors Mestrovič and Rosandič.

1919
Glasgow Society of Painters and Sculptors founded. Members included Cowie, A. A. McGlashan, R. Sivell and Miller Parker.
Redpath discovered Siennese Primitives during her travelling scholarship.
Alexander Reid showed Vuillard for first time in Scotland.

1920
Cadell began to paint vividly coloured still lifes and interiors. Peploe joined Cadell for first time on his annual trip to Iona.
Mackintosh, resident in Chelsea, designed theatre for Margaret Morris.
D. Y. Cameron elected RA.
GI included works by Gaudier-Brzeska, Epstein and Schotz.

1921
Print Room inaugurated at Glasgow Art Gallery.
Benno Schotz, President of Glasgow Society of Painters and Sculptors, asked D. Y. Cameron to open the controversial 3rd exhibition. Hanging committee of Sivell, Cowie, McGlashan and Schotz had hung their own work to the exclusion of the rest of the membership.
Society of Artist-Printmakers founded in Glasgow by art students. Founder-members included Chika MacNab, Cheyne, Joan Haswell Miller, Miller Parker and Lumsden, who later became President and moved the focus to Edinburgh. Fleming, Cheyne and William Wilson also gave lifelong support until its decline in the late 1940s.
Contemporary Art Society and Imperial War Museum lent contemporary British art to SSA.

1922
The 1922 Group founded by MacTaggart, Gillies, Crozier, Gunn, Geissler, Wright and Hall and exhibited in Edinburgh and London.
John Quinton Pringle exhibition at GSA.
M. Greiffenhagen and R. Anning Bell elected RSA.
Charles Murray exhibited at Society of Artist-Printmakers.
Fergusson, Peploe and Hunter painted in South of France.
Hunter visited Epstein and Matisse in Paris.
SSA included sixteen French works from Galerie Fiquet, Paris.

MacTaggart began annual painting trips to France which continued until 1929.

1923
Crozier won Carnegie Travelling Scholarship from RSA; studied with André Lhote in Paris and went to Italy and Southern France.
Peploe, Cadell and Hunter, group show at the Leicester Galleries, London.
Gauguin woodcuts, shown by Alexander Reid, Glasgow.
Mackintosh moved to Port Vendres in South of France.

1924
Les Peintres de L'Ecosse Moderne exhibition of works by Cadell, Fergusson, Hunter and Peploe at Galerie Barbazanges, Paris.
Gillies in Paris on travelling scholarship studied with Lhote.
Alexander Reid showed works by Matisse, Picasso, Vuillard, Dufy and Rouault in Glasgow.
Gerald Moira became head of ECA.
D. Y. Cameron the only painter on the recently appointed Commission of Fine Arts. Cameron also served as Trustee of Tate Gallery and of the National Galleries of Scotland; on executive committee of the National Art-Collections Fund and 1925–28 chaired painting section of British School at Rome.

1924–27
Baird and McIntosh Patrick both students at GSA.

1925
Stanley Cursiter appointed Keeper of the National Galleries of Scotland, in charge of the Portrait Gallery.
Kirkcaldy Art Gallery founded.
S. J. Peploe, Leslie Hunter, F. C. B. Cadell and J. D. Fergusson, group exhibition of works, the Leicester Galleries, London.
Gillies joined staff of ECA.
Johnstone showed two works at RSA and awarded Carnegie Travelling Scholarship; studied in Paris under Lhote.
Epstein's *Rima* exhibited at GI.

1926
Hugh Adam Crawford won a Rome Scholarship from GSA.
Benno Schotz, first solo exhibition at the Reid Gallery, Glasgow.
GI included graphic works by Gill, Beaumont, Hermes, J. Nash, Pellew, Raverat, Stanton and Underwood.
Gillies appointed part-time lecturer at ECA.
Hunter visited South of Franch with Fergusson and met Dunoyer de Segonzac.

1927
Craigmillar Scottish Historical Pageant.
Opening of Scottish National War Memorial, designed by Robert Lorimer; sculpture by Carrick, Pilkington Jackson, Phyllis Bone, G. and A. Meredith Williams and Hazel Armour; glass by D. Strachan.
RSA included eleven French works from Manet to Segonzac.
Peploe elected RSA.
MacTaggart elected to Society of Eight.
SSA exhibited modern Swedish sculpture and decorative arts through Pilkington Jackson's

Cover of *The Modern Scot* (Vol.I, No.2, summer 1930), subtitled 'The Organ of the Scottish Renaissance'. This issue included essays by William McCance, Hugh MacDiarmid and P. Morton Shand

contact with Carl Milles.
John Maxwell studied under Léger and Ozenfant at the Académie Moderne in Paris.

1928
Bain visited Paris.
Death of Mackintosh.
Fergusson visited USA.
S. J. Peploe exhibition of paintings at C. W. Kraushaar Art Galleries, New York.
Hunter visited St Paul de Vence; Peploe painted at Antibes; Peploe and Hunter painted at Cassis.
SSA included nine works from Michael Sadler's collection, nine Viennese works and fabric designs by Morton Sundour.

1929
George Leslie Hunter exhibition at Ferargil Galleries, New York.
Fergusson moved to Paris.
John Summerson and Maxwell joined staff of ECA.
Johnstone returned from California and painted *A Point in Time*.
GI showed works by Modigliani, van Gogh, Utrillo, Pascin, Manguin and watercolours by Mackintosh.
RSA showed works by Epstein, Skeaping, Hepworth ('Fantails'), Nevinson, Cedric Morris, Winifred Nicholson, William Roberts, Paul Nash.
SSA showed Derain, Segonzac, Matisse, Nevinson, Nash, Wadsworth ('Sentimental Geometry') etc.

1930
James Whyte opened gallery in St Andrews which showed the work of Johnstone and McCance. Whyte also edited/published *The Modern Scot*.
McCance became Controller of the Gregynog Press, Newtown, Montgomeryshire.
Cursiter appointed Director of National Galleries of Scotland.
The Royal Commission on Museums and Galleries supported Cursiter's idea for a Gallery of Modern Art for Scotland.

Andrew Grant bequeathed £20,000 to ECA to fund travel scholarships and fellowships.
RSA exhibited French figurative sculpture including works by Despiau, Bernard, Pompon, Navellier and Drivier.
NGS purchased Bourdelle's *Vierge d'Alsace*.
GI included works by Pompon, Vuillard, Cézanne, Laurencin, Dufresne, Matisse, Monet, Manet, Utrillo and Gauguin.
SSA invited Yugoslav art exhibition to Edinburgh from London.

1931
GI included works by de Chirico, Gaudier-Brzeska, Despiau and Whalen.
SSA showed twelve works by Edvard Munch, selected by the artist; it was his first exhibition in Britain. R. H. Morton was largely responsible for this coup. Works by Ben and Winifred Nicholson also shown.
Les Peintres Ecossais exhibition of works by Peploe, Fergusson, Hunter, Cadell, Telfer Bear and R. O. Dunlop at Galerie Georges Petit, Paris.
Robert Matthew and Basil Spence joined staff of ECA.
RSA included section of Belgian sculpture and seven works by the late William Crozier.
Herbert Read, Watson Gordon Professor of Fine Art at Edinburgh University, gave inaugural lecture, 'The Place of Art in a University'.

1932
The Board of Trustees of the NGS included the provision of a separate gallery of modern art as part of its development policy.
SSA attempted to borrow proposed contemporary German art exhibition from Tate Gallery. When postponed (later cancelled), Polish art shown instead. Read suggested SSA should sponsor an exhibition of Matisse.
Town Planning department founded at ECA by Frank Mears (son-in-law of Patrick Geddes).
SSA exhibition included Epstein's *Genesis* and sculpture by Hepworth and Dobson.
Hubert Wellington appointed Principal of ECA.
Gillies elected to the Society of Eight.
Alexander and Rosalind Maitland purchased Gauguin's *Paysage exotique, Martinique*.

1933
C. R. Mackintosh Memorial Exhibition, McLellan Galleries, Glasgow.
Swedish and Norwegian sculpture shown at the GI and RSA.
Mellis studied with Lhote in Paris.
Peploe taught life-drawing at ECA.

1933–39
Tait designed St Andrew's House, Edinburgh.

1934
An anonymous benefactor proposed to finance a purpose-built gallery of modern art but an appropriate site not available.
SSA exhibition featured twenty-five works by Paul Klee due to efforts of Maxwell and Gillies. The show also included works on paper by Matisse, Picasso and Dali.
RSA included Danish sculpture section.
Lorimer spent winter with Eric Gill as postgraduate sculpture student.

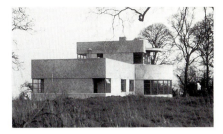

Dr King's house at Easter Belmont, Edinburgh, designed by Basil Spence, 1934

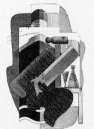

Cover of the exhibition catalogue *Scottish Everyday Art* held at the Royal Scottish Museum, Edinburgh 1936

1935
William Wilson studied contemporary stained glass in Germany.
RSA included Henry Moore's *Reclining figure* in Hornton stone, and works by Maillol, Epstein, Gill and Dobson.
SSA showed pictures by Braque and Soutine.
Perth Museum and Art Gallery opened.
Death of Peploe.
William Johnstone, first solo exhibition, Wertheim Gallery, London followed by exhibition at Aitken Dott, Edinburgh.
James Cowie, first solo exhibition, McLellan Galleries, Glasgow.
Contemporary Scottish Painting exhibition, The Gallery, St Andrews, including works by Percy Bliss, Cowie, Crawford, Johnstone, McCance.

1936
Scottish issue of *The Studio* (Vol.CXII, No.520).
Cursiter called for Gallery of Modern Art such as MOMA New York 'where students could broaden their outlook by witnessing at first hand the results of contemporary endeavour'.
RSA featured section on contemporary German sculpture, including Barlach, Kolbe, Lehmbruck.
Exhibition of Scottish Everyday Art at the Royal Scottish Museum, selected and designed by Basil Spence (assisted by Scottish Committee, Council for Art and Industry).
Alexander and Rosalind Maitland purchased Gauguin's *Les Trois Tahitiennes*.
SSA included six Gaudier-Brzeska works and works by Picasso, Dufy and Frances Hodgkins.

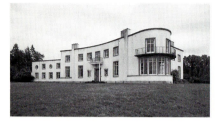

Gribloch, Kippen, Stirlingshire, designed by Basil Spence with Perry Duncan, 1938. Front and rear views

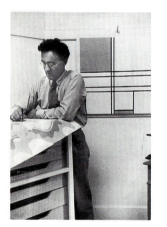

Alastair Morton in his studio, 1937. Behind him is Mondrian's **Composition** 1932–36

1938 Empire Exhibition at Bellahouston Park, Glasgow

1937
SSA featured Surrealism, including paintings by de Chirico, Dali, Picasso and ten by Max Ernst. W. Kininmonth exhibited a 'Model, A Gallery for Scottish Modern Art' in the same room.
Gear studied with Léger on travelling scholarship to Paris.
'Constructive Art' by Jackson, Piper, Nicholson, Stephenson, Holding, Moore and Hepworth featured at Edinburgh University's Fine Art Society's 2nd annual *Exhibition of Modern Art*, Minto House, Edinburgh.
Death of Cadell.

1938
Empire Exhibition at Bellahouston Park, Glasgow, attracted 13.5 million visitors. Tait (Controlling designer); Jack Coia and Spence among the architects; Whalen, Lorimer, Archibald Dawson, Crosbie and Crawford among the commissioned artists.
Cursiter drew up plans for new Arts Centre incorporating not only a gallery of modern art but also space for craft, industrial design, film, performance and exhibition rooms for a historical collection of Scottish art.
Spence attempted to obtain loan of contemporary Italian art for SSA.
Cowie became warden of the Patrick Allan-Fraser School of Art, Hospitalfield House, near Arbroath.
GI featured Swedish architecture.
Aberdeen Art Gallery acquired works by Wood, Wadsworth, Stanley Spencer, Sickert, Bevan, Hitchens.

1939
Exhibition of Scottish Art held at RA, London.
Exhibition of *20th century German Art* (reduced version of exhibition held at Burlington Galleries, London in 1938) at McLellan Galleries, Glasgow, organised by Saltire Society.
T. J. Honeyman became Director of Glasgow Art Gallery and Museum.
The French government purchased works by Peploe, Fergusson and Hunter.
Fergusson moved to Glasgow.
Wilson completed series of stained-glass panels for Caledonian Insurance Co.
Mellis settled in Cornwall, became involved with St Ives group.

1940
Stanley Spencer commissioned, as Official War Artist, to make paintings based on Lithgow's shipyard, Port Glasgow. From 1940–46 he produced a major series of paintings on shipbuilding.
Jankel Adler and Josef Herman settled in Glasgow.
New Art Club formed in Glasgow with Fergusson, Bain and Margaret Morris.
Barns-Graham moved to St Ives.
Alan Reiach drew up plans for Museum of Modern Art for Scotland, privately commissioned by Cursiter (who also made model). Project abandoned on account of the war.

1941
Josef Herman, solo exhibition at J. Connell & Sons, Glasgow.
RSA included contemporary Polish painting.
The Centre opened by David Archer in

Thomas Tait's Tower at the 1938 Empire Exhibition, Glasgow

Interior of Scottish Pavilion (South) at the 1938 Empire Exhibition, Glasgow

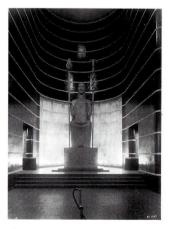

Thomas Whalen's **Service** in the Scottish Pavilion (North) at the 1938 Empire Exhibition, Glasgow

The bronze founder George Mancini with Alexander Carrick's figures of **Safety** and **Security** for the Caledonian Insurance Company building, Edinburgh 1939

Glasgow as gallery bookshop and coffee room. Interior decorated by Adler and Herman. It exhibited work by them, Crosbie and many others.
C.H. Waddington's *The Scientific Attitude* published.

1941–45
Cursiter and Hew Lorimer organised art exhibitions for British Council at NGS in the absence of the collection. Exhibitions included *Art of our Allies* (containing works by Kokoschka and Munch), war art, child art, Scottish art and contemporary American art.
Art for the People exhibition, organised by British Institute for Adult Education at NGS included work by Nash, Wyndham Lewis, Wadsworth, Smith, Sickert, Grant, Derain, Matisse, Vlaminck, Peploe, Hunter, Fergusson, Cowie, Baird, Maxwell and Gillies.

1942
New Scottish Group sprang out of New Art Club, to show contemporary Scottish art. Members included Bain, Innes and Fergusson, who was President.
Six Scottish Artists exhibition of work by Baird, Colquhoun, MacBryde, Johnstone, Maxwell and Gillies at Reid and Lefevre, London.
John Tonge wrote important article on 'Scottish Painting' in May issue of *Horizon*.
Czech Government-in-Exile presented Kokoschka's *Zrání* 1938–40 to NGS.
Benno Schotz organised *Jewish Art* exhibition at Jewish Institute, Glasgow, including works by Chagall, Modigliani, Zadkine, Bomberg, Soutine and others.
Adler left Glasgow for London.

1943
Fergusson's *Modern Scottish Painting* published.
Herman left Glasgow for London and Paolozzi left Edinburgh to enlist.
Naomi Mitchison wrote foreword for first exhibition of New Scottish Group at McClure Gallery, Glasgow.

1944
SSA Jubilee Exhibition, 1894–1944.

1945
Hugh MacDiarmid opened third New Scottish Group show in Glasgow.
D. Y. Cameron died and bequeathed major part of his collection to NGS, including sculpture by Epstein and Gill.
RSA exhibited large group of work by Samuel Palmer.
SSA exhibited contemporary French art including Ozenfant, Léger, Lurçat, Le Corbusier, Asselin, Manessier, Metzinger, Marchand, Picabia, Picasso, Marquet, Lhote, Valadon, Gischia, Rouault, Le Fauconnier.

1946
Gillies became Head of School of Painting, ECA.
Paolozzi made first series of Dada-inspired collages.
Matisse : Picasso exhibition shown in Glasgow.
Glasgow Art Review (later *Scottish Art Review*) founded by Honeyman.
French Institute opened in Edinburgh.

1947
August-September. The first Edinburgh International Festival.
RSA showed Scottish art from 1900.
SSA showed *Modern Scottish Painting* during EIF, including works by Colquhoun, MacBryde and New Scottish Group.
Enterprise Scotland exhibition held at Royal Scottish Museum, designed by Spence.
Gear and Paolozzi moved to Paris.
Paolozzi, first solo exhibition at the Mayor Gallery, London.
Society of Artist-Printmakers showed contemporary French works, including Villon, Lhote and S. W. Hayter.
C.H. Waddington appointed Professor of Animal Genetics at Edinburgh University.

1948
The term 'Scottish Colourist' first used at a group exhibition held at T. & R. Annan & Sons, Glasgow.
Schotz participated at Battersea Park open air sculpture exhibition.
Bain designed decor for Margaret Morris's ballet *A Midsummer Night's Dream*, Glasgow.
Cursiter appointed King's Painter and Limner in Scotland, retired to Orkney.
Vuillard and Bonnard exhibition, EIF.
Van Gogh touring exhibition shown in Glasgow.
Turnbull moved to Paris.

1949
Sculpture in the Open Air organised by Glasgow Corporation and Scottish Committee of ACGB in Kelvingrove Park ; Scots sculptors included Reid Dick, Clapperton, Innes, Pilkington Jackson, Dods, Lorimer, Schotz, Whalen ; British sculptors included Durst, Ledward, Hepworth, Hermes, Dobson, Lambert, McWilliam, Moore, Underwood and Wheeler ; also Rodin, Bourdelle, Maillol.
EIF exhibition at RSA included thirty-eight works by Cadell, forty-four by Peploe and forty by Hunter.
Gear exhibited with COBRA group in Amsterdam.

Scots printmakers, including Armour, Cheyne, Fleming, Laing, Lucas, Lumsden, Orr, Paterson, Tod and Wilson showed at *Exposition Internationale de la Gravure Contemporaine*, Petit Palais, Paris.
James Pryde memorial exhibition, RSA.
Paolozzi and Turnbull returned to London and for a while shared a studio.

1950
SSA included section on German Expressionist painting, featuring Kirchner, Kokoschka, Marc, Pechstein, Klee, Beckmann, Schmidt-Rottluff, Heckel, Nolde, Macke and Feininger.
RSA showed contemporary Norwegian painting and Italian sculptors Manzù, Greco and Marini.
Alan Davie, first solo exhibition at Gimpel Fils, London.
Paolozzi, Turnbull and Kenneth King, group exhibition at Hanover Gallery, London.
Edward Baird 1904–49, exhibition organised by Scottish Committee of ACGB.

1951
Secretary of State for Scotland announced that the Gallery of Modern Art would be built on the York Buildings site in Queen Street, Edinburgh.
Festival of Britain, London included a fountain designed by Paolozzi. Gear won a prize for abstract landscape in exhibition *Sixty Paintings for '51*. Show also included works by Colquhoun, Gillies, MacBryde and Maxwell.
Whalen designed 'Coal' reliefs for Spence's pavilion of Industry in Glasgow.
RSA showed contemporary English works by Smith, Weight, Spear, Hitchens, Clough, Burra, Scott, Minton, Richards, Sutherland, Tunnard, Vaughan, Heron, Moynihan, Nicholson and Hepworth.
Eardley visited Catterline for first time.

1952
Glasgow Art Gallery purchased Salvador Dali's *Christ of St John of the Cross*.
Ecole de Paris exhibition arranged by British Council for Scottish Committee of ACGB.
Degas, EIF exhibition at RSA sponsored by Festival Society and Arts Council.
RSA exhibited Sickert and his contemporaries.
Paolozzi presented *Bunk* slide show and lecture at ICA, London.

Installation of works for the exhibition *Sculpture in the Open Air*, Kelvingrove Park, Glasgow 1949

William Gillies, c.1955

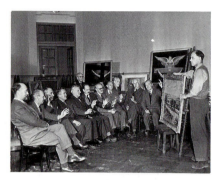

Selection Committee at the RSA, 26 March 1959. Seated from left to right are: J. Miller, J. McIntosh Patrick, J. Murray Thomas, W. MacTaggart, A.A. McGlashan, R. Henderson Blyth, W. Kininmonth, L.G. MacDougall, D. Moodie, E. Schilsky and N. Forrest. Note the Dali-inspired **Crucifixions** behind

Joan Eardley at Catterline, c.1961–63

1953
Renoir, EIF exhibition at RSA.
Lorimer carved figures for façade of National Library of Scotland.
The Expressionists, private collection of German Expressionists shown by Scottish Committee of ACGB.

1954
The University Club at 127 Princes Street considered as a temporary gallery of modern art but Government unable to provide finance.
Scottish Committee of ACGB published a catalogue of its collection of contemporary Scottish painting, and organised shows of *William MacTaggart, J. D. Fergusson* and *Charles Rennie Mackintosh*.
New Names in French Art shown at T. & R. Annans, Glasgow (from Arthur Tooth's Gallery, London).
Cézanne, EIF exhibition at RSA.
RSA included Francis Bacon's *The Cardinal* and works by Adler.
SSA included works by de Staël, Hartung, Soulages, Lanyon, Gear, Vieira da Silva, Pasmore and Mathieu.
Eardley showed seventeen works in a group show at Parson's Gallery, London.

1955
William Keswick began installing his private collection of sculpture at Glenkiln, Dumfriesshire, including pieces by Rodin and Epstein and Moore's *King and Queen*.
Gauguin, EIF exhibition at RSA.
RSA included Eric Estorick's collection of modern Italian art.

1956
Braque, EIF exhibition at RSA.
RSA included eight works by Henry Moore.
SSA included loan show of twenty-five works by Nicolas de Staël.

1957
Georges Braque elected Hon. RSA.
RSA included contemporary Paris-based artists.
Foundation of the 57 Gallery, Edinburgh by Daphne Dyce Sharp, Patrick Nuttgens, John Houston and others as a co-operative for contemporary Scottish artists.
Monet, EIF exhibition at RSA.
SSA had loan exhibition of *Jack B. Yeats* and annual show included works by Frink and Hepworth.
James Cowie 1886–1956 memorial exhibition, Scottish Committee of ACGB.

1958
The Scottish Modern Arts Association dispersed its collection on loan.
Inverleith House proposed as a temporary gallery of modern art.
Jack Knox in Paris studying with André Lhote.
Robert Colquhoun retrospective at Whitechapel Art Gallery, London (March–May).
Alan Davie retrospective at Whitechapel Art Gallery, London (June–August).
SSA loan exhibition of *Tachisme*, including works by Appel, Davie, Dubuffet, Francis, Jenkins, Jorn, Mathieu, Riopelle, Sugai and Tàpies.
The Moltzau Collection: From Cézanne to Picasso, EIF exhibition at RSA.

RSA included twenty works by Matthew Smith.

1959
The Government announced the foundation of the Scottish National Gallery of Modern Art to be housed temporarily in Inverleith House. The 'management of a Gallery of Modern Art in Edinburgh' added to the functions of the Trustees of NGS and a Grant-in-aid of £7,500 voted for the Gallery's acquisitions.
Craigie Aitchison, first solo exhibition at Beaux-Arts Gallery, London.
Jim Haynes's Paperback Bookshop opened in Edinburgh; it became a centre for avant-garde art, literature and discussion.

1960
10 August. The Scottish National Gallery of Modern Art opened by Sir Kenneth Clark.
Trustees purchased Henry Moore's *Reclining Figure (two piece) 1960*.
Maitland Gift of twenty-one 19th- and 20th-century French paintings made to NGS in memory of Rosalind Maitland.
Gillies became Principal and Robin Philipson Head of Painting at ECA.
The Blue Rider Group, EIF at RSA.

1961
Douglas Hall appointed first Keeper of SNGMA.
Schotz appointed Queen's Sculptor in Ordinary for Scotland following death of Sir William Reid Dick.
Epstein memorial exhibition, EIF in Waverley Market.
Scottish painting from 17th century to the early 20th century exhibition, GAGM.
Henry Moore exhibition SNGMA.
Robin Philipson, EIF exhibition, Scottish Gallery, Edinburgh.
GI included works by Moore, Paolozzi, Tilson, Bacon, Davie, Colquhoun, Nicholson, Herman, Gear, Richards, Heron, Moynihan and Pasmore.
Ian Hamilton Finlay and Jessie McGuffie founded The Wild Hawthorn Press.

1962
SNGMA exhibitions included *Collection of Dr R. A. Lillie, Contemporary British Sculpture, Paul Klee, Keith Vaughan, Helen Sutherland Collection*.
Lillie Gallery, Milngavie, opened.
Sonja Henie-Nils Onstad Collection, EIF, RSA.
Foundation of Scottish Opera.

1963
SNGMA exhibitions included *German Expressionist Prints, John Maxwell*.
Traverse Theatre Club, Edinburgh opened.
Richard Demarco invited to start an art gallery in the Traverse building, St James's Court, Royal Mile, for 'the interpretation and presentation of art . . . which is new, unknown, experimental and excellent'. Mark Boyle's junk reliefs shown in Traverse restaurant.
EIF, Theatre of the Future, International Drama Conference, McEwen Hall, University of Edinburgh. Included *In Memory of Big Ed*, Happening by Ken Dewey (performers *i.a.* Mark Boyle and Allan Kaprow).
New Charing Cross Gallery, Glasgow founded by Bet Low, John Taylor, Cyril Gerber and

Tom Macdonald (closed 1968 when site was redeveloped).
Robert Colquhoun memorial exhibition, Douglas & Foulis Gallery, Edinburgh.
Bellany and Moffat hung their paintings on railings in Castle Terrace during EIF.
Twentieth Century Scottish Painting, ACGB touring exhibition.
John Maxwell 1905–1962 and *Robert Colquhoun 1914–1962* exhibitions organised by Scottish Committee of ACGB.

1964
Joan Eardley RSA (1921–1963) memorial exhibition, Scottish Committee of ACGB, shown at GAGM and RSA.
Traverse Festival Exhibition of International Contemporary Art included Mark Boyle. Traverse Festival Gallery, 97–99 George Street, Edinburgh (temporary). Traverse Gallery opened in St James Court building in October 1964.
Mark Boyle and Joan Hills: first replica of a section of ground surface.
Contemporary Danish Painting and Sculpture. The Funen Painters EIF, Danish Institute, Edinburgh.
Delacroix at EIF, RSA.
Bellany and Moffat showed paintings on railings outside RSA during EIF.
Joan Eardley memorial exhibition, Scottish Gallery, Edinburgh.
Edvard Munch; *Lyonel Feininger*; ±*30 Contemporary Scottish Art*; *Dr Peter Davis Collection*, exhibitions, SNGMA.

1965
Contemporary Scottish Printmakers, EIF, 57 Gallery, Edinburgh.
Bellany and Moffat exhibition outside RSA during EIF.
Arshile Gorky; *Sam Francis and Richard Diebenkorn*; *Contemporary Scottish Painters*; *J. D. Fergusson*; *Victor Pasmore*; *Julius Bissier*; and *Giorgio Morandi* exhibitions, SNGMA.
Art and movement: an international exhibition, ACGB touring exhibition shown at RSA and GAGM.
Sir D. Y. Cameron 1865–1945 centenary exhibition, Scottish Committee of ACGB, at GAGM.
Anne Redpath memorial exhibition, Scottish Committee of ACGB.
Jasper Johns: lithographs, Traverse Gallery exhibition, EIF, Morton House, Edinburgh.

1966
Ian and Sue Finlay settled at Stonypath, nr Dunsyre, Lanarkshire and proceeded to transform the grounds into a neo-classical sculpture garden, which they later renamed 'Little Sparta'.
Richard Demarco Gallery opened, 8 Melville Crescent, Edinburgh.
'Auto-Destructive Art' event by Ivor Davies at Drill Hall, Forrest Road, Edinburgh; prelude to DIAS (Destruction in Arts Symposium) season held in London.
Rouault, EIF exhibition, RSA.
Paolozzi; *Jean Dubuffet*; *Christopher Wood*; *20 Italian Sculptors*, exhibitions SNGMA.
William Crozier and Alan Davie, Scottish Committee of ACGB exhibition.

1967
Extension considered for SNGMA at Inverleith House.
Name 'Scottish Arts Council' first used.
The 1st Edinburgh Open 100 organised by RDG, University of Edinburgh, EIF and SAC. David Hume Tower, University of Edinburgh.
Foundation of Edinburgh Printmakers Workshop.
International Open Air Sculpture Exhibition, Dunfermline Festival and Carnegie Dunfermline Trust, Pittencrieff Park, Dunfermline, included Moore, Hepworth, Lorimer, Schotz, Whalen, Scott and Turnbull. First conference on public sculpture.
Open Air Sculpture, SAC and National Trust for Scotland at Crathes Castle, Culzean Castle, Inverewe Gardens and Falkland Palace.
Derain, EIF exhibition at RSA.
Nicolas de Staël; *Sculptor's Drawings*; *Chinese painting*; *The artist and the book in France*, exhibitions, SNGMA.
Sixteen Polish Artists and *Contemporary Italian Art*, exhibitions, RDG.

1968
Compass Gallery opened in Glasgow by Cyril Gerber.
Canada 101, RDG, EIF and Canada Council at ECA.

Alexander Moffat and John Bellany with paintings exhibited outside the Royal Scottish Academy during the 1965 Edinburgh Festival

Ivor Davies about to perform a controlled explosion at the *Destruction in Arts Symposium*, Army Drill Hall, Edinburgh, 1 September 1966

Open air show of avant-garde sculpture, presented by Richard Demarco at Hopetoun House, EIF.
Emil Nolde; *Sir William MacTaggart*; *New Painting in Glasgow 1940–46*, exhibitions, SNGMA.
Three Centuries of Scottish Painting, National Gallery of Canada, Ottawa.
Young Scottish Contemporaries 4th annual exhibition; *Rory McEwan glass sculptures*; *Alan Davie retrospective*; *Geometric abstraction . . . optic and kinetic art*; *Wilhelmina Barns-Graham*; *John Wells*, exhibitions RDG.
Charles Rennie Mackintosh 1868–1928 exhibition, EIF at Royal Scottish Museum; *The Glasgow Boys* exhibition, SAC.

1969
Contemporary Scottish Art, RDG and Saltire Society, Hamilton. *Pat Douthwaite*; *Ian Hamilton Finlay*, *4 Romanian Artists*; *Arthur Boyd retrospective*; *William Scott*; *William Crozier*; *Paul Neagu*, exhibitions RDG
Mark Boyle launched *Journey to the Surface of the Earth* with object of duplicating 1000 randomly selected portions of the earth's surface.
Bruce McLean, first solo exhibition, Konrad Fischer Gallery, Düsseldorf.
Contemporary Polish Art exhibition, SNGMA.
Modern Art from Scottish Houses, inaugural exhibition, SAC Gallery, Edinburgh.
Publication of C.H. Waddington's *Behind Appearance. A study of the relation between painting and the natural sciences in this century.*

1970
Joseph Beuys performance on Rannoch Moor in preparation for his concert/performance *Celtic (Kinloch Rannoch) Scottish Symphony*, EIF, RDG.
Strategy: Get Arts, RDG with EIF and Düsseldorf Kunsthalle, an exhibition at ECA of works, events, concerts, films and environments by twenty-five artists living and working in Düsseldorf.
RDG organised performances and events at the Grail Art Centre, George Street, Edinburgh.
The Talbot Rice Art Centre opened, Old College, University of Edinburgh.

Joseph Beuys on Rannoch Moor, May 1970, in preparation for the Performance of *Celtic (Kinloch Rannoch) Scottish Symphony*. Beuys is seen rolling a ball of butter

Joseph Beuys's Performance of *Celtic (Kinloch Rannoch) Scottish Symphony* at Edinburgh College of Art, August 1970

Joseph Beuys **The Pack** at Edinburgh College of Art, August 1970 during the exhibition *Strategy: Get Arts*

1971
Eduardo Paolozzi retrospective, Tate Gallery.
Bruce McLean, first solo show in Britian, Situation Gallery, London.
Scottish realism: John Bellany, Robert Crozier, William Gillon, Ian Macleod and Alexander Moffat, SAC touring exhibition.
The Belgian Contribution to Surrealism, EIF exhibition RSA.
Magritte and *Julio Gonzalez* exhibitions, SNGMA.
Romanian Art Today (including Horia Bernea, Ion Bitzan and Paul Neagu); *5 Belgian Artists* (including Marcel Broodthaers); *Hamish Fulton*; *William McCance retrospective*, RDG exhibitions.

1972
York Buildings reaffirmed as site for new SNGMA. 1978 proposed as commencement of construction.
Original Print, first travelling exhibition of Edinburgh Printmakers Workshop.
Bruce McLean: King for a Day exhibition, Tate Gallery.
Aleksander Zyw; *Ian Hamilton Finlay*; *Henri Gaudier-Brzeska* exhibitions, SNGMA.
Atelier 72, RDG, EIF and Lødz Museum of Art, group show by forty-two Polish artists at RDG.

Tadeusz Kantor and his Cricot 2 Theatre, RDG, EIF.
Unlikely Photography, an exhibition of scientifically-based extensions of photography, SAC and ICA, London.
Futurismo 1909–19, SAC at RSA.

1973
Collins Exhibition Hall (later Gallery) opened at University of Strathclyde, Glasgow.
Glasgow Print Studio founded.
Onwin commenced salt marsh works (SAC exhibition *Saltmarsh*, 1975).
Maclean commissioned to do *Ring-Net* series.
Robin Philipson, President of RSA.
William Johnstone; *Bridget Riley*; *Earth Images*; *Edvard Munch*, exhibitions, SNGMA.
Edinburgh Arts 73, RDG and University of Edinburgh Department of Experimental Studies, included Joseph Beuys's *12 hour lecture*. Other lecturers included Tadeusz Kantor, Patrick Reyntiens, Hugh MacDiarmid, George Melly.
The Austrian Exhibition included Arnulf Rainer, Günter Brus, Hermann Nitsch, Peter Weibel and Valie Export, RDG, EIF.
RDG began long collaboration with Galleria del Cavallino, Venice.

1974
Marc Chagall and Henry Moore elected Hon. RSA.
Peacock Printmakers founded in Aberdeen, Arthur Watson first director.
Aachen International 70–74: works from the Ludwig collection, exhibition SAC, EIF at RSA.
Richard Hamilton; *Jim Dine*; *Roger Hilton*, SAC exhibitions.
Aspects of Abstract Painting in Britain 1910–1960, EIF at TRAC.
Alan Johnston, solo exhibition, Von der Heydt Museum, Wuppertal.
Henry Moore: Complete Graphic Work 1931–72; *Agnes Martin*; *François Morellet*; *Joseph Beuys*; *Paul Nash*; *Richard Long*; *Paul Klee* and *We are making a new world: 1st world war art in Britain* exhibitions, SNGMA.
Scottish Prisoners' Art, exhibition of work from the Special Unit of H.M. Prison, Barlinnie, EIF at RDG.
Joseph Beuys: 3 Pots Action, RDG, Forrest Hill, Edinburgh.
Oil Conference EIF at RDG.

Tadeusz Kantor's production of *The Water Hen*, Edinburgh Festival, August 1972

1975
Edinburgh Ten 30: the Work of ten Edinburgh artists, 1945–75, SAC and WAC.
The Goethe Institute, Glasgow, established (formerly Scottish-German Centre).
Glenshee Sculpture Park, Braemar founded. (First permanent sculptures installed 1983.)
Third Eye Centre, Glasgow founded.
Fruitmarket Gallery, Edinburgh founded and run by SAC (became independent 1984).
Sol Lewitt; *Duncan Grant*; *Wassily Kandinsky*; *Anne Redpath*, exhibitions, SNGMA.
Scottish Sculpture '75, RDG at FMG.
Aspects '75, RDG and City Art Galleries Zagreb, forty-nine artists and actions by Marina Abramović and others at FMG and RDG.
Stanley Spencer: War Artist on Clydeside 1940–45, SAC exhibition, TEC.

1976
MacLaurin Art Gallery, Ayr, opened.
Graeme Murray Gallery, Edinburgh founded.
Dan Flavin exhibitions, EIF, SAC and SNGMA.
Paolozzi touring exhibition, ACGB.
Tadeusz Kantor and Cricot 2: *The Dead Class*, RDG performance at ECA, EIF.
The future of Video in Scotland, SAC Conference, Glasgow.
Mark Boyle; *Inscape (I. H. Finlay, E. Lawrence, W. Maclean, G. Onwin, F. Stiven, A. Yule)*, exhibitions at FMG.
Glasgow University commissioned Paolozzi to design doors for new Hunterian Art Gallery.
The Land; *Merlyn Evans 1910–1973*; *The Edward James Collection*; *Prunella Clough: recent paintings*, exhibitions, SNGMA.
Kurt Schwitters exhibition, New 57 Gallery.

1977
Announcement of the purchase of former John Watson's School by the Crown Estate Commissioners and agreement of Secretary of State for Scotland that Government would lease the building for a new Gallery of Modern Art.
Crawford Centre for the Arts founded at St Andrews University.
Easterhouse Festival Society, Glasgow founded.
Workshop and Artist's Studio Provision (Scotland) Ltd (WASPS) founded; studios in Glasgow, Edinburgh, Aberdeen and Dundee.
Stills, the gallery of the Scottish Photography Group, opened in Edinburgh.
Four Abstract Artists (George Abercrombie, Alan Gouk, John McLean and Fred Pollock); *Ken Dingwall*, exhibitions, FMG.
People of the 20th century: photographs by August Sander, EIF, Scottish Photography Group at TRAC.
Boyd Webb exhibition, Graeme Murray Gallery.
The Modern Spirit: American Painting 1908–1935 exhibition, EIF at, RSA.
Joan Eardley exhibition, EIF at, RSA.
The Sculpture of de Kooning exhibition, FMG.
Expressionism and Scottish painting, SAC Collection and *Marcel Broodthaers: Books, Editions, Films* exhibitions, New 57 Gallery.
Graphic Art of German Expressionism exhibition, GAGM with Goethe Institute.
The Human Clay exhibition, SNGMA.

Glen Onwin making **Salt Room** on the occasion of his touring exhibition *Recovery of Dissolved Substances*, 1978. The 5 × 5m underground room was not on public view and its location not disclosed

1978

Plans for conversion of John Watson's held up, SNGMA opening postponed.

369 Gallery founded by Andrew Brown, 369 High Street, Edinburgh.

Highland Sculpture Park established at Carrbridge, Inverness-shire by the newly founded Scottish Sculpture Trust.

Stirling started the *Smith Biennial* exhibition, open to artists in Scotland.

Mark Boyle represented Britain in the 39th Venice Biennale.

Painters in Parallel, SAC, EIF, seventy-six 20th-century Scottish artists, exhibition chosen by Cordelia Oliver at ECA.

Paul Strand: the Hebridean Photographs exhibition, Stills Gallery and tour.

Another World: Wölfli, Aloise, Müller; *Will Maclean: The Ring Net* exhibitions, TEC.

Pat Douthwaite and Lindsay Kemp exhibition, 369 Gallery.

The Scottish Arts Council Travelling Gallery established.

The Photographers Image exhibition, EIF, SAC, at ECA.

Liberated Colour and Form: Russian Non-Objective Art 1915–22; *Bernard Lassus: The Landscape Approach*; *Alastair Morton and Edinburgh Weavers*; *James Cowie: the artist at work*; *Glen Onwin* exhibitions, SNGMA.

1979

The Pier Arts Centre, Stromness, Orkney opened.

Alan Davie: magic pictures exhibition, EIF, Scottish Gallery, Edinburgh.

Kandinsky: the Munich Years 1900–14 exhibition, EIF, SAC Gallery.

Otto Gutfreund 1889–1927 exhibition, SAC Gallery.

Ulrich Rückriem and *Joel Fisher* exhibitions, Graeme Murray Gallery.

Stanley Cursiter exhibition, Scottish Gallery, Edinburgh.

Wilhelm Lehmbruck; *Giacometti's 'Femme Egorgée'*, exhibitions, SNGMA.

1980

Work on plans for conversion of John Watson's for SNGMA delayed to allow consideration of Williams' Committee Report on National Museums and Galleries in Scotland.

Scottish Sculpture Workshop opened at Lumsden, Grampian; Fred Bushe first director.

City Art Centre, Edinburgh re-opened in Market Street.

Master Weavers: tapestry from the Dovecot Studios 1912–1980 exhibition, EIF, SAC, at RSA.

Barry Flanagan exhibition, EIF, New 57 Gallery, Edinburgh.

William Johnstone retrospective, ACGB, Hayward Gallery, London and TRAC.

New New Mexico, contemporary art from New Mexico exhibition, FMG.

Donald Bain memorial exhibition, Glasgow Print Studio.

Nature over again after Poussin: some discovered landscapes, prepared by Ian Hamilton Finlay and Sue Finlay, Collins Exhibition Hall, Glasgow.

Bruce McLean (exhibition and performance), and *Watermarks: Robert Callender and Elizabeth Ogilvie* exhibitions, TEC and FMG.

Paolozzi commissioned to design mosaics for Tottenham Court Road tube station.

1981

Secretary of State announced that conversion of John Watson's for SNGMA to proceed.

Robert Colquhoun exhibition, CAC and touring.

Contemporary abstraction: survey of younger Scottish artists exhibition, New 57 Gallery, Edinburgh.

Elizabeth Blackadder and *James Cowie*, SAC touring exhibitions.

American Abstract Expressionists. Works from MOMA New York, exhibition, EIF at CAC and FMG.

Edvard Munch: Paintings from the Munch Museum, Oslo; *Who Chicago?*; *Käthe Kollwitz: The Graphic Works* and *The avant-garde in Europe 1955–70: The collection of the Stäedtisches Museum, Moenchengladbach*, exhibitions SNGMA.

First *Scottish Sculpture Open* at Kildrummy Castle, Grampian, organised by Scottish Sculpture Workshop.

1982

Federation of Scottish Sculptors founded, Bill Scott first secretary.

Expressive Images (Murdena Campbell, Steven Campbell, Simon Fraser, Alastair Hearsum, Scott Kilgour, Mario Rossi and Andrew Walker); *Margaret Mellis. Constructions, paintings, reliefs 1940–80*; *David Mach* exhibitions, New 57 Gallery, Edinburgh.

Scottish Art Now (Michael Docherty, Graham Durward, John Kirkwood, Jack Knox, Derek Roberts, Ian McKenzie Smith) exhibition, EIF at FMG.

Steven Campbell moved to New York (returned to Glasgow 1986).

Steven Campbell, first solo exhibition at Barbara Toll Fine Arts, New York.

Miró's people: Joan Miró . . . 1920–1980; *Max Beckmann: Die Hölle*; *Henri Matisse: Jazz*; exhibitions, SNGMA.

Mayfest spring arts festival began in Glasgow.

1983

Burrell Collection, Glasgow: new building opened by H.M. The Queen; architect Barry Gasson.

Vienna 1900 exhibition, EIF and National Museums of Scotland, York Buildings, Queen Street.

Soviet Stage Design 1917–1982; *The Edinburgh Group*, exhibitions, CAC.

4 North East Artists, Peacock Printmakers touring show.

David Nash Sculptures exhibition, TEC.

Mülheimer Freiheit Proudly Present the Second Bombing; *Sandro Chia*, exhibitions, FMG.

Housing Art in the 21st Century, Richard Demarco conference with international participants.

Jack Knox . . . 1960–63, SAC touring exhibition.

Transmissions Gallery opened in Glasgow.

1984

15 August, SNGMA moved to refurbished John Watson's building, Belford Road, Edinburgh; opening exhibition *Creation: Modern Art and Nature*.

Inverleith House, Edinburgh, home of the Scottish National Gallery of Modern Art from 1960–84. Seen through William Turnbull's **Gate 2**

Scottish National Gallery of Modern Art at its new home in Belford Road, Edinburgh. Opened in 1984

1st Scottish Print Open, Edinburgh Printmakers Workshop.
Adrian Wiszniewski, first solo exhibitions at Compass Gallery, Glasgow and AIR Gallery, London.
Judy Chicago: The Dinner Party, Victoria Hall, Victoria Street, Edinburgh.
Kate Whiteford: Rites of Passage exhibition, TEC.
Richard Deacon Sculpture and *Francesco Clemente: Pastels* exhibitions, FMG.

1985
Cramond Sculpture Park opened at Dunfermline College of Education, Edinburgh.
Redfern became Artist-in-Residence, National Gallery, London.
New Image – Glasgow (Barclay, Campbell, Currie, Howson, Ross and Wiszniewski) exhibition, TEC and British tour.
Steven Campbell, solo exhibition; *Per Kirkeby*; *Komar and Melamid*; *Christopher Lebrun*; *Mary Kelly* and *Richard Tuttle* exhibitions FMG.
2nd Scottish Print Open, Peacock Printmakers, Aberdeen.
S. J. Peploe 1871–1935 (EIF); *L'Ecole de Paris: Art in Paris 1900–1960*; *German Expressionist Prints* exhibitions, SNGMA.
Colour, Rhythm and Dance, Paintings and drawings by J. D. Fergusson and his circle in Paris, SAC touring exhibition.

1986
Eduardo Paolozzi appointed Her Majesty's Sculptor in Ordinary for Scotland.
Young Sculpture Symposium, Scottish Sculpture Workshop, Lumsden.
Alison Wilding exhibition, TEC.
David Mach created a *Parthenon* from 10,000 rubber tyres in Princes Street Gardens during Spring Fling, Edinburgh's spring festival.
Ken Currie commissioned to do mural for People's Palace, Glasgow.
Mark Boyle and family exhibition, Hayward Gallery, London and tour.
3rd Scottish Print Open, Dundee Printmakers Workshop.
Bill Woodrow Sculpture exhibition, FMG.
John Bellany exhibition, EIF, SNGMA.

1987
Richard Demarco Gallery moved to larger premises at Blackfriars Street, Edinburgh.
Inverness Printmakers Workshop opened.
The Unpainted Landscape, SAC touring exhibition.
Luciano Fabro; *A. R. Penck*; *Gwen Hardie*; *David Salle*; *Enzo Cucchi*; *Alan Johnston* exhibitions, FMG
4th Scottish Print Open, Glasgow Print Studio.
The Vigorous Imagination: New Scottish Art (Ainsley, Braham, Campbell, Colvin, Conroy,

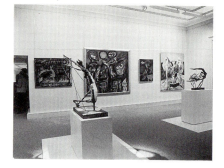

Creation: Modern Art and Nature. Opening exhibition at the Scottish National Gallery of Modern Art, 1984. Photograph shows sculptures by Richier and César and paintings by Appel, Jorn, Constant and Bellany

Currie, Hardie, Howson, Hughes, Mach, McIntyre, O'Donnell, Redfern, Rossi, Urie, Whiteford, Wiszniewski) exhibition, EIF, SNGMA.
Art of our Time: the Saatchi Collection exhibition, EIF at RSA.
Edinburgh International: Reason and Emotion in Contemporary Art, SAC exhibition selected by Douglas Hall, Martin Kunz and Michael Compton, RSA.

1988
Glasgow Garden Festival, Scottish and European sculpture sited throughout grounds.
First Fruitmarket Open exhibition, FMG.
Ken Currie exhibition, TEC.
Joan Eardley exhibition, EIF, TRAC and RSA.
Hew Lorimer exhibition, TRAC.
Glen Onwin: Revenges of Nature exhibition, FMG and TEC.
Francis Picabia 1879–1953 and *The Magic Mirror: Dada and Surrealism from a Private Collection*, exhibitions organised by SNGMA during EIF at RSA.
Lucian Freud; *Alexander Moffat: Portraits of Painters* exhibitions, SNGMA.
Ian Hughes Artist-in-Residence, SNGMA (exhibition 1989).

1989
Contemporary Scottish Painting, 369 Gallery and hosted by The Palace of Youth, Moscow.
Bacon, Baselitz, Kiefer: an important group of works on loan; *Antony Gormley* exhibitions, SNGMA.
Second Fruitmarket Open exhibition, FMG.

Selected Bibliography

1908

Sir James Caw: *Scottish Painting-Past and Present 1620–1908*, London 1908

1936

The Studio, Vol.CXVI, No.520, 1936 issue devoted to Art in Scotland contains: Stanley Cursiter: 'The National Collections', Ian Finlay: 'Everyday Art in Scotland', H. Harvey Wood: 'Contemporary Scottish Painting and Sculpture'

1938

John Tonge: *The Arts of Scotland*, London 1938
The Editor, 'What I think of Glasgow's Empire Exhibition' in *The Studio*, Vol.CXVI, No.545, August 1938

1939

Exhibition of Scottish Art. Exhibition catalogue, Royal Academy of Arts, London 1939

1942

John Tonge: 'Scottish Painting' in *Horizon*, May 1942

1943

J.D. Fegusson: *Modern Scottish Painting*, Glasgow 1943

1946

T.S. Halliday and George Bruce: *Scottish Sculpture: A Record of Twenty Years*, Dundee 1946

1947

William MacLellan: *The New Scottish Group*, Glasgow 1947

1948

Ian Finlay: *Art in Scotland*, London 1948
Ian Finlay: *Scottish Crafts*, London 1948

1949

Stanley Cursiter: *Scottish Art to the Close of the Nineteenth Century*, London 1949

1950

H. Harvey Wood: 'Contemporary Scottish Art' in *Scottish Art Review*, Vol.3, No.1, 1950
Stanley Cursiter: *Scottish Painters*. Exhibition catalogue, British Council in association with the Toledo Museum of Art and the National Gallery of Canada 1950
T.J. Honeyman: *Three Scottish Colourists. Peploe, Cadell, Hunter*, Edinburgh 1950

1961

Exhibition of Scottish Painting. From the early 17th Century to the early 20th Century. Exhibition catalogue, Glasgow Art Gallery and Museum 1961

1962

J.D. Fergusson: 'Memories of Peploe' in *Scottish Art Review*, new series, Vol.8, No.3, 1962

1963

Douglas Hall: *20th Century Scottish Painting*. Exhibition catalogue, Arts Council of Great Britain, London 1963

1964

David Irwin: 'A Revived Glasgow School' in *Scottish Art Review*, Vol.9, No.4, 1964

1965

Catalogue of Paintings. Kirkcaldy Museum and Art Gallery, Kirkcaldy 1965
William Buchanan: 'The Gallery At Langholm' in *Scottish Art Review*, Vol.10, No.1, 1965

1966

David Baxandall: 'The Maitlands and their Tastes' in *Apollo*, No.83, April 1966

1967

A Man of Influence. Alex Reid 1854–1928. Exhibition catalogue, Scottish Arts Council 1967
Douglas Hall: 'The Scott Hay Bequest to the Scottish National Gallery of Modern Art' in *Scottish Art Review*, Vol.11, No.2, 1967

1968

New Painting in Glasgow 1940–46. Exhibition catalogue, Scottish Arts Council touring exhibition 1968
The Permanent Collection Catalogue, Aberdeen Art Gallery 1968
Kenneth Coutts-Smith: 'Scottish Painting in London' in *Scottish Art Review*, Vol.11, No.3, 1968

1970

T.J. Honeyman, W.R. Hardie, Ailsa Tanner: *Three Scottish Colourists*. Exhibition catalogue, Scottish Arts Council, Edinburgh 1970
William R. Hardie: *Seven Painters in Dundee*. Exhibition catalogue, Scottish Arts Council, Edinburgh 1970
William R. Hardie: 'Painting in Dundee' in *Scottish Art Review*, Vol.12, No.3, 1970
'Art in Edinburgh' in *The Edinburgh Scene*, No.1, 1970

1971

The Edinburgh School. Exhibition catalogue, Edinburgh College of Art 1971
T.J. Honeyman: *Art and Audacity*, London 1971
Andrew Hannah: 'Collecting in Scotland Today' in *Scottish Art Review*, Vol.13, No.1, 1971

1972

15 Years of the '57 Gallery. Exhibition catalogue, New 57 Gallery at the University of Edinburgh 1972

1973

Alastair Auld: *Scottish Painting 1880–1930*. Exhibition catalogue, Glasgow Art Gallery and Museum 1973
Catalogue of the Permanent Collection. Dundee City Art Gallery, Dundee 1973

1974

Stanley Cursiter: *Looking Back. A Book of Reminiscences* (privately printed) Edinburgh 1974
Margaret Morris: *The Art of J.D. Fergusson*, Glasgow 1974

1975

Edward Gage: *Edinburgh Ten 30: The work of ten Edinburgh artists 1945–75*. Exhibition catalogue, Scottish Arts Council and Welsh Arts Council 1975
William Packer: *Scottish Sculpture '75*. Exhibition catalogue, Richard Demarco Gallery at the Fruitmarket Gallery, Edinburgh 1975

1976

Esme Gordon: *The Royal Scottish Academy, 1826–1976*, Edinburgh 1976
William Hardie: *Scottish Painting 1837–1939*, London 1976
1966–1976: 10th Anniversary Exhibition. Exhibition catalogue, RDG, Edinburgh 1976

1977

Edward Gage: *The Eye in the Wind: Contemporary Scottish Painting since 1945*, London 1977
Scottish National Gallery of Modern Art. Concise catalogue, Edinburgh 1977

1978

Cordelia Oliver: *Painters in Parallel*. Exhibition catalogue, Edinburgh College of Art 1978
Objects and Constructions. Selected Contemporary Scottish Sculpture, Scottish Arts Council at Edinburgh College of Art 1978

1979

Elizabeth Cumming: *City of Edinburgh Collection Concise Catalogue*, 2 Vols, Edinburgh 1979
Douglas Hall: 'Twentieth Century Painting' in *Companion to Scottish Culture*, ed. D. Daiches, Edinburgh 1979
Jack Firth: *Scottish Watercolour Painting*, Edinburgh 1979

1980

Peter Savage: *Lorimer and the Edinburgh Craft Designers*, Edinburgh 1980
Madelaine Jarry and others: *Master Weavers. Tapestry from the Dovecot Studios 1912–1980*. Exhibition catalogue, Edinburgh International Festival, Edinburgh 1980

1981

Benno Schotz: *Bronze in my Blood*, Edinburgh 1981
Ian Fleming and Ann Whyte: *Great Scottish Etchers*. Exhibition catalogue, Aberdeen Art Gallery 1981

1982

Scottish Art Now. Exhibition catalogue, Scottish Arts Council, Edinburgh 1982

1983

John Kemplay: *The Edinburgh Group*. Exhibition catalogue, City Art Centre, Edinburgh 1983

1984

Hugh MacDiarmid: *Aesthetics in Scotland*, Edinburgh 1984
Fiona Sinclair: *Scotstyle: 150 Years of Scottish Architecture*, Edinburgh 1984
J. Neil Baxter: 'Thomas S. Tait and The Glasgow Empire Exhibition 1938' in *The Thirties Society Journal*, No.4, 1984
100 Paintings. Aberdeen Art Gallery & Museums, Aberdeen 1984

1985

Roger Billcliffe: *The Glasgow Boys. The Glasgow School of Painting 1875–1895*, London 1985

Alexander Moffat: *New Image Glasgow*. Exhibition catalogue, Third Eye Centre, Glasgow 1985

Edinburgh and Dublin 1885–1985. Exhibition catalogue, Edinburgh College of Art 1985

1986

Pamela Robertson: *From McTaggart to Eardley. Scottish Watercolours and Drawings 1870–1950*. Exhibition catalogue, Hunterian Art Gallery, Glasgow 1986

Philip Wright: *New Art from Scotland*. Exhibition catalogue, Warwick Arts Trust, London 1986

Julian Halsby: *Scottish Watercolours 1740–1940*, London 1986

Scottish Sculpture Open 3. Exhibition catalogue, Cramond Sculpture Park, Edinburgh 1986

1987

4th Scottish Print Open. Exhibition catalogue, Glasgow Print Studio 1987

Charles McKean: *The Scottish Thirties: an Architectural Introduction*, Edinburgh 1987

The Vigorous Imagination. Exhibition catalogue, Scottish National Gallery of Modern Art, Edinburgh 1987

Douglas Hall and Andrew Brown: *Twentieth Century Scottish Painting*. Exhibition catalogue, 369 Gallery, Edinburgh 1987

1988

The Scottish Show. Exhibition catalogue, Glynn Vivian Art Gallery, Swansea 1988

Andrew Brown and others: *Art in Scotland 1987*. Book published on the occasion of the tenth anniversary of the 369 Gallery, Edinburgh 1988

Jude Burkhauser and others: *The Glasgow Girls: Women in the Art School 1880–1920*. Exhibition catalogue, Glasgow School of Art 1988

Perilla Kinchin and Juliet Kinchin: *Glasgow's Great Exhibitions 1888, 1901, 1911, 1938, 1988*, Wendlebury, Oxon 1988

Edward Lucie Smith and others: *The New British Painting*. Exhibition catalogue, Cincinnati Arts Center, Oxford 1988

Graeme Murray ed: *Art in the Garden. Installations. Glasgow Garden Festival*. Graeme Murray Gallery, Edinburgh 1988

Fiona Byrne-Sutton: *New Sculpture in Scotland*. Exhibition catalogue, Cramond Sculpture Centre, Edinburgh 1988

Shape + Form. 6 Sculptors from Scotland. Exhibition catalogue, Collins Gallery, Glasgow 1988

Lenders

Aberdeen Art Gallery & Museums

Dundee Art Galleries & Museums

City of Edinburgh Art Centre

Trustees of the National Library of Scotland

The Royal Commission on the Ancient & Historical Monuments of Scotland, Edinburgh

The Royal Scottish Academy, Edinburgh

Scottish Arts Council Collection, Edinburgh

369 Gallery, Edinburgh

Cyril Gerber Fine Art, Glasgow

Ewan Mundy Fine Art, Glasgow

Glasgow Museums & Art Galleries

Glasgow School of Art

Glasgow University Archives

Hunterian Art Gallery, University of Glasgow

The Royal College of Physicians & Surgeons of Glasgow

Kirkcaldy Art Gallery & Museum

Arts Council Collection, South Bank Centre, London

The Fine Art Society plc, London

Robert Fleming Holdings Limited, London

Francis Graham-Dixon Gallery, London

Trustees of the Tate Gallery, London

Waddington Galleries, London

Laing Art Gallery, Newcastle upon Tyne (Tyne and Wear Museums Service)

University of Stirling

John Bellany

John and Halla Beloff

Mrs Ruth Christie

James Cosgrove

The Viscount Cowdray

Alan Davie

Joanna Drew

Alan Gouk

Sean Hignett

James Holloway

Hew Lorimer RSA, OBE, LLD

Mrs Margaret McCance

Benedict Read

Mr & Mrs R. Macdonald Scott

William Turnbull

and various private collectors who prefer to remain anonymous

Photographic Credits

Photographs of works in the SNGMA collection are by Antonia Reeve, Tom Scott, Jack McKenzie and Annan. Other photographs have been provided by:

City Art Centre, Edinburgh

Ivor Davies

Richard Demarco Gallery, Edinburgh

Andy Dewar

Dundee Art Galleries & Museums

Fine Art Society plc, London

Francis Graham-Dixon Gallery, London

Cyril Gerber Fine Art, Glasgow

Gimpel Fils Ltd, London

Glasgow Museums & Art Galleries

Catrina Grant

Sean Hudson

Hunterian Art Gallery, University of Glasgow

Lady Hutchison

Kirkcaldy Art Gallery & Museum

Laing Art Gallery, Newcastle upon Tyne

Hew Lorimer

Marlborough Fine Art Ltd, London

Alexander Moffat

National Portrait Gallery, Edinburgh

Ron O'Donnell

Elizabeth Ogilvie

Colin Read

John Reiach

John Riddy

Royal Commission on the Ancient & Historical Monuments of Scotland

Royal Scottish Academy

Scottish Arts Council

Tate Gallery, London

369 Gallery, Edinburgh

University of Stirling Art Gallery